Reflections on the
history of art

Other books by E.H.Gombrich

In German: *Weltgeschichte*
With E.Kris: *Caricature*
The Story of Art
Art and Illusion
Meditations on a Hobby Horse
Norm and Form
Aby Warburg
Ideas of Progress and their Impact on Art
Symbolic Images
With R.Gregory: *Illusion in Nature and Art*
The Heritage of Apelles
Means and Ends
The Sense of Order
Ideals and Idols
The Image and the Eye
Tributes
New Light on Old Masters
Kokoschka in his Time

E.H.Gombrich

Reflections on the history of art

Views and reviews

edited by
Richard Woodfield

University of California Press
Berkeley · Los Angeles

University of California Press
Berkeley and Los Angeles, California

First published in volume form 1987 by Phaidon Press Limited, Oxford
This edition © Phaidon Press Limited 1987

Library of Congress Catalog Card Number 87-10795

ISBN 0-520-06189-6

Typeset and printed in Great Britain at The Bath Press, Avon

to Ilse Gombrich

The Editor and the Publishers wish to thank the following for permission
to reprint articles:
Architectural Association Journal (chapter 28); *Art Bulletin* (Appendix);
Burlington Magazine (chapters 4, 5, 8); *Encounter* (Chapter 32); *Journal
of Aesthetics and Art Criticism* (chapter 6); *Journal of the Warburg and
Courtauld Institutes* (chapter 9); *London Review of Books* (chapter 15);
Museum (chapter 27); *The Observer* (chapters 16, 31); *Revue de l'art*
(chapter 14); *Times Literary Supplement* (chapters 2, 12, 23). Chapters
1, 3, 7, 10, 11, 13, 17, 18, 19, 20, 21, 22, 24, 25, 29, 30 are reprinted
with permission from *The New York Review of Books* (copyright ©
1965–1985 Nyrev, Inc.)

Contents

Foreword

There is a special kind of knowledge which readers of surveys and textbooks rarely come across: it is the large body of accumulated wisdom which surrounds the practice of a discipline. This knowledge surfaces most frequently in book reviews, which serve as a kind of quality control department or experimental workshop for the academic world. It has, then, been a very pleasant surprise to discover that over the years Sir Ernst Gombrich has published a considerable number of reviews in literary journals. Unfortunately this knowledge is easily lost when it appears in publications which have a limited shelf-life in libraries, are quickly damaged and are easily stolen.

This volume is intended to give permanent form to a selection from Sir Ernst's reviews and related articles; it should interest general reader and specialist alike. It will supplement *The Story of Art* by providing an introduction to the world of art books, photographs, exhibitions and museums. Historians of art will find it a useful addition to the collected edition of his work, amplifying and reinforcing his views.

Some minor stylistic modifications have been made for the sake of consistency and illustrations have been added where necessary to support the text. There is a technical appendix for the benefit of readers interested in the current debates over the application of semiotic theories to the visual arts.

I am indebted to Peg Katritzky and the staffs of Trent Polytechnic and Nottingham University for their assistance and to Simon Haviland for his advice. I owe a special debt to Sir Ernst Gombrich, who gave me a completely free hand in the selection and presentation of the texts.

Richard Woodfield

Nottingham, January 1987

The art of the Greeks

There is a famous story in Plutarch's *Life of Aristides*, telling how this virtuous Athenian was asked by an illiterate voter to scratch the name of Aristides on a potsherd because he wanted him banished. 'But what harm has he done you?' asked the statesman. 'None', said the man, 'but I am tired of hearing him everywhere called the Just.' Needless to say, Aristides complied and went into exile.

For several generations now Greek art has laboured under a similar handicap. It was all but ostracized for having been called perfect too often. The plaster casts of famous antiques which were used in the academic tradition for the training of artists became the all too vulnerable symbols of cramping authority. Small wonder that most of them have now been shoved into attics if they were not actually smashed in an orgy of iconoclastic glee. Even the civilization which had given rise to these images did not fare better. Dubuffet, the spokesman of *l'art brut*, summed up this attitude conveniently in an interview he gave some time ago: 'If I am right that what is called "civilization" consists in the degeneracy of the values of savagery I consider it harmful. Long live savagery. . . . As to classical art which is so much revered, I am sorry, but I find it poor and devoid of tension. . . . It lacks depth . . . it is a parlour game.'

The large crop of books on Greek art which have been published in the last few years suggests that this reaction may be ebbing. But the source of this new interest is probably neither the art school nor the museum. It is Greece itself. Until recently it was a remote and inaccessible country, but now an ever increasing stream of tourists travelling with organized tours under expert guidance or singly under their own steam are visiting the mainland and the islands. If they have heard of M. Dubuffet's strictures and have ever suffered by being made to draw from plaster casts—which is doubtful—such memories will soon fade away on the Acropolis or in Delphi. They will come home with the desire to learn more about Greek art and to revive and fortify the impressions gained during their brief trip.

In most respects the five large picture books published here by Messrs. Abrams will admirably meet this demand. They all follow an identical plan, skilfully designed to appeal to a large public without alienating the specialist. In the aggregate they provide well over a thousand plates of monochrome and nearly two hundred colour photographs by Max Hirmer, who is a master of his craft. Each volume contains an informative Introduction by a specialist and an appendix of detailed notes on the plates complete with bibliography, ground plans, reconstructions, and all the apparatus of learning. The fact that the texts are translated inevitably impairs their readability slightly but care has obviously been taken, so that in one case the translator of the text on Greek vases, B. Shefton, himself a specialist, has also revised the original. It should not imply a lack

Originally published under the title 'The Art of the Greeks' in the *New York Review of Books*, 6 January 1966, as a review of Helmut Berve and Gottfried Gruben, *Greek Temples, Theatres, and Shrines*; R. Lullies, *Greek Sculpture*; Ernest Langlotz, *Ancient Greek Sculpture of South Italy and Sicily*; Paolo Enrico Arias, *A History of 1000 Years of Greek Vase Painting*; Spyridon Marinatos, *Crete and Mycenae*; G. M. A. Richter, *The Portraits of the Greeks*; and Joseph Veach Noble, *The Techniques of Painted Attic Pottery*.

of gratitude for this achievement if the question is here asked about the limits of the information imparted by this type of book. There are really two questions here. What do the objects themselves tell us in their present state of preservation, and what can the illustrations convey about the objects? Both of these questions obtrude themselves with particular insistence when one looks at the fine book on *Greek Temples, Theatres, and Shrines* by Helmut Berve and Gottfried Gruben. The sight of ruins is invariably moving, particularly if we approach them with the right associations. But how much do they tell us? Any room looks larger when furnished than empty, any house which is lived in acquires a different scale from that of its bare foundations. The shelter provided by an enclosure, the meaning connected with a room and its function, all this transforms our perception. The scattered bones of a building may yield a certain amount of information to the archaeologist. For the layman they are probably more misleading than evocative. This applies least of all to the great temple structures that are reasonably intact, but even here we should not deceive ourselves. The appearance of these shrines in antiquity must have been radically different.

Mr Berve's Introduction provides excellent factual information about the main religious centres of Greece, but if anywhere it is here that this information has to be supplemented by imagination. The simple fact that animal sacrifices were the centre of the ritual suggests how the senses must have been assailed by the stench of burning flesh and fur and by the lowing of cattle or the squealing of kids. How little we actually know of this aspect of ancient life of which the memory was so thoroughly eradicated by victorious Christianity! But one thing we do know. Where we see majestic isolation there were crowds and clutters of monuments and offerings. In this respect the text of the ancient guidebook to these shrines by Pausanias assists the imagination more than any photograph of their present condition. No modern traveller to Greece should neglect this source. The list of monuments he gives—and sometimes he gives little more than lists—suggests a traffic jam of statues inside and outside the temples which must have been overwhelming in its variety and confusion. A visit to one of the great centres of pilgrimage in the modern world may here help the traveller more than a walk around the deserted sites of Delphi or Olympia. How much can the photographs tell us of these sites? Some of Mr Hirmer's plates of Crete and of Greece are beautiful indeed. His colour plate of the Palace of Phaistos, for instance, with the fertile plains and the mountain range in the background is convincing and so is his colour plate of verdant Olympia from the high ground above Druwa. Where he fails is where the camera must fail; in the attempt to record and convey the unique setting of Delphi. No single view nor any succession of views can succeed here, for on that sun-drenched sloping terrace beneath the rocky peak of Parnassus we are not only aware of the wide vistas extending from the mountains to the distant sea, but also of the deep and inaccessible valley far down with its half-hidden river wending through the dense vegetation.

Clearly the camera had an easier task in recording decorative detail and works of sculpture. Once more, though, it may be useful to remind ourselves that few works of Greek sculpture have come down to us as they were intended to look. It is well known by now that stone sculpture was tinted and that eyes were either painted in or made of different material. Mr Hirmer deserves our special gratitude for a number of informative colour plates showing painted statuary and bronzes with seeing eyes. He has also succeeded in many monochrome plates in conveying something of the magic of marble surfaces. It is obvious that the information the camera can give with a single shot of a sculpture in the round is limited. What is a little less obvious perhaps is that such a series of plates has altogether a certain levelling effect. Precisely because these photographs are to some extent works of art in their own right, they make us look at the illustration of a humble terracotta figurine in a similar frame of mind as at the picture of a towering masterpiece. The inevitable assimilation of scale that reduces the monumental and blows up the small object adds to this drawback, which is not shared by the much maligned plaster cast.

Looked upon as objects, Greek vases, the subject of Mr Arias's book, are undoubtedly among the best preserved of Greek relics. Some of them surely look today as they looked when they left the workshop. The reason for their durability and the secrets of their workmanship, by the way, are well set out in a recent publication by The Metropolitan Museum of Art, the learned book by Joseph Veach Noble on *The Techniques of Painted Attic Pottery*. Its most engaging illustrations show Greek potters as they are represented on vases or Greek pottery in the context in which it was used. Unfortunately these well-preserved products of an industry that frequently reflected the discoveries of the major arts present a compensating difficulty to the photographer which is not even fully discussed in Mr Veach Noble's brief section on the photographer's problems. The paintings on the rounded bodies of these vessels can never be reproduced without some distortion. Those on the bottom of bowls fare relatively best, because they are nearly flat, but there are many illustrations in both these volumes in which heads of figures are squashed and foreshortened because they lie on the shoulder of the vase. Some beautiful details in *Greek Vase Painting* partly make up for this shortcoming but here the problem of scale begins to obtrude once more.

Moreover, to return to the Abrams series as a whole, it is the inevitable fate of any anthology that the information it can provide is discontinuous. Every lover of Greek art will miss some of his special favourites. There are only two vases from Boston here and none from Vienna. The number of Greek original statues being more limited, Mr Lullies's *Greek Sculpture* is more representative. That of Mr Langlotz on *Ancient Greek Sculpture of South Italy and Sicily* is particularly welcome because it covers a smaller body of less famous material more fully. Paradoxically, a special word of thanks is due to Spyridon Marinatos, the author of the volume on *Crete and*

Mycenae, for his omissions. He has largely excluded from the plates the heavily restored and partly invented murals which the discoverer of Knossos, Sir Arthur Evans, presented to the world with such enthusiasm and conviction. Instead we are given some delightful colour plates illustrating the incomparable taste and craftsmanship of Cretan potters.

There are two sources of information about Greek art which are not tapped in these beautiful anthologies—the two in fact which loom largest in traditional accounts of this subject—Roman copies and the literary sources that allow us to spot among these copies the reflections of some of the most famous lost masterpieces of the ancient world. One can understand the reaction against this traditional approach in which so much erudition frequently yielded so little solid evidence. And yet a valid history of Greek art can scarcely be written without taking cognizance of such works as Myron's *Discobolos* or Praxiteles' *Apollo Sauroktonos*, both of which are preserved in so many copies that we can claim to know pretty well what the originals must have looked like.

In this respect the scholarly work by G. M. A. Richter on *The Portraits of the Greeks* provides a radical contrast to the volumes discussed above. Miss Richter treats her great subject in the traditional way, collecting literary evidence and assembling the copies of portraits, basing her identification on descriptions and inscriptions. Moreover she aims at completeness, at least in her catalogues, and at very full coverage in the illustrations. Consequently the plates of these three volumes are less appealing than Mr Hirmer's photographs (there are only a few full-page illustrations) but they are more soberly informative. Most busts are shown *en face* and in two profiles and though this arrangement sometimes recalls the police record it also brings home to the student how different the same piece of sculpture may look in expression and even in quality when viewed from different angles. Miss Richter's book also allows us to form our own opinion about the value of Roman copies. Though unfortunately we have no work among the portraits where the original as well as Roman replicas are preserved, the degree of variety among the copies gives a good measure of their general reliability. They do not come off too badly. Who would want to miss that incomparable evocation of Demosthenes of which the catalogue lists forty-seven certain and twelve doubtful examples in the round and which she documents with 103 illustrations? Miss Richter describes the technique of these copyists with their pointing apparatus and makes it appear likely that plaster casts of the originals were used in the Roman workshops.

How much information do these portraits give us about the real appearance of famous Greeks? The question of what constitutes a good likeness is one of the most elusive of all questions connected with art. There is no doubt that statues were erected to public figures ever since the end of the sixth century. It is usual to say that these early monuments must have been mere types, but surely this is a matter of degree. Even the faces that smile at us from the windows of

a suburban photographer may strike us as types and so they are, because we all unconsciously try to mould our appearance according to some standard of decorum. Greek culture was certainly pervaded by this ideal of conformity. It is true that an author of the late fourth century, Theophrastus, includes among the tiresome features of the obsequious flatterer his habit of praising the likeness of his host's portrait, but would we also find it a likeness? Miss Richter is optimistic. She would like to think that the actual features of great men were often handed down in sketches from the life, and many years later embodied in the statues erected in their honour. It may be useless to speculate here. Even the reference to literary descriptions of their appearance may be deceptively circular, since some of these may be based on the imaginary portraits. But is this not a case where ignorance is bliss? Some great men look disappointing, either because physiognomics is fallacious or, as Socrates is said to have maintained, commenting on his own ugly face, because their mind overcame the base physical dispositions which their features truly reveal. Hence the conviction that has been current at least since the Italian Renaissance, that a portrait can be more like the sitter than he is himself. Hence, also, the desire and the skill of ancient artists to visualize the features of poets, thinkers, and lawgivers whose outward appearance was certainly beyond recall—notably those of Homer, who may or may not have been a real personage. There is a beautiful passage in the Encyclopaedia of the Elder Pliny where he discusses the ancient custom of placing the portraits of authors in libraries—the custom to which we owe so many of the replicas illustrated in Miss Richter's book. 'Our desire', he says, 'brings forth even the images of those whose features have not come down to us; for it seems to me that there is no greater kind of happiness than always to wish to know what someone was like.'

These are words that should be pondered. For in a sense they may serve as a motto not only to any book on ancient portraiture (an opportunity missed by Miss Richter, who does not quote them); they point beyond the portrait to the mainspring of ancient art, the desire for visualization. It is this desire that informs the miraculously vivid descriptions in Homer no less than the mythological narratives on black-figured vases, as early as the *François Vase* of c. 750. Mr Arias's commentary on the relevant plate keeps closely to the fact when he describes, for instance, the scene of the Athenians liberated by Theseus returning by boat to their homeland: 'There is great commotion amongst the crew, much gesticulation and joy, and a number of them have risen and let go their oars. Indeed one of them has jumped into the water and with rapid strokes is making for land. On land there is a dance of seven maidens and seven youths, each with their name against them.' Lively as are the pictorial chronicles of the ancient Orient recording campaigns and proclaiming victories, none of them exhibits this 'noble desire of wanting to know what it was like' when Gods and Heroes mixed with mortals. The Greek evocation of a myth or of a genre scene demands to be interpreted and dwelt upon, it asks for our collabor-

ation and our empathy which will bring it to life. At least from the sixth century onwards Greek art appeals to our imagination, by implying more than it can show. Every genuinely narrative illustration must be thus supplemented by us along several dimensions—by extending that of time we can see the figures move, by supplying that of space we can relate them to each other, and by projecting life into them we give their gestures and expressions meaning. It was to aid the beholder in this vital act of projection and reconstruction that the Greek artists embarked on that momentous campaign of conquest that enabled them to embody more and more cues in their paintings and statues. How keen competition must have been in this race towards a new perfection is shown by a famous inscription on a vase of Euthymides in Munich of c. 510, illustrated in the book of Arias and also quoted by Veach Noble: 'Never did Euphronios do anything like this.' It was a proud boast, for Euphronios is still regarded as one of the greatest pioneers of that generation; but Euthymides' picture of dancing revellers with the complex torsions of their bodies, one of them seen half from the back, obviously filled the artist with justified pride. The joy and movement of the dance is indeed most vividly conveyed.

It was at the same time that the sculptors' statues were also seen to 'come to life'. We sense the tension of the muscles under the surface, we see the play of the body under the garment, we feel the presence of a mind behind the smile. In discussing the illusions created by art, art historians (including this writer) have concentrated too much on the pictorial inventions of foreshortening, perspective, or light and shade, and failed to analyse the illusion of life that a Greek statue can give. It is not a delusion, of course. We are not 'taken in', as we may be by a wax figure in suitable setting. And yet it is hard to remain conscious of the fact that we look at an opaque block of stone rather than at a breathing body beneath the clinging drapery. There is an illusion of transparency, created by such masterpieces as the sculptures from the Parthenon, the Caryatides of the Erechtheion, and the balustrade of the Temple of Nike in Athens: the vivid illusion of a figure underneath the folds and of pulsating life underneath the skin.

In art the ends shape the means, but the means also shape the ends. There is no doubt that the discovery how to evoke such figures of dream-like beauty must have spurred the artists to further efforts. 'Never did Phidias do anything like this.' They were working for a public used to discussing physical beauty and perfection particularly of the young male body. The glorification of victors in sacred athletic contests demanded that step into fantasy we call misleadingly 'idealization'. What art could offer here is a dream image of flawless perfection that was not lifeless but animated and convincing. The illusion was created that such a being could exist and that its fair body reflected a captivating mind. If the relics of that art did not proclaim this aim, we could read about it in contemporary sources. For this is precisely what Xenophon conveys in two little dialogues in which he introduces Socrates talking to artists. Stripped

of their rather mechanical question-and-answer form they tell us that artists can imitate nature, but that when creating beautiful images they select the best features of different bodies so as to make their figures look beautiful. Moreover, as Socrates insists, they create the semblance of life, 'the flesh wrinkled or tense, the muscles taut or loose' and by token of this same skill they can, through the study of expression, represent 'the activities of the soul'. 'The most pleasing sight of all', we read, 'is that of a human being who looks beautiful, good and lovable.'

One cannot glance through the plates of Mr Hirmer's photographs without being convinced of the importance of this testimony (which none of the authors quotes). It is important because it explains both the world-wide influence of the Greek discovery of an art of beautiful illusions, and of the revulsion against it. To the sixteenth and seventeenth centuries it was a matter of course that the laws of beauty had been discovered once and for all and were enshrined in the famous statues of antiquity. But it was Winckelmann in the eighteenth century who stripped this assertion of its metaphysical armature and openly praised the erotic charm of Greek statues. Like his contemporary Edmund Burke he took it for granted that the feeling of beauty has its instinctual roots in our reaction to a healthy youthful body. It is a theory bound to mobilize resistance, and Winckelmann made this resistance easier by overstating his case. To him there was only one such perfection, the Greek canon of beauty. Put in these naturalistic and anthropological terms, it was easy for the Romantic reaction to dislodge the Greek ideal by pointing to the variations which the ideal of human beauty has undergone at different times and places. The gothic ideal notoriously contrasts with that of Rubens and the features praised in Indian love poetry would not win a beauty contest in the West. The argument appeared to be so convincing that art historians and archaeologists have long since expunged the word beauty from their vocabulary. It sounds so much safer to talk of 'plastic values' or 'closed forms' than to use the language Socrates used in his talk to artists. Nobody wants to revive the gush, not even that of Winckelmann. But a fear of M. Dubuffet's strictures should not prevent us from breaking this taboo and admitting that Greek art tries to place us face to face with the illusion of beauty at its most enthralling, most human and most unreal. The relativity of this illusion can surely be overstated. Granted that the canon varies, to deny the common core in this experience would mean to deny the unity of mankind. We know far too little about these things, less than ever perhaps, since talk of sex has replaced talk of beauty.

Is it true that members of other cultures and traditions would not be charmed by some of the plates in these books? It would be worth trying out. Put them on your coffee table by all means, but whether your visitors will come from the North, South, East, or West, I bet that once they have opened one of them, the coffee will get cold.

Chinese landscape painting

This attractive volume grew out of Michael Sullivan's Oxford Slade Lectures of 1974, which must have given his audience much pleasure. It is intended 'for anyone who loves art but knows little about Chinese painting, and would like to approach a little closer to one of the greatest artistic traditions of the world.' Written with evident warmth and sincerity, the text surmounts many of the obstacles which might have thwarted this purpose.

The first obstacle lies in the nature of the subject-matter itself. Some of the greatest monuments of the Chinese landscape tradition are hand scrolls of considerable length which were meant to be viewed (from right to left) by unrolling and rolling one section after the other. Works of this kind elude reproduction in a small format and so the author had to confine himself to details of scrolls, or preferably to hanging scrolls and album leaves which can more easily be fitted on to a conventional page. Even here, though, in the small and inevitably rather indifferent reproductions, little survives of the subtlety and force of the originals and it is a measure of Professor Sullivan's power of persuasion that we believe him when he says that a pale fragment of a scroll captioned 'Travelling Up-river in Mid-winter' 'gives such a vivid sense of a river journey in North China in the depth of winter that it makes us shiver to look at it.'

The same sense of involvement stands the author in good stead in the narrative sections of the book and makes the reader almost forget the tour de force needed to tell a story extending over some two thousand years in seven brief chapters. It is a story which, as the author reminds us, cannot be told without reference to the history of China, the rise and fall of dynasties and the consequent shifts in the centres of cultural activity. We are made to see the impact of these vicissitudes on the lives and position of the artists. From the beginning the history of art in China is rich in personalities about whom the sources give us many vivid character traits and biographical incidents: his panorama is enlivened by a number of thumb-nail sketches of those eccentric scholar-painters who carried the tradition of the art which concerns him.

Professor Sullivan is aware that his very skill in presenting an integrated picture has its pitfalls. Writing about the masters of the Southern Sung who had withdrawn to Hangchow after the fall of Kaifeng, he suggests that 'even the spring blossoms on the ancient plum trees by the waterside seem to express a poignant yearning, a struggle for survival rather than a joyful sense of renewal'. 'I do not know'—he continues—'if I am reading too much into these haunting pictures, and I have perhaps deliberately chosen ones that convey this mood. There are more cheerful ones.' Quoting some of the cynical utterances and despondent verses of the eighteenth-century master Cheng Hsieh he admits again that the painter's 'lovely paintings of bamboo and orchids give no hint of the bitterness he felt', as indeed how could they? Evocations of the *Zeitgeist* and of psycho-

Originally published under the title 'Under Western Eyes' in the *Times Literary Supplement*, 5 September 1980, as a review of Michael Sullivan, *Symbols of Eternity: The Art of Landscape Painting in China*.

logical traits are certainly useful literary devices for turning isolated facts into a coherent and memorable story, but for that very reason they tend to mask the complexities of life.

But in any case Professor Sullivan's true aims lie elsewhere. He wants to offer an interpretation of Chinese landscape art which will bring it closer to the Western reader. His title *Symbols of Eternity* offers the key to this interpretation. It is taken from the Sixth Book of Wordsworth's *Prelude* in which the poet describes his crossing of the Alps in words which strikingly recall the images of Chinese landscape paintings: '. . . The immeasurable height / of woods decaying, never to be decay'd, / the stationary blasts of water-falls, / . . . the rocks that mutter'd close upon our ears, / black drizzling crags that spake by the way-side / as if a voice were in them, the sick sight / and giddy prospect of the raving stream, / the unfetter'd clouds, and region of the Heavens, / Tumult and peace, the darkness and the light / were all like workings of one mind, the features / of the same face, blossoms upon one tree, / . . . the types and symbols of eternity, / of first and last, and midst, and without end.'

No doubt these lines show how much is universally human in the response of the Western poet and the Eastern painter to the sublimity of mountain scenery. But they might also be used to point to the difference between East and West. Wordsworth feels crushed by the overwhelming power of divine omnipotence; his emotion is rooted in dread. Is that also the dominant reaction of the Chinese painter? Is it not relevant here that after all it is he who has created—or at least re-created—these symbols of eternity? The power is his to manipulate the forces of nature in magic and ritual, in gardening and in painting. Sullivan reminds us that in the early fourth century 'Royal parks were landscaped on a huge scale to suggest Mount K'un-lun to the West, the Eastern Sea, the blessed island P'eng-lai and haunts of nature deities, fairies and immortals', and that during the T'ang dynasty miniaturized landscape scenes were devised on trays, the ancestors of the Japanese *bonsai*. In like way, he suggests, 'a picture could become a mysterious thing that . . . contained the essence of the world of nature'. It was in fact in that glorious eighth century, the period of the great poets Li Po and Tu Fu, that Wang Wei, himself an outstanding poet, became the most famous landscape painter. We do not know what his paintings looked like, and no doubt later achievements were subsequently attributed to him, but the conception of the artist as a creator which he shares with his contemporary Wu Tao-tzu remains inseparable from the tradition.

Here one might think less of Wordsworth than of the chapter in Leonardo's *Paragone* entitled 'The Painter is Lord of all kinds of people and of all things': 'If he wants to look from the high peaks of mountains at a great plain and desires to see behind it the horizon of the sea he is its master; [as] if, from the deep valleys, he wants to look at the mountains . . . in fact whatever exists in the universe as essence, as presence or as imagination he has it first in his mind, and then in his hands.'

Maybe this conception is not incompatible with the interpretation

that what the artist creates are not so much symbols of eternity but rather symbols of transience. We learn in fact that the seventeenth-century painter Hung-jen was a devout Buddhist in whose landscapes the author senses the expression of the idea of his creed 'that all phenomena, the very evidence of the senses itself are illusion, *maya*, akin to a dream ... To express this notion of illusion and non-attachment in the visible forms of mountains, rocks, and trees, in such a way as to move us by their beauty would seem to be impossible. Does Hung-jen', Professor Sullivan asks, 'achieve it because, being Chinese, he is not only a Buddhist but also a Taoist, to whom nature is not mere illusion but a manifestation of the Real, to be identified with and felt in his innermost being? If we could, by sympathy and intuition, probe to the heart of this mysterious duality, we might come some way toward understanding the mind of the Chinese landscape painter.' It is a noble ambition, but is it ever capable of fulfilment? Can we 'understand the mind' of Altdorfer or of Ruysdael, and how could we be sure if we did?

One approach to this goal which the author hints at seems almost bound to lead us astray. He likes to suggest that the philosophy and the religion of the Far East have become more intelligible to us because 'we have arrived, chiefly through the physical sciences, at a view of the nature of reality that in certain fundamental respects is strikingly similar to the view that the East arrived at, through intuition and reflection, over two thousand years ago'.

Pleas of this kind do not improve with repetition. Some seventy years ago Kandinsky proclaimed that modern science had dissolved solid matter and was about to confirm the spiritual insights of Eastern wisdom. But any comparison between Taoist mysticism and Einstein's theories can never do justice to either. Unlike the mystic the modern scientist does not seek to grasp the essence of reality; he tries to construct a hypothesis that stands up to observational tests. The fact is relevant, because Sullivan also invokes the authority of Ruskin, whose conception of landscape painting he finds to be close to that of the Chinese. No doubt Ruskin expressed the hope that landscape painting might 'become an instrument of gigantic moral power', but we need only open *Modern Painters* to see where he looked for this power in the chapters 'Of Truth of Skies', 'Of Truth of Earth', 'Of Truth of Water', etc, with their notorious demonstrations of how far Turner surpassed his predecessors in the accurate observation and rendering of all these natural phenomena.

What Chinese landscape painting shows is simply that Ruskin was wrong in regarding truth to appearance as the indispensable criterion of artistic achievement, and that not because its symbols convey a deeper or higher or more essential truth but rather because all art operates with symbols. The age-old formulas for peaks, rocks, pines, waterfalls, clouds or huts can be combined, modified and refined in countless ways, they can incorporate more or less of natural appearances, but they could never serve as faithful records of a particular view without losing their identity and purpose. There is no need to apologize for the absence of perspective, all the less since

central perspective could not be reconciled with the format of a hand scroll. Chinese artists were in any case discouraged from taking this road by the view that any concession to mere realism was vulgar.

While this caveat may sound agreeable to the contemporary Western reader the lack of originality which is so apparent in the history of the genre must put him off. Professor Sullivan tries from the beginning to overcome this resistance by reminding us of the role of music in Western society: '. . . in listening to music we are, for the most part, listening to familiar works, and this does not trouble us at all. In the hands of a master interpreter each familiar work is born again and much of our pleasure comes from the performer's understanding of the theme, from subtle nuances of interpretation and, above all, his touch. In Chinese painting too . . . what matters is not the novelty of the theme . . . but the artist's interpretation of it, and the quality of his touch.' The author admits that the analogy is incomplete, but it is still illuminating, for it is indeed tempting to link the Chinese art of painting with the mastery of performance rather than with the skill of craftsmanship. This alone can help to explain the emergence of that type which has no exact parallel in the West, the scholar-painter who lays stress on his amateur status. Whatever the intellectual and social aspirations may have been of a Leonardo, a Rubens, a Poussin or a Delacroix, their virtuosity was the result of hard grind. The Chinese conception, as has often been stressed, links up with calligraphy as an art of the élite which does not depend on physical effort but rather on the personal touch.

It was from the aesthetics of this esoteric art that Chinese critics distilled their criteria of excellence in painting. That excellence, we hear in many variations, is not dependent on the formula but on the way it is infused with something else, be it spirit or force or sense of life or vitality. Western scholars have been somewhat exasperated by the vagueness and ambiguity of these alleged criteria of quality, but would it be absurd to sum them all up in the term 'magic', leaving the term to oscillate freely between the literal and the metaphorical meaning? We have all experienced the disconcerting impression of a faultless performance in the theatre or the concert hall which failed mysteriously because it 'lacked magic'. It is disconcerting precisely because we feel unable to analyse, let alone to prove this failure. But then this disability extends from art into real-life situations. However much we hope and believe that we can distinguish between an 'empty' formula and the expression of real feelings, we obviously lack the touchstone to tell the synthetic from the genuine—for any such infallible touchstone would soon put not only confidence tricksters and politicians but also actors and orators out of business. Yet critics of art, both Eastern and Western, have had to talk as if they were in possession of such a 'lie detector'.

That precious fragment of ancient rhetorical theory, the treatise on the sublime attributed to Longinus, ultimately turns on the question of how we can distinguish the genuinely sublime utterance from its counterfeit, 'frigid' bombast. The answer that the true sublime is the 'ring of a noble soul' pushed criticism towards an expressionist aes-

thetics, but strictly speaking it merely shifts the question from the performance to performer without leaving us any wiser.

It sometimes looks as if the critics of Eastern painting were trapped in a similar predicament. Faced with a tradition which is profoundly conventional they must decide when the convention is 'hollow' and when it is charged with psychic power, as no doubt it sometimes is. No wonder they are so often thrown back on subjective impressions or withdraw behind a string of tautological terms, all of which indicate the presence or absence of the mysterious soul-stuff. One cannot help feeling that here as elsewhere the critic must bolster up his confidence by using extraneous knowledge.

The illustration in Professor Sullivan's book of a landscape by Li Tang would certainly not permit us to say that it is a 'coldly monumental work' and that the brush-strokes of an earlier master have here 'hardened into a formula'. But then the painter of that landscape was the doyen of the imperial academy in the eleventh century which is accused of having created 'a gulf between officially approved court art and the kind of painting that scholar-gentlemen did for their own pleasure'. Given the bias of our time in favour of outsiders and against academies there must be a strong temptation to invest the work of the former with more expression than that of the latter. Yet those of us who are fortunate enough to remember the great Chinese Exhibition at Burlington House in 1935/36 are unlikely to forget the famous scroll 'A myriad miles of the Yangtze' by Hsia Kuei, a master whose style is also dismissed by the author for its 'immediate and obvious appeal', though we read that 'it came to represent to Laurence Binyon, Ernest Fenollosa, and other early enthusiasts the very quintessence of Chinese pictorial genius'. Were they really wrong because in China 'not everyone shared these exquisite feelings, or expressed them in such conventional terms'?

Of course we must allow Sullivan his personal taste, all the more as he helps to overcome a prejudice which was much in evidence at the time of that memorable exhibition. Visitors then used to linger in the rooms where early paintings were displayed but hurried through the remainder since they would not bother with 'late' productions. Here Professor Sullivan redresses the balance by teaching us to see the range and individuality of eighteenth-century masters who knew how to forge a personal style or styles from the rich gamut of the tradition which they studied so eagerly. It is only in the nineteenth century that he finds nothing of merit to report—a view which is not altogether borne out by the works from the Hashimoto Collection recently shown at the Museum Yamato Bunkakan of Nara. About the twentieth century the author is again eloquent and persuasive; having devoted a monograph some twenty years ago to Chinese art in the twentieth century, he pleads for an open-minded appreciation of the varied styles now practised. Naturally he has no truck with the 'cultural revolution' which all but smothered these hopeful developments, but did he have to write of Chiang Ch'ing, Mao's widow, that she 'is said' to have 'despised the masses'? To one reader, at least, this gratuitous aside introduces a jarring note into an engaging book.

3
Tribal styles

Since the days when Jean-Jacques Rousseau shook the self-confidence of Western man, the mentality and the art of simpler societies have been a potential object of nostalgic admiration. We are just celebrating the second centenary of Goethe's first publication, his passionate manifesto in favour of Strasbourg's Gothic minster. The association of the term 'Gothic' with the idea of barbarism made him exalt the art of a 'noble savage' which he could never have seen:

> And thus the savage may use weird lines, horrible shapes, strident colours for a coconut, feathers or his own body. However arbitrary these forms, they will harmonize without his knowing anything about the laws of proportion, for it was one single emotion that fused them into one significant whole. This significant art is the only true one.

Three generations later that eloquent reformer of Victorian design Owen Jones opened his sumptuous volume *The Grammar of Ornament* (1857) with an illustration of the tattooed head of a Maori woman.

> In this very barbarous practice the principles of the very highest monumental art are manifest, every line upon the face is best adapted to develop the natural features. . . . the ornament of a savage tribe, being the result of a natural instinct, is necessarily always true to its purpose. . . . if we would return to healthy conditions, we must even be as little children or savages; we must get rid of the acquired and artificial. . . .

These were the portents of an intellectual movement that was to convince Gauguin at the end of the century that sophistication suffocated creativity and made him leave for the Fortunate Isles for solace and inspiration. Soon even the stay-at-homes were falling under the spell of 'primitive art', prompting the aestheticians to pay increasing attention to these outlandish products. Most of them were steeped in the evolutionist theory which saw in tribal societies something like living fossils, preserving an earlier phase of human mentality. Like the art of the child, the art of the 'primitives' thus offered a key to the understanding of 'origins'.

We owe it to aesthetic primitivism and anthropological evolutionism that our collections are comparatively rich in products of tribal crafts and that picture books on the subject are plentiful. But both tendencies have also imposed a reading of these exotic styles that calls for revision in the light of more detailed knowledge. Briefly, they have tempted commentators to dwell on those features that distinguish all tribal images from those of the classical tradition—but however much this negative approach may be couched as a commendation of styles that are *not* naturalistic, *not* courting

Originally published under the title 'Zebra Crossings' in the *New York Review of Books*, 4 May 1972, as a review of Marian Wenzel, *House Decoration in Nubia*; James C. Faris, *Nuba Personal Art*; Andrew and Marilyn Strathern, *Self-Decoration in Mount Hagen*; and Robert Brain and Adam Pollock, *Bangwa Funerary Sculpture*.

sensuous beauty or mathematical proportions, it still remains 'ethnocentric'. We have heard too much of the contrast between our approach and that of 'the' primitive artist and less than enough about individual tribal craftsmen and the conditions under which their works took shape. Took—for we all know that the sands are running out. The traditions of tribal crafts are rapidly disappearing, and even where they are kept alive by the tourist trade, they are cut loose from their original purpose and setting.

It is for this reason that all students of art must give a special welcome to a new series called 'Art and Society' launched by Gerald Duckworth of London and distributed in the United States by the University of Toronto Press, of which four volumes have so far come out. Their editor, Dr Peter Ucko, is an anthropologist and prehistorian whose astringent studies of primitive art forms have deflated many theoretical balloons. Given the high level of generality of most books on so-called 'primitive' art, he wants the series to offer basic texts on specific art forms 'which are in danger of debasement or extinction'.

In this respect the subject of Marian Wenzel's book, *House Decoration in Nubia*, is almost symbolic of the whole situation. The products of the village crafts she lovingly describes are by now submerged or washed away by the artificial lake resulting from the Aswan Dam, and the people who lived in these houses have been resettled in dreary concrete huts miles away. Hers, in other words, was a deliberate rescue operation supported by, among others, the Sudan Antiquities Service and the University of Khartoum Sudan Research Unit. Being an artist in her own right and an experienced archaeologist, she could record this vanishing world with brush and pen as well as through photographs as a poignant memorial to a whole mode of life.

James C. Faris, the author of *Nuba Personal Art*, takes a more detached view of the fascinating customs he has studied.

It is probably not in the national interest of new socialist states that art traditions such as those described in this book survive.

One need not accept his Marxist bias to realize why this art must soon disappear. The young men of this isolated tribe close to the centre of the Sudan spend a good deal of their time decorating their own and each other's bodies with coloured earth, renewing or changing the elaborate designs as soon as they get smudged. Here as elsewhere it is the women who do most of the work, and this situation is indeed unlikely to survive the impact of Western mores.

The rituals and customs in the centre of New Guinea described in the book by Andrew and Marilyn Strathern, *Self-Decoration in Mount Hagen*, have already been impaired by the influence of Western civilization. The principal occasion for the magnificent displays of costumes and masks illustrated in its pages are the feasts or *mokas* in which these tribes outdo each other in giving presents and parading wealth. Not long ago these feasts were embedded in a mode of life that involved continuous warfare with neighbouring

24

tribes. They provide, in fact, a belated answer to the rhetorical question which Ruskin once asked when he wondered why one only hears of war paint and never of peace paint. The Mount Hageners knew both, but the Australian administration appears to have succeeded in 1945 in forbidding war and imposing peace. The authors even tell us that their informants described war as a 'bad thing', but since we are told that the same derogatory term is also applied to the sex organs this valuation is unlikely to express a pacifist bias.

Finally, the book by Robert Brain and Adam Pollock, which is somewhat misleadingly called *Bangwa Funerary Sculpture*, describes a mountainous area in West Africa in which Western influence and the tourist trade have already made considerable inroads. Some of the masks, fetishes, and other carvings, which once served a great variety of purposes but were most conspicuously displayed during the funerary rites of a chieftain, show traces of this change. Not long ago the women were naked, but they now wear a Mediterranean style of dress. The members of the 'Royal Society' are described as wearing elaborate and very costly garments.

> Dancers wear nineteenth-century waistcoats and jackets with fringed epaulettes and red flannel gaiters; their headgear consists of soldiers' felt hats traded from the Germans who occupied their country in the early years of the century. Wealthy chiefs are proud possessors of brass helmets. . . .

We read, moreover, that the function of the once powerful Night Society has been largely taken over by the West Cameroon Administration. This society was much concerned with the identification and execution of witches and commissioned the powerful and terrible masks which have found their way into several collections and anthologies of primitive art. But if the lover of art must regret the passing of these conditions he must also remember the danger of sentimentalizing them. We hear that the most prominent Bangwa chief Assunganyi (1885–1951), whose photograph looks enigmatically from the pages of this book, is still remembered with awe.

> He ruled his country and his large compound (he had over a hundred wives) with a generous if iron hand. His prodigality was proverbial. . . . Tales are told of his feats of strength, his cunning, his hunting and his fighting and dancing prowess. He could flay a wife and stop in the middle to listen to a birdsong.

But whatever our attitude, it cannot diminish our gratitude to the editor and his authors who underwent much hardship in their efforts of recording and analysing these doomed societies. All four books are profusely illustrated with most informative and beautiful colour and black-and-white photographs as well as line drawings. If there is a minor flaw in the arrangements it is that these various types of illustration are differently numbered and since they are distributed throughout the book with little reference to the text, the conscientious reader is constantly distracted by having to hunt for visual

evidence. May one hope that future volumes will add page refer-
ences to facilitate this search? It would be a real pity if the difficulties
of this hurdle race were to deter readers from doing justice to the
important texts.

Various as is the material which is presented here, and various as
are the approaches of the authors, there is one conclusion on which
they all agree and which the student of art must accept. Although the
links between ritual, magic, and art in tribal societies are close, there
is also evidence everywhere of an independent enjoyment of shapes
and colours which serve no ulterior purpose. True, this point was
also made long ago in that classic work, *Primitive Art* by Franz Boas
(1927), but we still need the reminder that Goethe's intuition in this
respect was sound. Not that magical practice is not frequently
mentioned in these volumes. In Nubia plates and other shining
objects are placed above the door to catch the evil eye; among the
Bangwa certain fetishes have no purpose save that of warding off
witches; the ritualistic decorations of Mount Hagen include 'medi-
cation'; and certain pigments among the Nubas are endowed with
potency to secure, say, the victory of a wrestler. But it is well to
remember that our own word 'charm' also signifies both the magic of
an amulet and the attraction of a piece of jewellery, and if we find
the illustrations of these four books 'enchanting' we submit to their
'spell'.

Given this general framework, however, the method and outlook
of the various authors could hardly be more divergent. Like all
academic disciplines anthropology is prone to intellectual fashions,
and the degree to which these come into play differs significantly.
The book by James Faris is the most ambitious in its method. His
detailed and informative account of cicatrization and body painting
used in a large variety of circumstances by both sexes of this vigorous
tribe culminates in the attempt to write a 'Generative algorithms for
Southeastern Nuba representational design'.

In other words, he wants to construct what would amount to a
computer program for the production, at least, of those designs
which he calls 'representative', by which he means patterns named
after animals—names which do not necessarily imply a closer con-
nection with the creature than does the English term 'zebra crossing'
for striped pedestrian passages. These pages with their symbolism
and their technical terms are likely to impress some readers and
depress others, and since they will probably attract attention and
emulation they invite critical scrutiny. Not feeling competent to
discuss them unaided I have sought the help of a computer expert,
Mr Romilly Cocking, who was kind enough to read the book and to
guide me through the maze of the algorithm. I am afraid I emerged
with less awe and less faith in the usefulness of this new toy.

The nearest analogy I can suggest as a first approximation is that of
a knitting pattern which offers instruction for a sequence of stitches.
It is worth remembering in this respect that the important tool of
programming, the punched card or tape, was in fact developed (by
Bouchon in 1725) for pattern-weaving looms. The technique used

by Mr Faris goes beyond this method in that it gives general rules for the production of all possible instructions by listing the alternatives from which the maker must select the next move. He is anxious to be strictly economical in this listing, but it must be said that his restriction to animal patterns excludes many of the most striking designs shown in his illustrations. He has no symbolism even for the generation of radial configurations or of spirals.

Moreover, he can only give us flat, carpetlike designs. Now what is characteristic of the decorations he analyses is precisely that they enclose features of the three-dimensional human head or body: an eye may be framed by a dynamic curve, an arm may be ringed. The Nuba artist, therefore, cannot be solely concerned with the 'knitting' of flat patterns. He must avoid the pigment getting into the eye or the mouth, and more importantly he must consider the powerful physiognomic effects that accompany any manipulation with human features—witness those subtle and almost unpredictable changes that go with any kind of 'make-up'.

But this need to adjust the design to a pre-existent three-dimensional form is only one aspect that the algorithm obscures. The production of patterns rarely proceeds from the element to the whole. More often it is the result of subdivision of larger forms into smaller units. The 'knitting pattern', in other words, is designed ex post facto and does not reflect a psychological process. The way the algorithm analyses the 'generation' of dots is a case in point. We are asked to take the element of a semicircle shaped like the letter c, join it to its own reversal to obtain a shape like the letter o, and then to fill it in with colour. Surely such an operation would never result in the smudgy roundish splashes of pigment that we see in some of the photographs.

Alas, there are even more serious theoretical objections to this attempt at emulating Chomsky's generative grammar in the field of design. Whatever difficulties the linguists may have encountered with this method, its purpose at least was clear. It was to test the capacity of rules to generate novelty in the way in which a speaker of a language has to do it in uttering sentences he has never heard spoken and to try them out for intelligibility. There can be no analogy here with Mr Faris's algorithms. After all, he starts from a small finite number of animal patterns, and since he cannot go beyond it to test new designs for their acceptability the exercise cannot produce the insight at which Chomsky was aiming.

Andrew and Marilyn Strathern in their book *Self-Decoration in Mount Hagen* also talk of 'pictemes' and 'allopicts' in analogy to the linguist's phonemes and allophones, but they also point out that 'there is no further explicit concatenation of patterns into sets, as phonemes are connected to form morphemes in the structure of language.' Instead they are looking for another type of binary code in the varied and fluctuating decorative usages which they record with meticulous care.

The method, of course, ultimately stems from the structuralism of Lévi-Strauss, which is in its turn connected with the pioneer work of

Roman Jakobson in phonemics, but here again the application of this fashionable tool disappoints in its results. In some cases one even wonders whether the authors are making the best use of it. We are told that bright decorations are believed to attract favours and gifts and that the donors at the give-away feasts tend to wear fewer bright colours. Could one not conclude that those whose very function excludes the attraction of presents should set themselves off from the recipients? But this inference is not made by the authors—who rather seek for an explanation in the latent aggressiveness of these customs.

The example shows what I believe to be the principal weakness of this method. It is all too easy to apply, and all too difficult to test. In the Stratherns' chapter on the connotations of colour they seek to decode the system of decoration and arrive through a succession of tables and oppositions at the underlying contrast between white semen and red blood, two substances which naturally arouse ambivalent emotions and can thus be linked with almost any desired connotation. Their concluding remarks here are as disarming as they are disturbing:

> In analysing the results we have been led to develop the concepts of contextual intrusion, suppression, and reversal, which find no exact replica in what Hageners themselves say. All anthropologists are faced with similar difficulties in analysing their material. . . . We have . . . translated these meanings into a more abstract form, and it is here that our operations have become in part conjectural. . . . Ultimately our interest is in explaining the behaviour of Hageners; and in understanding what it means to a row of men to dance in a proud amalgam of dark and bright decorations before their allies, rivals, enemies and spectators.

Imagine a future anthropologist of the Hagener tribe applying these methods to our culture, conscientiously studying graduation ceremonies and Christmas celebrations, and emulating our authors by investigating how many of the professors borrow their gowns for the occasion and where we all buy our Christmas decorations, but hoping not only to explain our behaviour but also to understand what it means to us. The first thing to tell them would be that both 'explanation' and 'meaning' are slippery terms: explaining a ceremony demands a knowledge of origins, of the historical dimension which eludes the anthropologist. Nor can the meaning of a ritual be identified with possible unconscious determinants. The fact that trees can be classed with phallic symbols will not tell our visitors what Christmas celebrations mean to us—provided, indeed, one can speak of such a collective meaning at all. In any case we would have a right to object if these investigators were to come up with a system of meanings 'that has no exact replica' in what we ourselves have told them.

It so happens that we learn from an aside what the Hageners say about their ritual dance festivals, and what they say provides food for thought.

They have a more ethological version of how they came to set up ceremonial grounds and display at them: they say they follow the bower bird, which clears a space to dance in and attracts sexual partners to itself.

The explanation is suggestive, not because it is likely to be literally true but because it illuminates the significance of colours. For the male of the incredible bower bird clears an area of dead leaves and decorates it every day with fresh leaves of certain trees which he saws with his serrated beak. He places them with their light underside visible and if they are reversed he turns them back. Some broken snail shells are usually added. While this behaviour is unique, evolutionary pressure has favoured the development of attractive or threatening colouration among many species and this is surely quite unconnected with the colour of semen or blood.

If the authors had been ready to follow this clue they might have arrived at a different method of exploring the connotation of colours. I am referring to the theory of the Semantic Differential used by C. E. Osgood and his associates in their book *The Measurement of Meaning* (1957). What this theory postulates is, briefly, that we are all disposed to assign any experience a place in what it calls the 'Semantic Space', whose three dimensions are marked by polarities of good and bad, strong and weak, active and passive. I do not wish to be dogmatic about this theory, but it seems to me to offer at least the possibility of finding out more exactly what the members of a given tribe say about the feeling tone of colours.

It must be admitted, though, that interviews alone are never likely to settle all the anthropologist's questions. Robert Brain and Adam Pollock in their book *Bangwa Funerary Sculpture* offer an instructive instance of the difficulties they encountered in trying to elucidate the symbolism of the masks of the Night Society:

> The blown-out cheeks are a good example. Most Bangwa say they are carved in this way to frighten women and children. Others, perhaps, say that they are so made to make a poor man laugh, so that he will be forced to pay a fine to the society. Others point out that fat cheeks are a sign of wealth and power; great chiefs are always fat of face.

A typology of these masks is attempted to show the spectrum of expression, ranging from the serene to the terrifying. We are warned not to interpret this series as a historical sequence, but it does help to identify the underlying configurations which these masks have in common.

On the whole these authors travel with less intellectual baggage than do those of the two previous books under review. They do not shun the technique of the travelogue in giving an admittedly composite account of a 'big cry' after the death of a chieftain. But by way of compensation we are introduced to a variety of real people whom the authors knew and liked. Thus we read of the carver Atem:

> his prowess with the adze and his devotion to pleasure are

29

equally renowned. . . . Once a mask or drum has been completed and the money handed over, the money is mostly invested in drink which he shares with his crowds of friends. . . . He works in a small decrepit wattle-and-daub hut miles away from the Bangwa centres. . . . In spite of his many opportunities for wealth he has only a single wife. This is startling to a Bangwa . . . since a man's success is usually determined by the number of wives housed in his compound. . . . Atem is also an expert musician. . . .

Reading these and similar passages one suddenly realizes with a shock that individuals never figured in the two previous books. It used to be said in old-fashioned schools that geography was about maps and history about chaps. If we are to trust etymology, anthropology, the science of man, should also be about people, but an increasing number of anthropologists today see it as their task to make maps of a people's mental structure. Like the earlier doctrine of the *Volksgeist*, this approach implies a degree of collectivism that ultimately negates the humanist faith. Not that even a convinced humanist will ever deny the interest of exploring systems of thought or of values that govern the reactions of certain groups, but he will never want to neglect the way these collective traditions interact with individual human beings who may develop them or opt out of them as the case may be.

Marian Wenzel's *House Decoration in Nubia* shows triumphantly that an anthropologist can also be a humanist. When she began recording these modest products in the doomed villages by the Nile she expected, as she says, that she would encounter an old tradition. It turned out that the style was invented by a Nubian, Ahmad Batoul, around 1925 (Fig. 1). He had been a builder's assistant who had to spread a layer of fine mud on newly built houses and 'thought up the decoration as a special finishing touch to enhance the plates that the women were putting over the doors'. Derided at first, he soon was in demand and was able to employ as assistant the builder for whom he had worked. His end, however, was tragic. After he had started the fashion, house decoration 'became a grand art in the hand of masters . . . and whoever fell out of favour lost. Ahmad Batoul lost'. He finally had to prepare the mud ground for his chief rival, the talented Hasan Arabi, who was well connected and who copied his designs from European tin boxes.

It is curious that Ahmad Batoul retained his prestige even though he fell out of fashion, a fact that was never properly explained to us. The very people who put Batoul out of work were those who most strongly praised his contribution.

1 Ahmad Batoul: façade entrance, Ashkeit, 1928. White-lime relief on mud. According to Marian Wenzel, this is 'the earliest known example of imitation stone-work, punched-out triangles and surface hatching used on mud relief'.

It would be misleading, though, to give the impression that Marian Wenzel's approach is primarily anecdotal. Although there are no algorithms and no binary codes, she has much to tell us about the connection of these paintings with marriage customs and the consequent differentiation between the styles proper to men and to women.

31

Both men and women painted wild animals of an apotropaic and mythical character, such as crocodiles, scorpions and lions with swords. . . . Women alone painted fish, although a few fish were made by male professional artists. 'Fish mean nothing', we were told, 'unless they have been painted by a woman'. The reason for this was not given.

Future historians will surely be grateful to the author for preserving this snippet of a verbatim record and refraining from facile explanations. Theories date rapidly, but documents, like diamonds, are forever. Not that she adopts a positivist position. Having described the various aspects of the decorations that reveal their twentieth-century character, she adds a chapter with interesting speculations about certain motifs which may reach back beyond the Islamic era as far as the repertory of Coptic Christian art.

Modest as is the tradition Marian Wenzel recorded, she engages our interest precisely because she neither inflates its value nor ever treats it with condescension. The rural 'backwater' with its artist-decorators copying motifs from biscuit tins of Huntley and Palmers in Reading thus becomes a microcosm that mirrors the major world like the proverbial drop of water. What the student of art will learn in examining this mirror is precisely what the other studies under review tend to withhold from us, the contingent nature of human activities, the influence of chance, and the unpredictable whims of taste and of fashion.

Not that this insight should discourage us from looking for general principles or for theoretical explanations. Those who study hydraulics know that the laws of fluid dynamics can be mapped but that the sequence and shapes of waves and vortices in a turbulent brook will defy calculation. But while the engineer is entitled to disregard these elusive eddies, the humanist who wants to know, in Ranke's words, 'what actually happened' cannot afford to rise to this level of abstraction. After all, the incalculable eddies in his field of observation are human beings, unique and unrepeatable, whether their name is Michelangelo or Ahmad Batoul.

4
A medieval motif

The Metropolitan Museum in New York has mounted a delightful exhibition at the Cloisters (until 12th January), devoted to The Wild Man, that motif of medieval folklore, literature, pageantry and art to which the late Richard Bernheimer dedicated a classic study in 1952. The sixty-two items comprise all artistic media, illuminated manuscripts, early printed books, engravings, drawings, carvings in ivory and wood, metalwork, stained glass and tapestries. Most of them date from the fourteenth and fifteenth centuries, but there are some earlier and later examples. The theme, the life and the antics of these children of nature, favours the naturalistic and grotesque tendencies of late Gothic art and thus makes for an entertaining and varied show which will give pleasure also to the general public. The twenty-four lending institutions listed include the British Library, the British Museum and the Victoria and Albert Museum.

The catalogue (*The Wild Man, Medieval Myth and Symbolism*, by Timothy Husband with the assistance of Gloria Gilmore-House) is beautifully produced with excellent black and white illustrations of all exhibits and a good deal of subsidiary material, fifteen attractive colour plates and a thoughtful introduction. It can be enjoyed as a lasting souvenir of a unique occasion. It is perhaps a pity that the public have been conditioned to expect even more of a catalogue. It should display a weighty apparatus of learning and offer exhaustive stylistic, iconological, sociological and psychological commentaries on all aspects of the subject. The author of this catalogue should not be blamed if he has fallen somewhat short of such an unattainable ideal. Among the nearly three hundred titles listed in the bibliography there is at least one which never was: *A documentary History of Primitivism and Related Ideas in the Middle Ages* by A. O. Lovejoy and G. Boas. The enterprise stopped after the first volume devoted to classical antiquity, though Boas published a volume of essays concerned with medieval primitivism which have no bearing, however, on the theme of the exhibition.

The catalogue is subtitled 'Medieval Myth and Symbolism', but was the wild man a myth, and are all wild men symbols? Can we be sure that the dense and dangerous forests of medieval Europe were not sometimes haunted by savage humans? (Savage, *sauvage* are terms derived from Latin *silvaticus*, of the wood). Bernheimer thinks they were, and we have recently been reminded by Robert Shattuck's book *The forbidden experiment* of the Wild Boy of Aveyron who emerged from the French woods in 1800. We may also remember Kurosawa's beautiful film *Dersu Uzala* of the solitary huntsman and trapper ranging the endless forests of Siberia. Granted that these forest dwellers were not all as hirsute and stylized as they were shown in art, anxious travellers who caught sight of such creatures may well have endowed them in their imagination with the features they expected to find. Be that as it may, people certainly believed in their existence as they believed in elves, fairies and hobgoblins; is

Originally published in the *Burlington Magazine*, January 1981, as a review of *The Wild Man, Medieval Myth and Symbolism*, the catalogue of an exhibition at The Cloisters, The Metropolitan Museum of Art, New York.

myth the right term for such beliefs, and do they ask for interpretation in terms of symbolism? The answer must depend on what we consider the aims of interpretation. We must distinguish between the deciphering of a code, the spelling out of a metaphor, and the diagnosis of a symptom—to mention but three distinctions which have become somewhat blurred in recent art historical literature. The learned entries of this catalogue are not free of these confusions. Commenting on the engraving by the Master E. S. of a wild man at the root of a thistle (Fig. 2) the author finds it 'significant' that both the Wild Man and the thistle 'can be associated with evil'. But if he implies that the engraving is to be read as an emblem of evil he is almost certainly mistaken. Why should such emblems be circulated in prints destined to be used as models for craftsmen? The association of leafage with lively creatures can be traced back to the inhabited scrolls of classical antiquity, and if they ever had a meaning it was certainly lost in the playful genre of medieval drollery.

Even less does it seem necessary to read a specific political meaning into the magnificent Wild Man who serves as the support of the shield crowning a ewer, presumably made for a master of the Teutonic Order (Figs. 3 and 4). 'It is tempting'—says the entry—'to suggest that Hartmann von Stockheim chose wild men to adorn these ewers for their connotation with virility at a time when his order was weak'. Tempting, perhaps, in the psychiatrist's consulting room, but hardly in the workshop of a goldsmith. After all, such motifs were often chosen as supports by knights whose virility is unlikely to have been questioned. If we have to grope for an interpretation we should, I suggest, leave diagnosis aside and turn to the code of

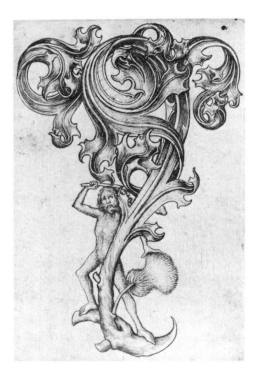

2 The Master E. S.: *Wild man climbing a thistle.* Engraving, c.1466. Chicago, Art Institute

34

heraldics. The stick brandished on top of the vessel may well be a punning or 'canting' device for the name *Stock*heim. At any rate Francesco Sassetti used the centaur with a stone in his sling in this way to signify *sasso*.

Perhaps a similar uncertainty about the aims of interpretation mars the entry accompanying the charming figure of a wild woman with a unicorn (Fig. 5). We are told of a number of 'symbolic traditions' which merge here, such as, of course, the legend of the unicorn seeking refuge in the lap of a virgin, but here (we read), 'rather than seducing the unicorn she has been ensnared by it, caught by the bonds of faithfulness'. According to the author 'this paradoxical reversal of her moral condition explains her otherwise enigmatic lament'. But before we look for paradox and reversal should we not try to identify the image as an illustration of a story to which the inscription may give us the key? It reads: '*Min zit . . . Welt gegebn, nuon mus ich hie* (not *nie*) *im ellenden leben, Owie*'. Presumably: 'I gave my time to the world, now I must dwell here in exile, alas'; *ellend* is both exile and misery. While failing to identify the theme Bernheimer convincingly associated it with similar tales of fair wild maidens encountered in the woods. In such a narrative context the designer could use the unicorn without paradox to indicate that the maiden doing penance for the time she had 'given to the world' had not lost her innocence, and that we could hope for a happy end to her story.

3 *Pair of ewers with wild man heraldic finials*. Germany, c.1500. New York, Metropolitan Museum of Art
4 Detail of Fig. 3

Or take finally the 'Play of the Wild Man hunt' represented in a woodcut with the name of Bruegel (Fig. 6). At the end of a long and learned entry the catalogue tells us that 'the Wild Man is the

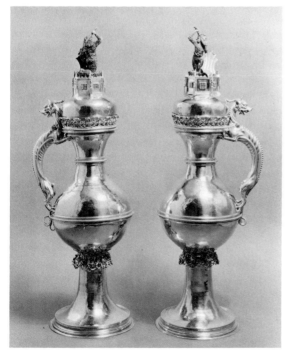

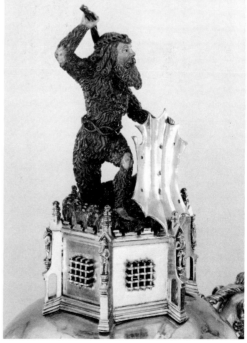

subliminal incarnation of man's evil nature, which is cathartically expunged by his ritual death'. Yet he is not unaware of the link (also stressed by Bernheimer) of this folk ritual with the ancient custom of driving out the winter. It is no more concerned with 'man's evil nature' than our Father Christmas is a 'subliminal incarnation' of man's benevolence.

Such motifs and figures do not have determinate meanings, they rather lend themselves as metaphors or outlets for an ever changing variety of ideas and emotions. In my native Austria the unlikely ancestor of Santa Claus, St Nicholas, walked the streets on 6th December with mitre and crozier, distributing bounty to 'good'

5 *Wild Woman with a unicorn.* Fragment of a tapestry. Germany (Alsace), c.1500. Basle, Historisches Museum

36

children. He was accompanied by a shaggy black devil with a long red tongue who rattled his chains and threatened to carry the naughty ones to hell. This *Krampus* was a 'Wild Man', if ever there was one. Whether his 'myth' 'was adopted to preserve the values of a decaying . . . society' (as the author claims for his counterpart) I do not know; if it was, the method was not very successful. But I know of the fun that was had by all who impersonated or watched the bogeyman or shaped his image out of dried plums and gingerbread to be relished by children and grown-ups alike. Is it likely that medieval man (if there ever was such a being) reacted differently to the romping figures we see in this enjoyable exhibition?

6 Anon. after Pieter Bruegel the Elder: *Play of the Wild Man Hunt*. Single-leaf woodcut, dated 1566. New York, Metropolitan Museum of Art

37

Expressions of despair

In Xenophon's *Memorabilia* Socrates urges the sculptor to represent 'the workings of the soul' by accurately observing the way 'feelings affect the body in action'. But the soul is an elusive thing, and so historians of art have generally preferred to concentrate on the way artists rendered measurable space or the fall of folds rather than expressive movement. Professor Moshe Barasch's short study must therefore be welcomed as a contribution to an unduly neglected field. The 'Gestures of Despair' on which he focuses are 'actions of violent self-injury' such as gnawing the hand, scratching the face or tearing the hair. His thesis, briefly, is that such actions were first considered appropriate to sinners in Hell and, perhaps, to Adam and Eve at their expulsion, but that from the late Middle Ages onwards, especially in the fourteenth century 'such unrestrained gestures also appear in other scenes', notably the Lamentation of Christ (Fig. 7). Following Warburg and Panofsky these 'pathos formulae', which were taken up by Donatello and his school, have usually been regarded as a revival of the classical type of *conclamatio*, known to the Renaissance from ancient sarcophagi, but Barasch rightly points out that precisely the extreme acts of self-injury, such as the literal pulling out of bundles of hair, are absent from the Graeco-Roman prototypes.

The observation remains important even though the postulate that there was a shift in the motif from sinners to saints is less convincing. Indeed the author is too good a scholar not to realize that he has not made a watertight case. The evidence remains ambiguous because the representational resources of early medieval narrative art are too limited. We read that a gesture 'may indicate the biting of the hand, but . . . could also be read as a forceful clutching of the beard' (p.12); 'one cannot say whether Adam is grasping his chin or only holding his hand to his mouth in a gesture of sadness' (p.13); 'the action performed cannot be identified, one may perhaps even doubt if the artist intended to portray a specific action' (p.15). Such expressions of caution—which could be multiplied—certainly do credit to the author, but they also tend to blur the outlines of his hypothesis. These do not emerge much more firmly when he asks at the end of his sixth chapter 'how are we to explain the fact that violent gesticulation, which in a somewhat earlier period seems to have been characteristic of sinners, is now performed by sacred figures in holy scenes?' 'Are we to assume a change in the meaning of the gestures, or was there rather a radical modification in the meaning of the religious scenes and sacred figures?' (p.57). In pursuit of the answer he richly documents the 'new emotionalism' in religious texts and imagery, a change which is familiar to historians of late medieval art. And yet one may wonder whether the author has really asked the right question. One's doubts arise first of all from the self-imposed limits of the evidence. By concentrating on Italian art he presents the change between a hieratic Byzantinising style of religious narrative

Originally published in the *Burlington Magazine*, November 1978, as a review of Moshe Barasch, *Gestures of Despair in Medieval and Early Renaissance Art*.

and the new realism of Giotto and his school almost as Vasari might have seen it. It would go far beyond the scope of a review to attempt an adjustment of focus, but so much is clear that the expression of intense emotions occurred in earlier styles in many contexts outside the Last Judgement. Whether or not the death of Edward the Confessor on the Bayeux Tapestry depends on a *conclamatio* (which is unlikely) we find there a weeping woman and hands raised in sorrow. The burial of Judas Maccabaeus in the Winchester Bible even shows an old man clasping his face in both hands which Professor Barasch would elsewhere have described as coming close to a gesture of despair. The Weeping Mothers of Bethlehem in the German thirteenth-century MS. of the *Lied der Magd* (formerly Berlin, cod.germ.oct.109) do not yield in emotional power to the 'maenad'-like figures of Renaissance art.

Even if a closer survey would still confirm that extremes of self-injury were more frequent among sinners than saints in early medieval art, the reason need not lie in any specific meaning

7 Giotto: *The Mourning of Christ.* Wall-painting in the Cappella degli Scrovegni in Padua. Probably completed in 1306.

attached to such actions, but rather in the observance of decorum. Realism in art frequently starts 'from below'. It is the executioners in scenes of martyrdom who tend to exhibit facial and bodily contortions even in periods in which saints are often represented in formulaic impassivity. If Professor Barasch had included in his search gargoyles and grotesques he would have found even more extreme examples of his gradation of violence. After all, the dragons and demons of early medieval art have a strange propensity for self-injury; they bite themselves at least as often as they bite other creatures. If there is any field where we can study the emergence of means for the rendering of fury and frenzy it is among these monsters. One of the gestures which interest the author, the tearing of the mouth with both hands, is a frequent trait of demonic masks, though it also turns up among the damned in Hell.

To ask after 'the meaning' of such gestures, as the author does right at the beginning of his book, may easily get the investigation on to the wrong tack, for with gestures 'meaning' is at best something secondary. No doubt, as Socrates knew, 'feelings affect the body in action' but these actions only reveal the 'working of the soul' in a roundabout way. It has proved useful in this context to distinguish between symptoms and signals though both may serve the purpose of communication: the symptoms of fear exhibited by one member of the herd may act as a warning signal to the others. Students of animal behaviour have come to speak of 'ritualization' where certain reactions become stereotyped for easy recognition. The author has evidently avoided becoming involved with this large body of research, and one can easily see that such involvement would have made his task less manageable, but such a self-denying ordinance also obscures to him the vital distinction between emotional behaviour and conventional gestures.

In modern studies of the subject overt behaviour under stress is usually regarded as a result of conflicting drives for the release of tensions. If Hitler really chewed the carpet in fits of impotent rage these antics would be seen as an example of 'redirected' aggression, but also as a symptom of regression, a return to infantile reactions where sucking and chewing offered their own comfort. Such behaviour, in other words, serves a variety of psychological functions, but it would be straining the term to speak of its 'meaning'. When, on the other hand, a German minister sued a cartoonist for representing him chewing a carpet he implied that here the symptom had been turned into a symbol and that he was being lampooned as another Hitler. What we learn from this bizarre example is merely that the road from life to art is often devious and hard to trace. Even the gestures with which the author is concerned are no exception to this rule. He has himself described how the symptoms of grief and despair had become ritualized in human culture. In the mourning of the dead certain types of behaviour—whatever their psychological roots—were expected and cultivated till they ceased to be genuine symptoms and became conventional signs. The severity of the injuries which the wailing women inflicted on themselves while beating

their breasts and scratching their faces probably depended less on their grief than on the reward they were promised.

I have argued elsewhere that many expressive gestures of this kind reached the vocabulary of narrative art through the formulae of ritual. Professor Barasch has shown that this transition is far from complete or mechanical. But this observation might also have alerted him to the risks of consulting literary texts as evidence. Both art and literature tend to be extremely selective in their attention to real behaviour. Even various languages act as different filters for the description of expressive movement. There is no exact equivalent in English for the German idiom *'man greift sich an den Kopf'* (one clutches one's head) to characterize a reaction of incredulous exasperation, while German has no phrase for 'I want to kick myself'. These and countless other instances prove, if proof were needed, that it is usually illicit to argue from art to life or vice versa. Every period and every medium, like every language, applies a different code. The constraints of pictorial representation, moreover, with their absence of movement, have always favoured stylization, though photography and the modern 'comic' have brought home to us how much the range can be expanded and yet remain intelligible in certain contexts. To study these matters adequately we shall still have to refine our tools; what remains interesting in Professor Barasch's material is precisely the changing degree of permeability of the filter.

One critical remark must not be suppressed, however; it concerns the treatment of the text on the part of the New York University Press. The number of misprints is inexcusable: 'perpahs' (p.12), 'plams of the hands' (*ibid*), 'main conern' (p.15), 'gestrues' (p.17), 'vice' (for voice) (p.22), and twice 'importance' for impotence (pp.41 and 44). *Man greift sich an den Kopf . . .*

6
The impact of the Black Death

Professor Millard Meiss writes real history. Throughout this lucid and scholarly analysis of a neglected period of Tuscan painting he is concerned with the interpretation of primary documents, visual and textual, and with the way they can be made to illuminate each other. Yet aesthetic problems are not only incidental to his research as they sometimes are in works of connoisseurship. They govern the direction of his interest and form an important link in his argument. For in this book Professor Meiss ranges himself with the historians and critics who, since the turn of the century, have revised our notions of the past by re-examining its once despised styles—Late Antiquity, Baroque, Mannerism, or Victorianism—in the light of our changing scales of aesthetic values. Florentine Trecento Painting between c. 1350 and 1400 has been under a cloud for nearly 500 years. In a passage not discussed by the author Leonardo da Vinci held it up as a warning example of what happens to Art when the study of Nature is neglected. Giotto, he says, was able to revive art, for as a shepherd's boy he knew Nature at first hand. 'After him Art suffered a relapse (*ricadde*), for everyone imitated paintings already made and so it went on from century to century (sic) till ... Masaccio demonstrated by his perfect work how those who had taken as their authority anything but Nature had laboured in vain'.[1]

Professor Meiss would not, perhaps, deny the essential veracity of this simplified account. He would grant that measured by the Renaissance standards of Leonardo's naturalism the works of his period must be found wanting. But his point is, that in the years after the Black Death with its social upheavals and spiritual crises the values of Giotto's serene art were 'opposed by other values'. In a series of subtle descriptions of works by such leading masters of his period as Orcagna, Andrea da Firenze, and Barna da Siena, Professor Meiss demonstrates how the achievements of Giotto's generation are rejected by these masters in favour of more hieratic and archaic modes of representation. Dramatic narrative is often replaced by symbolic ritual, spatial rendering by flat forms, free movement by rigid frontality, lively expression by mask-like features. Now it seems important to stress at this point that these incontestable findings in themselves might be interpreted as confirming rather than refuting the traditional estimate of the period. For all these traits, after all, have this in common that psychologically speaking they are more 'primitive', that is to say, closer to the conceptual image than the intellectual achievements that preceded them. The love of gold and splendour which Professor Meiss notes would also be in keeping with this evaluation. Thus one might even accept Professor Meiss' historical interpretation of the influence of the Black Death and yet side with Leonardo by saying that the catastrophe brought about a lowering of standards, be it among the painters who failed to master the complexities of naturalistic rendering or the public who failed to appreciate the autonomous artistic values of Giotto's style. Such a

[1] Cf. *The Literary Works of Leonardo da Vinci*, compiled by J. P. Richter, Oxford 1939, No. 660.

Originally published in the *Journal of Aesthetics and Art Criticism*, XI, 1953, as a review of Millard Meiss, *Painting in Florence and Siena after the Black Death*.

reasoning would perhaps make sense even for those who personally happen to 'like' primitivism better than sophistication. It might then be said that this art 'expresses' the crisis of the Black Death less by its emotive content than by the symptomatic character of regression,[2] true to the old dictum that 'devout pictures are often bad paintings'. It is not quite clear, however, how far Professor Meiss would accept such a verdict. On the whole he would probably counter it by pointing to evidence in certain works he analyses which, to him, betray a deliberate renunciation of 'tactile' values or even a sophisticated exploitation of the disharmonies resulting from the clash of incompatible styles within one work. But in a way this increases rather than obviates the aesthetic problem. As a historian of art Professor Meiss is entirely within his right to follow Riegl's tradition and not only to give the artist the benefit of the doubt but even to accept any shape or form as evidence of aesthetic 'intention'. Unfortunately the critic who follows the same procedure really surrenders his last position. If inconsistencies are no evidence of a falling off of standards what criterion of quality remains?[3] Professor Meiss, of course, does not apply this most ingenious device of special pleading to works he considers poor. His sense of quality speaks from every passage of the book, especially from the passing but illuminating references to Giotto's great art. But the dilemma remains.

Perhaps the author could have made his plea for the 'other values' more convincing if he had set the Tuscan period he describes more firmly into the contemporary European scene. He might then have shown that the inner consistency of the anti-realistic movements in fourteenth-century art is really greater elsewhere than in Florence where the memory of Giotto's revolution prevented a full unfolding of these tendencies and thus resulted in a rather hybrid style. Some thirty years ago Wilhelm Pinder detected and analysed these tendencies in German fourteenth-century sculpture.[4] In a brilliant comparison between a classically draped thirteenth-century figure from Bamberg (Fig. 8) and a disembodied fourteenth-century Virgin from Rottweil (Fig. 9) he demonstrated the depth of the reaction against the heroic age to which Giotto also belongs. Pinder speaks here of 'renunciation in favour of unification'; he admits an element of decline but shows that this apparent enfeeblement is pregnant with new possibilities. Now strangely enough this parallel would have much strengthened the result of Professor Meiss' aesthetic analysis—but only at the expense of his historical argument. The Rottweil Madonna and the style she represents antedates the Black Death by more than a generation. In fact most of the symptoms which Professor Meiss ascribes to this catastrophe, the religious fervour and new inwardness, are described by Pinder as characteristic of the first half of the fourteenth century. To the German historian the plague only marks the final culmination of these waves of mysticism and hysteria, a culmination which is at the same time the turning-point towards a more optimistic and shallow attitude to life. He quotes a chronicle as saying that 'after the mortality, the

[2] Cf. my article 'Wertprobleme und mittelalterliche Kunst', *Kritische Berichte zur kunstgeschichtlichen Literatur*, VI.3–4, 1937.
[3] Cf. for this problem H. Hungerland, 'Consistency as a Criterion in Art Criticism', *Journal of Aesthetics and Art Criticism*, VII.2, 1948.
[4] W. Pinder, *Die deutsche Plastik vom ausgehenden Mittelalter bis zum Ende der Renaissance*, I. (Handbuch der Kunstwissenschaft), Wildpark-Potsdam, 1924. Pp. 31 ff.

pilgrimages, the flagellants and the pogroms the world began to live again and to be gay'[5] and he interprets the German monuments of the subsequent decades in the light of these words. Not that Professor Meiss overlooks this paradoxical effect of the plague to which we owe Boccaccio's *Decamerone*—he only does not find it expressed in the painting of the period. The issue here is one of the methodology of historical explanation rather than of facts. For granted that events may and must have their effect on art, need art also 'express' them? Is not the effect of such a trauma on personality much less predictable than one might at first expect?

Such occasional qualms, however, cannot diminish our gratitude to Professor Meiss for the sensitivity and learning with which he presents a conspectus of a whole period with art placed securely into the centre. The fruitfulness of this approach is particularly apparent in the chapter where he can show how much the imagery and the visions of St Catherine of Siena must owe to paintings rather than texts. Here is a real and substantial advance in the quest for some unifying principle of which the importance for aesthetics needs no elaboration.

[5] Loc. cit. p. 45.

8 *The Virgin Mary*. Bamberg Cathedral. c.1240
9 *The Virgin Mary*. Rottweil Chapel. c.1340

New revelations on fresco painting

Birnam Wood has come to Dunsinane. What was rooted in Florence, what was bound to the walls of churches and town halls, has been freed by newly refined techniques ...

Professor Millard Meiss's dramatic opening words of the Introduction to this catalogue reflect the sense of wonder and surprise which all visitors to this unprecedented exhibition must have experienced in New York and are now experiencing in London. These words may also betray something of the suppressed anxiety that underlies our wonder. Shakespeare does not tell us what happened to the cut-off branches of Birnam Wood after they had served their purpose. It is a relief to be told that after this extraordinary transplant operation at least most of the frescoes here exhibited will be returned to 'the architectural fabric to which they so intimately belong'. Unfortunately this desirable solution is not always feasible where the building itself has been damaged or cannot offer enough protection, and thus the exhibition may after all become the forerunner of a new Museum, to daunt the tourist with acres of frescoes as he is daunted today by acres of altar paintings.

Not that the idea of treating murals like easel paintings is peculiar to our time. Vasari tells us that François I of France was so taken with Leonardo's *Last Supper* in Santa Maria delle Grazie that he 'tried to find out in every way whether architects could be found who could make a scaffolding of timber and iron and so to frame it that it could be safely transported regardless of expense'. He did not succeed and thus, as Vasari remarks, the work stayed with the Milanese. This unsuccessful attempt is not mentioned in Ugo Procacci's instructive summary of the history of the technique or techniques, which have been and are used to remove and reset the frescoes. By the nineteenth century, however, the practice was common enough for a number of fragments to be sold abroad: there are some, for instance, in the London National Gallery and in the Victoria and Albert Museum.

But both the need and the temptation to detach frescoes have increased enormously during the last few decades. Long before the catastrophe of the Florentine floods the greater catastrophe of the War led to the ruin of buildings with frescoed walls. The most famous of these was of course the Campo Santo in Pisa, and it was here that the destruction of the surface first revealed to the general public the preparatory drawings known as *sinopie*. Their unexpected charm in turn increased the temptation to take off frescoes, damaged and overpainted as they frequently were, and to look for what was underneath. The condition of many of these monuments, in fact, has visibly been getting worse even in undamaged buildings.

Opinions about the cause of this deterioration differ. Italian authorities appear to be somewhat reluctant to blame the side effects of tourism, the dust, the exhaust fumes, the vibrations caused by

Originally published under the title 'Art Transplant' in the *New York Review of Books*, 19 June 1969, as a review of *The Great Age of Fresco: Giotto to Pontormo*, with an Introduction by Millard Meiss.

heavy traffic; they prefer to think that after some five hundred years many frescoes have really reached the end of their natural span and must be artificially kept alive. But there is evidence elsewhere that the motor car is a potent factor and that murals far from the roar of the traffic are generally in better condition than those in busy centres.

Be that as it may, the last few decades have witnessed an almost feverish activity in Italy to rescue the frescoes which were once the glory of Tuscan churches by detaching them carefully from their crumbling support. The first demonstration of these efforts for the public at large came in 1958 with an exhibition of detached frescoes and the underlying *sinopie* in the *Forte di Belvedere* high above the city of Florence. The work continued apace and a perusal of the catalogue shows that in fact some nine-tenths of the works here displayed had been removed from their setting before the Florentine floods necessitated further interventions. The oily mess from central heating systems that the Arno waters swept into churches thus only completed the process which the internal combustion engine had begun. But it dramatized the threat to our common heritage and elicited so generous a response that the Florentine authorities were moved to send these treasures across the seas as a token of their gratitude.

They have emphasized that this gesture cannot be repeated, but even as a one-time act it has served to remind us of the speed with which the dissolution is taking place. For there is no denying that the detachment of frescoes does dissolve the tightly knit fabric into which these works had once fitted both materially and metaphorically and that the extraction of the *sinopie* from underneath, which were not meant to be seen, is another symptom of this dissolution.

Admittedly all this is a matter of degree. Not only the altar paintings mentioned before, but nearly all the objects in our collections were once intended to serve a definite social purpose from which they were alienated by collectors. Works of art have always proved capable of serving a multiplicity of ends, and of surviving many shifts of emphasis, from utility to delight, from content to form; but there can be few occasions which provide more food for thought on this process of change than this exhibition. Its catalogue proves how rarely we know even the original context and purpose of the images with which we are here confronted.

We know only by analogy that these frescoes in churches were mostly commissioned to honour a Saint whose intercession was devoutly expected by a religious order, a confraternity, a parish, or an ordinary citizen who was concerned for the good of his soul and spent some money on the family chapel, often leaving an income from vineyards or other estates to the church to secure that Mass could be read in perpetuity for his benefit. We do not know how long these injunctions were observed in most cases. Often, we must suppose, the investment ceased to yield an income or the family became extinct in the course of time even where the black death did not hasten this process. A new patronage of a chapel often meant a renewal of the images on its walls. Often, but not always, for the

religious function of these frescoes cannot be seen in isolation from their artistic worth.

Even an ordinary Florentine parish priest or merchant in the *trecento* would probably be aware of the widespread prestige which the local painters enjoyed. Dante, that fierce exile, had briefly alluded to the acclaim accorded to Giotto, who was subsequently invited by the citizens of Florence in the most flattering terms to settle there. It was a matter of pride for a workshop such as Taddeo Gaddi's to claim a knowledge of Giotto's methods and procedures, and we can be sure that discerning patrons would take such claims into account before they closed with a master craftsman. It is true that the traditional terms of contracts rarely reflect any special consideration for these masters. They were notoriously treated like any other tradesmen: they had to work to rigid stipulations and to guarantee the best quality of material and of workmanship. The documents sometimes included the promise not to leave the principal parts of their work to apprentices, but here as in other cases we cannot tell how seriously such assurances were taken, for obviously the patron had few means of checking and hardly any sanctions unless the appointed arbitrators of the Guild agreed that the work was not up to standard. The secrets of artistic teamwork were probably fairly impenetrable to outsiders even at the time, and have become much more elusive to an age which thinks of art as self-expression.

This, certainly, was not the way in which the *trecento* thought of Giotto, but the 'cult of personality' was round the corner, when the frescoed chapel was no longer seen as a memorial to the patron and a reminder of his religious aspirations, but as a monument to one of the artists who constituted the city's pride. Occasionally this pride took precedence over memory, and the most famous name was attached indiscriminately to works which looked remotely like claimants to that distinction. By 1510 the artistic monuments of Florence rivalled those of Rome in the minds of travellers: witness the first guidebook by Albertini which takes the tourist to churches for the sake of the art he can enjoy there.

In the middle of the sixteenth century Florence's pride in having been the birthplace of the new art and the scene of its progress to the perfection of Michelangelo's achievement found expression in the first history of the craft, Vasari's *Lives*. It was Vasari who systematically inspected the monuments of the past to weave their changing style into a coherent story, and first collected drawings of earlier masters as documents illustrating the progress of the art. The shift of interest from the commissioned work to the procedure of the artist had received a fresh impulse. It was not a shift of which the greatest of the Florentines approved. Vasari tells us that Michelangelo made a bonfire of his own drawings before his death, because he disliked the idea of prying eyes tracing the steps of his creation from its inception to the finished work, which alone was meant for the world at large. But of course he could not stem the tide of taste and fashion.

A new attitude toward art was taking shape in the late Renais-

sance, though it was still confined to a small circle. Connoisseurs enjoyed the company of artists; they wanted to share in the miracle of creation at least vicariously, to peep over the artist's shoulder while he was working, eaves-dropping on the shop talk in the studio and discussing with the master those problems of his craft which happened to be in the centre of topical interest. For this new type of patron the drawing was even more valuable than the finished product, because it recorded the process of creation. There is evidence that a similar attitude had existed among sophisticated art lovers in the ancient world, for Pliny tells us that the unfinished paintings of great masters were sometimes admired more than their completed works since 'they showed the very thoughts of the artists'. To appreciate the radical nature of this reversal of values we need only try to imagine what the ordinary patron would have said or felt if the master whom he had entrusted with the images for the chapel had failed to complete them.

Something like this reversal is reflected in Professor Meiss's remark that the uncovering of the *sinopie*, the rough preliminary outlines under the frescoes,

> represent one of the greatest additions ever made to our artistic heritage. They have brought to light a corpus of monumental drawings from a crucial period in Western painting. For the first part of this period, furthermore, we previously possessed very few drawings of any kind.

It is incontestable that the evidence provided by the *sinopie* is of tremendous interest to the historian of styles and techniques. But are we not subtly misinterpreting these traces of working procedures if we call them 'drawings' and thus equate them with the treasured sketches of later masters? No one has set out the historical reasons which prompt these doubts with greater precision than Professor Meiss himself has done in the same Introduction. He tells us why the *sinopia* on the wall had gradually to give way to the drawing on paper. The standards of artistic inventiveness and originality had changed. The earlier technique had the inconvenience that the artist had to cover up the preliminary outline patch by patch before he actually painted the final stage. Such a procedure

> was appropriate only to an era in which forms were relatively conventional. All heads, for instance, approximated canons to such a degree that the singularities of each could be remembered or invented as the artist quickly painted his daily patch without benefit of the drawing.

A period, we learn, in which art was seen as a personal creation 'that had been studied and developed at leisure' could no longer rely on such summary methods. It developed the cartoon as a preparatory stage which could be worked out in detail and transferred to the wall by pricking so that the final phase could be executed without hesitation. The cartoon, to revert to Professor Meiss's masterly formulation,

recorded on the final surface the highly individual form; the *sinopia* recorded on a preliminary surface the comparatively canonical form.

But does not this difference in function also reflect a profound difference in the psychological and aesthetic significance between the *sinopia* and the sketch? Raphael's drawings for his frescoes in the *Stanze* may be compared to the drafts of a great poet, recording his inspiration, his search, his rejections, and his triumphant solutions. The *sinopia* is perhaps closer to the draft of a legal document which contains a large proportion of time-hallowed formulas. In drafting such a text the notary will not need to write out these formulas in full, but will simply indicate them with a few abbreviated scrawls which his scribe will be able to read and write out. These rapid strokes, then, may conceivably look similar to those of a poet driven along by the fury of inspiration, but their meaning bears no comparison. Although the parallel may be somewhat exaggerated, it reminds us that on Professor Meiss's own showing the outlines which the early masters roughed out on the wall were not so much forms emerging from the depth of their minds as shorthand indications of schemata they and their apprentices almost knew by heart. The abbreviations and simplifications which delight the modern observer because they remind him of Matisse tell the historian that once communication served the need of the workshop and stood in no need of redundancies, while today it is the public who want to feel part of the workshop.

It is to this desire that Professor Meiss appeals when he still insists that the *sinopie* give us 'the kind of insight provided for later paintings by much smaller preparatory drawings' and 'that at this earlier time too creation was a process of sustained searching'. But surely even the most convention-bound craftsman will have to adjust the formula to the requirements of a particular scale and location. Granting the need for some degree of trial and error in any process of making, we might also argue that a careful inspection of the early *sinopie* in this exhibition confirms rather than refutes the conception of medieval painting as a craft demanding the mastery of traditional formulas.

The comment in and about the exhibition where the *sinopie* are often displayed side by side with the finished work gives the impression that we are in danger of losing contact with an art of this nature and find it easier to enjoy the rough indication than the finished work. Many seem almost to have lost the capacity of appreciating the subtle craftsmanship that goes into the careful modelling of a drapery with its changing tones and its delicate lights, the result of those methodical procedures which were once the pride of Florence and were described with loving care in the handbook by Cennino Cennini who recorded *trecento* workshop practices going back to the Gaddis and to Giotto. Even the artistic revolution of the next century with its need to rethink the formulas in the light of fresh demands for verisimilitude in spatial arrangement and expression

did not lead to a break in this tradition: the surface craftsmanship is as rich and controlled in the frescoes by Andrea del Sarto and by Pontormo shown in this exhibition as it is in the earlier works. For though the exhibition leads up to the period which first appreciated the rough sketch as a record of inspiration, we are still far from the time when insistence on finish was dismissed as a sign of philistine ignorance.

The wish to identify with the artist, to share in the thrills of creation but not in its pains, has led to an increasing shift from the product to production. Art in its turn has responded with its present emphasis on 'action' or the impermanent 'happening'. Needless to say, a good deal of critical confusion has entered into this process, which began with the depreciation of the formula in favour of spontaneity and has ended in the devaluation of any kind of skill that can be taught or learned.

It is only in the performing arts that this process has been halted by the obvious demands of mastery. It is here, therefore, that it can most easily be seen that spontaneity and mastery are not mutually exclusive, though there may be a certain degree of tension between them. It can be an exhilarating privilege once in a while to hear an accomplished musician play a piece at sight and thus to participate in his pleasures of discovery. It may also happen that a performance may sound stale and over-rehearsed. But it is the hallmark of the great artist that such mishaps are rare and that he can retain the zest of creation to the end. He does so precisely because he knows that his effort will ultimately bring the work closer to the idea he has in his mind instead of taking it further away. His skill and his care help him to realize his intention in that process of trial and error, of daring and self-criticism, that accompanies all true creation. In preferring the first stage to the later elaboration we may be in danger of insulting unwittingly the artist and his work.

But did not artists sometimes have to compromise? Were they not forced to adjust to tastes and standards which were not their own but those of their patrons? Is this possibility not inherent in the craftsman's status which the documents reveal?

There is at least one work in the exhibition which suggests such an interpretation, but even here we must be careful not to project our twentieth-century standards into the past. The problem concerns a dramatic change of plan for the fresco of an Annunciation in the Oratory of San Galgano at Montesiepi near Siena, attributed to the Lorenzetti workshop and possibly to the great Ambrogio Lorenzetti himself. The preparatory drawing on the wall shows a most striking departure from convention (Fig. 10). Here the artist emphasized to an unusual extent the account of the Gospel that, on receiving the Angel's salutation, the Virgin was 'troubled' and was told to 'fear not'. She is often shown drawing back, as for instance in Simone Martini's Uffizi *Annunciation*, but the first *sinopia* developed this motif, unconventionally showing the Virgin sitting on the ground and seeking the support of a column behind her in her sudden fright.

We would of course love to know who rejected this extreme

solution—whether the master himself, the patron, or the ecclesiastical authority. It is tempting to think that it was the latter, and that the conventionalism of *trecento* art was supported or even enforced by the Church. But we cannot be sure, all the less as we know that the degree to which the Virgin displayed fear at that moment remained a subject of artistic rather than ecclesiastical debate up to the High Renaissance. None other than Leonardo da Vinci came out strongly in favour of decorum in these matters, and ridiculed a painting he had seen in which the announcing angel 'appeared to be chasing Our Lady out of her room . . . while it seemed as if she in despair would throw herself from a window'. The degree to which holy personages should be shown to yield to fear and weakness may have been seen as an artistic problem.

There is an interesting parallel also in the work of Albrecht Dürer. This time it is Christ in the Agony in the Garden whom the master showed lying prostrate, with outstretched hands, the face buried in the ground in a woodcut for the 'Small Passion' (Fig. 11) which he

10 Ambrogio Lorenzetti and assistant: *The Annunciation*. Detail. Mid-1330s. Sinopia. Oratory of San Galgano in Montesiepi

subsequently replaced by a much more restrained rendering (Fig. 12). In these cases too our bias is all for the wild against the tame, but this too is a bias.

The problem posed by the detachment of works of art from their original setting lies precisely in the temptation to indulge this kind of bias unchecked. We cannot jump out of our skins or forget to which century we belong. But even an unprepared tourist who enters a village church in Italy, guidebook in hand, will be made aware of the emotional needs which the frescoes were intended to serve. Whatever his outlook on religion, whatever his knowledge of history, the experience will provide an aid for the understanding of these images which we can ill afford to miss. Some time ago André Malraux launched the slogan of the 'Museum Without Walls' to indicate the changes that have come about in our attitude to the art of the past through the ubiquity of photographs and other reproductions. Unless we remain on our guard we may yet witness the counterpart, the stripped church, the wall without the Museum.

11 Dürer: *Small Woodcut Passion: The Agony in the Garden* (B54)
12 Dürer: *Small Woodcut Passion: The Agony in the Garden* (B26). c.1511

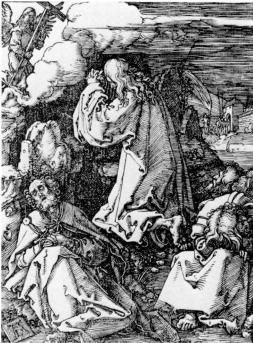

Kenneth Clark's 'Piero della Francesca'

'What Apelles could excell Petro de Burgo for perspective, Albrecht Durer for drapery, Michelangelo for action?' Whatever the reasons which may have prompted Henry Peacham in 1634 to refer to 'Petro de Burgo' (Piero della Francesca) in such terms,[1] it remains surprising that an artist who was introduced to the English public in such illustrious company should have had to wait three hundred years for an adequately illustrated monograph in English. We are thus doubly grateful to the author and publisher of this volume which, for its combination of a suitable theme, a beautiful set of plates, an authoritative text and a type face and production rising to the occasion may well be judged the most handsome that has so far come from the Phaidon Press. Many of the plates are based on photographs specially taken for this book by Cav. Cipriani and in nearly all cases the standard of reproduction does justice to their excellence. Most of the details (with the possible exception of Plates 40, 74, and 90) are not simply blown up enlargements but fresh photographs which will not only commend the book to amateurs (as the preface modestly suggests), but to any student of Piero's art. The colour plates may not be very faithful—which ever are?—but they are never loud and crude and the general arrangement of the volume with an introductory essay, complete and detailed illustration of the master's *oeuvre* and a commentary supported by subsidiary illustrations comes close to an ideal solution for a monograph of this kind. The only addition one might wish for the type would be a chronological conspectus of all documents and a guide to the bibliography. The omission of these features has led the author to some oversights. His attempt to vindicate Vasari's (and Ruskin's) derivation of the name from the master's widowed mother is disproved by Mancini's publication of the document (*Bolletino d'Arte*, xii, 1918) showing that Piero's father died a nonagenarian in February 1464. His chronology still relies on the alleged evidence according to which the Uffizi portraits must be dated 1465, while Creighton E. Gilbert has shown in *Marsyas*, 1941, that all external evidence at any rate points to a date shortly after 1472.

With an artist whose work is so sparsely documented as that of Piero the arrangement of the plates themselves will have to rest on an interpretation of the artist's change of style. The sequence adopted by the author is based on the picture he has formed of the artist's inner development but he does not neglect such clues as history can offer. At one point the author even tries to secure such a clue. Rightly rejecting the supposed connection of the Urbino *Flagellation* with the murder of Count Oddantonio he tries to tie it on to another date by suggesting that the flagellation might be symbolic of the tribulations of the Church and that the painting may, therefore, refer to the fall of Constantinople in 1453 and to the Councils for the organization of a crusade. But is there any evidence that scenes from the Passion were painted in the fifteenth century to allude to contemporary events or that such three figures as the mysterious bystanders

[1] *The Gentleman's Exercise*, London [1634], p. 7. The passage is an elaboration of a similar reference in the same author's *The Art of Drawing*, London [1606]. Though it is very likely that to Peacham Piero's fame was purely literary, evidence has recently come to light to show his continued prestige in the seventeenth century. A painting by Nicolas Tournier in the Toulouse Musée des Augustins, representing the *Battle of Constantine*, is clearly based on Piero's Arezzo fresco of the same subject. (*Cf.* H. Naef: 'Französische Meisterwerke aus Provinzmuseen', *Du* [July 1951].)

Originally published in the *Burlington Magazine*, 94, 1952, as a review of Kenneth Clark, *Piero della Francesca*.

(none of whom wears ecclesiastical insignia) could be then accepted as signifying a Council? It is true that one of them wears a gown that might suggest a Greek or Byzantine costume but neither were the Greeks present at the Council of Mantua nor did they belong to the Church since the efforts to achieve a union had failed. Is it not much more likely that Piero's painting illustrates two connected scenes from the gospels? There is, in fact, such an episode which would fit the context well and which would probably have been recognized long ago but for the secular bias of historians of Renaissance art—the *Repentance of Judas* (Matt. xxvii, 3, 4): 'Then Judas, which had betrayed him, when he saw that he was condemned, repented himself, and brought again the thirty pieces of silver to the chief priests and elders, Saying, I have sinned in that I have betrayed the innocent blood ...' The scene is rare in art[2] but it was a regular feature of late medieval Passion plays. At least in one of them, whose text has been preserved, we find the same juxtaposition with the Flagellation as in Piero's painting, for Castellano Castellani's *Rappresentazione della Cena e Passione* contains the stage direction: *Mentre che batton Cristo, Giuda dice a' sacerdoti: Peccavi,*[3] etc. There is even a pictorial representation reflecting this tradition of the stage—a woodcut by Urs Graf of 1507 which shows a room where on the left, in the background, Christ is assailed by soldiers while in the right-hand foreground Judas returns the money to the priests and elders (Fig. 13).[4] No such exact parallel can be quoted from Piero's own generation but it may be worth mentioning that Fouquet, whose affinity to Piero has often been felt, shows the episode of Judas' suicide in the background of his *Road to Calvary*.[5] It might be argued against the interpretation of Piero's 'oriental' bystander as Judas that he does not look sufficiently wicked, but neither does Piero's villainous Jew who hid the cross in the Arezzo series. Moreover the nineteenth-century interpreter who described the group as Duke Oddantonio and his two wicked counsellors must have felt that there is something sinister in the figure in black, for according to the chronicles one of these counsellors was a true Judas who was sent by Sigismondo Malatesta to make the duke lose first his popularity and then his land.[6] The main puzzle, which remains if the identification with Judas is accepted, is the absence of the money-bag or any sign of the money—can it be that Judas lost it in the same process which cost the high priest his nose? That the figure in brocade qualifies for Caiphas seems obvious, but who is the barefooted youth? Before its deterioration the picture is said to have been inscribed with the verse from the 2nd psalm: *convenerunt in unum*, and the commentaries explain this verse in a manner fitting our interpretation well: 'Astiterunt et principes, scilicet Sacerdotum, videlicet Anna et Caiphas, *convenerunt in unum*, id est in unam pravam voluntatem.'[7] Perhaps, then, the figure is Annas or just an anonymous representative of the Elders, such as appears on frequent representations of Judas' betrayal in the *Biblia Pauperum* (Fig. 14).[8] Possibly, however, the real clue may still be found in the various figures introduced into the Passion plays.[9]

[2] It occurs in Ravenna and on the bronze doors of Benevento. Cf. William Porte: *Judas Ischariot in der bildenden Kunst*, Jena Dissertation, Berlin [1883].

[3] Alessandro D'Ancona: *Sacre Rappresentazioni*, Florence [1872], i, 311. The date of this play is unknown but Castellani was born in 1461. For records of similar Passion plays in Piero's lifetime, see Alessandro D'Ancona: *Origini del Teatro Italiano*, Turin [1891], esp. p. 280 ff.

[4] Cf. W. Porte, loc. cit., p. 92 and Passavant: *Le Peintre Graveur*, ii [1860], p. 140, No. 13.

[5] P. Wescher: *Fouquet*, Bâle [1945], pl. ii. Cf. also O. Goetz: 'Hie henckt Judas', *Form und Inhalt, Kunstgeschichtliche Studien Otto Schmitt zum 60. Geburtstag*, Stuttgart [1950].

[6] A. Reposati: *Della Zecca di Gubbio*, Bologna [1772], i, 153.

[7] Petrus Lombardus: *Commentarius in Psalmos Davidicos*, Migne Patr. Lat. cxci.

[8] *Biblia Pauperum*, ed. P. Heitz and introduced by W. L. Schreiber, Strasbourg [1903]. The composition closest to Piero's group is in the *Biblia Pauperum* of 1470, Schreiber, iv, p. 93 (Fig. A).

[9] In that of Ferrara of 1489, for instance, Judas was confronted with St John the Baptist: 'All' incontro venne sancto ... Zoanne Baptista, il quale, vedendo Juda, vulgarmente comenzò a reprendere ... Juda non rispoxe mai, ma mesto passezava suso il tribunale, grattandose spesso il capo, facendo acti de essere mal contento. Finito il parlare di sancto Zoanne, se partì. Juda andò a rendere li denari ...' (D'Ancona: *Origini, loc. cit.,* i, p. 294). In French fifteenth-century Passion plays Judas' suicide is often preceded by a lengthy dialogue with the allegorical figure of *Désespérance* (cf. Gaston Paris and Gastond Reynaud: *Le mystère de la Passion d'Arnould Grebau*, Paris [1878]).

The last word has certainly not been spoken about this or any other problem of iconography and chronology in Piero's *oeuvre*. But the author has made it quite clear that his 'text is not intended to be a full, critical biography of Piero della Francesca but a guide to the appreciation of his work'. If it is the purpose of such a guide to attune the reader's mind to the enjoyment of the illustrations through the even rhythms of a perfect prose the author has admirably succeeded. The high emotions of his encounters with Piero's art are here recollected in tranquillity and crystallized in passages of such beauty that some of them (notably the descriptions of Piero's palette on p. 12 and p. 29) may well find their way into anthologies of poetic prose. Indeed, future generations may turn to this text, with its dedication to Henry Moore, for an explanation of all that the mid-twentieth century valued in Piero's art—much as we turn to Walter Pater's essays on Giorgione or Botticelli if we want to evoke the mood of the *Fin de Siècle*. Sometimes the author seems to invite this comparison for he deliberately catches the echo of Pater's prose hymn to the *Gioconda* in his description of Piero's *Madonna of Mercy*: '. . . set her beside the smiling Buddha heads of Indo-China or China itself, and how strongly she asserts her Mediterranean humanity!'

It is a curious paradox that the art of Piero, the art which Bernard Berenson recently represented as the prototype of *l'arte non eloquente*[10] should thus have given rise to a revival of eloquence in criticism. For Sir Kenneth Clark is not the first author so to respond to

13 Urs Graf: *Repentance of Judas and Christ mocked*. Woodcut, 1507
14 *Judas selling Christ*, from the *Biblia Pauperum* of 1470. Strasbourg edition (1903), IV, p. 93, No. 1

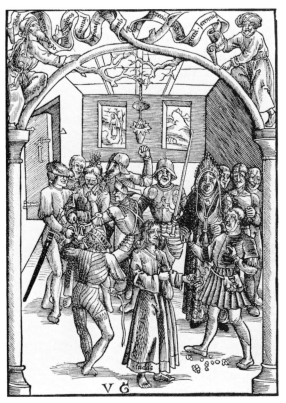

the challenge of Piero's remote and reticent beauty. Möller van der Bruck and R. Longhi, J. v. Schlosser and Adrian Stokes, each according to his lights and to his command of language, have all felt the need to translate their experience of Piero's 'impersonal' art into a very personal imagery. One may agree with our author that 'one cannot describe the quality of these forms without resorting to moral analogies' and still feel that there is a danger in this approach which must not go unmentioned. It arises whenever such a description is allowed to take the form of an historical statement. This danger is well illustrated by Möller van der Bruck who considered the 'hard, cold, almost petrified lucidity' of Piero's style evidence of the artist's 'Nordic' ancestry which made him 'a barbaric pagan and a philosophic peasant rather than a Roman Catholic'.[11]

Sir Kenneth Clark, of course, would never allow his intuition to give support to so crude and blatant a theory. But he lends his authority to psychological ideas which may ultimately prove no less destructive of the standards of rational historical criticism. His penultimate paragraph on Piero's art reads: 'No painter has shown more clearly the common foundations, in Mediterranean culture, of Christianity and paganism. His Madonna is the great mother, his risen Christ the slain god; his altar is set up on the threshing floor, his saints have trodden in the wine-press . . . This unquestioning sense of brotherhood, of dignity, of the returning seasons, and of the miraculous, has survived many changes of dogma and organization, and may yet save Western man from the consequences of materialism'.

When Kant fell under the spell of Rousseau's Nature worship he decided to read these writings again and again till he was 'no longer disturbed by the beauty of the style'. The critic faced with the heady message of this creed is under a similar obligation, the more so since the mystique of the 'soil' has so far proved a dangerous remedy for the ills of our civilization. Now Julius von Schlosser, describing his first encounter with the *Madonna del Parto* was moved to rather similar language. He tells how he found himself unexpectedly in the presence of 'a primeval mother of chthonic power . . . a Christian Demeter, and yet a contadina',[12] but he took care to give the passage an autobiographical framework. Sir Kenneth Clark received his intuition in front of the *Resurrection* of San Sepolcro. The risen Christ, whom Longhi calls *orrendamente silvano e quasi bovino* made him 'conscious of values for which no rational statement is adequate . . . this country god . . . has been worshipped ever since man first knew that seed is not dead in the winter earth.' Believing, as he does, that concentrating on the ostensible content of a painting has mainly 'the merit of occupying our conscious minds and leaving our unconscious free to discover what we can' he apparently accounts for his emotion in front of the painting by some direct contact with primeval states of mind. The implications of this theory of art—for it is a theory—are sufficiently important for us to hope that the author will still make them explicit. For here he touches on problems which were the constant preoccupation of Warburg, and

[10] B. Berenson: *Piero della Francesca o dell' Arte non eloquente,* Florence [1950].

[11] Möller V. D. Bruck: *Die italienische Schönheit,* Munich [1913], p. 463.

[12] Julius V. Schlosser: *Künstlerprobleme der Frührenaissance, Sitzungsberichte der Akademie der Wissenschaften in Wien, philosophisch-historische Klasse,* [1933], p. 214.

which are now generally formulated in Jungian terms. One thing seems certain—no rational theory of survival, such as occurs in folklore, could explain the identification Sir Kenneth Clark alludes to. To the Christian of the fifteenth century Christ was not a corn god. This remains true even if it could be shown that the Easter story itself owes something of its form to earlier mythologies or spring rituals. For while such a statement—whether true or false—would be capable of a commonsense explanation, only Jung's assumption of some kind of 'collective memory' could account for the fact that Piero's illustration of the *Resurrection* should contain more of these forgotten origins than any other picture of the same event. Moreover, since the artist would surely have rejected any suggestion that his painting recalled the heathen horrors of Tammuz and Cybele we have to assume that the memory of these things remained unconscious with him and remained so till our own unconscious detected it. Now the psycho-analyst of Jungian persuasion may be able to claim that he tests his intuitions in the laborious and expensive process of the consulting room but not even he could put Piero on the couch. It is precisely those of us who feel in sympathy with any attempt to make use of the insights and discoveries of modern psychology for the elucidation of art who should strive for the greatest possible clarity in the formulation of these problems. It may well turn out that the records of history are hardly ever sufficient to provide the psychologist with material for his kind of interpretation. But that would not mean that historical data have become worthless for our understanding of art. In the case of the *Resurrection* we even have a few such data which Sir Kenneth Clark does not mention. The fresco was painted for the town hall of San Sepolcro to mark the special ties which were believed to link this city with the Holy Sepulchre. It was thus more than the usual episode in a large narrative cycle. As was natural with such a commission Piero deviated but little from the hallowed tradition of the scene known to his fellow citizens, but he raised it to a new monumentality.[13] Of course these circumstances do not 'explain' the artistic merits of the painting but they help us to appreciate the precise task that confronted Piero and with it the grandeur of his solution. It is this task rather than any recrudescence of ancient lore which may account for the hieratic and almost heraldic solemnity of the painting. For historically speaking there is no evidence that Piero was closer to the soil than other artists of his day. On the contrary. He worked for the humanist courts of Rimini, Ferrara and Urbino and he wrote treatises on the most complex problems of applied geometry. Not that Sir Kenneth Clark ignores that aspect of his personality. There are some beautiful passages on the aesthetics of number and proportion in his book but ultimately he still finds a conflict between the 'earthy' peasant artist of his intuition and the learned mathematician praised in the early sources. At least he believes that only in his early and mature works could Piero always integrate these two sides of his nature while eventually the mathematician stifled the artist creating by instinct. But here is a point where history should perhaps claim precedence

[13] Hubert Schrade: *Ikonographie der christlichen Kunst, I. Die Auferstehung Christi*, Berlin, Leipzig [1932], p. 238 f.

over aesthetic criticism. For seen in the wider context of the Quattrocento scene this distinction between the artist and the scientist becomes difficult to maintain. Was it not his preoccupation with solids, with elemental shapes surrounded by space and light that led Piero to eliminate and reject from his art the elements of Gothic expressiveness and gesticulation that characterizes the style of his great contemporaries, the art of the late Donatello, of Castagno, of Cosimo Tura and even of Mantegna? He may have found sanction for this bent in the art of some *oltramontani* and even—who knows?—in Greek vases and terra-cottas, he may have strengthened this tendency—as Vasari tells us—by working from clay models, but without this single-minded act of concentration his art would hardly convey the feeling of noble restraint and untainted simplicity that calls up in the mind of recent observers these various images of primeval existence. Seen in its historical setting Piero's art stands in no need of support from archaic emotions and modern associations. For in the last analysis these are but rationalizations of our feeling of strangeness. Yet, if this feeling should gradually give way to a more intimate understanding we shall owe this to perceptive critics like Sir Kenneth Clark who heightened our sensibility to the stereometric harmonies of a master of form.

15 Piero della Francesca: *The Flagellation of Christ.* c.1455. Urbino, Gallery

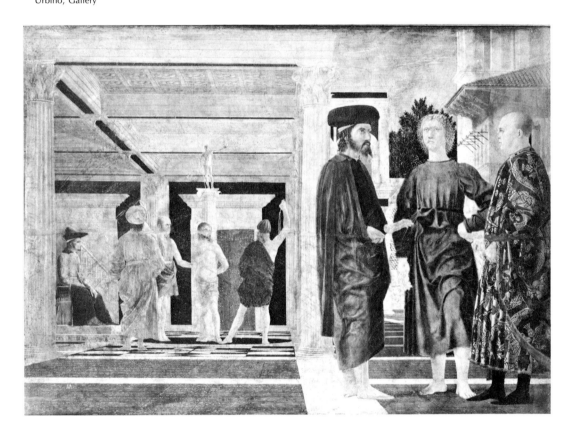

9

The repentance
of Judas

Some years ago I put forward the hypothesis that the enigmatic bystanders in Piero's *Flagellation of Christ* (Fig. 15) may represent the scene of Judas' repentance (Matt. xxvii, 3, 4).[1] I do not know whether the literary and iconographic parallels I was able to cite convinced anyone.[2] Having examined the picture in vain for any traces of the thirty pieces of silver I was ready to join the sceptics. The drawing in the Albertina (Fig. 16), recently attributed to the circle of Tura,[3] has occasioned a relapse. There are no coins here either, but the type and gesture of the main figure clearly fit the story of Judas throwing the money at the feet of the Elders. There is no need to dwell on the difference between this crude drawing (which may well, as Berenson saw, be the copy of a painting) and Piero's *arte non eloquente*.[4] But this very character of Piero's narrative style makes it possible to see behind the undeniable similarities of type, gesture and pose an identity of subject.

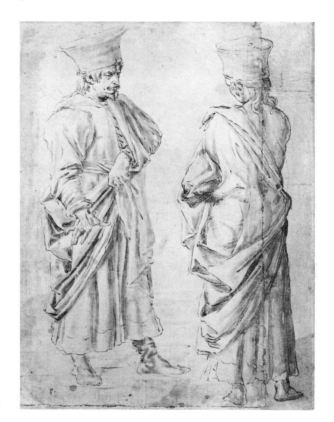

[1] See pp. 54–5.
[2] The counter arguments were presented by Creighton Gilbert, 'Subject and Not-Subject,' *Art Bulletin*, xxxiv, 1952, 202–216.
[3] Eberhard Ruhmer, *Tura*, London, 1958, Plate VI (a); Inv. no. 33, *Beschreibender Katalog der Handzeichnungen in der Graphischen Sammlung Albertina*, III, p. 5; Berenson, no. 1909.
[4] The allusion, of course, is to B. Berenson, *Piero della Francesca o dell'arte non eloquente*, Florence, 1956.

16 *Two Orientals*. Italian drawing, 15th century. Vienna, Albertina

Originally published under the title 'The Repentance of Judas in Piero della Francesca's *Flagellation of Christ*' in the *Journal of the Warburg and Courtauld Institutes*, 22, 1959.

Seeking a key to Leonardo

Among the manuscripts of Leonardo da Vinci at the British Museum there is a famous and pathetic note written by the master in his fifty-sixth year:

Begun in Florence in the house of Piero de Braccio Martelli on March 22nd, 1508. And this is to be a collection without order, taken from many papers which I have copied here, hoping to arrange them later according to their proper place under the subjects of which they will treat. And I believe that before I shall be through with this, I shall have to repeat one and the same thing several times. Hence, reader, do not curse me, for the subjects are many and memory cannot hold them and say 'I do not want to write this, since I wrote it before'. And if I did not want to fall into this error it would be necessary for me always to reread all that had gone before before I copied anything, to avoid repetition, particularly since the intervals are long between one time of writing and the next.

The master's forebodings were justified. He never succeeded in bringing order into his vast collection of papers and so posterity had to struggle with that awe-inspiring legacy of notes, jottings, drafts, excerpts, and memoranda in which personal trivia alternate with observations on optics, geology, anatomy, the behaviour of wind and water, the mechanics of pulleys and the geometry of intersecting circles, the growth of plants or the statics of buildings, all jostling each other on sheets that may contain sublime drawings, absent-minded doodles, coarse fables, and subtle prose-poems.

It is one of the permanent gains we owe to Professor Pedretti's new book that we now know a little more about Leonardo's own procedures in his attempts to subdue this chaos, and about the efforts of his faithful heirs to succeed where he had failed. It had always been known that it was only after Leonardo's death that systematic attempts were made to retrieve at least one coherent group of notes from his literary remains, those directly or indirectly concerned with problems of painting. The resulting selection is known as the *Codex Urbinas* in the Vatican and it was this arrangement that formed the basis for all subsequent publications of what came to be known as Leonardo's *Treatise on Painting*. By careful detective work on this manuscript (which was published in facsimile and translation by A. P. MacMahon in 1956) Professor Pedretti can make a convincing case for the authorship of this priceless compilation. He attributes it to none other than Leonardo's companion and legal heir Francesco Melzi; moreover he shows that in this difficult work of sorting and copying Melzi adopted procedures which Leonardo himself developed. The original notes were marked with various signets cancelled as soon as they were entered into a fresh notebook. This demonstration alone adds much authority to the treatise that pre-

Originally published under the title 'The Mystery of Leonardo' in the *New York Review of Books*, 11 February 1965, as a review of Carlo Pedretti, *Leonardo da Vinci on Painting: a Lost Book (Libro A)* and Sigmund Freud, *Leonardo da Vinci and a Memory of his Childhood*.

viously had sometimes been neglected as an apocryphal work. More than that. Professor Pedretti succeeds in reconstructing through the treatise one of Leonardo's notebooks which is no longer extant. Great as is this achievement, and exciting as it proves to be in its consequences for the Leonardo specialist, it should perhaps be said for the sake of prospective buyers that the title of this valuable study is open to misinterpretation. *Leonardo da Vinci on Painting*: *A Lost Book* promises to the uninitiated a text by the master not previously known. This, alas, is not the case. What we get is only the rearrangement of parts of the text in the form in which Leonardo probably presented it. It will not surprise readers of my initial quotation that this arrangement itself is puzzling enough. Notes on light, on movement, on colour, and general remarks alternate according to no detectable order. One wonders in fact whether Leonardo really copied them out in that sequence or whether he started at the end of the book (being left-handed) or possibly on both sides. One thing is likely—the notebook itself was hardly intended as more than a preliminary stage towards order. In fact one of Professor Pedretti's most brilliant accomplishments is to show that Leonardo himself extracted notes on hydrodynamics from it for a later manuscript. He used it, in other words, exactly as Melzi was to use it.

What emerges from this analysis is the surprising fact that much of the material we find in the *Treatise on Painting* does not date from Leonardo's first Milanese period, the period of *The Last Supper*, as had been generally assumed, but from the sixth decade of his life, the period, that is, when we saw the ageing master trying to bring in his harvest. This in its turn may necessitate a good many revisions of previous views. Admittedly, to appreciate the flood of light that Professor Pedretti can throw on many Leonardo problems in his digressions, appendices, and notes, we must not only read this book but study it, in a well-equipped library where all the relevant publications are close at hand, preferably in the Elmer Belt Library of the University of California (Los Angeles) where the author teaches and works. It is clear, moreover, that this study presents only the first step towards a new edition of Leonardo's writings that will, one hopes, make them at last intelligible as a human record.

For, paradoxically, the arrangement by subjects towards which Leonardo groped has ultimately tended to confuse and obscure our image of Leonardo's researches. Meritorious as were the great anthologies by Richter and MacCurdy in showing the tremendous range of Leonardo's scientific and technical interests, they really made it impossible to follow his processes of thought by indiscriminately assembling his excerpts, his false starts, his revisions and conclusions extending sometimes over a period of some thirty years as if they were all equally valid documents of the master's views. Imagine the same procedure adopted for any scientist or scholar, with his notes being jumbled and printed without regard for their sequence in time! Small wonder that the picture of Leonardo one derives from a casual perusal of these publications is so self-contradictory, that some have seen in his jottings the miraculous

anticipation of practically everything science was later to discover, while others have come to stress the autodidactic and apparently undisciplined character of these miscellaneous observations. Hence the conviction of the present generation of Leonardo scholars (of whom Professor Pedretti is an outstanding representative) that we should hold our judgement in many cases until we can trace the development of the master's ideas step by step, from his original acceptance of traditional errors to his first crude guesses and subsequent refinement of methods and ideas that may not always have resulted in miracles but that invariably command respect and admiration. Until this work is done and Leonardo's cryptic jottings are placed in their proper chronological and factual context, any attempt to reconstruct the master's thoughts and inner life now appears to be premature.

It may thus seem almost unfair to discuss against this background the new translation by Alan Tyson of Freud's famous psychoanalytic study of *Leonardo da Vinci and a Memory of his Childhood* that has just been included in the Standard Edition of Freud's Works. In 1910, when Freud's study first appeared, few of these problems were even thought of. Freud, moreover, did not rely on a study of the manuscripts, but, to a large extent, on a German anthology published by Marie Herzfeld. It is well known by now that this anthology misled him. It had Leonardo recall a curious childhood memory when a vulture had settled on his cradle and pushed its tail into the infant's mouth. But if there were vultures in the environs of Florence he did not speak of them. The bird in question was a kite. So much is acknowledged in the editor's note that prefaces this volume. We are asked, however, to examine the situation coolly and to excise from Freud's book only those deductions that directly derive from this mistranslation, notably his discussion of the myths about vultures in ancient Egyptian lore, and Pfister's fantastic attempt to read the outlines of a monstrous bird (such as rarely overshadowed the smiling vales of Tuscany) into the drapery of Leonardo's *St Anne*. Grateful as one must be for this reminder, one wonders why the editor has not at least drawn attention to the large literature that has grown up around this most controversial of Freud's studies, notably the article by Meyer Schapiro in the *Journal for the History of Ideas* of 1956 and Dr K. R. Eissler's vast monograph of 1962 which it provoked. Had this been done the editor could not have wondered about 'the strange fact that until very recently none of the critics of the present work' had spotted the mistake. It was discovered more than forty years ago by Maclagan in the *Burlington Magazine* of 1923. One would also have expected the reader to be told of another factual error, due to Freud's use of an inaccurate copy of one of Leonardo's anatomical drawings, that led him to quote an interpretation of an alleged mistake which was not the master's but the copyist's. Finally it might at least be arguable that the few new facts that have come to light about Leonardo's childhood story should have been made available—the account of his baptism discovered by Möller in 1939, and the documents about his stepfather Accatabriga recently

published by Renzo Cianchi (they were not available to Dr Eissler) which tell us that the husband of Leonardo's mother was a rural craftsman, a *fornaciaio* who operated a kiln. (What pleasant opportunities for dreaming about the future scientist minding the kiln and experimenting in the workshop!)

Freud loved Jewish anecdotes and it is not too irreverent to apply a famous Jewish joke to the situation. It is the story of the admired *Wunder-Rabbi* of Tarnopol who overawes his assembled followers one Friday evening by gazing into the distance and announcing that he can see the Synagogue of Lwow burning. A few days later a traveller arrives from Lwow and is told of the miracle. He is unimpressed; there was no fire. However, consternation among the rabbi's disciples soon gives way to the consoling thought that it is not that little detail that matters. It was the fact that their rabbi could see as far as Lwow at all that was the great miracle.

Joking apart, Freud could see far. The first sixteen pages of his study before the unfortunate vulture makes its appearance present a fascinating and coherent psychological portrait of Leonardo based on Freud's wide reading of the literature then available to him. True, he may have trusted Vasari a little too much in some things and too little in others. Following a remark by a contemporary he implies that Leonardo more or less abandoned art for science—one of the points where chronological studies may enforce a revision. Strangely enough, moreover, he failed to include in this character sketch one of Leonardo's most puzzling traits, the sanguine optimism with which he advocated what might be topically called 'hare-brained schemes'. Vasari tells of his plan to divert the Arno so as to deny it to Pisa. Thanks to an astonishing find in the Turkish archives we now know that around 1503 he made the Sultan an offer to build a bridge across the Bosporus 'so high that nobody will agree to walk over it . . . so that sailing ships can sail under it'.

But is not Leonardo's whole programme of research evidence of this incredible optimism? He must have believed that he could not only read the whole book of nature at one go, but even copy it out and publish the results of his innumerable observations and calculations. Even his artistic projects are on a similar scale. Did he really think that his instructions for painting a battle or the deluge could ever have been followed? These are among the psychological questions Freud did not raise. But even though the portrait is in need of retouching nobody can deny that this first attempt to make psychological sense of the scattered evidence about this mysterious genius has guided and fructified the historical imagination ever since.

Where Freud proceeds, however, to justify his intuitive image by presenting his reconstruction of Leonardo's childhood story it is not only the philological mishap that worries the historian. What Freud depicts is the sad story of the illegitimate child, or rather, in a way, the tragedy of the boy's mother to whom that child of love is the only consolation and who, through her over-fondness, arouses both the future artist's sexual desires and sexual curiosity. It was the resulting fixation on his mother that turned the boy into a homosexual, but it

was also the resulting curiosity that was sublimated in his research. Knowing that he had been abandoned by his father Leonardo abandoned his own 'children'—his paintings—in his turn. But if this attitude harmed his art it benefited his science, for rebellion against his father turned into rejection of all authority. Freud's real heroine, however, remains Leonardo's mother. It was her smile, he thinks, that continued to haunt Leonardo's art and was evoked in the smile of Mona Lisa and of St Anne. 'From that time onward, madonnas and aristocratic ladies were depicted in Italian painting humbly bowing their heads smiling the strange, blissful smile of Caterina, the poor peasant girl who had brought into the world the splendid son who was destined to paint, to search and to suffer.' The downtrodden woman 'who was forced to give up her son to her better-born rival, as she had once given up his father as well' had triumphed at last.

Did Freud really derive this elaborate reconstruction from the story of the 'vulture' and such scanty evidence as the documents yielded? He did not and could not. All the documents tell us is that Leonardo was the illegitimate child of one Caterina, later married to Accatabriga, and that at the age of five he lived in the house of his father whose marriage was still without issue. It is well known, however, that Freud brought to his readings of the documents the image he had derived from one of his favourite books, D. Merezhkovsky's historical novel, *The Romance of Leonardo da Vinci*. In the eleventh chapter of that romantic evocation, which reminds the skeptical historian of Beerbohm's skit *Savonarola Brown*, there occurs a 'flashback' when Leonardo visits his childhood haunts. The artist fondly remembers his mother's tender and mysterious smile and recalls how he used to abscond from his father's house to visit his poor mother 'who covered his face, his eyes, lips and hair with her kisses'. It is in the next paragraph, however, that the student of Freud will prick up his ears. For here we read Merezhkovsky's account of the boy's nightly visits to his mother, climbing out of the window so as not to awaken his grandmother, and snuggling down in his mother's bed 'pressing his body against hers in the dark under the blanket'. Was it not this frank description of an Oedipus situation that caught Freud's imagination and sparked off his interest in Leonardo's childhood story? Did he not read the 'vulture' incident with this image already firmly planted in his mind? We may never know. But one thing is sure—Freud himself did not want his reconstruction to be taken as gospel truth. In fact, sending his study to the painter Hermann Struck in 1914 he describes it as half novelistic fiction (*Romandichtung*). 'I would not want you to judge the certainty of our other results by this sample.' A careful reader of the study itself can find many similar qualifications sandwiched between Freud's bolder flights of fancy. Thus he reminds art lovers that he knows full well that Leonardo's famous smile was anticipated by his teacher Verrocchio. Most of all he protests that he 'does not in the least aim at making the great man's achievements intelligible', that he 'never reckoned Leonardo as a neurotic', that even if material were flowing more abundantly, there are 'two

important points' at which a psychoanalytic enquiry would not be able to account for a person's development. Neither his repression of his early erotic experiences nor their sublimation into a craving for knowledge can thus be explained, and 'since artistic talent and capacity are intimately connected with sublimation we must admit that the nature of the artistic function is also inaccessible to us along psychoanalytic lines'. Freud remained convinced that hereditary dispositions played their part in these matters.

We shall never know whether Leonardo's mother smiled, wept, or was glad to be rid of him. We shall never even know whether Leonardo was in earnest when he wrote down the story of the kite's visit, or whether he was merely poking fun at the belief in omens. What we do know is that Leonardo was miraculously endowed. For the rest, alas, we must be satisfied with the evidence such as it is. Professor Pedretti has shown us how much can still be done by minute attention to details in reconstructing some parts of Leonardo's story. Even his book, as the author acknowledges, 'is almost entirely based on deductions, inferences and hypotheses'. These, one may trust, will prove their worth as they are tested by further research. But will it ever be possible again to perform the true miracle of seeing as far as Lwow?

Leonardo in the history of science

The 1964 volume of *Isis*, the official quarterly of the History of Science Society, opens with a tribute to Vassilii Pavlovich Zubov who had posthumously been awarded the Society's George Sarton Medal for 1963 for his outstanding contributions to the history of science. Born in 1899 in the vicinity of Moscow, Zubov must have received his schooling before the Revolution. He spoke and wrote fluent French and also corresponded in perfect German. Having read History and Philosophy at the University he soon found employment with the Academy of Sciences, becoming the chief scientific adviser to its Library at the age of thirty-two. His main publications before the war concerned the history of architectural theory in the Renaissance. He translated into Russian the great treatise by Leon Battista Alberti on Architecture, adding the first detailed commentary to this important text of which he traced the ancient and medieval sources. He did the same for the sixteenth-century commentary on Vitruvius' ancient treatise on architecture by Palladio's patron, the Aristotelian philosopher Daniele Barbaro. It would be hard to think of an enterprise more typical of 'cloistered scholarship' than such a commentary on a commentary published in the worst period of Stalinist terror.

The official bias against functional and for classical architectural styles possibly helped Zubov in securing this quiet haven, but from all that is known he never practiced the 'cult of personality'. As an expert on architectural theory he joined in 1940 the team which was charged with the restoration of St Sergos at Zagorsk, and in the same year he became a member of the Academy's very active Institute for the History of Science, where he remained until his death in April 1963, publishing, we read, some 200 papers and reviews, not only in Russian but also in Western learned journals. From the history of architectural theory he had advanced to the history of mathematics, mechanics, and philosophy, notably the study of Aristotelianism and Epicurean Atomism and their effect on medieval and Renaissance science. In his last years he had become particularly interested in the Scholastics of the fourteenth century, and rumour has it that he could read the microfilm of a difficult Latin manuscript with all its abbreviations as easily as other people read a newspaper. Attending several of the International Congresses on the History of Science held in the West he gained not only the respect but also the friendship of many colleagues. Though I met this great and humane scholar only for one brief hour when, most of the time, he was in the company of a younger Russian colleague, the impression of his warmth, his modesty, and his unconditional commitment to learning has remained with me.

In 1961 (not 1962, as is incorrectly stated in this edition) Zubov published a book on Leonardo da Vinci, having previously edited an anthology of his writings. It is the first of his books to have become accessible to readers who have no Russian, and it fully confirms the

Originally published under the title of 'In Search of Leonardo' in the *New York Review of Books*, 5 December 1968, as a review of V.P. Zubov, *Leonardo da Vinci*.

intellectual stature of its author. Only one word of caution is necessary to prevent disappointment. A book called 'Leonardo da Vinci' (without any subtitle) would probably be expected to deal with the two aspects of his life which are, for good reasons, best known to the general public his achievement as an artist and his fame as an inventor. Zubov's book takes the first for granted, and is not much concerned with the second. The few illustrations (still fewer in the English-language edition) serve only to elucidate certain passages in the text; their artistic merit is ignored to the extent that some of Leonardo's drawings were even 'redrawn' for the edition under review. Nor must the reader expect an analysis of Leonardo's mechanical inventions and contraptions, few of which figure in the illustrations. Even the introductory section on Leonardo's life is somewhat perfunctory and not free of errors. (Leonardo never joined the 'guild' of Florentine artists but their confraternity: it is doubtful whether, as an illegitimate child, he could have joined any guild, and it is not impossible that this disability had something to do with his move to the Court of Milan.) The true value of the book rests in the chapters in which a great historian of science attempts to define Leonardo's position in the history of scientific thought. Indeed it will be read and studied with most profit by those who are familiar with the debates which have centred on this baffling question.

In his lucid introduction to the volume Professor Gilmore reminds us that the problem is a comparatively recent one. A hundred years ago Leonardo was still seen mainly through the eyes of his Renaissance biographer Vasari, who merely regretted that this greatest of artists had dissipated his talents in whimsical researches. The publication of Leonardo's notebooks, most of which did not become available until 1883, allowed the Victorians to revise this image and to fit him into the picture of the Renaissance as they saw it: the era, in Burckhardt's words, of the 'discovery of man and the world' after the darkness of medieval clericalism. It was fitting that an artist should have inaugurated the rise of science by simply looking around and observing nature, disregarding the logic-chopping of the scholastics and the formalism of the humanists. There exist isolated pronouncements by Leonardo that lend credence to this interpretation, which still survives in popular literature. Alas, it will not do, for it can be squared neither with the history of science nor with the bulk of Leonardo's notes. Science is not, and never was, a mere matter of looking around and observing. One is reminded of the quip in Bernard Shaw's *Saint Joan* where a cleric anachronistically speaks of Pythagoras as a man who believed the earth went round the sun, only to receive the crushing reply, 'the fool, could he not use his eyes?' Leonardo noted down in one tantalizing sentence that 'the sun does not move' and it cannot have been his eyes that told him so. There are countless other passages which are about theories, speculations, and predictions, in other words about science, and these formulations, not surprisingly, link up with the traditions of the despised ancients and the notorious scholastics.

Thus a closer study of Leonardo's notes led to a profound reaction

from the view of the self-made artist-explorer. In particular the great French historian of science, Pierre Duhem, represented Leonardo as the last of a line, the line of the great scholastic thinkers who had pondered the secrets of nature. Understandably this interpretation of an artist who proudly called himself an unlettered man also encountered criticism. Was it not likely that Leonardo picked up in conversation rather than through the study of books much of the traditional lore that he appears to have known? Is he not rather the representative of the craftsman tradition, too long ignored by the intellectual historian, and should we not look for an explanation of his interests and his bias in the workshops of Florence and Milan? But if we are to see him as a versatile technician with an insatiable curiosity, should we not delete his name from the role of honour that records the names of Copernicus, of Galilei, Kepler, and Newton?

Indeed, an eminent mathematician has been provoked by the popular praise of Leonardo's achievement to launch a broadside against his reputation as a scientist. What laws has he discovered? What formula is owing to him? Unable to grasp complex mathematical relationships, he talked a lot about experiments and measurements, but what did he really measure?

Zubov, of course, is fully aware of what he calls 'the tragedy of Leonardo,' his inadequate mastery of mathematics (p. 179). But, as he says in his Preface, we must neither archaize nor modernize. Steeped as he is in the reading of late medieval science, Zubov has succeeded for the most part in steering his way between these extremes. He is particularly interested in Duhem's derivations of Leonardo's ideas from late scholasticism, but he shows with authority and penetration why Duhem's interpretation is still mistaken. It rests on an insufficiently close analysis of Leonardo's statements. It is true that many motifs and ideas in Leonardo's notes recall earlier discussions. But Zubov is able to show in a number of important cases that, far from quoting his authorities uncritically, Leonardo modified their formulations, sometimes radically and sometimes subtly. He also successfully defends Leonardo against the charge of having naively relied on analogies in his scientific explanations. The analogies, like the theories of his predecessors, serve Leonardo as a starting point for his own investigations. In the comments with which Zubov intersperses his many quotations from Leonardo's writings he is always anxious to avoid those current oversimplifications of the master's views which frequently stem from lack of familiarity with his very personal terminology. Thus he shows that when Leonardo talks of 'mathematics' he frequently means what we would call 'physics' and that he uses the concept of the 'eye' in a far from literal sense.

Even at the few points where one may remain unconvinced of a particular interpretation one must admire Zubov's sensitivity to nuance. He has an equally fine ear for the musical cadence of Leonardo's language, the expressive force of his repetitions and variations. It is not surprising to learn from the pages of *Isis* that he was praised by none other than Sviatoslav Richter's master,

Neuhaus, as an accomplished pianist who could have made his way as a performer.

If Zubov's reading of Leonardo can be summed up in one sentence it is that his 'thinking developed in an atmosphere of traditional Aristotelian ideas, but followed a course of critical refutation of them'. It is a reading which is completely in tune with other recent studies of some aspects of Leonardo's work, for instance Dr Keele's monograph on Leonardo's study of the heart. It could also be applied to an analysis of the master's art. He clearly took over many types and formulas from Verrocchio's practice, but he modified them in the light of his observations and preoccupations. Nothing could be more fallacious than the view of Leonardo as an artist relying only on his miraculous eye. The visible world looks very different from the world he created in his paintings. But his paintings, no less than the fables and fantasies which he wrote down in his notebooks, and which are used to good effect by Zubov in his interpretation, all bear the stamp of the same mind, a mind that constantly strove not only to grasp the unique and particular but also to arrive at an understanding of the general laws that govern the operations of nature.

In stressing the inevitable tension between these aims Zubov convincingly contests Cassirer's comparison of Leonardo with Goethe. Goethe resigned himself to the contemplation of irreducible basic phenomena; Leonardo knew of no such resignation, but he lacked the means to explain the phenomena of nature. Atomism, the classical hypothesis of invisible events, was still outside his range. Thus the Leonardo who emerges from these pages is in many respects a tragic figure, but Zubov clearly preferred to end on a more positive note. His motive may simply have been the admiration everyone must feel who comes into contact with this intellectual giant, but it is possible that in this respect Zubov's conclusion was influenced by his environment. Even a scholar of Zubov's detachment could not quite live up to his programme 'neither to archaize nor to modernize'. Like the modern materialist, his Leonardo regards the Universe as a machine and man as part of it, but he still retains his faith in the perfectibility of reality.

> Leonardo overcame the determinism of his naturalism and mechanics, which condemned reality to an endless cycle, with the concept of *homo faber*, the concept of man as the creator of new implements, of things that are not in nature. This is not some heroic 'idealizing', not the contrasting of man to nature and its laws, but creativity based on these very laws . . . For Leonardo, technical and artistic creativity made the first breach in unyielding nature . . . Dams could be erected to counteract the flooding of rivers, artificial wings could be constructed to lift man into the air.

It is a noble vision, but not everyone who remembers Leonardo's prophecies of doom will find it convincing. No formula will ever fit Leonardo. His outlines remain as elusive as the contours of his figures which disappear in mysterious shadows. But Zubov certainly

strained every nerve to peer into this darkness, and the sponsors of this translation deserve our gratitude for having made his work available. Read in conjunction with other monographs, notably Sir Kenneth Clark's book on Leonardo's development as an artist, Zubov's book will certainly be of inestimable value to undergraduates and specialists.

It is all the more regrettable that the English translation suffers from two disabilities, of which the first is nobody's fault, but the second is reprehensible. Like all books on Leonardo this one has become somewhat obsolete through the recent discovery, or recovery, of further notebooks by Leonardo in the Royal Library of Madrid. Not that their content is likely to alter materially the outlines of the picture, but such items as the further list of books owned by Leonardo would certainly have fascinated Zubov and might have led him to alter or supplement some of the pages in this book.

What his book did not deserve, and what was avoidable, was that it should have fallen into the hands of editors who were simply not up to the job. I cannot check the translation, which reads reasonably well, but I am sure Zubov did not refer to the painters Andrea del Sarto and Rosso Fiorentino as 'scientists' (p. 39). Unfortunately there is plenty of other evidence to show that nobody at all familiar with the subject can have read the proofs. Complaints of this kind may seem more appropriate to a review in a more specialized journal, but it seems to me a matter of general concern that a book by a great humanist from Soviet Russia should have been published under the solemn imprint of 'the President and Fellows of Harvard College' disfigured by barbarous illiteracies. We read of Pythagorus (twice), of a Pythagorian concept, of scholasticists, of Antheas; de immortalitate animorum, botteghi.

What is worse than these oversights in the text is the evidence of ignorance in the bibliographical list, which is eighteen pages long. The Russian edition has no such list. It uses the good old method of footnotes at the bottom of the page and these always appear to be scholarly and sensible. The Harvard Press preferred to remove references to the back and to separate them from a fuller bibliographical description. It is a possible method, but one that needs care if the reader is to be really helped. He is not in this case. When, for instance, Zubov compared Leonardo's contest between music and painting with Lessing's classic treatment of the arts of time and space in the *Laocoön* of 1766 he quoted the relevant passages in a footnote together with the sections and paragraphs of the treatise, adding for good measure the page reference of an edition he happened to have at hand. The English version omits the textual quotations and speaks unidiomatically of Gotthold Lessing's Laocoön. (It happens to be either 'Lessing', as in Zubov, or Gotthold Ephraim Lessing.) If you want to follow up the reference in the note at the back you will there find the inane repetition 'Lessing, Laocoön'. True, you may then turn to the bibliographical list, where Lessing gets his full name and where the title of the treatise is correct, but here there is no excuse for listing a random edition of 1922, which looks all the more puzzling

as we are also given the title of an English translation of 1855. That the index lists *Lacoön*, was, alas, to be expected.

There are worse blunders. The Russian alphabet has no x and so Zubov refers to Curtius's life of Ale*k*sander the Great. For the Harvard Press to repeat that spelling is as inexcusable as to change Zubov's quotation of Diderot's *Oeuvres* into *Opera*. The first edition of Vitruvius' *Ten Books on Architecture* is described as having *ten volumes*, quite a feat for a publication of 1483! One final gem for connoisseurs culled from page 309: 'Migne, Jacques Paul. *Patrologiae cursus completus*. Latin series, one and two. Paris, 1844–1864. 221 vols. (Referred to by Zubov as *Patrologia latina*)'. May one inform whoever penned this parenthesis that Zubov probably shared this habit with the President and those Fellows of Harvard College who have had occasion to turn to this standard collection?

One gets the impression that publishers increasingly leave this kind of work to hacks, or, worse, to computers. The mechanical application of bibliographical rules leads to a lot of redundant information even where it does not end in similar disasters. The sooner publishers of scholarly books get together and work out a more sensible and more flexible system the better it will be for them, for their authors, and for their readers.

The marvel of Leonardo

In recent years observers of the art-historical scene have sometimes sensed the danger of an increasing failure of nerve among the newcomers to the field. What had started as a healthy reaction against the amiable amateurishness of unqualified enthusiasts threatened to solidify into a rigid professionalism which excluded the tackling of any theme demanding a grasp of wider issues. Martin Kemp's excellent monograph on Leonardo da Vinci must dispel any such fears. His sensitive and original descriptions of the master's paintings and his evident familiarity with the traditions of medieval and Renaissance science justify his stated hope of combining the achievements of Kenneth Clark's classic on the artist with V. P. Zubov's unsurpassed account of the scientist in the context of his age.

What has made this enterprise possible is the advance which has been achieved during the past few decades in the dating of Leonardo's notes and drawings. Thanks, largely, to Lord Clark's catalogue of the drawings at Windsor Castle and the researches of Carlo Pedretti, evidence from paper, handwriting, even ink can now be used to establish the chronology of the notebooks. Hence the classic anthologies of his writings by J. P. Richter and E. MacCurdy, which present Leonardo's researches and reflections according to their subject matter, are seen to be somewhat misleading where they juxtapose early jottings with his mature thoughts on the same topic. Profiting from this new framework Professor Kemp has been able to offer the reader a narrative of the artist's life together with a fresh interpretation of his inner development, and in doing so, he has looked again at many of the problems of Leonardo's oeuvre and career.

Dividing his book into five chapters, Kemp calls the first 'Leonardo the Florentine' to stress the master's intellectual roots in the city of Brunelleschi, the great architect, sculptor, inventor of scientific perspective and engineer, and the environment of the Pollaiuoli, whose oeuvre testifies to a firm grasp of human anatomy. Kemp shows that the emphasis on sculpture in Verrocchio's workshop in all likelihood exerted a lasting influence on the pupil's ability to visualize forms in space, despite his later preference for the art of painting. He offers convincing reasons for dating the angel in Verrocchio's *Baptism* later than the Uffizi *Annunciation*, where he brings out the contrast between the fine detail and the awkward construction. There are eloquent pages on Leonardo's unfinished *Adoration* of 1481 which stress the novelty of his methods of drawing and sketching: 'The flow of his thought cascaded onwards in a rough and tumble of ideas, sometimes splashing off in unexpected directions— unexpected, we may suspect, even to Leonardo himself'. Emphasis upon this fluency and flux in Leonardo's project enables the author to keep his own interpretations fluid also, hinting at possible connections and associations in the symbolism of the composition without

Originally published under the title of 'Between Intellect and Imagination' in the *Times Literary Supplement*, 15 January 1982, as a review of Martin Kemp, *Leonardo da Vinci: the Marvellous Works of Nature and Man*.

presenting them as established facts. It is a method which stands him in good stead in the later chapters.

The complexity of the story Kemp has to tell compels him to divide the most fertile of Leonardo's periods, the eighteen years he spent in Milan, not so much chronologically as systematically. Having paid due tribute to the Louvre *Virgin of the Rocks* and its artistic and spiritual significance, he shows us the natural movement of Leonardo's mind from architecture to engineering (including plans for the construction of a 'bird'), and on to investigations of the human body, its sense organs, the action of light and the laws of mechanics coupled with his interest in geometry stimulated by Luca Pacioli, with less stress on the astounding diversity of his interests than on their underlying unity:

> Those authors who have written that Leonardo began by studying things as an artist but increasingly investigated things for their own sake have missed the point entirely. What should be said is that he increasingly investigated each thing for each other's sake, for the sake of the whole and for the sake of the inner unity, which he perceived both intuitively and consciously.

It is for this reason that Kemp has called this chapter 'The Microcosm', since in his interpretation the old doctrine of the correspondence between man as a little world and the universe as a macrocosm provided Leonardo with a unifying principle. Though the artist often expressed his contempt for mere book learning and claimed to rely on 'experience' alone, we have long since learnt, in Kemp's words, that 'observation requires a structured context to acquire meaning, and exposition of its significance can only take place within a system of shared reference'. It was this necessity which launched Leonardo on the uphill path of mastering traditional disciplines which were usually accessible only in Latin texts.

In an early anatomical drawing, one of the imaginary 'ventricles' of the brain is reserved by Leonardo for both the intellect and the imagination, *fantasia*, a departure from tradition which has led Kemp to devote his next chapter to the 'Exercise of fantasia'. Here he introduces the reader to the admired entertainer of the Sforza Court, devising pageants and stage effects, improvising music, telling fables and inventing emblems and allegories of astounding intricacy. Emphasizing the role of Vigevano (the Sforzas' country retreat south-west of Milan), Kemp suggests that Leonardo may well have contributed to the amenities and the charm of the place. But today his activities as a court artist can best be grasped in considering the ruined murals of the Sala delle Asse in the Castello which are here analysed with much tact and imagination for their possible emblematic allusions and artistic import. The chapter includes a refreshing account of the *Last Supper* and its perspectival subtleties; a vivid appreciation of the *Lady with the Ermine*; and a discussion of the artistic and technical problems of the colossal monument to Francesco Sforza on which so much new light has been shed by one of the newly found Madrid notebooks.

Inevitably the next chapter, entitled 'The Republic: New Battles and Old Problems', reflects the fragmentation of Leonardo's life after his departure from Milan in 1500, when he was tossed about by the political storms of the age, as well as his own restlessness. He undertook and abandoned artistic and military enterprises for the Florentine Republic, accompanied Cesare Borgia on his campaigns, returned to Milan, left and returned again, while remaining elusive all the time to would-be patrons who wanted works from his brush. Not even Kemp can weave a wholly integrated narrative out of this tangled skein, but he compensates for this lack of unity through his thoughtful discussion of individual problems, the cartoons for the *St Anne*, the *Battle of Anghiari*, the geometrical studies, the dissections, and finally the *Portrait of a Lady on a balcony* (as he prefers to call the 'Mona Lisa'), suggesting convincingly that this most famous of all the master's works may have been begun by him in Florence as a portrait of a particular sitter, but retained to be revised and reworked over the years till it crystallized into that image of mythical power, the counterpart in the painter's oeuvre of the lost 'Leda' celebrating the mystery of beauty and the beauty of mystery.

In the author's interpretation this sense of mystery came to the fore in the last decade of Leonardo's life. He takes us from the problem of the London version of the *Virgin of the Rocks*, which, as he says, has become more and not less complex through the recent discovery of archival material, but in which he still wants to see evidence of the master's handiwork, to the Trivulzio monument and the late manuscripts and drawings dating from Leonardo's stays in Milan, Rome and France. Outwardly these are years of recapitulation and systematization comprising the ambitious project for an anatomical atlas, a study of the movement of water of which the *Codex Leicester* (now *Codex Hammer*) gives a good idea, and (partly) the *Trattato della Pittura*, with its sections on the behaviour of light. But psychologically, as the author shows, these were also times of resignation and retreat: the more the master extended his grasp of a subject the further did his goal of total comprehension recede.

That analogy between the macrocosm and the microcosm on which he had relied in his earlier years proved inadequate to account for the movement of the blood in the body and the water in the universe. 'There is something heroic', writes the author, 'in this rejection of a theory which he had cherished for so many years'. 'Ultimately', we learn also, 'the beguiling goal of the late anatomies—the marriage of organic complexity and mathematical certainty in the context of mechanical law—proved to be elusive for the most part'. At the same time the contradictory traditions on which he had drawn in his superhuman attempt to classify and explain the infinite shapes of waves and vortices refused to jell and forced him to admit defeat. But Kemp also shows that these intense efforts brought Leonardo into contact with the most advanced thinkers on this problem.

He stresses the link between Leonardo's reflections on compound motion and those of Nicolas d'Oresme, who discussed the example

of an arrow shot into the air from a moving ship and landing again on the deck. The medieval author, we read, used the example to present the arguments for the possibility of a diurnal rotation of the earth, but Kemp does not mention that this connection may at last furnish an explanation of one of Leonardo's most enigmatic notes in a late anatomical manuscript, the laconic sentence 'the sun does not move'. The unlikelihood of Leonardo having anticipated Copernicus has made some scholars propose that he was not talking about the real sun at all, but about a pageant—a most unsatisfactory proposal, for why should the planet sun remain stationary in a pageant if it was thought to move in the Universe? But if the note refers to the diurnal rather than the annual motion of the earth, it might indicate that Leonardo took sides where the French bishop hesitated to commit himself—an important step indeed, but quite unrelated to the Copernican system.

If Leonardo had admitted this complication it would fit the picture of his late thought which Kemp presents in his account of the artist's studies of the eye and the nature of light. 'It is a measure of his intellectual integrity', Kemp again comments, 'that he allowed his optical studies to disturb the attractively tidy assumptions he had adopted as a "painter-perspectivist".' He was now attracted by 'the infinite variables of the visible world, its illusions, ambiguities, deceptions and fleeting subtleties'. His late studies of trees and of light playing on their foliage are a case in point, just as his famous 'deluge' series is evidence of Leonardo's continued striving for a comprehension of those creative and destructive forces which pervade the universe. Perhaps his last painting, of St John the Baptist, captures something of the enigma which confronted Leonardo and which continues to confront us in his own personality.

It is not lack of gratitude and appreciation which makes one pause once in a while, and ask whether the author's very fluency, his method of *sfumato*, has not occasionally tempted him into veiling the outlines of this enigma. For the closer one tries to get to Leonardo, the more puzzling he becomes. One aspect of this puzzle is apparent to anyone who turns the pages of his notebooks in any facsimile edition.

Indeed it might be helpful to newcomers if Kemp, in a future edition of this book, prefaced his narrative with a brief account of these extraordinary documents. The same page will often exhibit an exasperating jumble of topics and trivia together with a dogged persistence in arriving at the formulation of a thought that had pursued Leonardo for years. Conversely we find sheets of drawings in which fleeting ideas for any number of images are started and abandoned, while a trivial doodle of Leonardo's favourite 'nutcracker face' is meticulously finished and shaded. At times he would give free rein to his *fantasia* only to tighten the reins suddenly, as if to discipline it beyond endurance. That he advised artists to let their imagination be stimulated by patchy walls is a familiar fact; it is less well known that for him the condition of talent in a boy was not his inventiveness but his capacity to 'finish a drawing with shading'.

No doubt it is the tension between these two tendencies which accounts for Leonardo's most notorious weakness, his apparent inability to complete any work in hand. It is a weakness already remarked upon by the Florentine humanist Ugolino Verino at a time when Leonardo was in his thirties. Paying a poetic tribute to the artists of his time (not quoted by Kemp), Verino wrote: 'Perhaps Leonardo da Vinci surpasses all the others, but he does not know how to take his hand from the panel, and like Protogenes spends many years in perfecting one'. The criticism is modelled on a remark attributed to Apelles by Pliny, but its truth was and remained only too apparent. Maybe Verino was here alluding to the *Adoration of the Magi*, for which the artist's ideas flowed so abundantly and which he left unfinished. The dreamlike plenitude of inventions he crowded into the underpainting makes us forget to ask whether even Leonardo could have turned these poetic suggestions into a finished painting without packing it too tightly. He was later to warn painters not to impede the flux of their inventions by premature finish. But his insistence on standards of completion, both in his writings and in his paintings, makes one doubt if he could ever have brought his composition of the *Battle of Anghiari* to a successful conclusion. He would have had to follow, for instance, advice from his own *Treatise on Painting*:

> If you depict horses running away, paint them with little clouds of dust as far apart as are the intervals between the impact of their hooves; and the cloud that is farthest from the horse is least visible, as well as high, scattered and thin, while the one that is nearest to it will be most visible, small and dense.

This advice was combined with observations on how to differentiate these clouds of dust from the smoke of artillery 'which will be bluer'. But how are we to relate this to the way he combined his apocalyptic visions with an almost pedantic insistence on the laws of optics?

> When the flashes caused by the bolts of heaven were reflected there were seen as many highlights on the waves . . . as there were waves to reflect them to the eyes of those who stood around . . . and the number of these reflections was diminished in proportion as they were nearer to the eye.

Surely the wonder is not that Leonardo finished so few of his projects, but that he left enough masterpieces to mark an epoch in the history of art.

No doubt, however, Isabella d'Este's Florentine correspondent was right when he held out little hope that she would obtain one of these rare creations 'since Leonardo is working hard at geometry and has no patience with the brush'. How much patience he could summon for this alternative pursuit only becomes clear to those who turn the pages of the *Codex Atlanticus*. Even Kemp, who has so much empathy, throws up the sponge in a fit of impatience:

> His geometromaniac desire at this time to discover ever more intricate relationships of area between circles, triangles, squares,

polygons, segments, sectors, falcated triangles and *lunulae* became an intellectual itch he found impossible to scratch satisfactorily. Each new bout of scratching stimulated fresh itches. Even the most devout admirer of Leonardo must wonder if the whole matter had not got out of hand.

The witty piece of irreverence certainly brings light relief into a serious and difficult study, but is it justified? If Kemp was right, in the passage quoted earlier, that Leonardo 'investigated each thing for each other's sake and for the sake of the inner unity he perceived', may this search not also offer the key to these exasperating obsessions? It is likely that all these investigations are connected, directly or indirectly, with the notorious problem of squaring the circle. Success in this enterprise would have removed from mathematics what was felt to be the 'scandal' of the discipline, the irrational nature of the relation between the radius and the circumference of a circle, the impossibility of expressing π in arithmetically finite terms. Maybe Leonardo's researches, like Einstein's life-long quest for a 'unified field theory', concerned the unification of geometry and arithmetic—which would have delivered a most powerful intellectual tool into the hands of the scientist. Would he otherwise have noted down with so much solemnity the exact hour and place where he believed he had found the solution of this problem? The solution never worked, and so his expenditure of energy seems to us misguided, but was it really just thirst for knowledge that inspired Leonardo's superhuman efforts to penetrate the secrets of nature?

We must not forget that during the period of his intellectual formation in Florence leading philosophers pinned fresh hopes on 'natural magic'. Frances Yates has shown in her writings how the idea of the Magus was fed by the Hermetic corpus translated by Marsilio Ficino. The methods and means for fulfilling this role must have struck the young artist as misguided, if not fraudulent. Indeed it is possible to detect in his satirical prophecies a parodistic element, mocking the portentous tone of these philosophers. What sounds mysterious can be seen to be quite natural in the light of cool reasoning. Is it not possible that Leonardo harboured the ambition to prove, through his labours, that the miracles claimed by these self-styled wonder-workers could indeed be achieved, but only through a rational penetration of the secret of nature's effects?

If this interpretation could be substantiated, it would suggest that the unity of intellect and *fantasia* in Leonardo was even greater than Kemp's Milanese chapters allow for. More often than not, however, *fantasia* was in the lead and demanded the impossible of the intellect. This is an aspect of Leonardo's personality which his contemporaries sensed very strongly, but which Kemp's biography leaves in the shade—his lack of realism, his 'fantastic' leanings. It is a characteristic which is illuminated by a document mentioned by Zubov but not by Kemp, a letter (c.1502) from Leonardo to Sultan Bajezid II, of which a Turkish translation was found in the archives in Istanbul. In it the master pledged himself to build a bridge with a single span,

1150 feet long, across the whole width of the Bosporus. The further details of this utopian project matter less than the question of whether Leonardo himself believed in its possibility. But maybe we should not ask this question, for without this unrealistic faith in achieving the impossible Leonardo would not have been Leonardo. The Leonardo of Kemp's book is far removed from the wizard of popular belief who anticipated every invention or discovery later made by modern science and technology. He did not. But even though we must discard this anachronistic picture we should still acknowledge that he dreamt of performing miracles which only modern science finally achieved—and that by his chosen method of rational enquiry.

13
Michelangelo's last paintings

When the International Historical Congress met in Rome in 1955, members assembled in the Vatican to listen to an address in Latin by the Pope, after which they were accorded the rare privilege of entering the Paoline Chapel with the frescoes which are the subject of Professor Steinberg's book. I well remember an eminent historian seeking me out in some excitement and asking me incredulously: 'Are these really by Michelangelo?' They are, and one can only hope that this welcome publication will spread the news outside the narrow circle of specialists.

Though they are mentioned with due reverence by the master's first biographers they never entered the public consciousness to anything like the same degree as most of his other creations. There are intrinsic reasons for this comparative neglect, sensitively analysed by Mr Steinberg, but there is also the contributory factor that they have always been out of bounds to ordinary art lovers and tourists (it used to take six weeks to get permission for a visit). Perhaps by way of consolation earlier accounts stressed their poor state of preservation. Jacob Burckhardt's influential *Cicerone* (1855), for instance, says that they were disfigured by a fire and so badly lit that they are better studied from engravings. According to Mr Steinberg their first full restoration (around 1934 and again in 1953) 'revealed the original surfaces in surprisingly good condition' though we also hear that the results were not uncontroversial. A study of the sixty-four large plates (twenty-four in colour) with many striking and informative details suggests that, by and large, we can trust what we see, and we must be grateful to the author and the publishers for bringing these enigmatic works so close to us.

Mr Steinberg is a splendid advocate and a very good writer. We learn from his preface that he had written the script for a one-hour film on the chapel for CBS television in 1965 and that some of the ideas incorporated in the present text were first voiced in that programme. There is indeed a sense of drama in his presentation which should make his text also accessible to readers who do not normally read the historical introductions to picture books. The first chapter, 'The Artist Grows Old', provides the biographical setting with a moving and concise flashback recounting the tangled tragedy of the tomb for Pope Julius II, a burden from which the master had at long last been released in November 1542. The second chapter, 'The Fame of the Frescoes', describes the reaction of critics to the frescoes and skilfully relates their reappraisals to certain intellectual trends of the twentieth century—a bias for the creations of aged artists (where a reference to Beethoven's Late Quartets would have fitted in), and the desire to clear the style of 'Mannerism' from the taint of decadence and affectation. Thanks to these trends in the tides of taste the author can describe the Paolina frescoes as 'Michelangelo's gift to the twentieth century', but he rightly feels that the gift still remains to be fully evaluated.

Originally published under the title 'Talking of Michelangelo' in the *New York Review of Books*, 20 January 1977, as a review of Leo Steinberg, *Michelangelo's Last Paintings: The Conversion of St Paul and the Crucifixion of St Peter in the Cappella Paolina, Vatican Palace*.

Three of the subsequent chapters are devoted to *The Conversion of St Paul* (Fig. 17), and only one to the *Crucifixion of St Peter* (Fig. 18), as if the author had responded with particular immediacy to the psychological drama which transformed Saul into Paul. For what lifts this book above the common run of art books is the sense of personal involvement, the wish to make us share a personal experience. The heading of chapter five, 'The Included Self', refers to Michelangelo's identification with the *dramatis personae*; it could also be used as a description of the critical approach favoured by Mr Steinberg. He avoids the cool detachment of formal analysis deriving from Wölfflin no less than the more recent trends of iconology in which the work of art sometimes disappears behind a web of learned references. There is a good deal to be said in favour of this approach, which brings to mind nineteenth-century critics such as Ruskin or Walter Pater. After all, Michelangelo did not paint to provide seminar fodder; he demands a response and what else can

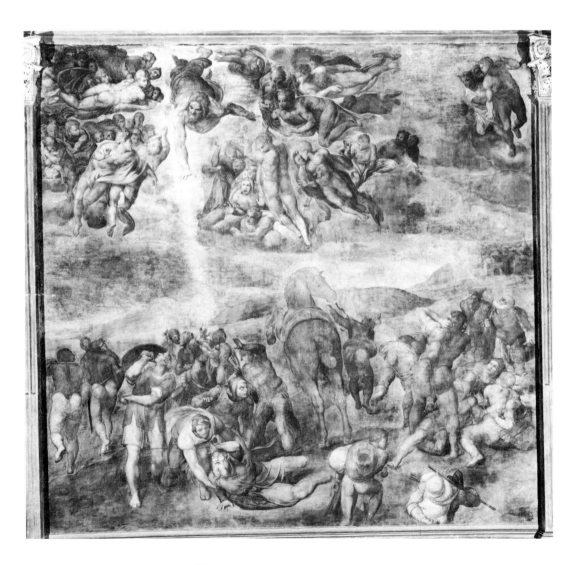

17 Michelangelo: *The Conversion of Saint Paul*. Fresco, 1542–5. Vatican, Cappella Paolina

such a response be if not personal? But it would seem from the preface that the author aims higher. He seeks a synthesis of all these approaches.

I have tried not to avoid the responsibilities of interpretation, though my symbolic readings tend to be interfused with what used to be called 'formal analysis'. That term no longer seems helpful. In Michelangelo's pictorial structures, 'form' and 'content' are not to be pried apart. Only in the narrowest sense do his depicted scenes illustrate their pre-given subjects; as the artist's conceptions materialize, they engender new meanings, engage wider, deeper registers of significance. The sweeping curve of a leg—St Paul's right leg in the *Conversion*—makes a melodious line, but as it aims at the city indicated by Christ, it also foretells, visibly, where Paul is to go. Linear rhythm, dramatic posture, imminent destination and destiny—all collapse together in the unique visual substance.

18 Michelangelo: *The Crucifixion of Saint Peter*. Fresco, 1546–50. Vatican, Cappella Paolina

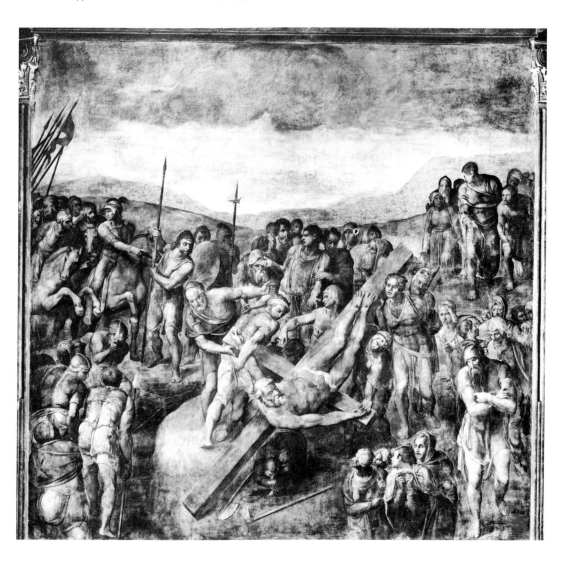

Precisely because the issue of method raised here by the author is important it seems a pity that he illustrates it by so unconvincing an example. The city of Damascus appears indeed near the horizon at the right-hand edge of the fresco, which shows, in the centre, St Paul thrown from his horse. It is a matter of opinion whether the shape of the leg of the saint lying on the ground can rightly be called a 'curve', let alone a 'melodious' line, but to describe this short imaginary line as 'aiming' at the city seems eccentric. The calf does not point there, neither does the foot. But why should the theme of the fresco require such pointing? It is true that the apparition of Christ, according to the texts, commanded Saul to go to Damascus, but he was going there in any case, and the command referred not to the destination but to the way the saint would be healed of his sudden blindness. Moreover anyone who wanted to follow the 'line' in the direction of distant Damascus would find his searching eye interrupted by a turmoil of figures.

The way the author interprets form and content of one of these may serve as a further illustration of his procedure, though the intricacy of the argument is likely to tax the patience of the reader. Briefly, he discerns among the terrified bystanders one man who has fallen to the ground. Though he is only partly visible between the legs of a soldier Mr Steinberg wants us to recognize in his posture the attitude of a recumbent classical river-god. It is a formula which was undeniably influential in the Renaissance, though its exact relevance is not easy to determine, since one can hardly lie on the ground with the upper part of the body raised without remotely echoing this pose. The author also finds it reflected in the prostrate figure of St Paul, which thus becomes a counterpart to the one he had disentangled from the human knot.

The pattern of two recumbent river-gods confronting each other leg-to-leg reminds him of a pair of such statues which had been brought to the Capitoline hill during the Renaissance, the very hill that Michelangelo was to transform into the Capitol. He thus finds in the configuration an 'allusion' to the Campidoglio group which is 'unlikely to be gratuitous or inadvertent'. 'More probably', we read,

> the master was again thinking on several levels—but one is staggered by what his thinking implies. Was Michelangelo invoking a visual parallel by which to make present to the beholder, along with the moment of Paul's vocation, an image of the political heart of Rome? Was he anticipating the historic sequel to the moment depicted? Paul of Tarsus, proud of his Roman citizenship, is being appointed Apostle unto the Gentiles, and with a specific mission for Rome.... If Michelangelo was not being thoughtless, he was visually linking the converted Paul with his last destination.

Nor is that all. We learn that since the fresco occupies the eastern wall the Capitol might be imagined to lie in that direction. Actually a glance at a map will show that the Capitol lies pretty far to the southeast of the Vatican, but whether or not this deviation matters,

we are presented with a text by Pope Innocent III dating from some 350 years earlier, exalting Peter and Paul, both martyred in Rome, as the twin guardians of the city. Few readers may be expected by this time to remember the beginning of the argument, which rests on the similarity of an only partially visible member of the crowd to the formula of a river-god. I am not exaggerating here, for strangely enough Mr Steinberg retracts his other equation of St Paul with that formula in a subsequent chapter. There he rightly calls the comparison between the pose of St Paul and that of river-gods 'unproductive'.

> No river-god figure in sixteenth-century painting or sculpture sustains such precarious disequilibrium. Paul's supporting arm is too acutely bent and retracted to steady the toppling mass of the torso. Moreover, the figure turns to us frontally, so that its forward falling, accentuated by the impetuous advance of the helper, is aimed at the spectator. These two distinctions, the sudden imbalance and the frontal address, are without precedent, and they charge the figure with new meaning and urgency.

The description shows Mr Steinberg's gifts at their best, and so does his further analysis of the counterpoint of attitudes which underlies the composition. It is within this context that he draws attention once more to what he still calls the 'yoking of the two "river-gods" into a single bi-partite motif', and though there is an element of overstatement in this description we can easily grant that Michelangelo here as elsewhere used the time-honoured device of mirroring variation to give unity to his groupings. But if the episodic figure of the man on the ground really reflects the pose of the saint who does not resemble a river-god, what becomes of the Roman Capitol re-enacted or evoked somewhere on the road to Damascus? Was it not a mirage, a fleeting association by the author solidified with the help of illustrations and quotations which have nothing to do with the work in front of us?

Mr Steinberg knows that he is vulnerable to the criticism of over-interpreting Michelangelo's paintings, and in his preface defines his position beforehand.

> I am aware of the position that frowns on excessively free speculation at the expense of the Masters. But there are, after all, two ways to inflict injustice on a great work of art; by over-interpreting it, or by under-estimating its meaning. If unverifiable interpretations are rightly regarded as dangerous, there is as much danger of misrepresentation in restrictive assertions that feel safe only because they say little.

What he demands of his interpretations is merely that they be 'probable if not provable, ... make visible what had not previously been apparent; and that, once stated, they so penetrate the visual matter that the picture seems to confess itself and the interpreter disappears'.

These are important criteria, but it is to be feared that they are

insufficient. For the author may well underrate the power of projection and suggestion which makes us all read into a picture not only meanings but shapes. It is difficult to illustrate this point without appearing to be frivolous, but the risk must be taken for the sake of the methodological issues raised.

Suppose someone were struck by the fact that the book under review was published in England by the Phaidon Press, originally named after Plato's *Phaidon*, the dialogue in which Socrates in prison expounds his faith in the immortality of the soul. Is it not strangely fitting that the frescoes painted at the time when Michelangelo's thoughts turned increasingly to death—as can be documented from his poetry—were associated with the particular work of Plato whose thoughts on beauty had previously obsessed him? And once we discover this connection, are we not entitled to look in the composition for the shape of the signet of the Phaidon Press, the Greek letter Φ? I refrain from carrying the illustration further, though the circle with the vertical axis would lend itself quite well to such an exercise. It must be resisted precisely because once we have 'fused' such meanings and forms it becomes difficult to separate them again, and before we know where we are we have imposed on a great work of art a reading which is hard to get rid of.

It is for this reason that I cannot agree with Mr Steinberg that—to put the matter simply—under-interpretations are as bad as over-interpretations. The first keeps the work intact, though it may fail to exhaust the inexhaustible; the other lodges itself in the mind and distorts our experience for ever after, even if we refuse it credence.

Hence the responsibilities of the critic seem to me greater even than those of the historian. It is easy to ignore a misguided historical explanation, it is less easy to restore a work of art to its pristine form once a persuasive critic has run it through his mill. The critic should therefore look upon his interpretation much as the performing artist, musician, or actor does or should. In interpreting a symphony or a part in a play we want him first of all to strive to carry out the creator's instructions rather than to impose his own reading. He need not fear that this act of submission will deprive his performance of life or interest. The notations of music or of literature can never be so complete as to leave no scope for a personal element. The same is true of the visual arts where what I have called 'the beholder's share' is equally needed to turn the brushstrokes into an image. We cannot but call in conjecture at every level, whether we estimate the depth of the stage, the fall of light, or extrapolate from the position of the immobile figures their movements and their states of mind. To look is to interpret. We cannot lay down a limit beyond which the critic must not go, provided always he respects his text. But we have a right to know what kind of meaning he thinks he has uncovered.

As far as the criticism of literature is concerned this point has recently been made once more with particular force by Professor E. D. Hirsch, Jun., in his book, *The Aims of Interpretation* (University of Chicago Press, 1976). He has given good reasons for confining the term 'meaning' to the intended meaning of a text, reserving the term

'significance' for other aspects. The situation may be a little less clear-cut in the visual arts, but it would still be helpful if we could be told every time what exactly is implied in a proposed interpretation. Are we to regard it as a hypothesis about the artist's conscious intention or about the artist's unconscious? Is the critic speculating about motivations or goals? In other words, is he offering us an explanation of what made the master do this rather than that, or is he trying to tell us what meaning the artist wanted the beholder to find in his work?

There is a chapter in Ruskin's *Modern Painters*, entitled 'Of Imagination Penetrative', which includes a celebration of Tintoretto's painting of the *Crucifixion* at the Scuola di San Rocco in Venice. It culminates in the interpretation of what Ruskin considers the 'master stroke' of the painter: 'In the shadow behind the cross a man, riding an ass colt, looks back at the multitude, while he points with a rod to the Christ crucified. The ass is feeding on the *remnants of withered palm leaves*' (Ruskin's italics). These palm leaves, Ruskin conjectures, are those with which the same crowd that demanded the death of Jesus had greeted him but five days earlier when he was entering Jerusalem on an ass. There was no better way, in Ruskin's view, of reminding the beholder of the reasons for the crowd's behaviour, their rage and disappointed pride.

Here is an interpretation which, though not provable, is probable in the sense that Tintoretto would certainly have known the story of the Passion and the events of Palm Sunday, and though Ruskin may have overemphasized the episode in his joy of discovery we can fit it into our reading of the picture without strain.

Thus, whether or not we accept Ruskin's interpretation—and I find it convincing—its implications are clear. It seeks to establish the intended meaning of the episode. There may have been other thoughts and associations in Tintoretto's mind as he painted this passage—he may have liked or disliked donkeys, or may have had guilty memories of having once fed the palm leaves of Palm Sunday to an ass. But even if we could ever know the exact mixture of motives which led to the painting of the episode it would not add to our understanding of the work—though conceivably to our understanding of the painter.

Mr Steinberg's unformulated premise is that the two cannot be separated. He adheres to that expressionist conviction which C. S. Lewis has dubbed the 'personal heresy'. It is a heresy which pervades much of contemporary criticism, but I believe it to rest on a confusion between the cause, the purpose, and the meaning of an utterance. There may be any number of shades linking the one to the other, but the critic must still try to keep them apart.

A story told by Vasari about Michelangelo is a case in point. We learn that while he was at work on *The Last Judgement* the Pope's master of ceremonies objected to the nudity of the figures, whereupon the painter took his revenge and portrayed his critic as Minos in Hell, caught in the coils of a serpent; here both the cause and the meaning are clear, but our understanding of *The Last Judgement* remains unaffected by our knowledge of this private joke.

When Mr Steinberg speaks of 'levels of meaning', however, he has a different model in mind. Something like Freud's model of the dream in which the manifest surface meaning must be peeled away to reveal the deeper and 'ultimate' meaning. What he himself calls his 'musings' about the meaning of the inclusion of possible self-portraits in the fresco of the *Crucifixion of St Peter* makes it even more desirable to clarify this issue than does the earlier example of the alleged allusion to the Capitol. For there are two figures in the fresco which have been seen as likenesses of the master, one an old man in a resigned attitude, close to the foreground, and one a beturbaned head in the background, close to the Roman commander of the executioners. Since the commander has a handsome classical head the author is tempted to see in the juxtaposition a self-accusation of the aged master who regretted having served classical beauty rather than the Faith. He therefore interprets the whole composition as the 'descending graph of Michelangelo's destiny that runs, from his early idolization of pagan beauty and art, . . . down to his own self again . . . from his own denial of Christ to his present contrition'. I have omitted, for brevity's sake, the 'formal analysis' of the elements linking the two images and explaining the author's claim that 'the work's ultimate meaning flows in the geometry of its structure'.

Mr Steinberg himself calls this reading 'beyond proof or disproof', but it is not proof one would like to be offered but documented analogies. Not for the inclusion of self-portraits in narrative paintings, but for the kind of sublime punning with forms of multiple meaning which this book so frequently postulates and finds. Vasari tells us of Michelangelo's private revenge, but why does he never refer to any work of art of his or any other age in which the postures and actions of figures in a story are so cunningly devised that they also convey a topographical allusion, as we are expected to believe of the fallen men in the *Conversion of St Paul*, or of any such painted autobiography as the descent from an earlier to a later self? To be sure Vasari missed certain things and was altogether not a very profound man, but he knew Michelangelo quite well and admired him unconditionally. Moreover he loved iconographic complexity, as his comments on his own fresco cycles testify.

Is it not more likely that Mr Steinberg's desire to bring the work close to his twentieth-century audience has made him approximate Michelangelo to artists of our own time whose creations may indeed resemble dreams where personal and public meanings interpenetrate? But history is about the past, not the present, and for all its intensity and all its erudition this reading of the works leaves many lacunae for the historian to fill. Two of them may be mentioned: one, concerning the *Conversion of St Paul*, relates to the interpretation of the fresco's subject matter, the other, concerning the martyrdom of St Peter, supplements the author's observation about its historical position.

Mr Steinberg's reading of the *Conversion* centres emphatically on the event on earth. He refers to 'our knowledge of what it means to be

dive-bombed on an open beach' to give immediacy to the sudden apparition of Christ in a desolate landscape, and he sustains this mood throughout the description of the writhing saint and his panicking companions. The angels surrounding the figure of Christ, by contrast, are only perfunctorily described, as in the unexplained remark that 'the angelic hosts play a celestial charade'. But it is unlikely that Michelangelo wished us thus to subordinate his vision of heaven to the drama on the ground. For this vision may well be intended to be that of St Paul himself. In the second Epistle to the Corinthians (Chapter XII) St Paul speaks of such a vision in terms so enigmatic that they have engaged the commentators ever since. 'I knew a man in Christ above fourteen years ago (whether in the body I cannot tell; or whether out of the body, I cannot tell; God knoweth); such an one caught up to the third heaven . . . how that he was caught up into paradise, and heard unspeakable words, which it is not lawful for a man to utter'.

It has always been accepted that the experience here described was that of St Paul himself, though when exactly it happened fourteen years before the writing of the epistle was and remains uncertain. Nor was it clear what the saint meant by the Third Heaven, and whether or not he identified it with Paradise, which is also mentioned. St Augustine, in his *De genesi ad litteram*, devoted a long chapter to these puzzles; but whatever their solution, Paul was regarded as the saint who had been vouchsafed a vision of heaven— the 'Third Heaven' being (in Dante and elsewhere) the special abode of Love. Here is a clue which seems to be worth pursuing, for whether or not Michelangelo wished to telescope Paul's visionary experiences into one, he certainly did not want us to disregard the realm of love and of grace which opened up before the apostle—a sphere, admittedly, which is less in tune with twentieth-century sensibilities than the cruel blinding.

In describing the *Crucifixion of St Peter* Mr Steinberg starts auspiciously by explaining what must have made Michelangelo decide to depart from the traditional type which shows the saint immobile, hanging upside down from the cross. In fact Michelangelo assimilated the scene to a less static prototype, not mentioned by Mr Steinberg, that of *Christ's Procession to Calvary*. It is here that we first encounter that wheeling movement with figures arriving from the back of the scene on the right and turning away from the beholder on the opposite side, with the large cross forming the pivot of the composition. The type was adopted by Raphael in his painting now in Madrid known as *Lo Spasimo di Sicilia*, which was engraved by Agostino Veneziano and shows more than one suggestive parallel with Michelangelo's work, including, perhaps, the group of women in the foreground. But strangely enough one also feels reminded of an earlier version of the theme, an engraving by Martin Schongauer, the artist whose *Temptation of St Anthony* Michelangelo is reported to have copied in his youth.

Admittedly such a correspondence is also beyond proof or disproof, because whatever echoes there may be have been fully

transmuted into Michelangelo's personal idiom. And yet it could be argued that in attending to this historical dimension we learn more about the work itself than in following Mr Steinberg's suggestion that 'the strange wheeling motion of the executioners' should again be regarded as a 'topographical cue'. 'It is as though these men, acting under a superior compulsion, were tracing the circular plan of the monument that would commemorate the site of the crucifixion'—Bramante's Tempietto to which Philipp Fehl had drawn attention in an interesting study of the topography of the fresco.

A word needs still to be said about the illustrations to the text, for they are no less original and no less erratic than Mr Steinberg's readings. Their great merit is that they skilfully keep the works discussed before the reader, almost as if he were watching a television screen. Not counting the plates there are in the text ten illustrations of the whole area of the *Conversion of St Paul* taken from various angles, and ten details of incomplete views. One would not want to grumble about such lavishness except for the fact that there are strange omissions. In an interesting survey of the renderings of the subject before Michelangelo, the author illustrates eight examples, but not the Baccio Baldini engraving of c. 1465 over which, as we read, 'Michelangelo must have lingered with special affection' as it 'anticipates the general scatter effect of Michelangelo's composition with men protecting their ears as they run'. A niello dependent on this engraving is singled out in a note as presenting an even closer precedent, but not illustrated either. More surprising, perhaps, is the detailed discussion of the figure of a kneeling workman probing the hole into which the cross of St Peter is to be lowered, without mention or illustration of the master's drawing for this figure in the British Museum; for that matter another drawing in the Ashmolean Collection and the fragment of a cartoon in Naples might also have figured in this monograph.

Very likely the author felt that these would have delayed or impeded the sweep of his argument. There is no denying the sweep. He has produced a book to be reckoned with—but a dangerous model to follow. In putting it aside one feels like having attended a performance of a Shakespearean play by one of the star directors of our time who will grip and exasperate you in turn but will, at any rate, send you back to the text.

14

The rhetoric of attribution—a cautionary tale

'L'Art de deviner l'Auteur d'un tableau, en reconnaissant la main du maître, est le plus fautif de tous les arts après la Médecine.' In placing these sceptical words of the Abbé du Bos at the beginning of this article I am not intending to denigrate connoisseurship. After all, medicine, which the Abbé considered even more fallible, has made undoubted progress in the period since he wrote. It is worth pausing for a moment to ask what obstacles it encountered and how they were overcome. The problem has always been that the cures claimed to have been invented by doctors tend to lack objective criteria. Man is a gullible animal and astoundingly responsive to suggestion. Tell him that a cure works, and it will work in many cases. To overcome this problem of testing the efficacy of a new drug, medicine (as is well known) has resorted to innocuous deception, the use of the so-called placebo. In trying out a new treatment some patients are given the real substance and others are only told they receive it, whereas what they take is a harmless but ineffective pill. Sometimes the placebo also 'works', but sometimes the real stuff has more effect, from which science concludes that the cure is not simply a matter of suggestion. True, it has even been found that the knowledge of those who administer the dose may influence the response, and the method of the 'double blind' has been introduced as a safeguard. Suggestion has been eliminated in favour of objectivity.

Nobody doubts that suggestibility also plays a part in our response to works of art. The acclaim which greeted such frauds as Van Meegeren's *Disciples at Emmaus* is on record. Unlike medicine, however, we cannot operate with placebos, let alone with the device of the 'double blind', for the works which interest us are in the public domain. The attempt which is here made to defy such limitations by testing the power of arguments often found in art-historical writings cannot therefore claim to be taken seriously. It is only intended to point to a need which is unlikely ever to be met, the need for criteria more objective than plausible rhetoric.

Vasari tells us that Michelangelo burned a great number of his drawings, sketches and cartoons before he died. He claims that the master did not want posterity to see how hard he had worked, but might there not also have been another reason? Posterity has perhaps been too ready to accept the legend of Michelangelo's refusal to employ assistants. In particular it has accepted without criticism the story related by Condivi and Vasari that the Sistine Chapel ceiling is in its entirety an autograph work by the master. Thus a prior conviction has blinded art historians to the obvious difference in quality and in character between some parts of the work and others. In particular it has shielded the twelve figures of Prophets and Sibyls from that kind of critical scrutiny to which we are used in the work of other masters. Now it seems obvious that most of these inventions bear the stamp of

Originally published under the title 'Rhétorique de l'attribution (*Reductio ad absurdum*)' in *Revue de l'Art*, 42, October 1978.

the master's authentic works. But precisely for that reason it should have been noticed long ago that the prophet Ezekiel (Fig. 19) does not fit into this company.

To remember the true characteristics of Michelangelo's style we need only look at the figure of Jeremiah (Fig. 20), which exhibits them all to perfection. We find there how the figure is enclosed in a simple outline that recalls the marble block in which the sculptor discovered the 'concetto' by means of *levar*, of taking away. That solid cohesion, in which the limbs are drawn close to the body without leaving a gap, does not exclude the spiralling torsion of the movement which Lomazzo records as one of the master's principles. We feel the tension of this muscular body under the drapery and can grasp its articulation down to the hands and fingers. The psychological import of the posture reflects this self-enclosed formal composition. The figure is entirely self-sufficient in its lonely meditation.

It would be a work of supererogation to show that these essential formal and psychological characteristics can also be found in ten of the remaining figures of the series. In nine of them their isolation from the outside world is marked by their absorption in the written word. Only Jonah is turning upwards as if to argue with God. Even he, however, obeys the laws of Michelangelo's structural principles. The arms are kept close to the body and the torsion of the figure results in an enclosed spiral, of which the Isaiah and the Delphic Sibyl offer further examples. It is profoundly characteristic of Michelangelo's style that he always negates the picture plane, Jonah being of course the most famous example of this space-creating and surface-denying imagination, which so aroused the admiration of Renaissance writers.

How can anyone have overlooked the signs that the Ezekiel fails

19 Michelangelo: *Ezekiel*. 1509–10. Vatican, Sistine Chapel ceiling
20 Michelangelo: *Jeremiah*. 1511. Vatican, Sistine Chapel ceiling

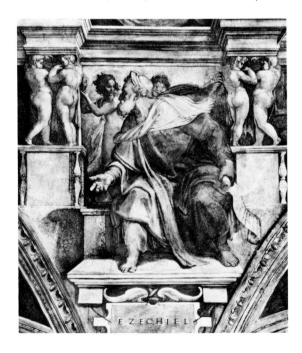

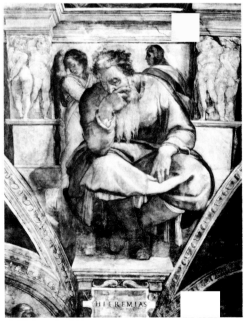

92

by all these criteria to be accepted as a product of Michelangelo's individuality? Far from denying the picture plane, the figure asserts it; in fact it asserts it so emphatically in its lucid, silhouetted con-figuration that it hardly coheres in spatial terms. Mark how the legs are so far apart that one wonders how they can be joined under the drapery—indeed the drapery does not suggest the presence of any body beneath. Instead of the heavy fall of cloth that we find in all the other figures, we see a frayed and billowing scarf round his neck, a neck, by the way, of monstrous thickness carrying a very small head. That volumetric plasticity, so essential a characteristic of Michel-angelo's style, is absent from the torso, not to speak of the lump which stands instead of a left hand. But least of all can the posture of the figure be reconciled with the master's creative imagination. Instead of being self-enclosed it impetuously moves to the right, addressing an unseen partner in what looks like a violent argument. It is this implied movement which tears the cohesion to pieces and introduces a note of shrill drama entirely absent from the other creations. The composition is only superficially Michelangelesque. Instead of the serpentine torsion we find a diagonal running from the head to the left foot, reinforced by the long and incongruous piece of drapery cutting the figure in half. If art historians had encountered the invention anywhere but on the Sistine ceiling they would surely have seen at once that here was an artist trying rather unsuccessfully to hide his own personality in a superficial imitation of Michel-angelo's accents.

Who was that artist? I believe that once we have freed ourselves of the spell of tradition we have no difficulty in recognizing him even in disguise. It is Raphael.

We do not know exactly when Raphael came to Rome, nor why he came, but could he not have been enlisted by Michelangelo as a promising assistant? Michelangelo started work in May 1508 which would fit the hypothesis well that Raphael joined in the design of the series of Prophets and Sibyls. That he was intimately acquainted with it stands, of course, in no need of proof, since the fresco of the prophet Isaiah (Fig. 21) at Sant' Agostino in Rome speaks louder than any words. It is interesting—and possibly significant—that in this work he conformed more closely to Michelangelo's principles of figural composition than he had done in the Ezekiel. This Isaiah is superficially more self-enclosed, and the hand gripping the scroll completes something of the spiral formula Michelangelo had evolved. And yet on closer analysis the affinities with the Ezekiel begin to stand out. There is first of all the lower part of the figure, the way the drapery hides rather than reveals the structure of the right leg, there is the streaking fold running down between the legs and the zigzag fold forming the outer contour again emphasizing the picture plane; notice also the way the left foot is set back into the shadow and the curling of the scroll to which the prophet fails to attend. But most of all it is the outward direction of the gaze and of the turn of the head, less obtrusive in the Isaiah than in the pre-sumably earlier Ezekiel, but all the more in conflict with Michel-

angelo's own principles of psychological self-containment. Even the diagonal we noticed running from Ezekiel's right shoulder down to the toes of the left foot finds its echo in the other prophet. The two belong together in their basically planar composition.

But is not the facial type, at least, of the S. Agostino Isaiah thoroughly Raphaelesque, while the same cannot be said of the fierce physiognomy of the Ezekiel? This must be granted, but, then, the head of the Ezekiel also has little in common with the marmoreal firmness and restraint of the remaining Prophets and Sibyls. In other words it is not Michelangelesque, it is Leonardesque. The high forehead, hooked nose, staring eyes and bulging chin hidden behind a profuse growth of beard immediately recall Leonardo's favourite type (Fig. 22). We do not need to speculate whether Raphael can have known it and admired it, for it is well known that he used one of Leonardo's old bearded men with such an intense look for a philosopher in the *School of Athens* (Fig. 23). Could he not have used another for his Ezekiel? We need only broach this possibility to recognize the Leonardesque character of the whole conception. Indeed it is hardly too much to say that Ezekiel would fit comfortably into the groups of apostles in the *Last Supper* of S. Maria delle Grazie.

For it was ultimately from Leonardo that Raphael learned the art of relating one figure to another along the picture plane by means of expansive gestures. He, if anybody, understood and absorbed the quintessence of Leonardo's compositional method. His figures always reach out to their fellow humans, psychologically and often physically. He became the master of the 'speaking gesture', that gesture which, in the Ezekiel, leads nowhere and thrusts into the void. Now characteristically such outward gesticulation can be

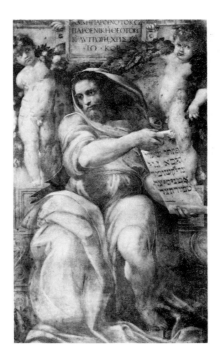

21 Raphael: *Isaiah*. 1512.
Rome, Sant'Agostino

94

documented from the very work Raphael is said to have left unfinished when leaving for Rome, the *Madonna del Baldacchino* (Fig. 24). Look at the outstretched arm and hand of St Augustine on the right. Does it not foreshadow the posture of Ezekiel, albeit in more subdued form? Soon, as we know, Raphael was given the opportunity of exercising his mastery of linking figures through movements of thrusting arms and emphatic hands. The *Stanza della Segnatura* offers more such instances than can be discussed in the present context. But more significant even than the frescoes themselves are the drawings for these compositions, among which I must single out the one at the British Museum (Fig. 25). Not only does it testify once more to Raphael's interest in the language of arms and hands, it also shows a drawing of a foot which repays attention. It corresponds so closely to the right foot of the Ezekiel on the Sistine ceiling that a coincidence is impossible. He who drew that foot also designed the figure of the prophet.

Was Raphael aware of the jarring note his gesticulating and outward looking figure had introduced into the solemn rows of Michelangelo's self-sufficient visionaries? It would be surprising if an artist of his sensitivity had failed to regret it. And if proof were needed, he supplied it in the very *Stanza della Segnatura*. When, as an afterthought, he introduced into the *School of Athens* the portrait of Michelangelo he emphasized precisely those formal and psychological features on which I have concentrated. The spiralling form of the enclosed figure wrapped in self-communion seems to convey a message to the rival master. Put into words it would read, 'I am sorry I failed to understand you when I designed the Ezekiel. Now I know better.' But Michelangelo, it seems, was not to be mollified. The

22 Leonardo da Vinci: *Adoration of the Magi*. Detail. *c*.1481–2. Florence, Uffizi

23 Raphael: Cartoon for the *School of Athens*. Detail. *c*.1508–11. Milan, Ambrosiana

grudge he bore Raphael is notorious. And at last we can guess the reason . . .

Placebos, despite their name, are not intended to give pleasure. They can be bitter pills, or sweetly coated ones. How much their introduction has really contributed to the advance of medicine, I do not profess to know. Maybe the science of healing would also have come a long way without such trickery, as connoisseurship undoubtedly has. I can only hope that the masters of that skill will not take offence and that the spirits of Michelangelo and Raphael will also forgive me this harmless fabrication.

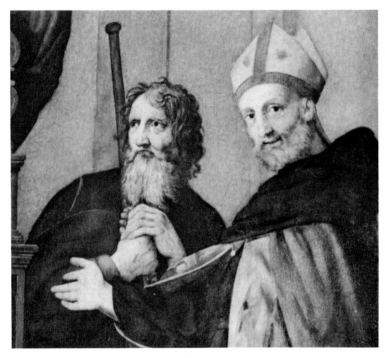

24 Raphael: *Madonna del Baldacchino*. Detail. *c*.1508. Florence, Galleria Pitti
25 Raphael: Studies for the group in the right foreground of the *Disputa*. *c*.1508–12. London, British Museum

15

The worship of ancient sculpture

Here, at last, is a book of which we can sincerely say in the old phrase that it meets a long-felt want. It offers, in the modest words of the Preface, 'a series of illustrations (which are now often impossible to find except in specialized libraries) of the principal sculptures which were at one time accepted as masterpieces'—that is, of antique statues with which, until a hundred years ago, the educated public were expected to be familiar. Of these, some of us can still visualize the *Laocoön*, the *Apollo Belvedere* or the *Hercules Farnese*, but would we, or would our students, be equally able to distinguish the *Farnese Flora* from the *Capitoline Flora*, or the *Minerva Giustiniani* from the *Pallas Velletri*? In future, we shall be spared any embarrassment on that score, for here is a catalogue raisonné of 95 of these once canonic works arranged in alphabetical order according to their most frequently used appellations, and providing all the relevant information about their history, their restorations, their changing fortunes in the hierarchies of taste and also the most recent archaeological opinion. The authors would never claim that their list is exhaustive: indeed they mention, but do not illustrate, a number of other works such as the *Juno Ludovisi* or the *Clytie* which occasionally rose to comparative fame. Understandably, they generally keep clear of portraits such as the Naples bust of Homer, the Vatican statues of Sophocles and Demosthenes or the *Augustus of Primaporta*, but, maybe, in a next edition they might include some of the works for which high claims were made by Winckelmann, such as the *Minerva Albani* or the *Barberini Muse*, which has meanwhile changed sex and is displayed in Munich as an Apollo. Even so, the invaluable repertory fills more than two hundred pages, packed with information. It is preceded by 15 equally crowded chapters admirably surveying, not only the formation and decline of the canon, but also the history of its publication in engravings, books, plastercasts and miniature copies up to the nineteenth century. The authors have refrained—quite rightly, of course—from chronicling the recent iconoclastic movements which resulted, not only in the removal of these casts from view, but in various gratuitous acts of vandalism: I know at least of one art school in the Middle West where, a few decades ago, they were thrown out of the window and smashed in a belated ritual of liberation.

It was mainly their role in the academic curriculum which provoked this hatred, the implied or explicit claim of the canon to embody and teach the 'rules' of art. No dogma of the Classical creed is more alien to twentieth-century views of art than this acceptance of authority, and any discussion of the canon cannot but prompt reflections on the gulf that separates the aesthetic convictions of our century from those which are here exemplified. Perhaps it helps in this context to recall the central position which the theory of language and oratory occupied for so long in Western criticism. The fact that languages have rules which must be learned and observed is

Originally published under the title 'Perfection's Progress' in the *London Review of Books*, 5–18 November 1981, as a review of Francis Haskell and Nicholas Penny, *Taste and the Antique: The Lure of Classical Sculpture, 1500–1900*.

still accepted without demur. However many efforts are made to undermine the authority of grammar and spelling, it is obvious that in a total absence of such rules of the road, communication would break down. Given this social function of speech, teachers of language have always insisted on models which represent the norm; the very term *classicus* refers to authors suitable as models and the idea of the canon is originally rooted in this tradition. In the aesthetics of language no firm line can be drawn between the need for rules and the effect of their non-observance. Once we have acquired these arbitrary conventions we are conditioned to dislike certain lapses from grammatical speech.

It is a fact of cultural history, easily intelligible, that the subject-matter of model authors also entered the canon of literature which was deemed indispensable for communication among members of the culture. Take that magic litany of love from *The Merchant of Venice*, 'In such a night as this', in which the stories of Troilus, Thisbe, Dido and Medea are evoked. It is almost irrelevant to ask whether we admire those stories. They have entered the fabric of our civilization and allow the poet to weave his spell, even though the demand that one 'ought' to know these names differs in character and cogency from the need to obey the rules of grammar.

The acceptance of a canon of ancient statues which is here under discussion takes us a step further towards an apparently arbitrary cultural authoritarianism. But even here the comparison with language and literature remains helpful. As long, at least, as art was closely linked to narrative, the budding artist had to master the basic vocabulary of human types and gestures. The *Laocoön* offered (in L. D. Ettlinger's words) an *exemplum doloris*, the *Hercules Farnese* an extreme example of a muscle man. It was indeed the language of the body which could best be studied in these famous exemplars: the taut athletic posture of the *Borghese Warrior*, the sensuous relaxation of the *Barberini Faun*, the ebbing life of the *Dying Gladiator* exemplified the expressive potentialities of the male nude, which greatly extended the range of the artist. No modern critic has approached this role of the antique with more tact and success than Kenneth Clark in his book *The Nude*, and it is a pity that this title is absent from the extensive bibliography given by the authors.

It would certainly be possible to interpret the 'rules of art' derived from this approach as technical rules for the achievement of certain effects. 'If you want to represent a noble warrior dying on the battlefield, study the *Dying Gladiator* and you cannot go wrong.' All would have been well if critics of the past had confined themselves to recommending the canon of ancient statues merely as a repertory of types more easily studied and less expensive to maintain than hired models. But it lies in the dynamic of this situation that soon living bodies were judged by the degree of their correspondence to the canonic figures and that few scored well on this test.

The ambiguities arising from this role of the antique as a touchstone of nature make themselves felt in one of the earliest

references to the canon (not mentioned by the authors): the Preface to part III of Vasari's *Lives*. Here the rise of the 'Perfect Manner' is partly attributed to the discovery of 'certain ancient works mentioned by Pliny, the *Laocoön*, the *Hercules*, the big *Torso of the Belvedere* and also the *Venus*, the *Cleopatra*, the *Apollo* and countless others'. These, we learn, 'helped to rid art of a certain dryness and coarseness' associated in Vasari's mind with the laborious study of nature. To illustrate the inevitable shortcomings of this earlier manner, he mentions Verrocchio's restorations of the marble *Marsyas* in the Medici Palace, which still fall short of the perfections of the antique. But for Vasari even this perfection does not represent an absolute. In his view, Michelangelo 'surpassed the antique by so much as the antique surpassed Nature'.

It was this gap between Nature and the Antique that no theory of art succeeded in filling. Vasari at least had the honesty to admit the impossibility of specifying 'the licence within the rule which, while not following the rule, is still governed by the rule'. The imitation of nature was necessary but not enough. Thus 'slavish' naturalism remained a vice to most critics of art from the sixteenth to the twentieth century, but the desired direction of the departure from mimesis was harder to formulate and justify. Neither ancient metaphysics in its Platonic or Aristotelian version, nor modern rationalism in its eighteenth century form, proved adequate to this task. The many high-sounding sermons commending the superiority of the best antique statues over the products of Nature could only be preached to the converted. Hence, perhaps, the dogmatism which so often became associated with the canon. Its rejection appeared to threaten the community of values on which civilization depends in art no less than in poetry or speech.

It is this social function of something that cannot be justified in words any more than can the rules of grammar which may be responsible for the appearance of tame conformism in so much of the literature on the subject quoted by the authors. One is reminded of the splendid chapter in Samuel Butler's *Erewhon* describing the 'Musical Banks' which demand and exact reverence, though their currency is of no practical value. Butler, of course, aimed his satire at the Church, but what is nowadays called the 'Art World' has always shared some characteristics with established religion, including its intolerance.

The violence of Lord Shaftesbury's outburst (*Advice to an Author*, Part III, Section 3) would do credit to any Lenten Sermon:

> I like: I fancy: I admire: How? . . . Grotesque and monstrous figures often please, Cruel spectacles and barbarities are also found to please . . . But is this pleasure *right*? . . . Effeminacy pleases me. The Indian figures, the Japan-work, the enamel strikes my eye. A French and Flemish style is highly liked by me at first sight, and I pursue my liking. But what ensues?—Do I not for ever forfeit my good relish? How is it possible I should thus come to taste the beauties of an Italian master, or of a hand happily formed on Nature and the Ancients?

One thing emerges clearly from this diatribe. For Lord Shaftesbury, as for his contemporaries, the word 'taste' meant something radically different from 'liking'. When the authors called their book *Taste and the Antique* they must have had the eighteenth-century meaning in mind. It is a meaning which strangely enough excludes any connotation of relativism, let alone of subjectivity. With his usual perspicacity, Reynolds put his finger on the problem of this ambiguity when he wrote in his Seventh Discourse:

> We apply the term Taste to that act of the mind by which we like or dislike, whatever the subject. Our judgement upon an airy nothing, a fancy which has no foundation, is called by the same name which we give to our determination concerning those truths which refer to the most general and most unalterable principles of human nature; to the works which are only to be produced by the greatest efforts of the human understanding. However inconvenient this may be, we are obliged to take words as we find them; all we can do is to distinguish the *things* to which they are applied ... The arts would lie open for ever to caprice and casualty, if those who are to judge their excellencies had no settled principles to regulate their decisions.

This conviction even leads him in the last Discourse to quote with approval the opinion of James Harris that 'we are on no account to expect that fine things should descend to us'—'our taste, if possible, must be made to ascend to them.' Hence Reynolds endorses the recommendation 'even to feign a relish, till we find a relish comes; and feel, that what began in fiction, terminates in reality.'

To any modern reader reared in the cult of sincerity, this notorious advocacy of hypocrisy in matters of taste would seem to overstep the bounds of decency. But to the historian who wants to understand the laws governing the 'tides of taste' so splendidly plotted in this book, the remark may also suggest that for good or ill there can be no innocence of taste any more than an innocence of the eye. Man is a social animal and he is in need of approval. Even if we are entitled to hope that our moral convictions are sufficiently firmly grounded to withstand social pressures, few people could claim the same for their aesthetic preferences. We are all more or less suggestible if the right reflexes are triggered. That the existence of a canon led to conditioned responses which strike us as sheer attitudinizing has been obvious since the time of its emergence. Interestingly enough, this undesirable side-effect was observed at a time when the canon had hardly begun to form, in 1512. It was in that year that the younger Pico, Gianfrancesco, complained of the uncritical preference for ancient sculpture in his *De Imitatione*, an attack on Pietro Bembo's Ciceronian orthodoxy. 'I have very often observed this, where statues are concerned; any sculpture which is reported to be of recent make, even if it excels those made in ancient times, is considered inferior. To such an extent has the vain image of a thousand years invaded the judgement of people like a plague. If they are believed to be ancient, or even if the beholder is not sure

whether they are antique or not, the praise is astounding; but as soon as it turns out that they are more recently made and the name of the artist is mentioned, we get at once a thousand Aristarchuses [severe critics] and even a whistle of disapproval is sometimes heard ...'
The passage sounds like an allusion to the famous episode a few years earlier when Michelangelo's *Sleeping Cupid* was presented in Rome as an antique.

The history of artistic hoaxes and forgeries offers, indeed, inexhaustible materials to the student of human gullibility, but if the history of the canon did not also offer more it would not be worth studying. What it also shows is the tendency of the mind to make sense *post factum*, as it were, of what must have started as a conditioned reflex. The critics who praised the famous antiques were not mere parrots. Nearly all of them looked for ways of accounting for their 'astounding' admiration. Like theologians, they felt prompted to justify a dogma that should rather be accepted as an article of faith. It would be instructive if the authors were to supplement their book with an anthology of these uncritical critical writings of which they must have collected many in their notes. They would show us to what length honest writers could go to rationalize an inculcated preference. To pick an example almost at random: in 1862, the miscellaneous writer R. H. Patterson included in his *Essays in History and Art* two celebrations of the canonic sculptures. What is noteworthy in this late product is the author's search for scientific authority. In one essay he quotes the findings of the Scottish naturalist and divine J. G. Macvicar to prove the conformity of Greek sculpture with Plato's geometrical speculations: the Platonic triangle which has for its angles 90°, 60° and 30° marks the outline of the *Dying Gladiator* and of the *Nile*. Of the *Venus de Medicis* the author tells 'the curious fact communicated to me by a learned professor of anatomy, who discovered it during a minute examination of this beautiful relic of Greek art': the figure 'is of such a posture that half an inch further stoop of the body would, were the same attitude retained, make it lose its balance. The figure, therefore, though still self-poised, trembles on the very verge of motion—a circumstance which doubtless enhances the indescribable charm of this statue which enchants the world'.

No doubt the rich vein of comedy which the authors have inadvertently tapped when they embarked on their learned project would seem grist to the mills of cynics who feel anyhow inclined to dismiss the cult of art as mere self-deception. But before we accept this conclusion we may well ask who were the main victims of this epidemic? The very names by which these marbles are still known offer a clue to their social standing. The *Borghese Warrior*, the *Farnese Bull*, the *Barberini Faun*, the *Medici Venus*, the *Ludovisi Mars*—these point to the powerful owners and collectors, the princes and dignitaries of the Church, whose prestige was enhanced by such possessions.

Naturally some of these treasured relics also changed owners, but they still tended to remain in such ownership that access to them was

restricted. Even the purchase and display of copies and casts had strong social and political overtones, as the authors amply document in describing the efforts of the French Kings and of Napoleon to turn Paris into a 'second Rome'. In this atmosphere of proud owners and eager gentlemen on the Grand Tour, men of taste were certainly prone to be overawed when at last they found themselves in the presence of a work which they had long known by reputation. Artists, as the authors remind us, generally adopted a more factual approach. Their admiration often centred on sarcophagi which offered so many more useful examples of figures in dramatic movement. Nor, as we are also told, were scholars particularly involved in the creation of the canon as it is here presented. They, of course, preferred to patched-up monumental statues coins and tombstones with inscriptions which could serve them as historical documents.

In a seminal article on 'Ancient History and the Antiquarian' (*Journal of the Warburg and Courtauld Institutes*, XIII, 1950), A. Momigliano has shown the increasing use made, from the seventeenth century on, of material relics to check and revise the testimony of ancient authors. In the long run, this critical attitude was bound also to include the statues for which such high claims had been made. But this slow process of corrosion, which runs parallel to the rise of historical criticism in Biblical and other studies, would hardly have had such a cataclysmic effect on the canon if it had not also affected the basic aesthetic assumptions of eighteenth-century critics. The increasing interest in the growth and decline of culture demanded to be satisfied by a greater precision in the assignment of monuments to periods and to masters. It is generally agreed that it was Winckelmann who gave the study of ancient art this impulse. It is true that those who turn to his *Geschichte* of 1764 will be disappointed if they expect the shedding of antiquarian ballast in favour of a clear sequence of monuments, but there is one chapter in which we find a description of the postulated sequence of styles—however few monuments Winckelmann was able to assign to these categories, which he had largely abstracted from literature. Winckelmann's approach sowed the seeds of further doubts, for it was an article of faith with him that Greek art was infinitely more creative and therefore superior to the art of the Romans. These doubts were bound to bear fruit in the second half of the eighteenth century when the word 'original' had become a term to conjure with, as in Edward Young's *Conjectures on Original Composition* of 1759, which had a strong echo in Germany. Henceforward the term 'A Roman Copy' was tantamount to a condemnation.

In a sense, it demonstrates the strength of the 'canon' that the critical spoilsports were so slow in moving in. There had been rumblings before, but it was not before the 1770s that Winckelmann's friend the painter Anton Raffael Mengs dared to formulate his belief that most of the admired statues in Roman collections could not be originals. The detailed history of this momentous development has been traced for the first time in a thesis by Alex

Potts, and the relevant chapter has meanwhile been published in the *Journal of the Warburg and Courtauld Institutes* (XLIII, 1980). What he shows is the way the canonic statues succumbed to a kind of pincer movement carried out by scholars and artists. Mengs himself argued mainly as an artist whose exacting standards of truth and sensitivity were rarely satisfied by the treatment of the surface of works like the *Niobe* and the *Apollo Belvedere*. The edifice of academic aesthetics swayed for a time, but the push it had been given had fatally weakened its stability. Henceforward the question to be asked in front of an ancient statue was not 'why is it so sublime?' but 'what lost work may it reflect?'

Once this question was asked in earnest, it was not too difficult to identify copies, reflections or imitations of some of these once famous works among the masses of statues which crowded the collections of Rome, Florence and Naples. In retrospect, it is also strange how long delayed was this recognition, on which we so largely rely in our picture of Greek art history. Winckelmann himself identified the *Apollo Sauroktonus* by Praxiteles, but only after the publication of his *History*. There followed the *Discobolus*, the *Doryphoros*, the *Diadoumenos*, and the *Apoxyomenos*, which were only discovered in the nineteenth century. Valuable as were these discoveries, they were meanwhile put in the shade when the archaeologists moved into Greece and brought back from there the sculpture of Aegina, the Elgin marbles, the treasures of Olympia, of Delphi, of Pergamon and of Ephesus. How could the battered and much restored remnants of the copying trade stand up against these original creations?

Nobody would want to forgo the gains we have made in our appreciation of Greek art during these past two centuries. And yet it seems possible that as a result of this revolution in taste our attitude is further removed from that of the average Greek or Roman than was that of the upholders of the canon.

There is an amusing letter by Cicero which illuminates this attitude in a vivid context. He had evidently commissioned his agent M. Fadius Gallus to buy some pieces of sculpture for him and was shocked by the purchase and by the price.

> Not knowing my practice you paid more for these four or five pieces than I value all statues in the world. You compare those Bacchantes with the Muses owned by Metellus, but where is the analogy? In the first place I would never have thought the Muses worth all that money, and all the Muses would have agreed. Still they would have been suitable for the library and harmonize with my literary pursuits. But where would I find a place for Bacchantes? To be sure they are pretty. I know them well and have often seen them. Had I wanted them I would have specifically asked you to buy them. I am used to buying statues which would adorn my palaestra and make it look like the gymnasia. But what can I, a champion of peace, do with a statue of Mars? I am only glad there was not also a statue of Saturn, for the two together would surely have made me bankrupt . . .

Clearly Cicero took it for granted that the available works, though differing in price and quality, were all copies or replicas. When he claims that he knew the Bacchantes well, he means that he had seen replicas. But before we dismiss him as a *homo novus* let us remember that when we say with equal assurance that we know the 'Emperor' Concerto we mean that we know it through the mediation of a performer. This may seem an eccentric comparison to make, and indeed it would not hold up to detailed scrutiny: but it serves its purpose if it reminds us there are arts where we cannot and do not always insist on the 'Original' with the same moral rigour that we apply to paintings and statues.

Even in their dealings with works of the visual arts, whether created for the cult or for decoration, few cultures are much interested in this distinction: the highly aesthetic approach of Chinese collectors is much less dismissive of copies or paraphrases than we have become. Concerned as they must be with questions of dating and attribution rather than with the less tangible problems of artistic worth, our students are taught to look at the history of art as a series of easily remembered innovations. Admittedly it was in Greece that this historiographic schema, which Vasari was later to transfer to his account of the Renaissance, was first applied. In any case, this convenient approach notoriously works only over a limited stretch of time. Once progress has led to 'perfection', as with Lysippus and Michelangelo, we really lack a paradigm for dealing with subsequent periods.

Here the historian of ancient art is much worse off than his Modernist colleague, who can deal with personalities, schools and currents to his heart's content. There are few such signposts in the seven hundred years between the death of Alexander the Great and the age of Constantine. Accordingly, his desire to assign a date to works of this period is often frustrated. The magnificent horses of San Marco are a case in point. We are told by the authors, who rightly include them in their catalogue of canonic antiques, that 'scholars appear to be no surer today than they have been in the past about the dating ... which in recent publications has varied between 300 BC and AD 400.' But does it matter? To ask this question may sound like the ultimate heresy, but it has become a heresy only because of our acceptance of progressivism in art, with its attendant cult of originality. It is this attitude which has made us use the term 'derivative' as a term of contempt when applied to works of art. But, after all, there is no work of art which is not derivative to some extent. Miraculous as was the advance of Greek art from archaic rigour to baroque exuberance, we should not ignore the degree to which even these centuries remained wedded to types and formulas which were subsequently varied, revived and reinterpreted in greater and minor creations. Need we, then, be ashamed of admiring the *Spinario* when we read that it may be 'a pastiche of the late Republican or early Imperial period in which the naturalism of [a] Hellenic prototype is made more piquant by the addition of a head copied (or, possibly, literally taken) from an earlier Greek statue'? Why, after

all, 'pastiche', and why 'piquant'? Were later artists not entitled, as poets and composers have always been, to use the styles of the past for their own legitimate purposes? Even if it should turn out, as has also been proposed (though not in this book), that the *Apollo Belvedere* is not even a copy after a lost bronze by Leochares but rather a later re-combination of earlier artistic inventions, must we therefore remove it from our mental furniture? Surely the hold which these and similar works once had on the European sensibility demonstrates the power and flexibility of the visual language created in the ancient world. Moreover there is better evidence than the subjective reaction of gullible art-lovers for the objective value to mankind of the currency minted in Classical Greece: not only did it provide the arts of the Eastern and Western Middle Ages with their basic medium of exchange, it was carried via Afghanistan and India to China and Japan to generate new styles and new masterpieces. Before this background of the world-wide triumph of Hellenism, the lure of Classical sculpture, so lucidly chronicled in this thought-provoking book, can perhaps be seen in a wider perspective.

Patrons and painters in Baroque Italy

When our grandparents made their pilgrimage to Florence they paid homage to the city of Dante and to the birthplace of the Renaissance. What came later carried the stigma of decadence attributed variously to Spanish oppression and Jesuit obscurantism. How they would have rebuked a generation that has deserted the almond-eyed madonnas on golden grounds for gloomy altar paintings of martyrdoms and boastful frescos with billowing clouds! It was Roger Fry who, almost 30 years ago, discerned the first symptoms of this dramatic reversal of taste and even gave it a guarded welcome 'because only a zealous devotion can hope to undertake the arduous task of bringing to life again a whole period of art which has nearly lapsed through neglect from our artistic conscience'.

Mr Francis Haskell's admirable book is the latest fruit of this new devotion which has meanwhile transformed the literature of art, the itinerary of the grand tour and even the buying policy of the National Gallery. His aim is indeed to bring the Italian art world of the seventeenth and eighteenth centuries to life again and for this purpose he has digested an imposing mass of published and unpublished sources.

His beautifully produced and well-illustrated book is the first English addition to the handful of historical studies on our shelves which deal systematically with the social context for which the pictures and statues in our museums were originally created. Its title is significant. Mr Haskell deals with patrons and painters, in that order.

The Popes and Cardinals of seventeenth-century Rome, their worldly ambition and (sometimes) their other-worldly aspirations, the religious orders dependent on imperious secular patrons, scholars with limited means but great discernment, foreign princes eager to decorate their homes with mythological nudes, English milords with a sober taste for portraits and accurate *vedute*, Venetian noblemen creating in their eighteenth-century palaces a world of make-believe that is in poignant contrast to their declining power, agents and treasure hunters ranging as far afield as Stockholm, Dresden and Moscow—such are the figures who crowd the 400-odd pages of this history.

Not all of them emerge with equal vividness from the documents. Mr Haskell is a scrupulous historian and he quite rightly restrains his imagination from filling the gaps left by the records. Sometimes one regrets that the vastness of his canvas prevents him from giving even more attention to those patrons whose activities are better documented and whom he still presents with tantalizing brevity, referring the reader to more detailed publications which few will have the time and persistence to hunt up.

Indeed, there are no concessions in this book to readers not already steeped in the art and history of the times, and so it will more frequently be consulted than read through, as it deserves to be read,

Originally published under the title 'A golden age of patronage' in *The Observer*, 23 June 1963, as a review of Francis Haskell, *Patrons and Painters: A Study in the Relations between Italian Art and Society in the Age of the Baroque.*

unfolding its fascinating story of the fortunes of the baroque, as we now call the current of art that owed its most dazzling efflorescence to Bernini's patron Urban VIII and that gave a last sparkle to the Venetian views of Guardi which the propagandists of the new neo-classical creed seem to have neglected, if not despised.

Mr Haskell has not much love for the academic doctrines that chilled and killed this exuberance. His sympathies are all with patrons who can be shown to have relished good painting for its own sake, regardless of learned themes or doctrinaire design. He warms to collectors such as the Grand Prince Ferdinand de' Medici, who, at the end of the seventeenth century, introduced the Florentine diehards to the pleasures of Venetian colour, or his contemporary, the Elector Wilhelm, who assembled in Düsseldorf a memorable collection of painterly masterpieces.

The peaceful co-existence of such a liberal outlook in several patrons with symptoms of academic orthodoxy tends to puzzle Mr Haskell. But is not such a catholicity of taste quite compatible with genuine enthusiasm? Is a love of Verdi really in conflict with a genuine admiration for Bach? The possibility of achieving excellence in very different styles and modes was a commonplace which Cicero had already illustrated with an example from paint-ing. Even the ambivalence towards genre painting was prefigured in antiquity in Peiraikos, dubbed the 'dirt-painter', whose paintings of barber shops and donkeys were yet reported to have fetched the highest prices.

It is these continuities and complexities of attitude which frequently thwart Mr Haskell's hope of finding in the taste of a patron the symptoms of a general outlook or allegiance that would also throw light on the social significance of certain stylistic trends. Used as we are to pigeon-hole our contemporaries as progressives or reactionaries and sometimes even to venture a guess at their political loyalties when we hear of their aesthetic preferences, this applica-tion of Marxist sociology comes natural to most of us. After all, we know it to be politically dangerous in present-day Russia to possess abstract paintings and socially risky among our less tolerant friends to be known as an eager collector of Munnings's paintings.

Paradoxically, one of the most interesting and unexpected lessons of Mr Haskell's valuable study is the reminder that in the past the lines of loyalties frequently followed quite different patterns. Ties of citizenship and of clan often counted for more than allegiance to common ideals. A Florentine cardinal was in honour bound to favour Florentine artists. The accident of a Pope's death could thus lead to the dispersal of one group and the ascendency of other artists. Yet one can perhaps detect a note of disappointment in the crucial passage in which Mr Haskell sums up these negative conclusions: 'Nothing in my researches has convinced me of the existence of underlying laws which will be valid in all circumstances. At times the connections between economic or political conditions and a certain style have seemed particularly close; at other times I have been unable to detect anything more than the internal

logic of artistic development, personal whim, or the working of chance.'

Even such a negative conclusion would amply have justified the enormous labours that went into the making of this book. For do they not quietly dispose of the facile conception of art as the 'expression of the age'? Yet, somewhere in these pages one can also discern the germs of a more positive theory that still awaits to be developed. Writing of Tiepolo's success Mr Haskell remarks: 'It is hard to resist the conclusion that his marvellous gifts and brilliance of execution created a need for his art fully as much as they satisfied it'.

But why try to resist it? Do we not see all around us how technology creates fresh needs and demands and are there no technological elements even in stylistic innovations? Did not Bernini's inventions create new demands for splendour and illusion in the remotest Alpine valleys, where Gothic interiors were covered with stucco clouds and rapturous angels? And can these visions in their turn have remained without effect on people's tastes and people's minds? We are still far away from understanding the complexities of such mutual induction that result in the triumph of a style. But thanks to Mr Haskell's book we are a little nearer to that goal than we were before.

17
Dutch genre painting

In what is called the 'art world' of today exhibition catalogues have acquired an almost ritualistic function. Too heavy to carry around, too detailed to be read in their entirety, they serve to reassure the public of the care and thought that have gone into the arrangement of the show. The catalogue of the circulating exhibition 'Masters of Seventeenth-Century Dutch Genre Painting', which went from the Philadelphia Museum of Art to the Berlin Gemäldegalerie and finally to the Royal Academy of Arts in London, has many of the drawbacks of the genre. Its 400 pages, its 127 full-page colour plates, its countless black-and-white illustrations and extensive bibliography inevitably present a contrast with the paintings to which it is devoted, since many of them are lighthearted and unpretentious.

In this particular case, however, it would be wrong to dismiss the enterprise as inflated, for not only the individual entries but more exceptionally the introductory essays carry their justification in themselves. The organizer of the show, Peter C. Sutton of the Philadelphia Museum of Art, is responsible for the two preliminary texts, a detailed account of the masters represented and a chapter, 'Life and Culture in the Golden Age'. These essays must be warmly recommended to all lovers of Dutch art for their informative content, their aesthetic sensitivity, and their sanity. Strangely enough this last and most precious quality can no longer be taken for granted in art historical writings on the topic concerned. For somehow we seem to have lost our innocence in dealing with these pictures. It used to be accepted as a matter of course that the genre paintings produced in such quantities by major and minor masters in various prosperous cities of Holland were intended to please and amuse. It is only of late that they have appeared to present a puzzle. They remain agreeable enough, but what do they *mean*?

This preoccupation with meaning is due, of course, to the success and prestige of the branch of art historical studies known as iconology, which concerns itself with the interpretation of allegorical and symbolical images. But the founders of this discipline never wished to imply that any statue that could not be given a title such as 'Liberty Enlightening the World' was therefore meaningless. Only in the discussion of language can we distinguish between statements that have a meaning and strings of words that are devoid of meaning. Images are not the equivalent of statements, and to ask in every case what a painting 'means' is no more fruitful than to ask the same of a building, a symphony, or a three-course meal. A painting of a moonlit landscape does not 'mean' a moonlit landscape, it represents one.

In her book *The Art of Describing*,[1] Svetlana Alpers had reason to reassert this common-sense view, devoting a special appendix to the 'emblematic interpretation' of Dutch art. She there takes issue with the attempt to apply the methods and aims of iconology wholesale to

[1] This book is discussed in the next chapter.

Originally published under the title 'Scenes in a Golden Age' in the *New York Review of Books*, 13 June 1985, as a review of the catalogue of the exhibition *Masters of Seventeenth-Century Dutch Genre Painting* (edited by Peter C. Sutton).

the study of the period in question by reference to a genre of art that once enjoyed great popularity, the tradition of emblem books. Emblems are illustrations of objects or scenes which are given a symbolic meaning in their captions and texts. Thus a pretty volume of *Zinnebeelden* (emblems) by one Claas Bruin contains indeed a minute picture of a moonlit landscape, the moon being reflected in a pool below. The accompanying motto, in Latin and Dutch, explains the meaning: *Non fulgore suo* (not with its own light). The lengthy poem on the opposite page adjures us never to forget that just as the moon owes its light to the sun, so we owe everything to God.

Nobody would conclude from this application that all paintings of night pieces in Dutch art are intended to preach this particular sermon, but it remains true that the absence of this or any other meaning can never be proved, for as the lawyers say, *negativa non sunt probanda* (you cannot prove a negative). You cannot establish beyond doubt that the painter of such a landscape or its owner never meditated on this particular truth, which he may have heard in a sermon. Here as elsewhere I have found it useful to remember the distinction proposed by E.D. Hirsch, Jun., between meaning and significance. The significance that such a painting may have for any owner or viewer is likely to vary, whether or not it was intended by the painter to have a specific 'meaning' at all.

As I have indicated, Sutton takes a balanced view of these controversies. His sections entitled 'Mute Poetry' and 'Allegories and Accessories' point to convincing examples which demonstrate that occasionally there is indeed more in Dutch painting than meets the eye. We must be all the more grateful to him for not falling entirely under the spell of the search for meaning for its own sake. His words about a painting by Ter Borch owned by the Detroit Institute of Arts (Fig. 26) deserve to be quoted in full:

> Ter Borch was the master of refinement, not only in terms of his socially elevated subjects and peerless technique—renderings of satin and tulle to defeat an army of imitators and copyists—but also in terms of psychology. One can inventory the associations and potential symbolism of objects on a dressing table or discuss the implications of details of costume and furnishings, but the abstracted gaze of the woman fingering her ring speaks volumes.

How refreshing it is to read such a sensitive response to the essentials of a minor masterpiece, precisely because it contains both objective and subjective elements. That the volumes which her gaze appears to speak are closed books to us is suggested by the catalogue entry concerning the same painting, which rightly stresses the ambiguity of the lady's gesture. 'Is she merely daydreaming as she takes off her jewellery or does she toy with larger issues of romance or marriage?' But, one might interpose, is it certain that she is fingering or taking off her ring? Is it not more likely that she puts it on after having rinsed her hands and now waits somewhat impatiently for the maid to get her ready at last? Maybe the artist did not want us to know, but what he certainly wished us to observe was his mastery in the

rendering of satin, tulle, and other materials that Sutton so rightly admires.

Perhaps one could go even further than he does when he says of Frans van Mieris that his work 'established a standard of technical refinement never surpassed in paint. Only with the advent of photo-

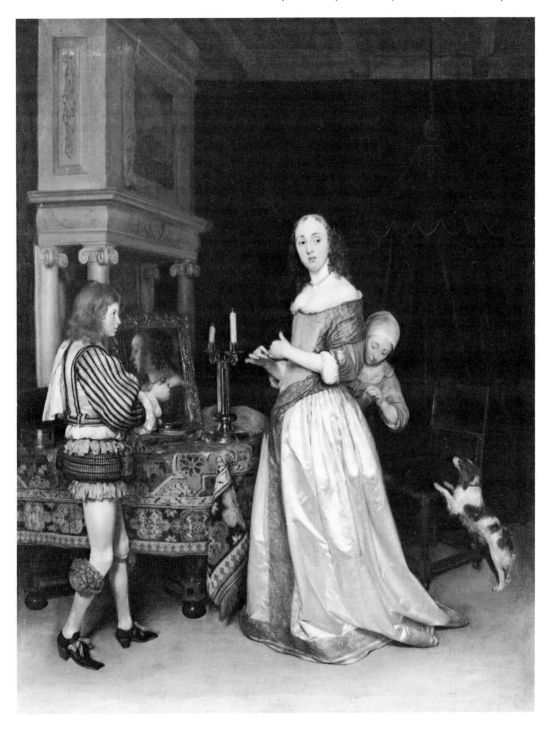

26 Gerard ter Borch: *Lady at her Toilet*. c.1660. Detroit Institute of Arts

graphy were genre images of greater detail realized'. Were they really? It is far from sure that photography can match the suggestive power of Dutch paintings in conjuring up the effects of gleam and glitter. The realism of this school is a 'superrealism', mobilizing our response to a greater extent than the unassisted photographic image might be able to do. Admittedly, there are no experiments known to me that would enable one to make such a comparison; it is to be feared that the very preoccupation with meaning among art historians would make them dismiss such an investigation as philistine or worse. And yet the author is surely right in frequently drawing our attention to the virtuosity of these masters in the rendering of light.

As one walked through the exhibition it indeed became clear that these painters competed with each other and tried to outdo their rivals in these magnificent conjuring tricks. It can never be sufficiently stressed that fidelity to natural appearances is never a simple matter of 'transcribing' reality. Reality must be recreated, even reinvented, in the medium of paint, if its image on the panel or the canvas is to be recognized as true to life.

It is this power, first to convince and then to enchant by the magic of the brush, that makes the masterpieces of the period so unforgettable. Minor specialists had come to excel in the creation of particular effects, but only painters of the stature of Jan Steen, Gerard ter Borch, Pieter de Hooch, and, of course, Johannes Vermeer were able to combine them all without stridency or ostentation and thus to transfigure an ordinary sight into a thing of beauty. It is true that in doing so they were frequently celebrating ordinary scenes from daily life but the author is surely right in stressing the selectiveness of their naturalism. A candid camera recording the behaviour of people in town and country would certainly have produced very different images. But once it is accepted that artists selected their subjects with an eye to their pictorial possibilities this difference cannot surprise. With the exception of Jan Steen's more boisterous compositions they were sparing in the representation of rapid or violent movement. Their figures are often posed in an attitude that can be held without strain, they are engaged in household chores, reading or quietly conversing. To be sure there are exceptions, but we need only glance back at the art of the preceding century to understand how the scenes and settings of Dutch seventeenth-century genre paintings were cunningly chosen to offer a quiet feast to the eye.

Of course it is precisely this interpretation of Dutch art which has been challenged by those who stress its emblematic leanings. It has been argued, particularly in Holland, that the view presented by nineteenth-century art lovers from Hegel to Fromentin was coloured by the art of their own time and was therefore anachronistic. The Dutch masters of the seventeenth century, it is now said, were neither realists nor impressionists; they were the heirs of a tradition extending far into the Middle Ages which used the visual image to illustrate, to edify, and to preach. Scenes of carousing, so the argument goes, were first created as illustrations to the parable of the prodigal son, and never quite lost their moralizing purpose; the

subjects of Jan Steen's revelries can be shown to be connected with the cycles of proverbs painted by Bruegel, who drew on an older tradition, and even pictures of smokers or drinkers still reflect the old didactic allegories of the 'Five Senses' created in the Middle Ages.

But interesting as these arguments are, they fail to convince because they present an oversimplified view not only of the art of the seventeenth century but also of that of earlier periods. We must never forget how fragmentary is our knowledge of the secular art of the Middle Ages; few of the murals in castles have survived, and even the costly hangings that adorned the halls of the mighty were discarded when they were overtaken by new fashions. Even so, enough remains to correct the idea of an art entirely devoted to didactic purposes. Mr Sutton rightly points to 'the survival through the end of the sixteenth century of vestiges of the love garden tradition—a central theme in the profane iconography of the Middle Ages'. There are other elements of continuity here: elegant lovers conversing, comic yokels disporting themselves as woodcutters or Morris dancers—pictures of hunts and of pastimes had all established themselves in the artistic repertory of the later Middle Ages, on tapestries, murals, and prints. Far from regarding the idea of 'pure genre' as a creation of the nineteenth century, we should acknowledge its relative ubiquity, in the ancient world no less than for instance on the margins of medieval manuscripts.

It is this powerful tradition as much as that of didactic illustration on which the masters of the seventeenth century were able to draw when they looked for opportunities of displaying their ever expanding powers of observation and representation. To suggest that the display of such powers was frequently their dominant aim, of course, need not imply that they were as anxious as were the Impressionists of the nineteenth century to purge their creations of anything that smacked of the 'anecdotal'. Manifestly they were not. They had also inherited the age-old tradition in literature and on the stage of observing what is called 'the comedy of manners', and, just as the writers did, they kept to certain environments and social strata for the exercise of their skill.

Sutton offers a helpful survey of the social strata of seventeenth-century Holland, with its patricians, merchants, soldiers, and outcasts; he reminds us of the restrictions placed on revelries and luxury by the city fathers, but also of the limited efficacy of these efforts. A social historian who wanted to rely exclusively on the testimony of art would certainly gain a very distorted picture of the times, but it is still surprising to learn that many of the elegant women seen drinking or making music must be prostitutes rather than respectable ladies. In inventories such scenes are often described quite openly as brothel pictures, *bordeeltjes*.

Why were these subjects so popular, and what prompted the well-to-do citizens to display them in their houses? In other words, what did such paintings signify to their average viewer? Did he look at them as a warning against vice or vicariously enjoy these illicit pleasures? But should we not pause once more to consider whether

we are asking quite the right question? There is an epigram among the *Xenien* jointly composed by Schiller and Goethe which art historians too anxious to establish symbolic or social meanings might do well to ponder:

If you desire to please the worldlings and also the saintly
Paint them a picture of lust—but with the devil nearby.

Admittedly this is an advice which Hieronymus Bosch followed more closely than did the painters of the seventeenth century. Their pictures of 'lust' are muted by a strong sense of decorum, and far from ever including the devil they were content with an occasional discreet reminder of the bad end to which such goings-on can lead. It is unlikely that they were out to convert or to improve the moral tone of society. Thus a close reading of the catalogue does not compel us to revise the traditional view that most of these pictures were meant to please and entertain. How else could the painters expect to make a living?

Some two hundred years before their time a Florentine merchant sent to Flanders to purchase tapestries for the private residence of the Medici wrote to his masters that the only set he found available represented the story of Samson, with many dead bodies making it quite unsuited for the purpose. After all, he remarked, in such a room one wants *'cose allegre'*, cheerful things. It is unfashionable to appeal to 'human nature' in such matters, but it seems likely that the Dutch citizens of the seventeenth century would have agreed.

Mapping and painting in the Netherlands in the seventeenth century

More than two decades ago Svetlana Alpers placed us all in her debt by publishing a strikingly new analysis of Vasari's famous *Lives of the ... Painters* (1550). She taught us (or in any case me) that we misread and therefore undervalue that foundation charter of art-historical studies if we fail to distinguish between what Vasari sees as the means of art and what is its purpose. Far from naively regarding the faithful imitation of nature as an end in itself, Vasari saw the development of representational skills as the perfection of means which always served their main social function—the evocation of a sacred or edifying story, in other words: dramatic narrative.

Confirmation of this important insight can be found in a neglected passage from Leonardo's *Trattato della Pittura*, where the master talks about mechanical means of imitating natural effects (such as the tracing of outlines on the surface of a transparent sheet and observing the shadows and lights). There is nothing wrong, Leonardo avers, if this method is used as an aid, but if artists begin to rely on such short-cuts, 'they will always remain poor in inventing and composing narratives which is the aim of that art'.

In the challenging book under review Professor Alpers argues convincingly that we are still the heirs of this tradition, which did indeed dominate the teaching of art in the academies of Europe. Thus Sir Joshua Reynolds in his *Discourses* could freely acknowledge what he called the 'mechanical excellencies' of the Dutch school while regretting the vulgar use frequently made of such skills. But her argument has a further aim. In her view the historiography of art, including the teaching and writing of art historians today, remains wedded to this conception, which introduced an unconscious bias in favour of Italian art. The methods and attitudes appropriate for the critical evaluation of works in that tradition have proved inadequate to explain other types of art and have therefore led either to their neglect or to their misinterpretation.

Both in her introduction and in an appendix Professor Alpers criticizes in particular the tendency of applying to Dutch painting the methods developed by Erwin Panofsky and others for the interpretation of images conceived in the classical tradition. The search for hidden meanings, the reference to emblem books and enigmatic 'hieroglyphs' which has enjoyed a certain vogue among historians of Dutch art, has led, in her opinion, to a fundamental misinterpretation of one of the greatest periods of artistic creativity. In this demonstration she has succeeded triumphantly. There is no doubt that thanks to her highly original book the study of the Dutch masters of the seventeenth century will be thoroughly reformed and rejuvenated.

True, it might have clarified matters if she had talked of the academic rather than of the Italian tradition of art, for she knows very well that not all Italian art is dominated by the values of 'history painting'. Maybe, in fact, adopting this alternative terminology

Originally published under the title 'Mysteries of Dutch Painting' in the *New York Review of Books*, 10 November 1983, as a review of Svetlana Alpers, *The Art of Describing: Dutch Art in the Seventeenth Century*.

would also have helped her to diagnose the roots of her dissatisfaction with current art-historical practice. Academics are naturally attracted to the academic outlook, for it encourages an intellectual approach that thrives in the classroom. Like it or not, the teacher of art history must talk, and what lends itself better to such discourse than the demonstration that there is more in any image than 'meets the eye'?

Marshalling her evidence from a wide range of disciplines Professor Alpers makes a case for the opposite approach: What matters in Dutch art is precisely what meets the eye. One can only admire the zest and erudition with which she drives home this conclusion. But in a sense her insight must create a problem for her, and for all those who still want to (or have to) talk about Dutch seventeenth-century art. It is a problem of which nineteenth-century writers on art were fully aware.

Eugène Fromentin, in his epoch-making study of the arts of the Netherlands, *Les Maîtres d'autrefois* (1876), begins his account of painting in Holland with a reminder of the surprising fact that there is in Dutch painting 'a total absence of what we today call a subject matter . . . ever since that painting ceased to borrow from Italy her style and her poetics . . . the great Dutch school seemed to think of nothing but of painting well'. The French critic here takes up a theme from Hegel's lectures in aesthetics to which Professor Alpers refers but which she does not quote: 'Even though the heart and mind are not given their due, we are reconciled by a closer look . . . indeed if one wants to know what painting is, one must look at these little pictures to say of this or that master: *he* can paint.'

The author, of course, fully appreciates the role which such masterly 'crafting' plays in the tradition of Dutch painting, but though she also acknowledges that 'northern art does not offer us an easy verbal access' her book is intended to fill that lacuna. As her title indicates she wishes to pit the 'art of describing' as practiced in the north against the art of narration developed in the south. 'Narration has had its defenders and its explicators but the problem remains how to defend and define description'. The chapters that follow indicate that by 'defend' she means assigning to description a social function different from, but equal in relevance to, the religious and moral message of the academic mode.

In pursuit of this aim the author calls as her first witness that renowned Dutch man of letters, Constantijn Huygens, whose well-known autobiography she uses to good purpose. She quotes an interesting passage in which Huygens describes the experience of looking through one of the early microscopes and being reminded of the art of Jacques de Gheyn II who had drawn insects with consummate skill. If only he could have drawn the creatures of that 'new world' which the microscope revealed!

Such drawings were in fact made and engraved in the course of the century and added appreciably to scientific knowledge, and yet it could be argued that in stressing this descriptive function of art as typical of a new concern Professor Alpers somewhat overstates her

116

case. What might be called the recording function of the visual image surely did not have to wait for the seventeenth century to be recognized. Several millenniums earlier the ancient Egyptians recorded on the temple wall of Deir el-Bahari the appearance of plants and animals that an expedition had brought from the land of Punt. It was neither the first nor the last such use of a pictorial record. After all, what are herbals—which existed since classical antiquity—than visual records of medicinal plants for the use of those who have not seen any live specimens?

The author disclaims any intention of wanting to monopolize this function for Dutch art; but any uninitiated reader of her book may still get a somewhat one-sided picture of the true situation. Such a reader might find it useful to glance into the hefty catalogue of the Florentine Medici exhibition of 1980 devoted to 'Commerce, the Rebirth of Science, Publishing and the Occult', which shows the Dutch contribution—great as it was—in its European setting. There is no doubt, of course, that the voyages of discovery and the advent of printing gave a new scope to the image as a conveyor of visual information, and that this presented a challenge to the purely verbal education of classical erudition.

In celebrating this movement, which in more than one respect ushered in the modern age, the author tells us that 'art can lead to a new kind of knowledge of the world' or even that 'pictures challenged texts as a central way of understanding the world'. Not everybody will be inclined to accept this sweeping claim. It is not just hairsplitting to point out that no picture can perform such a feat, when divorced from a caption or other contextual pointers. It is not for nothing that we speak today of 'visual aids' when referring to illustrations, diagrams, or films. Nobody would be inclined to underrate the vital role of these aids in supplementing and enriching a verbal account, but the information imparted by images remains embedded in language.

To revert to the wish of Huygens that Jacques de Gheyn could have recorded the new world seen through the microscope, it is clear that any such image without a caption (or its equivalent) could never have imparted 'knowledge', let alone 'understanding'. The creature he drew would have lacked a scale and a context, it might have been a mere grotesque or a fabulous monster from Mandeville's travels. What made the illustrations of microscopic observations so important was the use made of the new knowledge that they incorporated.

This happens to be precisely the point made by Michel Foucault in his book *Les Mots et les choses*, to which Professor Alpers appeals in her interpretation. He points out that the microscope was used in the seventeenth century to solve problems. Take the example of the Italian physician Francesco Redi who, in his book of 1668 (no. 9.45 in the catalogue mentioned above), illustrated among other specimens a louse peculiar to donkeys (Fig. 27). He thus disproved Aristotle's contention that donkeys do not harbour lice, and apparently incurred the wrath of his contemporaries. But what is this slight contribution to knowledge compared with Redi's conclusion,

derived from an examination of the reproductive organs of insects and fortified by experiments, that the universal belief in the spontaneous generation of maggots and vermin in carcasses was untenable, and that all these creatures emerged from eggs laid by flies? Here, surely, is a milestone on the road to Pasteur's achievement which could never have come about without the microscope, but never through the microscope alone, or, be it said, through a collection of pictures or specimens, however accurate and however complete. Important as was the art of describing, the art of thinking also needs its defenders.

The author devotes a number of interesting pages to the books by John Amos Comenius, who rightly championed the use of visual aids in education, because he wanted to free children of the empty drudgery of memorizing. His illustrated textbooks should enable the learner to grasp the parts and varieties of trees, etc., while sitting in the classroom, but the role of the captioned picture here is that of a substitute. The teacher could have done even better with the aid of a pointer if the lesson had taken place in a garden; but knowledge acquired through pointing is not yet scientific knowledge.

There is a splendid passage in Swift's *Gulliver* describing the 'school of languages' in the grand academy of Lagado, in which he describes

> a scheme for entirely abolishing all words whatsoever; . . . since words are only names for *things*, it would be more convenient for

27 *A louse.* Plate 21 from Francisci Redi, *Opusculorum pars prior, sive experimenta circa generationem insectorum.* Amsterdam, 1668

all men to carry about them such *things* as were necessary to express the particular business they are to discourse on. . . . The room where company meet who practice this art, is full of all *things* ready at hand, requisite to furnish matter for this kind of artificial converse.

Swift goes on to commend this invention as a 'universal language to be understood in all civilized nations'.

The butt of Swift's satire, of course, is the Royal Society and its tendency to value the immediacy of observation above the use of words, and indeed it is to this tradition that Alpers refers us in her central chapter. She quotes amply and suggestively from the writings of Francis Bacon whose emphasis on visual observation reminds her of the Dutch 'art of description': 'Bacon too manifests an intense interest in the minutiae of the world. This is combined with an anonymity or coolness (it is as if no human passions but only the love of truth led him on) that is also characteristic of the Dutch. The world is stilled, as in Dutch paintings, to be subjected to observation'.

The passage offers a fine and characteristic example of the author's forensic skill, but it is to be feared that Bacon would have let her down in the witness box. True, she is able to quote him for his dictum 'I admit nothing but on the faith of the eyes', but she also knows that he uttered many warnings against reliance on our fallible senses. In fact she is too good a historian to pin the efflorescence of Dutch art on the author of the *New Atlantis*. She writes:

> It will not do, of course, to claim Bacon as a cause for the effect of Dutch painting, in spite of the Dutch enthusiasm for his writings. However, in arguing for craft or human artifacts and their making, Bacon, who lived in a country without any notable tradition of images, can help deepen our understanding of the images produced in Holland, a country notable for its lack of powerful texts.

The question arises whether in yielding to this desire to find 'texts' she has not succumbed to the academic temptation she has been trying to banish. Do we need these texts for our understanding? Alpers herself very rightly stresses the continuity of Dutch art, which can be extended as far as the fifteenth century. There is a famous chapter in that classic of cultural history, Huizinga's *The Waning of the Middle Ages*, where the author meditates on the contrast between the miraculous art of Jan van Eyck and the tedious texts composed by his contemporaries. Both, he concludes, pile detail upon detail, but what is tiresome in literature becomes enthralling in painting. Maybe Huizinga exaggerated, but his warning against the search for such equivalences should not fall into oblivion.

For stressing the relevance of traditions not only implies an attention to the way art feeds on art, it should also make us aware of the cumulative nature of any such skill. What happens in such a hothouse atmosphere is that ambition leads to competition and frequently also to specialization, as it notoriously did in Holland. But if the Dutch masters vied with each other, trying to outdo their

119

rivals in certain accomplishments, it was hardly the didactic func-
tion of the image that drove them on. 'Consider the lemon, one of the
favoured objects of Dutch vision', writes Professor Alpers:

> Its representation characteristically maximizes surface: the peel is
> sliced and unwound to reveal a glistening interior from which a
> seed or two is frequently discarded to one side. In the hands of
> Willem Kalf, particularly, the lemon offers a splendid instance of
> what I have termed division. The representation of the wrinkled
> gold of its mottled surface, with the peel here pitted, there swel-
> ling, loosened from the flesh and sinuously extended, totally
> transforms the fruit.

Alpers's own 'art of describing' here splendidly matches Kalf's, but
while her prose is didactic, Kalf's painting is surely not. We go to her
book to learn about Kalf, but not to Kalf to learn about lemons.

It is true that the 'sincere hand and faithful eye' that emerged from
centuries of cultivation could also be put into the service of a didac-
tic purpose. Here the author's most striking demonstration concerns
a print of 1628 after Pieter Saenredam 'to belie rumours about the
images found in an apple tree'. Apparently the dark core of an apple
tree which had been cut down near Haarlem was interpreted as a
portent since the dark patches resembled images of a Roman priest
and thus raised fears among the Protestants that an invasion was
threatening them. The print in question carefully copies and
explains the portentous black shapes and shows how little they re-
semble the figures that had been projected into them. Clearly such a
demonstration presupposes a developed skill in the faithful
rendering of surfaces, which is a 'spin-off' of Dutch virtuosity. But is
Dutch painting also an offshoot of scientific observation? There are
few artistic traditions which equal the arts of the Far East in the
minute observation of flowers and birds, but it seems that Japanese
culture at any rate was largely devoid of scientific interests.
Admittedly the absence of such a parallel elsewhere does not dis-
prove its importance in Holland, but it suggests at least that the
autonomy of artistic traditions should never be underrated.

The case is different with the comparison to which the author
devotes a special chapter, the relation of geographical maps to
Dutch prints and paintings of landscapes and towns. In the period of
its greatest commercial expansion Holland was also the principal
centre of cartography, and the maps and atlases published there set
the standard for centuries to come. This remains true and significant
even though it might have helped the reader again if she had
acknowledged at least in passing that what she calls the 'mapping
impulse' was not confined to the Dutch. Another catalogue of a
recent exhibition, this time devoted to Leonardo's astounding
achievements in this field (*Leonardo e le vie d'acqua*, Florence,
1983), might serve to adjust the balance since it shows his drawings
of Tuscan mountain ranges found in the Madrid codices in connec-
tion with the project for regulating the Arno, side by side with
striking photographs of these and other areas he drew and mapped.

Not that Professor Alpers needs reminding of Leonardo, but maybe she has forgotten the proliferation of townscapes in Italian decorative murals (such as the courtyard of the Palazzo Vecchio in Florence), not to speak of the Galleria Geographica in the Vatican through which we tend to hurry on our way to the Sistine Chapel. And remembering the Vatican, she should also, perhaps, have made a nod in the direction of Raphael's *Stanza della Segnatura* when formulating her claims for the role of the written word in Dutch paintings.

By themselves these precedents do not, of course, invalidate the important conclusions of this instructive chapter concerning the common frontiers which, in Dutch culture, extend between paintings and maps. But it is not easy to see how this kinship between painting, print-making, and cartography can be reconciled with the thesis of Professor Alpers's second chapter, called 'Ut pictura, ita visio', which offers a most stimulating account of Kepler's contributions to the science of optics. It was Kepler, we learn, who first regarded the image formed on the retina as the equivalent of a painting, and this definition, once more, serves the author as an argument for her identification of picturing with seeing and knowing. Leaving aside her extension of the chapter into the much contested field of perspectival theory, I would not want to dispute the relevance of these discoveries to the theory of painting, but of course they cannot have much bearing on the theory of mapping. Maps are made by surveyors who record pointer readings, not retinal images.

But then, do paintings ever record them?

Far from wishing here to mount my old hobbyhorse and canter across the field of my book *Art and Illusion* to which the author pays such generous tribute, I should like to take it into another direction, that of aesthetics. To put it less portentously: Why did and do people enjoy looking at Dutch paintings and cherish the best of them, as Professor Alpers so movingly cherishes Vermeer's masterpieces? Here, obviously, the line of 'defense' she has adopted for the 'Art of Describing', by pleading its value to knowledge, must seem less than adequate. Indeed, since it was her purpose 'to bring into focus the heterogeneous nature of art' that important enterprise might have profited from a further move. Clearly the art of describing can again serve various heterogeneous purposes. Think of a description of London's river in a guidebook as fitting her dominant category and then remember Wordsworth's sonnet 'Composed Upon Westminster Bridge, September 3, 1802,' which, famous as it is, still deserves to be quoted and pondered in the present context:

Earth has not anything to show more fair:
Dull would he be of soul who could pass by
A sight so touching in its majesty:
This City now doth, like a garment, wear
The beauty of the morning; silent, bare,
Ships, towers, domes, theatres, and temples lie
Open unto the fields, and to the sky;
All bright and glittering in the smokeless air.

Never did sun more beautifully steep
In his first splendour, valley, rock, or hill;
Ne'er saw I, never felt, a calm so deep!
The river glideth at his own sweet will:
Dear God! the very houses seem asleep;
And all that mighty heart is lying still!

Disregarding the difference in the time of day and in the mood evoked, I would argue that Vermeer's *View of Delft* can be more effortlessly grouped with Wordsworth's poem than with any guidebook. So much is obvious, but where could we look for an explanation of its poetic rather than prosaic character?

If there is any aspect of art that 'does not offer us an easy verbal access' it is surely this transformation of a topographic view into pure poetry. But we need not quite give up all the same. It might be helpful here to recall Constantijn Huygens's wish that Jacques de Gheyn could have recorded the view through a microscope. Helpful, for we might 'compare and contrast' this appeal to the prosaic function of the image with another text, written a century earlier. I am thinking of Pietro Aretino's beautiful letter rapturously describing his view of the Grand Canal in Venice during a sunset, which makes him cry out: 'Oh Titian, where are you?'

Alas, the marvel Aretino admired has vanished and all we have is his, not Titian's, poetic description.

Today, perhaps a photographer might have preserved the scene for us—as Visconti did in some of his beautiful shots in his film *Death in Venice*. But though photography, the perfect recorder of factual information, is certainly capable also of entering the service of poetic description, its very achievements also make us see why the painting by Titian which Aretino dreamed of could never have been a similar transcript of the scene. De Gheyn might have made a patient drawing of any of the little creatures he saw through the microscope, but for Titian the magic moment would have gone before he even had put his brush to the canvas. He would have had to compose it from memory with the help of his knowledge of light effects. He would have had to resort to poetic fiction.

Trivial as this observation may sound, I believe it has far-reaching consequences for the 'art of describing', because it applies not only to the faithful rendering of a fine sunset but to the representation of any motif under natural conditions.

When we say that a wax model of a lemon is a perfect facsimile of the fruit, all we can mean is that the two may be visually indistinguishable when seen exactly in the same light. The lemon Kalf painted in the still life discussed by the author shows us of course the fruit in a particular illumination; without complicated artifice the illumination could not persist. Even the still-life painter cannot describe what he sees, for what he sees must change every moment. It is the simple fact of what Gibson called 'ecological optics' which makes it almost irrelevant to ask whether and when Vermeer used a camera obscura, for the instrument could only have shown him the

122

evanescent aspects of the motif which even the most rapid brushstroke could not have fixed on the canvas. However much he might have been aided in the rendering of outlines, he had no choice but to invent the uniform illumination which pervades his pictures. It must always be a creation rather than a record. But it may also be a fact of ecological optics that we bring to the task of perception an immensely fine tuning to the nuances of ambient light. Without ever knowing why, we will not respond to an arbitrarily contrived illumination as we do to a harmony such as nature might present.

When Huygens, as quoted by Alpers, says of Dutch artists that they can even represent the warmth of the sun, he hinted at an important truth, but he should really have said that they can *create* the warmth of the sun, as Cuyp mysteriously did. Our sensual and emotional response to light is indeed as mysterious and varied as is our reaction to sounds. We have all known moments in life when light appeared to transfigure a familiar scene and to make us feel what Wordsworth felt on Westminster Bridge. But the great artist cannot and must not wait for such a rare and fugitive spectacle. He has it in his power to transfigure the most commonplace view by the way he imagines and handles the light. Maybe this is the secret of Vermeer, and also, to a lesser extent, of the best paintings by Pieter de Hooch.

In her thought-provoking book the author carves out a niche for Rembrandt, whose art she sees as standing in dialectical opposition to the Dutch vernacular style. Here, as elsewhere, she breaks new ground. Even so, the traditional evaluation of Rembrandt as the master of chiaroscuro might still help to integrate his towering achievement with that of his lesser contemporaries. It is to be hoped that having so ably completed her defense of one mode of the 'art of describing', the author will now turn to the other. She herself has the verve, the knowledge, and the sensitivity to make us see familiar sights in a new light.

19
The mastery of Rubens

Arriving at the Antwerp railway station last September, during the fourth centenary of the birth of Rubens, the visitor was greeted by a large display with the words RUBENS'S HOME TOWN WELCOMES YOU. If he turned to a restaurant recommended by the tourist agency he was offered a 'Rubens Menu', with 'Rubens steak' and a Flemish dish named 'Helena' for this occasion (after the master's second wife Hélène Fourment). Making one's way to the Royal Museum of Fine Arts where the Rubens exhibition occupied the ground floor, one found the entrance blocked by two sheer endless lines winding around the building, one reserved for organized tours and school parties, the other for individual visitors. Reaching the gates after an hour or so, and having paid one's fee, one discovered, of course, that the waiting was not yet over. Jostling crowds enlivened with boisterous schoolchildren had also formed in front of every individual painting, particularly in the first rooms.

One could not help wondering what most of these people thought when they managed to catch sight of the first exhibit, a large panel thronged with half-naked bodies. In the centre a man with a bare trunk is seen lying on the ground and trying to raise himself from a bulging pillow. His head is being guided by a naked boy, who sprawls on his body, toward a well-aimed jet of milk which a portly woman squeezes from her breast into his mouth, while another female, in armour, interposes her hand. Only initiates can have found it obvious that we have here a rendering of the familiar theme of the struggle for the soul of man between Venus and Minerva, Pleasure and Virtue, further orchestrated by a grinning figure of Bacchus and that of Father Time, not to mention others.

Most visitors could be forgiven if they were relieved to discover in the catalogue that this unprepossessing painting did not bear the signature of Rubens but the initials of his last teacher, Otto van Veen. It was placed at the beginning of the show because, as we read, 'the style of the painting is more plastic than is usual with him [van Veen] and we may suppose that the young Rubens had at least some part with it'.

The example would not be worth mentioning if it did not illustrate in somewhat grotesque magnification the obstacles which the average visitor must have encountered in his initial approach to the paintings of Rubens. Their message and symbolism must have struck him as remote, their forms heavy and unappealing, and the controversies about the degree of their authenticity bewildering. But being carried along in the crowd he must also have fallen under the spell of these extraordinary creations. He could appreciate the bravura of the small oil sketches such as those for the series of tapestries celebrating the *Triumph of the Eucharist* (Fig. 28) without being put off by the information in the catalogue that old Father Time is here carrying a young woman personifying Truth while 'Luther lies

Originally published under the title 'The Life-giving Touch' in the *New York Review of Books*, 9 March 1978, as a review of *P.P. Rubens: Paintings, Oil sketches, Drawings*, Royal Museum of Fine Arts, Antwerp; Frans Baudouin, *P.P. Rubens*; Keith Roberts, *Rubens*; Michael Jaffé, *Rubens and Italy*; and John Rowlands, *Rubens, Drawings and Sketches*.

lamenting among his books and Calvin still tries to defend his doctrine'.

Maybe he felt like the visitor to an opera who no longer cares if the libretto is unintelligible and the heroine fat so long as the music envelops him. The images and themes that may have seemed so alien at first had been transfigured by Rubens into a poetic idiom to which anyone could respond without caring for the commentaries of the learned and the controversies of the connoisseurs. That pictorial charade of the first exhibit had turned into its opposite in *The Garden of Love* from the Prado, where the power of Venus and her cupids is glorified in a lyrical vision of unfailing appeal. We would understand its message even if Rubens in his fifties had not written to a friend about his marriage to the young Hélène Fourment: 'I have not found that I am as yet suited to celibate abstinence, and just as I earlier mortified my flesh I am now gratefully enjoying permitted pleasures'.

28 Rubens: *The Victory of Truth over Heresy*. Modello. c.1625. Madrid, Prado

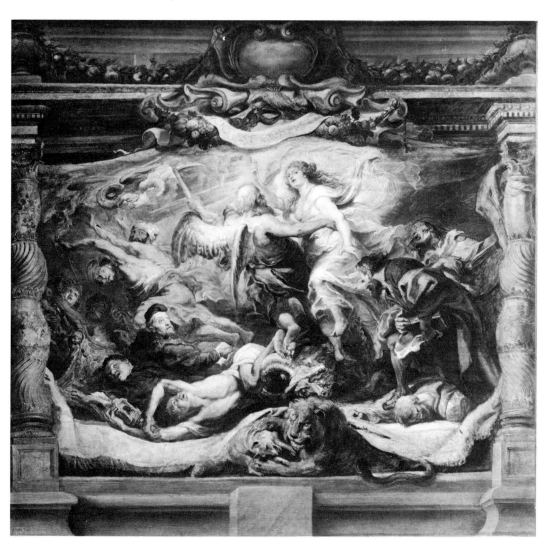

In penning this intimate confession he switched from Italian into Latin, which surely came as naturally to him in writing as did the use of ancient mythology in his compositions. In that pictorial praise of married bliss the master represented himself leading his wife with great tenderness into the presence of the Goddess of Love, a cupid helping him by pushing her from behind. Loving couples and cupids abound, and no Minerva descends to spoil their permitted joys. There is no break between this world of enchantment and the real world. Three of the studies in black and red chalk Rubens made from models for this most personal of his creations were shown at the exhibition, and if these did not complete the conquest, the famous portrait drawing of his children from the Vienna Albertina must have revived the spirits even of the most tired visitor.

In attributing this response to the average tourist I am not only relying on personal observation. There is solid evidence for the selectivity of the public taste in this matter. London can boast of housing the only large-scale decorative work by Rubens which is still in its original place and setting—the ceiling of Banqueting Hall, that magnificent palace by Inigo Jones, with its allegorical paintings in praise of James I. There are no jostling lines of tourists waiting to be admitted, in fact one wonders who among the millions of foreigners who watch the Changing of the Guard, right opposite, have any wish to see this historic place. So unless we want to attribute the attendance at the Antwerp exhibition simply to the power of publicity and the attractions of the Rubens menu we must ascribe it to the presence in this and other exhibitions—including one in London itself—of works more intimate and accessible than the grand machines of official art on which Rubens was so frequently engaged. His *oeuvre*, so vast in scale, so varied in themes and moods, offers something to everyone, but few can grasp and appreciate it in its entirety.

From this point of view 1977, despite its many exhibitions, lectures, and articles, did not yet prove the year to take stock. The monumental enterprise which aims to do this is still far from completion; I am referring to the *Corpus Rubenianum*, a series of twenty-six monographs on Rubens's *oeuvre* published in Antwerp and based on the material collected throughout his life by the late Ludwig Burchard. It is characteristic, however, that even this international enterprise will leave the reader with the task of arriving at a conspectus, for the various specialists have been assigned different slices of the *Corpus* as if no living scholar could be expected to cover it all.

The sumptuous volume by Frans Baudouin, the curator of the Rubens House in Antwerp, simply called *P.P. Rubens*, may therefore be regarded as something of a stopgap. Its introduction and fifteen chapters (of which seven have been previously published as articles) are designed to spotlight various aspects of the master's work and career, notably his first two decades in Antwerp and the setting of his life. The essays on 'Rubens the Diplomat' and 'War and Peace in Rubens's Work' cover fairly well trodden ground, but that on

126

'Rubens and His Social and Cultural Background' offers a useful counter to the stereotype of Rubens as a servant of the mighty. Many of the patrons who commissioned the works in Antwerp that established his fame were members of the middle class, not very different in social status from Rembrandt's early patrons. It was only later that the Bourbons, Stuarts, and Hapsburgs took notice of Rubens and loaded him with those enormous commission which often proved a burden. The chapter on 'Rubens's Personality' may not tell us much that is startling, but it conveniently assembles a number of precious testimonials which are quoted in full in the notes. In addition the book is worth having for the sake of its 276 illustrations including ninety-five colour plates, to which I shall return.

The folio paperback of 108 reproductions compiled and with an introduction by Keith Roberts evidently aims at a more popular market, though as the author says in his introduction, 'It is well known among publishers that books on Rubens do not easily sell'. Unfortunately it is even better known that introductions to picture books are rarely read, though in this case I prefer Roberts's sensible and perceptive text to the pictures, of which sixty-four are in colour. The selection tries to be fair to all aspects of the master's output while still remembering the likely preferences of prospective buyers. It would be interesting to know how far such a volume overcame or created sales resistance to Rubens.

Except for exhibition catalogues—besides those of Antwerp and London, that of Cologne should at least be mentioned—the only contribution to Rubens studies of lasting importance to be published in his centenary is the long-awaited book by the director of the Fitzwilliam Museum in Cambridge, Professor Michael Jaffé. It also deals with one aspect only, albeit one which is central to the understanding of Rubens's art. *Rubens and Italy* is the fruit of many years of intense research. We learn from the preface that the author's interest reaches back to the year 1950 when he embarked on a dissertation entitled 'Rubens in Italy, 1600–1608'. These eight years which span the painter's career from his twenty-third to his thirty-first year were indeed decisive for the formation of his style, so decisive that the author rightly felt that in his final treatment he could omit neither the effect of this experience on the master's later development nor the impact which the art of Rubens had on the subsequent history of Italian Baroque painting.

The bibliography to the book lists no fewer than forty-six separate studies published by Jaffé between 1953 and 1972, and it is on these solid foundations that he has based his text, often incorporating not only his results but also his formulations. The outcome is a work which no art historian can afford to ignore, but which will inevitably present some difficulties to the non-specialist who lacks the relevant knowledge of languages and of monuments. For though the book is generously supplied with 346 illustrations in black and white and sixteen colour plates there are inevitably still many works mentioned or even described for which the conscientious reader would have to turn to a specialized library.

Even in such a library, however, the layman may be in danger of not seeing the wood for the trees, for the author takes it for granted that the wood is known to his readers. By the wood I mean the history of the classical idiom in European art in which Rubens plays such a dominant part. The range of this idiom, as Aby Warburg was the first to emphasize, extends from the calm dignity of ancient statuary to the wild frenzy of Bacchic revels and murderous battles. The assimilation of these pagan forms and contents starts, of course, with the Renaissance, and the prestige of works 'in the ancient manner' secured the spread of this imagery from monumental decoration to such minor arts as majolica and metal work. In the years of Rubens's apprenticeship these displays of contorted nudes were as fashionable in the courtly arts of the North as they were in Italy. Even so it must have been a revelation to Rubens, when, on taking up his appointment as the court painter of the Gonzagas in Mantua, he first set eyes on the great paganizing cycles by Giulio Romano in the Palazzo del Tè and the Ducal Residence.

Not that Jaffé ignores the importance of this encounter for Rubens. He writes eloquently that a 'conspicuously productive part of his universal nature had been nourished by Giulio's abundance', but this abundance is taken as read. Here as elsewhere his text keeps to proven examples of works Rubens copied or used rather than to the impact which must have been made on the young artist by these carousing nymphs and satyrs and the fierce battle friezes which sometimes look like Rubens *avant la lettre*. If an antidote was required for the coarseness of Giulio's sensuality, it was also at hand in Mantua in the compositions by the most delicate of the Renaissance paganizers, Correggio. Here one may even wonder whether one of these famous allegories for the *grotta* in Mantua might not have directly inspired Rubens. The torturing of the satyr, as an embodiment of vice (now in the Louvre), seems to foreshadow in composition and in mood Rubens's painting of *Hercules and Omphale* of about 1602.

Admittedly such a dependence is less certain than are the studies after Correggio that Jaffé pinpoints, and it is again on these that he likes to concentrate. The organization of his book demands that he should review the leading Italian masters one by one for what Rubens may have taken from them. Starting with Michelangelo, and proceeding to Raphael, whose importance for Rubens he rightly emphasizes, he goes on to Leonardo, Andrea del Sarto, Correggio, Parmigianino, Titian, Tintoretto, Paolo Veronese, only then to Mantegna and Giulio Romano, and finally on to the Mannerists and the contemporaries of Rubens including the leading masters of his time in Rome, Annibale Carracci and Caravaggio. It is only after this detailed and fruitful scrutiny of possible sources for Rubens's art that we return to the theme of Rubens *in* Italy, his activities as a portraitist, and—rather strangely placed in the book—his studies of the antique and his antiquarian interests.

Biographically the most detailed of the chapters, well supported by archival materials, concerns Rubens's work for the Oratorians in

Rome toward the end of his stay when he was recognized by Italian connoisseurs and patrons as a rising star—having established a reputation which could not be effaced by his precipitate departure from Italy at the news that his mother was dying. He returned to Antwerp, his mind stocked with impressions he had absorbed in Italy, a store of images on which he could draw for the rest of his life and which he could share with his pupils and collaborators.

It is with this development that Jaffé's book is mainly concerned, and its outstanding contribution lies in the thorough documentation of this strange process. I call it strange, because it turns out that the method of study Rubens adopted must have differed radically from that of the average Northerner who crossed the Alps in order to master the fashionable style of the Italians. It is true that Rubens, like the rest of them, had grounded his training on the copying of prints and had subsequently gone to the sights in order to study at first hand the Sistine Ceiling, the *Stanze*, and the *Laocoön*. But it seems that his attitude was not merely that of an apprentice trying to learn the formulas of the masters. From the outset his copies are less concerned with accurate imitation than with assimilation. He transposed his model into his own visual idiom—not incidentally, as may be unavoidable, but systematically and apparently with relish.

The reader may be forgiven if he is somewhat sceptical at first when confronted with the assertion that the copies Rubens made as a boy after Holbein's *Dance of Death* show 'an astonishing increase in vitality', and that his drawing after a portrait by the same artist 'distinguishes itself from Holbein's original neither in quality nor in scale nor really in technique, but in the idiosyncratic rhythms of the silhouettes and in the subtleties of modelling in chiaroscuro'. Could such judgements not be attributed to the author's partiality for his hero? But the further we read the more we become persuaded that this creative copying is indeed distinctive of Rubens's personality.

To mention but two instances: we learn that he 'felt free to transform the character of Raphael's design, both physiognomically and in the more lavish display of the roundings of the black-haired Grace', and of Rubens's drawing after Titian's *Fall of Man* that 'the morphology and the muscling of the bodies are subtly but unmistakably his. His is the new rhythm in the tree trunk, the new turn of Eve's left arm and wrist, and the new tension in the gesture of protest by Adam's left arm'. Even these examples, however, hardly prepare us for one of the main themes of Jaffé's book, the way Rubens transformed existing drawings not in copying them but in working them over with brush or chalk.

Jaffé quotes the observation of the great eighteenth-century connoisseur Mariette who wrote that 'when Rubens came across mediocre or badly preserved drawings after the great masters he took pleasure in retouching them, transforming them according to his personal taste, so that these drawings can be regarded as the products of that great man himself'. Many examples of this procedure are listed and analyzed in this book. A drawing by Farinati in pen and wash with hatchings of white (not illustrated) 'has been

largely converted by Rubens, brushing on a brown ink, with rose and pale buff body colours, to his own forms and rhythms'. Dull copies after Giulio Romano's *Triumph of Sigismund* 'show over many areas the enlivening touch of Rubens's brush . . . in order to increase the intensity of expression or the elasticity of tread'. It appears that he did not even hesitate to subject not copies but master drawings to this treatment. A drawing of the *Expulsion* by Salviati 'is the scene of great liberties. Rubens invested the bodies of our first parents with a plastic fullness and force unforeseen by the sixteenth century'.

In his catalogue of the Rubens exhibition at the British Museum, which includes a good many such copies and retouched drawings, John Rowlands rightly remarks that 'we might perhaps regard such tampering as amounting to little short of vandalism', but assures us that any objections will be quietened by the results. No doubt; but what is their secret? Certainly Rubens's approach to the works of his predecessors totally differs from the drudgery which was expected of any apprentice-painter bent on mastering the craft. He did not only copy or trace to practice his hand and eye or to extend his vocabulary. He evidently enjoyed testing his creative prowess in these encounters with his predecessors as he watched a new life entering these comparatively inert images. Dare one suggest that psychologically these transformations may not be all that far removed from the vandalism that indulges with more or less wit in the alteration of posters on display? They were also an exercise of power, but what turned the process into a 'permitted pleasure' was the master's conviction that they also resulted in a real improvement.

Steeped as we are in historical relativism the very idea of improving a work of the past must strike us as bizarre. It is all the more noteworthy that this possibility was admitted right into the middle of the nineteenth century and precisely in the context under discussion. John Constable's friend and biographer C. R. Leslie writes in his *Handbook for Young Painters* (1855), 'The colouring and harmony of Rubens, instead of injuring the dignity of Raphael, would, if applied with the discrimination with which Raphael was sure to apply them to his works, unite with it and add to their value. Imagine, for instance, the *Galatea* with the tone and harmony of a Rubens, and the image of a work is immediately presented to the mind of far greater perfection than that picture in its present state'.

Now this idea of an objective improvement may conceivably even affect the problems of the connoisseur, for if this was how Rubens saw the matter, can we quite exclude the possibility of his having occasionally encouraged his own students to follow his practice? It is clear on the other hand that the ability to impart the 'life-giving touch' was most vital to the head of the workshop who had found a means of improving and transforming the hackwork of apprentices. Whether the master invariably reserved this privilege to himself is again a matter for connoisseurs to worry about.

One thing is sure. Rubens thought deeply about the rights and wrongs of copies and transformations. That great champion of his art, the French critic Roger de Piles, has preserved for us in his *Cours*

de Peinture (1708) a Latin essay by the master on 'The Imitation of Ancient Statues'. Rubens shared the conviction of his age that classical sculpture reflected a human physique healthier and more beautiful than could be found in the modern age and he had no doubt that these works should be assiduously studied, indeed 'imbibed'; but he also warned against certain pernicious effects which had led some artists to ruin. For 'some inexperienced and even experienced masters fail to distinguish the form from the material' so that their paintings (as de Piles's eighteenth-century English translator puts it) 'smell of the stone'. 'Instead of imitating flesh they only represent marble tinged with various colours'. Statues show harsh and dark shadows, while with the living body 'the flesh, skin and cartilages, by their diaphanous nature soften, as it were, the harshness of a great many outlines. . . . There are, besides, certain places in the *natural*, which change their figure according to the various motions of the body, and, by reason of the flexibility of the skin, are sometimes dilated, and at other times contracted. . . . To this we must add, that not only the shade, but also the lights of statues are extremely different from the *natural*; for the gloss of the stone . . . raises the surface above its proper pitch' and dazzles the eye.

No explanation could be better suited to help those who want to find their way through the wood. For here is the summing up of what Rubens had tried to achieve in Italy and what he asked others to achieve—the transmutation of the classical idiom into living flesh. Coming from the tradition of the North which had for centuries paid special attention to surface qualities, to the play of light on various textures, he admired the art of the South, its mastery of form and of movement, but he did not allow himself to be overwhelmed or 'led to ruin'. It is likely that he would have found even Michelangelo's paintings wanting in attention to the ever-changing modulations of the human skin. Most, if not all, of his transformations and retouchings show him improving this impression of mobility and transparency to which he attaches such importance. Indeed it is this characteristic of his nudes to which upholders of the academic ideal have implicitly or explicitly objected. The notorious complaint that the women Rubens painted are so 'fat' rests perhaps less on their vital statistics than on an unconscious comparison with ancient statues.

Kenneth Clark (to whom Jaffé's book is dedicated) subtly discerned, in *The Nude*, the role of movement in this impression. 'That suggestion of movement flowing across a torso, which, in the female body, antiquity had rendered by the device of clinging drapery, Rubens could reveal by the wrinkles and puckers of delicate skin, stretched or relaxed', in other words by the surface qualities on which he wanted the painter to focus his attention after he had first 'imbibed' the form of the antique. A study of his drawings and particularly his unfinished sketches reveals to what an extent he followed this precept. We find him first roughing out the outlines in a vigorous brush drawing, often in brown; next he generally models the form by shading, after which he brings the surface to life by a judicious distribution of whites. Not that this 'three stage method' is peculiar to

131

Rubens alone, but in his hand it reveals the power of defeating the rigidity of the frozen moment. For this, after all, is the paradox of painting, that it is meant to capture life in a 'still'. Nobody can find the world of Rubens motionless. Fat or lean, his figures palpitate with life.

Who can doubt that it gave Rubens immense pleasure every time to work this magic, that what inspired him above all was, in Keith Roberts's happy phrase, 'love of the art and act of painting'? It may seem redundant to quote sources where the works themselves proclaim this fact, but de Piles confirms our intuition. 'Since he took extreme pleasure in his work'—he says of Rubens—'he lived in such a way that he could work easily without impairing his health'. We are no longer used to associating artistic creation with enjoyment and with health, and there can have been few visitors to Antwerp who were not occasionally troubled by the fleeting suspicion that Rubens was more robust than was good for his art. But it is precisely these thoughts that were banished by the delicacy of his touch in his sketches and charcoal drawings, by the landscape sketches (of which London has an abundance), and most of all, perhaps, by the encounter with the self-portraits, notably the drawing from the Louvre, shown at Antwerp, and the slight but infinitely moving sketch from Windsor Castle shown in London, which probably dates from the last year of his life.

The fact is that the art of Rubens more, perhaps, than any but that of Watteau, who learned so much from him, relies for its effects, as we have seen, on the most subtle modulation of surfaces. Alas, painting is an impermanent art. Dirt and varnish can interfere with the delicate interaction of tones on which the enchantment of Rubens's style depends, and brutal overcleaning can kill it altogether. There were opportunities in Antwerp to study both types of disaster, not only at the exhibition but also in many churches where important paintings by the master had been polished up for the occasion. By and large it looked as if the paintings on loan from the other side of the Iron Curtain had fared best. The masterpieces from Dresden and from the Hermitage inspire confidence.

But if it is hard today to find one of Rubens's large compositions which still convinces by its tonal harmony and its surface sparkle, what should one say of colour reproductions in which the hazards are compounded? The colour plates in Jaffé's book certainly deserve praise. A judicious choice of subjects avoids the impossible and achieves the difficult. In the other two books mentioned caution is thrown to the wind, and so results vary from near-success to total disaster. One important factor here is scale. Even an exact facsimile matching every tone will look different when reduced or enlarged. It is hard to see, therefore, why M. Baudouin's book illustrates the portrait drawings of Rubens's boy Nicolaas as monstrous enlargements. Some of the details of paintings in the same volume, such as the heads of the double portraits of Rubens and Isabella Brant in Munich, can give much pleasure, and so do other individual heads reproduced close to the original size. Several of the smaller sketches

132

look convincing and even the so-called *Chapeau de Paille* from the National Gallery nearly comes off, while that miracle of a painting, the *Château de Steen* in the same gallery, loses all its magic.

This painting offers a good test case for the book introduced by Keith Roberts, since it so happens that it is there reproduced as a whole and in two details. In making this choice the publishers have surely given hostages to fortune; at any rate the details and the whole simply do not match. One only wonders which is less faithful to the original. Visiting the National Gallery in London with this volume under one's arm may be an unfair test, but it certainly leaves one depressed. The 'Rubens Menu' has largely been drowned in tomato sauce. In charity one may admit that some of the drawings have fared better, but should one even be charitable? No one—one hopes—would do this to Watteau. They should not do it to Rubens either.

On Rembrandt

There are any number of good reasons for remembering Rembrandt, but certainly one which is rather irrelevant—the fact that we have ten fingers on our hands and therefore regard centenaries as round numbers. Since Rembrandt died at the age of sixty-three, an undischarged bankrupt, on October 4, 1669, the calendar indicated last year that exhibitions had to be mounted and books published, not to speak of articles and radio talks asking the mock-solemn question 'How do we stand with respect to Rembrandt today?' How indeed? How do we stand with respect to the Psalms, to Chartres Cathedral? Such works are more or less protected by anonymity from the dangerous institution of centenaries, which not only tend to create a revulsion by surfeit but also are counterproductive of scholarship. The normal course of research depends on continuous argument; the ideas and suggestions advanced by one scholar are accepted or rejected by the next, and we all hope that in this sifting process we get a little closer to the truth. But it is rare, in the nature of things, that publications which appear in one given year can take notice of each other, and so the result is less like a dialogue than like a Babel of voices.

The present spate of Rembrandt books provides an instance which has become notorious. Invited by the Phaidon Press to bring their standard edition of Rembrandt's paintings by A. Bredius (1935) up to date, Professor H. Gerson has not only relegated 56 out of 630 paintings to an appendix of unacceptable pictures, he has also expressed his doubts in the notes about a good many others, among them such famous works as *David Playing the Harp before Saul*, the proud possession of one of Europe's most attractive galleries, the Mauritshuis in the Hague (Fig. 29).

> Ever since this famous picture—which does not have an old history—was acquired by A. Bredius in 1898 . . . it has been hailed as one of Rembrandt's greatest and most personal interpretations of Biblical history. . . . I fear that the enthusiasm has a lot to do with a taste for Biblical painting of a type that appealed specially to the Dutch public of the Jozef Israels generation rather than with the quality of the picture itself.

The allusion here is no doubt to the markedly Jewish type of the young David, which reminds the author of paintings by the famous Victorian painter of Jewish life. For it is this realistic type rather than the quality of the paint, he goes on, which has caused the enthusiasm.

> The painterly execution is superficial and inconsistent. Saul's turban is shining and variegated, and rather pedantic in treatment, in contrast with the clothing and the hand, which are painted

Originally published under the title 'Rembrandt Now' in the *New York Review of Books*, 12 March 1970, as a review of Abraham Bredius, *Rembrandt: the Complete Edition of the Paintings* (3rd edition); Horst Gerson, *Rembrandt Paintings*; Joseph-Emile Muller, *Rembrandt*; Jakob Rosenberg, *Rembrandt: Life and Work*; Christopher White, *Rembrandt as an Etcher*; Michael Kitson, *Rembrandt*; Bob Haak, *Rembrandt: His Life, His Work, His Time*; R. H. Fuchs, *Rembrandt in Amsterdam*; and Julius Held, *Rembrandt's 'Aristotle' and Other Rembrandt Studies*.

loosely, in one monotonous tone of brownish red. All this points to an execution in Rembrandt's studio. . . .

The picture, we learn, has been mutilated.

This may partly help to excuse the emptiness of the curtain motive, but not the somewhat 'larmoyant' interpretation. David's figure is the best and most consistent part of the picture, but not to the degree that I would recognize Rembrandt's touch in it. . . .

In the opening remarks of his own volume (from which the *David and Saul* is excluded) Professor Gerson has certainly nailed his colours to the mast:

The mystique of art has begun to be debunked, and surely all of us can breathe a sigh of relief over that. One element . . . that has assisted this process is the declining share of German interpretations as against critical work done elsewhere in the world.

The cheapness of this aside is out of keeping with the general standard of the book. Be that as it may, it happens that among the present crop of books, a brief monograph translated from the French of Joseph-Emile Muller shows no awareness of Professor Gerson's opinion. To that author the painting is not only a great work of art but also a document of Rembrandt's reaction to his bankruptcy:

His purpose in painting *David harping before Saul* (c.1657) was obviously to depict the mental torment and the relief, albeit accompanied by tears, which art is able to bring to the depressed and lonely man. Beyond doubt, the great powers of suggestion of this picture are due to Rembrandt's personal experience of these two feelings. Bowed down by melancholy, the King is seated holding a fold of the heavy curtain which hangs behind him. He conceals half his face as he wipes his left eye with it; the right eye blazes with anxiety. His long, thin, nervous hand rests limply on the shaft of a spear, incapable of throwing it at the target of his jealousy. Beside this man, impressive both in his size and in the splendour of his robes, David looks small, but the combination of light and shade on his own features gives him rather the demoniac appearance of a sorcerer. Rembrandt now knew that stirring, and even soothing, art could arise only from a mind from which serenity and peacefulness were excluded.

It is precisely this kind of response that explains Gerson's reaction, but does it also justify it? Must we not be on our guard precisely because of the trend towards 'debunking' for which Gerson renders thanks? Response to art demands a certain initial receptiveness. Granted that Gerson may be right that the reputation of a work may sometimes tend to make us overresponsive, it is equally true that you can inhibit response by sowing the seeds of doubt. Who wants to have fallen for 'bunk'? Tell us in the right tone of voice that such a crude melodrama as King Lear cannot have been written by Shakespeare, and we may begin to ask ourselves whether we have been

insufficiently sensitive. It is not a mood in which we can easily surrender to the spell of the play. Tell us that a painting is 'larmoyant' and we will strengthen our defences against being moved.

But what of the painterly qualities? Jakob Rosenberg, in what is still the most readable general book on the artist, *Rembrandt: His Life and Work*, showed himself moved not only by the story the picture tells:

> The glow and vibration of the colours add tremendously to the moving power of this picture, particularly the deep purplish red and golden-yellow lining of Saul's cloak and the gold embroidery of his robe. Here the colour is laid on with Tintoretto-like boldness and sketchiness, while the variegated turban, surmounted by a pointed crown, is executed in a more detailed manner. This flexibility in technical treatment lends the picture an unusual richness. . . . Everything, colour and brushwork, light and shade, spatial composition and pictorial design, serves primarily to express the meaning of the story. And for this purpose the artist's language has taken on a symbolic significance. . . .

Can it be that it is not so much the mystique of art but the mystique of connoisseurship that is in need of 'debunking'? In one respect this may indeed be the case. For connoisseurship in art, the craft of the

29 Rembrandt: *David Playing the Harp before Saul.* c.1657. The Hague, Mauritshuis

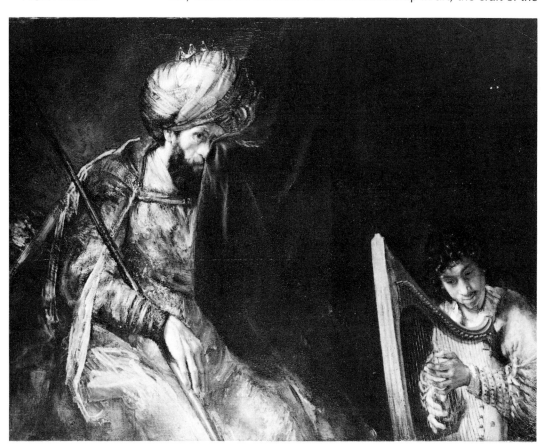

attributionist, has inflated the 'cult of personality'. Collectors want to own a 'genuine' Rembrandt. One by the master's own hand is worth a multiple of what is called 'a work by the school' or 'from the studio'. Thus to admire a painting of this lesser category is to betray insufficient discrimination, a damaging lack of fastidiousness. But, historically speaking, this is nonsense. Much of the art of the past was the product of teamwork under the inspiring guidance of a great master.

Perhaps the time has come for us to take more notice of the potentialities of such modes of creation. In science, after all, it is a matter of course that the director of research guides and inspires his younger collaborators and that none may be able to tell in the end who exactly did what. The same must be true of the most lively of contemporary arts, such as film and television where the producer must rely on others to carry out his ideas, but is also fed with ideas by them. Even our leading statesmen have their speechwriters who learn to express their policy and their thoughts. One wonders whether even they themselves can always tell in the end which passages were totally their own.

Admittedly it is much more difficult for the modern critic to imagine a painting to be the product of a collective. We are so wedded to the idea of every individual brush stroke being the expression of a unique personality that we have no use for second-hand creations. There is a cautionary tale for all who believe in the possibility of making this distinction, though it concerns a work by Raphael rather than by Rembrandt:

When the Duke of Mantua wanted to possess Raphael's portrait of Pope Leo X with two Cardinals (now in the Uffizi in Florence), the Pope instructed the owners to send it to him. Being unwilling to part with this treasure, however, they had a copy made by Andrea del Sarto and sent it instead. Vasari, who tells us this story, had watched Andrea doing the copy and when years later he came to Mantua he was surprised to find that Raphael's pupil Giulio Romano believed it to be the original. In fact—and this makes the story doubly relevant—Giulio assured him that he remembered having painted part of it himself. He was wrong; he obviously could not tell his own brushwork from that of Andrea del Sarto.

Modern connoisseurs are in less danger of being refuted, for they are rarely confronted with witnesses who watched the painting being done. Of course the fact that they are fallible does not prove that they cannot be right or that their activities are useless. Those who have spent a lifetime studying the works of a particular master do build up in their minds a picture of his personality which is sure to be more consistent and more valid than that of the casual observer. But the fact remains that different students build up different pictures and that we have no means, as a rule, of testing their vision against reality. Sometimes they may be too rigorous, sometimes too lenient in their criteria. We tend to prefer the first, and so did Max Liebermann, who is reported to have said that 'it will be the job of future art historians to deny that I ever painted my bad paintings'.

137

The history of Rembrandt research shows the pendulum swinging backward and forward; the canon of his etchings was the first battleground. Around 1800 it was thought to number some 375; during the late nineteenth century artists who were themselves etchers, such as Seymour Haden and Alphonse Legros, found that most of them were wanting by their standards; in fact only seventy-one were left after they had done their best or worst. In 1952 Ludwig Münz acknowledged 279, and some modern connoisseurs find him too strict. It is the same with painting: Hofstede de Groot early in the century listed more than a thousand, though his list was intended to be as comprehensive as possible. Rudolf Valentiner in the next generation included some 700 in his volumes of *Klassiker der Kunst*, while Gerson's own list now comprises only 420.

Perhaps some crude statistics may help us to see the meaning of these fluctuations from a different angle. Born in 1606, Rembrandt was about nineteen when he set up an independent studio. His active life thus comprised some forty-four years. Painting a picture every month on an average, he could have done 528 paintings, fitting the etchings in between. Naturally some of the monumental paintings and some of the etchings must have occupied him for a long time, but there are also authentic items in his oeuvre that he may well have thrown off in a few hours. From this purely numerical point of view, therefore, the restrictionist's case is perhaps not so strong as one would expect, if one remembers the incredible creativity of composers such as Bach, Mozart, and Schubert.

Here we come back to the elusive problem of the 'studio', which alone can explain the discrepancies in the size of the oeuvre attributed to Rembrandt. That Rembrandt's conception of art was not so individualistic as ours, we know. In his early years he shared a studio with Jan Lievens, and the two worked so closely together that collectors at the time described certain paintings as being 'by Rembrandt or Lievens'. After he had moved to Amsterdam, eyewitnesses tell us that he was surrounded by pupils whose work, they allege, he sold as his own—as indeed he was perfectly entitled to do under the law. We know something about his teaching activities, for we have several drawings by students which he can be seen to have corrected with a heavy stroke. The fact that such intervention cannot easily be shown in paintings does not mean that it did not occur.

Moreover it is generally agreed that his students sometimes worked out Rembrandt's ideas and inventions. Could he not then have guided the work even further by word of mouth or even by active collaboration? It was in this way, no doubt, that he impressed his personality and his outlook to a greater or lesser degree on a host of young painters. Indeed, as Jakob Rosenberg and Seymour Slive put it in their excellent chapter on the Rembrandt School in the *Pelican History of Art*, 'He was able to teach his best students naturalness, sympathy and human warmth, as well as drawing and colouring'.

For good or ill, such a term as 'human warmth' is not frequently encountered in the type of art historical literature that hopes to

'debunk' the mystique of art. But who can deny that there is such a thing and that it colours our response to Rembrandt's works? He stands for more in the history of art than for 'drawing and colouring'. Like many other great artists, he conquered a new province of expressiveness, and articulated a world of feeling that had never been given shape before. We are no longer so much used to seeing painters as discoverers of psychological states and attitudes for we still have a lingering fear of the 'anecdotal' in art. For anyone dealing with Rembrandt's achievement this fear is debilitating. What Rembrandt taught his students and indeed mankind was not only how to see the visible world in a novel way, but also how to reveal the inner life.

We do not have to rely on guesswork here. For though Rembrandt was certainly not fond of theoretical discussions, we have one remark from his pen which bears on this central aim of his artistic explorations. At the height of his success, at the age of thirty-two, he wrote to Constantijn Huyghens, the secretary to the Governor of the Netherlands, for whom Rembrandt was painting a series of the Passion of Christ. He apologized for the time he had taken over the *Entombment* and the *Resurrection*, and added that he hoped these paintings would give pleasure because in them 'the greatest and most natural movement had been expressed, which was also the main reason why they had taken so long to execute'. The phrase '*de meeste ende die naetuereelste beweechgelickheijt*' has been turned and squeezed by modern scholars to bring out the last ounce of what Rembrandt may have meant.

Literally the term means mobility, but could it not also mean expressiveness? In interpreting terms of criticism, particularly those used unselfconsciously, it is always advisable that we start at the negative end. Clearly what Rembrandt wanted to say most of all is that his paintings are not stiff and lifeless. To paint a stiff and lifeless painting may take a journeyman little time, but what he wanted to do and achieve needed profound study and thought. The painting of the Resurrection shows indeed almost an excess of movement. The soldiers guarding the tomb are hurled into the air as if the liberating angel had burst open the coffin with an explosive charge. One of them is seen falling head over heels, another is rushing away in terror, dropping his sword.

The *Entombment* on the other hand shows no violent gesture. All is quiet as Christ's body is lowered into the tomb, and only one of the women is raising her hand gently, as if to soothe the grief of the mourning Virgin. One can imagine Rembrandt, having started to write 'the greatest movement', remembering his second picture and inserting the other qualification which was dear to him, 'the most natural'. The opposite of natural is unnatural, artificial, or affected. His pictures live but they are not theatrical. They are, to exploit the possibilities of the English language, 'moving', in every sense of the term. It is not impossible that the word used by Rembrandt carried similar overtones. When the early collectors of medieval art in Cologne, the brothers Boisserée, brought home a Gothic painting,

they were pleased to report that their mother had called it '*ein bewegliches Bild*'. She was speaking low German rather than Dutch, but the connotation of 'moving' may well belong to the word in both languages.

It happens that we can even guess why Rembrandt, in his apology for the delay, mentioned this quality at which he was aiming. Some ten years earlier Constantijn Huyghens had visited the young artist, whose *Repentance of Judas* had deeply impressed him precisely for its expressiveness.

> The gesture of this one despairing Judas . . . who rages, moans, implores for mercy . . . the twisted arms, the hands clasped so tightly that they bleed . . . his whole body rising in desperate lamentations . . . this figure I place against every elegant work of art the ages have brought forth . . .

The picture has come down to us, and it is certainly 'moving', but it is also theatrical. It is rhetorical rather than 'natural'. Many of Rembrandt's early works show the same interest in dramatic gesticulation and facial expression. It is well known, however, that he gradually sheds these more obvious devices as he learns to convey the inner life of his figures by the slightest nuance. It is the difference between the barnstorming actor and the mature master whose very stillness can 'speak volumes'.

What makes Rembrandt's utterance so precious to us is that it shows how much this process of search was a conscious one. In a sense his oeuvre is a record of this search and its success. Who would dare to plot the path along which he found the means toward this end? His earliest biographers attributed his skill merely to his power of observation and to his retentive memory for gestures and movements. But there is more to it. Perhaps we do well to remember that Rembrandt was not only an illustrator but also a portrait painter. As such he had the opportunity of exploring the human figure at rest and of discovering the expressive power of the nuance.

Moreover, there was one area in which he could combine observation and introspection for the exploration of expressiveness—the painting of self-portraits. It is well known that some of Rembrandt's early self-portraits are studies of expressions he tried out in front of the mirror. But clearly such grimacing would never give him the insight he searched for, the knowledge of the way a real mood marks and moulds the face. The intensive self-scrutiny of his mature self-portraits must have shown him precisely this, for here he was the privileged observer who could watch both his mind and his face. Many have felt that he thus learned to watch and represent the minds of his sitters through their faces. As Christopher White puts it in discussing the etched portraits:

> By intensive study and experiment, he finally succeeded in penetrating the outer mask of the face, the place where so many lesser artists stop, and he created before our eyes a living and thinking being, with whom the spectator is immediately able to establish intimate rapport. The limited nature of portraiture . . .

does in the final result make it impossible for the artist to record the actual details of the sitter's thoughts and character. But if Rembrandt was unable to label the innermost feelings of his sitters, he went as far as possible in suggesting something of their character.

Michael Kitson, in his equally perceptive essay, meditates more critically on the claim, but in the end he comes to a similar formulation:

> ... it is evident that Rembrandt's depiction of character is far from being the total disclosure that it is sometimes made out to be. ... What Rembrandt achieves is all that a painter can achieve, namely to show, by artistic means, certain qualities in the sitter's character that we might be able to recognize in his face if we knew him in life. It is in the nature of things that we cannot specify or label these qualities very exactly and that our understanding of them is subjective. ...

It is, no doubt, but what else could our response to other human beings be? Whatever the advocates of objective tests may say, the 'feel' of a person, what we sense to be uniquely peculiar to his presence, his voice, his bearing, would not be individual if it could be objectively categorized. It is interesting that both authors stress that Rembrandt's 'characters' cannot be labelled. Precisely. If they could they would be character masks rather than human beings.

Indeed we may here come a little closer to the secret of Rembrandt's discovery. The emotions and expressions of his *Repentance of Judas* could easily be described and labelled, much to the pleasure of Constantijn Huyghens. But those distinct emotions which figure in the ancient manuals of painting and acting as the 'passions', remorse, contempt, anger, love, or joy, are only simplified abstractions out of the infinite gamut of fluctuating and ambivalent emotions that make up the life of the soul.

Hence Rembrandt came to reject these stereotypes and to explore the whole range of expressiveness which indeed far transcends what can thus be 'labelled'. Just as great music can be infinitely expressive precisely where it eludes the fixed stereotypes of joyful or mournful moods, so Rembrandt entered into an uncharted region of the soul where these descriptive terms lose much of their meaning. The small gesture of the woman's hand in the *Entombment* is infinitely touching in the tragic context of the scene precisely because it cannot be translated into words. Rembrandt learned how to be indefinite without being vague. Indeed his pictorial explorations of the chiaroscuro, the darkness broken by luminous reflections, the mysterious glow in a pool of shade are the perfect metaphor for his expressive means. And just as his light clarifies a special situation by the most unexpected stroke, so his pen or brush may bring out the expressiveness of a face not through the conventional signs of a smiling mouth or a wrinkled brow, but by the way the cheekbone indicates the structure of the head.

141

Few of these means have as yet been analysed, and there must be limits to what such an analysis could achieve. But one aspect of Rembrandt's artistic method is gradually coming into view: his use of the tradition. Far from looking only at nature, this ardent collector studied and used the works of others as any discoverer and inventor would study and use the results of his predecessors.

Christopher White illustrates such a telling example, the obvious derivation of Rembrandt's etching, *The Return of the Prodigal Son*, from a woodcut by the sixteenth-century artist Heemskerck. The similarity extends to the position of every limb of father and son. But the sixteenth-century woodcut is a pictographic illustration of repentance and forgiveness, Rembrandt's etching a human drama that eludes description; the father is not only dignified and forgiving, he shares the sorrow of the son, who is not only a petitioner, like Heemskerck's figure, but a man who has suffered and has come home at last. The way Rembrandt enriches the old composition by making the posture more supple and expressive reminds us again of his qualities as a teacher. The tool with which he probed life was art. It was the critical scrutiny of images, those he found in the tradition, those he had created himself, and those of his pupils, which brought him closer and closer to the springs of expression.

One of the few other utterances of Rembrandt about which we know points in this direction. Samuel van Hoogstraten, who was his pupil, tells that once when he had irritated Rembrandt by asking too many 'whys', he was told: 'Once you have learned properly to apply what you already know, you will soon also discover the mysteries which are still hidden from you'. You discover through painting, not through talking; provided, of course—and that Rembrandt took for granted—that you can step back from the canvas and scrutinize it with that critical gaze with which he scrutinized his own face in the mirror.

Did the *David and Saul* in the Mauritshuis pass this test? Gerson would want us to believe that it did not, or should not have done so. It would be cruel but not quite inappropriate to ask him in what way exactly Rembrandt might have improved it. He would have the right to retort, of course, that to answer this question he would have to be Rembrandt, but at least such a discussion would get us away from the mystique of connoisseurship.

There is an early painting by Rembrandt of the same subject which is acknowledged by Gerson to be from the same period as the *Repentance of Judas*. It shows Saul in regal splendour facing the spectator and fiercely gripping his javelin. His brow is wrinkled as he glances sideways at the half-hidden figure of the youth with the harp. The change of conception between this early work and the Mauritshuis picture, as Rosenberg has remarked, is away from the conspicuously obvious to a very different reading. There is a striking lack of 'decorum' in the type chosen for the later David and even more so in the gesture of Saul, who wipes his eye with the curtain. He does not grip the javelin, he fingers it. It is this rejection of the obvious rather than any memories of Israels that has convinced so

many lovers of Rembrandt that the master's spirit is here at work. 'Studio picture' or not, this is surely true.

It used to be thought that Rembrandt's voyage of discovery away from the obvious also determined his outward fate, in other words that the more he grew as an artist, the less success he had with the public. The legend of Rembrandt's rejection by the philistines has been dear to all artists who have felt themselves similarly misunderstood, but the facts are certainly not quite so simple. We now know that Rembrandt never lost his reputation and that he remained an international celebrity to the end.

And yet there may be something in the story that Rembrandt's tragic fate was bound up with his conception of art. His view of his calling certainly differed from that of the Dutch middle classes. Most of the painters of that milieu were specialists, some were portrait painters, such as Frans Hals, others specialized in landscapes, seascapes, genre pieces, still lifes or architectural interiors. Rembrandt served notice from the outset that his aspirations aimed higher. Nor did he have to look very far for a model of an artist of a different kind. Peter Paul Rubens across the political border was then at the height of his career. The same Huyghens who had admired Rembrandt in Leyden wrote of Rubens at that time that 'no one could compare with him in the abundance of creative ideas and the range of themes, encompassing every sphere of painting'.

Rembrandt had a right to feel that he was Rubens's equal and he probably hoped that his situation in wealthy Amsterdam would come to match that of Rubens in Antwerp. There were years when this comparison would not have seemed out of place. At the age of twenty-eight he had married Saskia, a rather wealthy heiress, and lived in style, surrounded by pupils and bidding at auctions for expensive works of art. But however great his success, the narrower world of Protestant Holland could not possibly provide the same sphere of activity that the courts of Catholic Europe offered Rubens. The detailed causes of Rembrandt's financial failure are more complex and still partly obscure. He had raised a large sum to buy an expensive house, and was not in a hurry to repay it, nor was he pressed to do so. But when his wife Saskia lay on her deathbed, she made a will to which many of Rembrandt's subsequent troubles can be traced.

Not that she was not a loving mother and trusting wife. She left half of her considerable fortune to Rembrandt and half to their son Titus, saying explicitly that she trusted her husband to administer the whole. But if he married again, his portion was to go back to her family. This involved Rembrandt in difficulties first with the nurse of Titus, who threatened him with action for breach of promise and whom he finally got confined in a workhouse, and then with Hendrickje Stoffels, who became his mistress and was officially admonished for living in sin. Moreover, when credit became scarcer in Holland the loan on the house was recalled and he was forced to sell his precious collection of art and of curiosities at the most unfavourable moment when it realized much less than he had spent

on it. He could not touch the portion which belonged to Titus and which had perhaps been artificially enlarged to keep it from the creditors' grasp.

Indeed from that period on, Rembrandt had to appear as a pauper in the eyes of the law in order to protect his belongings from execution. There is a pathetic document according to which Hendrickje had to perjure herself and swear that the valuable contents of a certain wardrobe in their house were her personal property, to save them for Rembrandt. How destitute Rembrandt really was at his death we do not know. The inventory drawn up at the time covers only his few personal effects and not the collection and paintings stored in three rooms which were sealed by the notary.

As might be expected, Gerson is particularly anxious that Rembrandt's biography and personality should be freed from sentimental accretions, and it must be admitted that some of the documents might bear a rather unfavourable interpretation; but the truth is that they do not tell us enough to form a judgement. Even the rather unpleasant incident with the nurse of Titus may be less damaging than Gerson implies, for after all she may indeed have been mentally deranged. We shall never know.

The book by Bob Haak bears the title *Rembrandt: His Life, His Work, His Time*, and deals most fully with the biography. Occasionally the figure of the artist all but disappears in the mass of background material. This applies in particular to the illustrations in which many of his masterpieces are sacrificed to facsimiles of documents, portraits of contemporaries, and other extraneous matter relating to Rembrandt's sitters or to local history. As a supplement to monographs on the artist this material is welcome, but standing by itself the compromise between Life, Work, and Time is not very successful.

Even less convincing in this respect is the book by R. H. Fuchs, *Rembrandt in Amsterdam*, which deals with a number of selected aspects of the subject but less successfully, it appears to me, than the earlier book by Christopher White, *Rembrandt and his World* (London, Thames and Hudson, 1964). The way in which Joseph-Emile Muller tries to make life and work interpenetrate has been illustrated above. His book certainly does not supersede Rosenberg's masterly monograph. We may well ask whether there was a need to translate it. What we need is rather the detailed study of individual works and problems.

Here we have every reason to be grateful to Julius Held for having collected his specialized studies on Rembrandt (including a new essay) in a handsome volume. To look at Rembrandt's *Aristotle*, his *Polish Rider*, his *Juno*, or his treatment of the Tobit story, under Held's very expert guidance, is to penetrate more deeply into the problems of Rembrandt's oeuvre than if we plough through the bulkier monographs. The reason is plain: this type of intensive study allows us to see a particular work in the round, and even where we may not agree with an individual interpretation, we never have the

feeling of arbitrariness and the awareness of gaps which the other books may give us.

At the other end of the scale we have a considered essay on Rembrandt's art, Michael Kitson's Introduction to the Phaidon volume, an effort at criticism of the kind more frequently practiced in literary studies. All the other books take the oeuvre to pieces in order to reassemble fragments. Where the topic is a technique, as in White's book on the etchings, the result is still coherent. Where it is merely a medium, as in Gerson's two books on the paintings, the reader is left with the feeling of conventional classification. The feeling is enhanced by the tendency of so many books on Rembrandt (including those of Rosenberg and White) to slice up the oeuvre according to the categories of portraits, landscapes, Biblical illustrations, etc., each of which is traced through the artist's career, thus breaking the subtle threads that lead from one to the other. Admittedly it is easier to criticize these principles of arrangement than to replace them.

Ideally, no doubt, we would like to follow the master's development chronologically as he alternated between the media of his choice and moved from one subject to another. But even if we could know the sequence we would have to face the fact that he must have worked at many things concurrently and that any linear arrangement would be misleading. The one attempt at such a chronological arrangement of the oeuvre of a well-documented artist, the *Dürer-katalog* by Hans and Erica Tietze, has not encouraged imitation. No one book on Rembrandt can serve every purpose, but it is doubtful whether we need any more anthologies of indifferent reproductions.

The impression with which one is left in dealing with this crop of books about a great painter is certainly the woeful inadequacy of our techniques of reproduction. To explain the range and subtlety of Rembrandt's art by means of these illustrations is like trying to demonstrate the virtuosity of a master of instrumentation on an old upright piano. The black and white pictures of the new Bredius are particularly disappointing. Those in Gerson's large folio volume are much better, but how much of those miracles like the *Polish Rider*, in the Frick Collection, or the *Jewish Bride*, in Amsterdam, is preserved in these shadows? The shadows are particularly black in the large folio by Bob Haak, but for those, at least, who know the originals, some of the details, such as the sleeve from the *Jewish Bride*, offer some compensation.

Unfortunately most of the colour reproductions are even worse, for here the 'upright' turns out to be badly out of tune. It is instructive but depressing to compare the same painting as it appears in the various books under review. The inexpensive Phaidon volume, oddly described as having 'fifty plates in full colour', shows the *Polish Rider* mounted on a blue-green horse, and the schoolboy Titus in Rotterdam with such a greenish complexion that one is glad to be reassured by the plate in Muller that shows a much healthier tan and by Gerson's volume which gives him quite a ruddy face, the red

145

extending from the lips into the corners of the mouth as if he had carelessly applied lipstick.

The Mauritshuis *Presentation* happens to figure in all four volumes, and here the plate in Gerson easily comes out on top. On the whole the plates in that work are probably the best, despite an excess of yellowish tones, which is preferable to the reds of the Abrams plates and the greens and blues of the Phaidon ones. One wonders what Rembrandt would have said about it all. He certainly would not have minced words. We know how much he cared about the exact tone of reproductions when he worked at his etchings.

Here the centenary has brought a most welcome addition to the literature, the two volumes by Christopher White, *Rembrandt As An Etcher*, in which this aspect of the master's oeuvre is illustrated with sensitivity and love. It is supplemented by the exhibition catalogue, entitled somewhat modishly *Rembrandt: Experimental Etcher*, where, for once, the disadvantages of the centenary rush were not allowed to operate; the Preface to this pleasant volume acknowledges the cooperation of Mr White.

But even these useful publications only serve to underline the obvious fact that no illustration can replace the study of the original. One of the subjects of Rembrandt's experiments was precisely the effect of different papers. He was fond of Japan paper, which has a yellow tone, while the tone of all the plates in these volumes is uniform. Here the book by Bob Haak scores, for some of the etchings are at least reproduced on a toned background.

In some respects the trickiest medium for reproduction is that of drawing, precisely because it looks comparatively easy. No book exclusively devoted to this aspect of the master's oeuvre has appeared since Phaidon's seven-volume corpus by the late Otto Benesch, but naturally all general books on Rembrandt illustrate some drawings. Once more Bob Haak's volume with its selected facsimiles may least disappoint the art lover who seeks to recapture one of the great pleasures of the recent Amsterdam exhibition— those slight sketches of landscape motifs where a sense of light and distance is evoked by the merest shade of difference in the pressure of the pen.

How did Rembrandt do it? We have no studies yet attempting to answer this simple-minded question—least of all when it comes to the pictorial effects of his paintings—yes, and those of his studio. We remember that when his pupil asked him how and why he did it, the pupil was sent back to work. No wonder the late Fritz Saxl, who had devoted much of his life to Rembrandt, used to say that if we had gone to Rembrandt's house in Amsterdam with such questions the old man would have thrown us down the stairs. Those of us who have stood in front of the self-portrait in the Frick Collection in New York will know exactly what he felt. Indeed when it comes to 'debunking', that formidable presence is more likely to debunk us than the other way round. The question is not really 'How do we stand with respect to Rembrandt?' It is 'How do we stand up to him?' Thanks for asking, not very well.

146

Adam's house in Paradise

The title of these architectural meditations is attractive. It is pleasant to think of Adam, the perfect man, living in a perfect house in Paradise. Not a primitive hut to be sure, but a well-appointed residence with plenty of labour-saving devices for Eve. Alas, like so many other pleasant fantasies this one must be heretical. Adam no more had a house in Paradise than Eve had a dress. In those balmy regions, the perfect pair before the Fall were in need neither of shelter nor of garments.

It is not surprising therefore that for all his wide reading the author ultimately fails to meet the promise of his title. The closest we are brought to a discussion of our forefather's accommodation problems is in a passage from the fifteenth-century architectural treatise by Filarete, but significantly that passage only speaks of what happened to Adam after he was driven out of Paradise. The balmy weather was over and it was raining. 'Since he had no ready shelter he put his hands up to his head, to defend himself from the water'. Mr Rykwert tries to make the best of this and suggests that Filarete thought of Adam 'pitching his hands as the origin of the displuviate, the double-pitched roof'. I find no evidence for this interpretation either in Filarete's treatise or in the charming illustration from one of its manuscripts reproduced by Rykwert. Since he was ready to extend his search outside the gates of Paradise he would have found many explicit illustrations of the primeval huts erected by the first pair and their offspring, Cain and Abel. Ghiberti, for instance, on the Baptistery Doors in Florence, gives the family a perfect primitive reed hut. (Fig. 30)

But since the author returns from his far-flung explorations without having discovered a trace of Adam's house in Paradise, we find him ready to settle for something else. He records a para-Talmudic legend about the wedding of Adam and Eve according to the Jewish ritual: 'The Holy One . . . made ten wedding canopies for Adam in the Garden of Eden . . . of precious stones, pearls, and gold'. These canopies are modelled on the traditional *huppah* of the Jewish rite which can indeed be interpreted as a symbol of the new house to be set up by the couple. Whether it had this meaning in Paradise is another matter.

But Mr Rykwert is not really concerned with the history of an idea—an idea that never was—but with a cluster of associations for which he looks in the writings of modern architects, in architectural treatises of the past, in ancient legend and religious rituals. He is concerned with memories or fantasies of an archetypal dwelling.

That, if at all, is why I must postulate a house for Adam in Paradise. Not as a shelter against the weather, but as a volume which he could interpret in terms of his own body and which yet was an exposition of the paradisic plan, and therefore established him at the centre of it.

Originally published under the title 'Dream Houses' in the *New York Review of Books*, 29 November 1973, as a review of Joseph Rykwert, *On Adam's House in Paradise: The Idea of the Primitive Hut in Architectural History*.

To track down and to map this cluster of associations the author adopts the methods of the psychoanalyst rather than those of the historian. He starts with the present and tries to follow the leads suggested to him by the utterances of twentieth-century architectural writers such as Le Corbusier and Adolf Loos. Like many apostles of reform these writers sometimes appealed from culture to nature. Architecture, they argued, has lost its way in artifice and we must return to essentials. We can only do so by reflecting on origins and observing the ways of the unsophisticated and the uncorrupted.

This response to the malaise of civilization is so universal that one cannot be surprised that it can also be richly illustrated from debates about architectural theory. Mr Rykwert embroiders a web of such illustrations with other instances of primitivism, as when he remembers the Tarzan films and Kipling's Mowgli in connection with Le

30 Ghiberti: *Cain and Abel*. Panel from the Gates of Paradise. 1429–36. Florence, Baptistery

148

Corbusier, or associates the *Blockhaus Sommerfeld*, a glorified log cabin Gropius built in 1921 for a Berlin timber merchant, with the art historian Strzygowski's interest in the history of timber construction.

It is from these illustrations and associations that the author tries to find a point of entry into nineteenth-century theories and debates about the influence of materials on architectural style, debates which centred around the German architect Gottfried Semper, and the discussions sparked off by the Gothic revival in the writings of Ruskin and Viollet-le-Duc. Pursuing these inquiries, *cancrizans* (as musicians call the backward steps of the crab), he arrives at the treatise of the eighteenth-century critic Laugier, whose meditations on the primitive form of the hut provoked the young Goethe to violent contradictions. With his gift for a pregnant phrase the author reminds us that 'Laugier's little hut had been built on Rousseau's river bank.'

There is indeed no dearth of material when it comes to speculations about origins and about the demands of nature in eighteenth-century writings. It certainly would not be easy to organize this vast material, but here as elsewhere Mr Rykwert prefers suggestive allusion to systematic presentation. Within half a page we are reminded of Robinson Crusoe, of Lord Monboddo's advocacy of an airbath, and of Pestalozzi's ideas on education, only to return to various attempts to 'reform' the architectural orders. An excursus discusses eighteenth-century speculations about the origin of Gothic vaults in the intertwining branches of northern forests—one of the ideas which have been thoroughly documented in Paul Frankl's monumental work, *The Gothic*.

We are more than halfway through the book before the author tells us that he now 'cannot avoid' a discussion of the text to which nearly all the architectural writers of the classical tradition were 'forced to allude'—the canonic passage from Vitruvius about the origin of architecture, in which the ancient author graphically describes the reaction of primitive man to a forest fire, the invention of speech, of handiwork, and the first construction of shelters 'in imitation of the nests and buildings of swallows out of mud and wattle'. The author attempts to relate these famous speculations to Stoic philosophy, but he appears to be unacquainted with that classic in the history of ideas in which these motifs are firmly set into their context, the book by Arthur O. Lovejoy and George Boas on *Primitivism and Related Ideas in Antiquity* (1935). It is to this book that we owe the famous distinction between the 'soft primitivism' expressed in the legends of the Golden Age and the 'hard primitivism' exemplified by Lucretius with his picture of early man's struggle for survival. In the same book Mr Rykwert would also have found most interesting passages from early Indian literature about the origins of timber architecture.

Be that as it may, the acknowledged importance of the Vitruvian doctrine compels the author to reverse gear and to return to Renaissance treatises on architecture. Anybody who has ever tried to write the history of an idea knows of this problem of reconciling an intelli-

gible systematic exposition with the needs of a chronological narrative. But whatever solution he ultimately adopts he must surely try to guide the reader by the establishment of signposts and points of reference. Mr Rykwert does not seem to feel this concern. In fact one must ask oneself what readers he had in mind. He presumably writes for architects and designers, and the sponsorship of his book by the Museum of Modern Art supports this conjecture. But would this class of readers know, for instance, who Filarete was? How could they find out, since the bibliography quite properly lists the modern edition and translation? How could such a reader spot behind an allusion to 'Opicimus de Castris' the fourteenth-century monk Opicinus de Canistris, or how could he find his way through the references to esoteric writings which influenced the architect of the Escorial?

Before we know where we are, we are confronted with speculations about the true appearance of the Temple of Jerusalem and the various reconstructions which were proposed for this archetypal shrine—a theme to which in any case only a separate study could hope to do justice. Whatever the Temple may have looked like, it certainly did not have much to do either with Adam's house in Paradise or with primitive huts. But maybe the author felt in need of this transition to religious architecture because the theme that appears to be closest to his heart is the motif of the hut in ritual and legend which we have already encountered in the Talmudic story.

He pursues not only huts but branches and twigs, reeds and papyrus plants, the ritual dismantling and rebuilding of shrines in Japan and the erection of temporary structures. The web of associations here becomes particularly rich and dense, but is not this type of motif-hunting rather frowned upon by anthropologists today? Maybe the reaction against Frazer's Golden Bough, the book to which both Freud and Jung were so much indebted, has gone somewhat too far, but in Mr Rykwert's hands the method is certainly open to criticism. He is looking for what is perennial and universal in man's reaction to buildings, but he ends by investigating a tribe of Australian aborigines who have no buildings but carry a ceremonial pole which apparently stands for a totemic animal or object. The object interests the author because of its geometric shape and its associations, but not even he wants to suggest that Adam carried such a contraption with him in Paradise. One cannot but wonder whether the method adopted by the author is best suited to throw fresh light on his underlying theme—man's nostalgia for the past and his desire for renewal.

It would certainly be merely pedantic to criticize such a romantic and almost whimsical essay for sins of omission, for if the book has a virtue it is that of comparative brevity. However, there is one text which Mr Rykwert would hardly have omitted if he had known it. It is one of the most seminal passages in the history of architectural thought and one moreover which must have been known to practically any person in the past who had a classical education, since it comes in Cicero's De Oratore, a wide-ranging discussion of rhetoric which was universally read. Here the author would have found

many elements of the cluster of ideas he has been pursuing, the comparison of the building with the human body, the interest in trees and in timber building, and, strangely enough, even a remark about the shape of the house to be imagined, if not in Paradise, at least in a pagan heaven. It is the passage (III, 179–180) in which Cicero illustrates the requirements of a perfect speech and propounds a functionalist aesthetics which, despite its vicissitudes, has indeed not lost its appeal:

> ... Carry your mind to the form and figure of human beings or even of other living creatures: you will discover that the body has no part added to its structure that is superfluous, and that its whole shape has the perfection of a work of art and not of accident. Take trees: in these the trunk, the branches and lastly the leaves are all without exception designed so as to keep and to preserve their own nature, yet nowhere is there any part that is not beautiful. Let us leave nature and contemplate the arts: in a ship, what is so indispensable as the sides, the hold, the bow, the stern, the yards, the sails and the masts? Yet they all have such a graceful appearance that they appear to have been invented not only for the purpose of safety but also for the sake of giving pleasure. In temples and colonnades the pillars are to support the structure, yet they are as dignified in appearance as they are useful. Yonder pediment of the Capitol and those of the other temples are the product not of beauty but of actual necessity; for it was in calculating how to make the rainwater fall off the two sides of the roof that the dignified design of the gables resulted as a byproduct of the needs of the structure—with the consequence that even if one were erecting a citadel in heaven, where no rain could fall, it would be thought certain to be entirely lacking in dignity without a pediment.

'When praising the French artist and sneering at the English painter, we neglect to put ourselves in the place of each'. These revealing words were written ninety years ago by the American sea painter and free-lance journalist, S. W. G. Benjamin, who collected his reports on the European art scene for *Harper's Magazine* in a book on *Contemporary Art in Europe* (1877). Each of the European schools, he insists, 'possesses marked traits of its own, but no one of them can be said to be in all respects superior to the others'. The point of view of this gifted observer was that of Hippolyte Taine, which he distills into the words: 'The truest, highest art is the spontaneous outgrowth of the tendencies of an age or a race . . . what may be the best art for one age or country may not be the best for another'.

Few art historians would explicitly reject these principles in theory, but fewer still would want to apply them in practice. Nowhere, perhaps, is this inconsistency more apparent than in our attitude toward nineteenth-century art, for nowhere are art historians more selective. It is instructive here to turn the pages of Benjamin's book and to compare his panorama of European art in the 1870s with ours. The difference is most marked in his chapter on French painting. Not unexpectedly he honours the memory of Corot and Millet, who had recently died, but does not even mention Manet nor any of the Impressionists. Some of the artists he does discuss and praise would probably be unknown even to specialists today. His first illustration is a painting by Chevilliard called *An Entertaining Story* showing two jolly clergymen relaxing in a country inn; another, *Expectation* by Toulmouche, of an elegant woman in evening dress impatiently watching the clock on the mantelpiece.

But while Benjamin's picture of French art thus differs radically from ours, his account of English painting corresponds much more closely to that now presented in Mr Graham Reynolds's excellent survey. In both books due weight is given to the figure of Sir John Everett Millais, whose very uneven *oeuvre* was recently presented in a large exhibition at the Royal Academy. But here the American critic also correctly estimated the relevance of more recent movements and reputations: he describes the role of the Grosvenor Gallery and lists among artists of the 'Romantic School' exhibiting there the young Walter Crane; he also comments on the strong note of social criticism in English painting and singles out in this context Luke Fildes as 'one of the most recent aspirants to artistic honours in England'. Fildes was subsequently to paint one of the most popular pictures of the late Victorian age, *The Doctor* (Fig. 31), which used to hang in many a waiting room. It shows a bearded doctor gazing worriedly at a sick child bedded on two chairs in a pauper's cottage. In a dark corner a woman has collapsed at a table while her husband stands helplessly beside her. As Mr Lister tells us in his text, 'such scenes were, alas, not uncommon in Victorian times. It was, in 1851, calculated that only about forty-five per cent of babies born in

Originally published under the title 'Calling for "The Doctor"' in the *New York Review of Books*, 13 July 1967, as a review of Graham Reynolds, *Victorian Painting* and Raymond Lister, *Victorian Narrative Paintings*.

Liverpool lived to be twenty years of age'. He urges that the picture is 'painted with deep understanding and sympathy', and his verdict is echoed by Mr Reynolds, who says that 'there is sentiment but not sentimentality about it'. However that may be, the painting has recently been brought up from the cellars of the Tate Gallery and is once more displayed together with *The Last Day in the Old Home* by Martineau and *Hopeless Dawn* by Frank Bramley. It would be far from easy to gain similar access through books and public galleries to French paintings which had once enjoyed a comparable success in the *Salon*.

There are many reasons for this discrepancy. The first is no doubt our continued resentment at the fact that it was the popularity of the French *Salon* painters which stood in the way of the true masters of their country. The English painters do not have to bear this stigma, because the artistic scene of the nineteenth century in England, vividly described in Mr Reynolds's book, was more complex than the embattled situation in France. True, there was also periodic dissatisfaction with the Academy; rival groups were formed, but the most significant of these groups, the Pre-Raphaelites, was blessed with an unconscious gift for publicity, and since its members enjoyed the championship of Ruskin, they soon rose to success and even affluence. In art as in politics England differs from most countries of the continent in having had no violent revolutions. The lines of communication with that past were never totally broken. Hence the English school enjoyed a certain prestige among the progressives

31 Luke Fildes: *The Doctor*. 1891. London, The Tate Gallery

153

on the continent of Europe, largely because of the role which the medievalizer William Morris played so paradoxically in the formation of the Modern Movement. When the German champion of Modernism, Richard Muther, published his *Geschichte der englischen Malerei* in 1903, he devoted enthusiastic chapters to Burne-Jones and Watts.

The revival of interest in Victorian painting to which the two books under review testify is therefore a less dramatic event than would be a similar revival of interest in the totality of French painting of the Second Empire and the Third Republic, embracing the *Salon* painters as well. Even this, of course, is not in the cards: witness a recent exhibition of Bouguereau in Paris, once the darling and then the butt of the critics. By now the crosscurrents of present-day taste and fashions are so complex that the very fact that these paintings strike us as corny may recommend them to the young. What was once popular appeals to the 'Pop' artist and his audience precisely because it does not rank as 'Art' with the Establishment.

The art historian who has followed the traditional line, depicting the nineteenth century as the scene of the heroic struggle of progressive artists against the foil of 'official art' may thus soon be confronted with an interesting dilemma. If he sticks to his guns that artists outside the modern movement represented a decadent and unworthy phase of painting, he may invite the charge of inconsistency. Did he not otherwise subscribe to the principles enunciated by Hippolyte Taine and applied by Benjamin, which enjoin the historian to look at the varieties of art as the botanist looks at the varieties of plants, without wishing to praise or condemn any of them? Was it not the triumph of the scientific approach to the history of style to have removed the stigma of decline from the Middle Ages, the Baroque, Late Antiquity and Mannerism? Is the retention of value judgements in nineteenth-century art not simply a symptom of the art historian's greater involvement, and is not involvement something he should shun as an impartial historian? I suppose his first answer would have to be that the study of art does differ from the study of botany, and that the art historian has always been involved and should be involved. All the revaluations of the past, though advocated in the name of objectivity, were in fact rooted in the new aesthetic preoccupations of the present. It was this response to new sensibilities which gave urgency and coherence to the writings of great art historians. Without this, it might be argued, they would have remained chroniclers who would indeed label and record the succession of styles and artists as a botanist surveys the flora of a region.

Much could be said in favour of this answer, but it is still possible to object that the responsibility for value judgements is merely shifted from the individual art historian to his age. The historian, in this reading, just applies the changing values of his time to the past, because that is all he can do. There are no objective values in art any more than there are in plants, and historical relativism is therefore

the only tenable philosophy. I am not sure that the historian need be satisfied with this position. As far as he is a historian rather than a chronicler he must try to offer an interpretation of the events he describes. It was such an interpretation that enabled critics of a distant past first to see the history of art as a coherent story. Both in Antiquity and in the Renaissance this history was seen as the systematic development of means toward an end. What is vaguely called the imitation of nature, the mastery of anatomy, or the rendering of spatial relationships in painting, served the end of evoking the convincing picture of a sacred or at least significant event before the eyes of the spectator, as if he were witnessing the event itself. A relativist is certainly entitled to reject this aim in favour of others embodied in the art of other cultures, but even if he prefers Far Eastern to Western art, he could still write a non-relativistic history of Renaissance painting interpreting the gradual conquest of the means that went into the painting of Leonardo's *Last Supper*, Michelangelo's *Creation of Adam*, or, at a later date, Rembrandt's *Denial of Peter*.

It might be interesting to apply this approach to the nineteenth century. In one respect it is traditionally so applied: The history of painting in that century is given coherence by the aim of the progressive painters in France to discard visual conventions and to render reality in a novel and convincing way. The triumph of Impressionism, the acceptance of a new pictorial notation that had first to be learned by the public, forms the climax of this story. We have no history yet of the pursuit of the other aim, the presenting of a moving scene exemplified by *The Doctor*.

The first step here would have to be to distinguish between this aim and that of earlier narrative traditions with which it is often confused. The Renaissance artist who represented *The Annunciation* or *Apollo and Daphne* did not expect the beholder to read off the story from the picture. His skill and his inventiveness lay in presenting a familiar episode in a novel and convincing way. We are meant to be able almost to hear the Virgin's *Ecce ancilla Domini* even without the benefit of a written scroll, or to listen to Apollo's amorous pleading; but it is understood that we have heard or read their words before, that we know them from texts deeply embedded in our culture. Hence such representations were frequently judged by contemporaries as we might judge the staging of a familiar classic, the way, for instance, in which the difficulties of the Balcony Scene in *Romeo and Juliet* are resolved by an imaginative producer. By contrast the narrative paintings of the nineteenth century are rarely concerned with familiar stories. They use painting not to interpret but to convey an episode. That is a very different aim indeed, demanding very different means. Instead of the producer of a classic we need an expert in dumb shows or what, in cinematic terms, is called a 'still'.

Admittedly the contrast between these two aims is here overdrawn for the sake of clarity. Religious and didactic narratives also sometimes shaded into storytelling, and yet the new aim was only fully

proclaimed and established in the eighteenth century with William Hogarth's didactic picture stories from modern life, such as *The Rake's Progress*. It is significant that Hogarth needed the context of serial dumb shows to tell his stories. Greuze took a further step in distilling his modern subjects into one dramatic and sentimental scene. At the same time Academic painters were increasingly casting around for novel and unusual historical or mythological themes, thus subtly unsettling the place of subject in the scheme of things. It was this attitude which the nineteenth century inherited, and which accounts for the range of subjects listed in the exhibitions of the *Salon* and the Royal Academy. Historical paintings should evoke a scene or episode never visualized before and do it as accurately as archaeological research will allow. The French and the Belgians including at times such painters as Ingres and Delacroix, liked to pursue this aim. Even with them, it is sometimes difficult for us to appreciate these efforts on their own terms.

Historical paintings wear even less well than do historical novels, because they can leave nothing to the imagination. Take Alma Tadema's painting *An Apodyterium*, reproduced in colour by Mr Reynolds. In spite of its learned title (or because of it?) the Roman ladies undressing in a bath look hopelessly Victorian. Perhaps the most embarrassing painting in this volume is Henry Holiday's *Dante and Beatrice*, once a famous composition, and even now frequently on sale in Florence as a picture postcard. It shows Dante with his inevitable hood by the bank of the Arno pressing his hand to his heart while a glum-looking Beatrice stares past him. The diaphanous and clinging dress of Beatrice's coquettish companion must strike a historian of manners as a curiosity in the thirteenth century, but it is probably explained by the fact that the artist was an opponent of the abuse of tight lacing and projected the longed-for freedom from this restriction into his vision of a golden age. As a reconstruction the painting is merely comic, as miming it is hamming, and as painting it is wooden. Even its period flavour cannot save it.

In this respect the scenes from contemporary life seem to us more promising. Mr Reynolds has already devoted a volume to *Painters of the Victorian Scene* in 1953, but he is all the more aware of their importance within the context of his present study. It was on this branch of painting that the reputation of the English school rested. 'With some notable exceptions', writes Benjamin, 'the best modern art of that country is in the treatment of this class of subject'. Here the storyteller's and stage manager's art is subjected to a special strain. We can still recognize Dante and remember his love for Beatrice, but what are we to make of a bewhiskered man holding hands with a pale woman who stares at a tree? The picture by Arthur Hughes is called *The Long Engagement*. The curate is presumably too poor to marry, and the woman is looking wistfully at an inscription they once cut into the bark of the overgrown tree. Could we guess this? Could we find out unaided when looking at William Holman Hunt's more famous painting *The Awakening Conscience*, that the woman who interrupts her music-making with a cheerful young man, and is

wringing her hands and gazing heavenward, has not just remembered that she had a chicken in the oven, but was intended to represent 'in actual life the manner in which the appeal of the spirit of heavenly love calls a soul to abandon a lower life'? Are the resources of genre painting adequate to meet such a high-minded purpose? Are facial expressions or gestures ever legible enough, when arrested, to convey these and similar nuances? Perhaps it is unfair to ask this question in front of this particular painting, for Mr Lister tells us that its original owner could not bear the expression on the woman's face and asked the artist to repaint it. But it is precisely this request which is revealing, for the owner surely had a point. The frozen expression easily turns into an intolerable grimace. Thus the 'distorted grimacing features' to which Mr Reynolds objects in many Pre-Raphaelite paintings may not really be due, as he alleges, to any desire on the part of the artists to *épater le bourgeois*. They are due to a genuine difficulty inherent in their self-imposed task. Nor can I see any 'deliberate ugliness' in the awkward gesture of the little boy in Millais's *The Woodman's Daughter*. Though I, too, dislike the picture, I am persuaded that children do stand and move in this way.

Here, as elsewhere, the story of this genre cannot really be told without judging the relation of ends and means. The new narrative themes must be admitted to have added to fresh explorations and to a widening of the painter's resources. Anecdotal paintings of the nineteenth century show an increasingly subtle observation of human behaviour, aided, perhaps, by the spread of photography. I would venture to say that the paintings of this kind dating from the last quarter of the century are more legible and more convincing in this respect than those of Hogarth or of Wilkie. It is up to us whether we want to take a painting such as Orchardson's *The First Cloud* seriously. Certainly the mixture of stubbornness and embarrassment with which the husband watches his wife stalking out of the room would impress one in an actor. Of course, the history of this technical progress could not be told by English art alone. The narrative genre had its famous representatives on the continent of Europe in painters such as Knaus, Vautier, and Defregger who might have influenced the repertoire of speaking gestures found in Thomas Faed's *The Mitherless Bairn* or *Jealousy and Flirtation* by Haynes King. Nineteenth-century critics were fully aware of the traditions of skill embodied in genre painting. In 1868 the English writer, P. G. Hamerton in a book on French painters told how 'a French classicist took to genre-painting to earn money', thinking it would be the easiest thing to do, only to discover that 'though he could paint a leg, he could not paint a face'.

But though it might conceivably be possible to write the history of this achievement in nineteenth-century painting as a coherent story much in the way the history of perspective in the Renaissance has been told, it might still be argued that such an analysis would also bring out the inherent obstacles in the way of a perfect solution to the problem of unaided pictorial narrative. Such pictures will either tell a trite story or resort to cues, symbolism, and 'programme notes'

which tend to turn the painting into a puzzle. The pathos of Redgrave's painting *The Poor Teacher* depends largely on our discovering that the letter she holds in her hand has a black margin. It is significant how often these paintings represent the reaction of people to letters or messages they are reading whose content we are asked to infer. In Raymond Lister's *Victorian Narrative Paintings* there are eight such examples which can be supplemented from Mr Reynolds's book. The poignancy of Godall's *A Letter from Papa* depends on our knowledge that Papa is far away in the Crimea. In every one of these cases the picture is only the starting-point for our musings, our projections. There are a number of other themes which lend themselves to this embroidery on the part of the spectator, the anxieties of the sickbed with its hopes and fears, the tryst observed or betrayed, the whole gamut of typical stage situations which bring out the actor's art or enable the composer of operas to mobilize the emotional potentialities of music. Indeed, if there is an art of the nineteenth century which still preserves a similar appeal, it is opera. We don't resent the nonsense of Verdi's librettos, but we would find the equivalent of *Il Trovatore* or *La Traviata* in paint difficult to take. Are we unjust here? Perhaps, but after all, the role of subject in the two arts is bound to differ. The subject in music is more readily detached than that in painting, and though a sentimental picture may be well-painted—as Mr Reynolds points out in individual instances—it should not be too difficult for a future historian of nineteenth-century art to account for the victory of the anti-literary camp. 'The day will come', exclaims the hero of Zola's *L'Oeuvre*, 'when a single turnip painted with originality will be pregnant with revolution'.

This single-minded concentration of the revolutionaries was almost bound to win over the divided aims of the opposing camp. For these aims were much less clearcut than the mental diagram presented above allowed for. Even the programme of the Pre-Raphaelites was inconsistent and contradictory. Ford Madox Brown, in writing about his painting *The Pretty Baa-Lambs*, asserted that his only intention was 'to render the effect of sunlight'. He doubted 'the genuineness of that artist's ideas who never painted from love of the mere look of things'. The narrative painter C. R. Leslie, Constable's biographer, specially commended in his *Handbook for Young Painters* (1855) the old Dutch masters for their 'absence of all affected and mawkish sensibility—all the stage trickery of the spectator by which he is made to believe himself touched at heart. This false sentiment began with Greuze and has ever since more or less infected modern Art'. He was right, the worm was in the bud, to speak in the Victorian way. For this is the real difference between the realization of the aims of anecdotal art and that of other coherent evolutions: that in anecdotal art the bud never burst into blossom. The art of the High Renaissance or that of Impressionism can be interpreted as a culmination, embodied in the famous masters of these styles. There is no great master of the narrative genre, at least no great painter. If our imaginary historian were to pursue its

development he would be more likely to find its climax in graphic artists such as Charles Keene than in any of the painters discussed in these books.

Of the two books, Mr Raymond Lister's is by far the slighter essay. But his explanations of some of the paintings, discursive as they are, sometimes light up a meaning which would otherwise escape a modern reader. Mr Reynolds, by contrast, covers much more ground. Much unobtrusive research has gone into his text, which deals with several aspects of the subject not touched upon in this review. But his book, like his subject, occasionally suffers from divided aims. The author of the standard work on Constable's sketches in the Victoria and Albert Museum cannot be blamed if he looks primarily for pictorial quality in the works he discusses. Where one may part company with him is in his attempt to see purely pictorial qualities, indeed an abstract imagination at work not only in the compositions of Burne-Jones but even in the saccharine confections of Albert Joseph Moore. If these well-groomed languid maidens, robed and unrobed in flowery settings of sickening obviousness, are 'the work of one of the first English artists to ignore the questions of subject matter in his pictures', as Mr Reynolds claims, I, for one, feel like calling for *The Doctor*.

23

The whirligig of taste

In the fourth of these five closely packed lectures on an absorbing topic Francis Haskell introduces the reader to a variety of nineteenth-century collectors for the sake of their interesting choice of old masters and then pauses for a remark which vividly illustrates his conception of the historian's task.

> I am indeed reluctant [he writes] to leave these cultivated and pioneering collectors, and many more whose names remain far less familiar, and who, like the ghostly figures beckoning to Virgil and Dante, seem to beg the scholar to tell the world of their activities. Their appeal to us must lie not in the fact that they bought pictures—a useful, but over-glamourized, hobby which has always met with far too much fawning adulation—as that, being very often uninterested in the written word, it was only through their collections that they could express their tastes, and these tastes can tell us something of great importance about which we would otherwise lack any information.

Anxious to lend these men and women a voice, Professor Haskell has felt compelled to supplement the scanty information the lecture form allowed him by lengthy and richly rewarding footnotes, which occasionally make the text really look like an edition of the Divine Comedy with its accumulated commentaries. In neither case can the value of the notes be in doubt. We learn where to look for further evidence and often even for work in progress which might throw light on dark corners of this story. They are sure to provide a mine of material for a whole generation of students; even so, the author misses no opportunity of warning his readers that he has had to be selective. With characteristic caution he has chosen the subtitle 'Some Aspects of Taste, Fashion and Collecting in England and France' as if to draw attention from the start to one of the inevitable lacunae of this narrative, the omission or near-omission of the German and Italian contribution. Yet to some extent these lectures can be seen as an organic extension of Professor Haskell's brilliant pioneering study *Patrons and Painters* (1963), which centred on Rome and Venice. We learnt from that book how the focus of activities shifted to England and France in the course of the eighteenth century; the shift continued in the period considered here (until about 1880), though the author has found no space even to glance at American pioneers such as J. J. Jarves whose rich collection of Italian 'primitives' was bought by Yale University in 1871.

What justifies the main title of these lectures, of course, is the fact that the shift was not only geographical. Between the period covered by the earlier book and the present one the universe of art had undergone a striking transformation. Several new stars had appeared in the sky: Fra Angelico, Botticelli, Piero della Francesca among the Italians, Frans Hals and Vermeer among the Dutch, Greco and Goya among the Spaniards, the brothers Le Nain in France. The author

Originally published under the title 'The tides of taste' in the *Times Literary Supplement*, 27 February 1976, as a review of Francis Haskell, *Rediscoveries in Art: Some Aspects of Taste, Fashion and Collecting in England and France*.

acknowledges the work done by others in tracing the history of these rehabilitations and discoveries, indeed one might say that he takes them as read. As the passage quoted at the outset indicates, he is more concerned with resurrecting people and events than with the analysis of critical theories.

He starts persuasively with the description of two works of nine-teenth-century art which tell us who the old masters were whose fame was taken for granted. In Delaroche's once famous 'Hemi-cycle' in the Paris Ecole des Beaux-Arts, completed in 1841, forty named painters and engravers are grouped around an apotheosis of art vaguely modelled on Raphael's frescoes in the Stanza della Segnatura. It was imitated in its turn here in London on the podium of the Albert Memorial designed in 1865 by H. H. Armstead, a work to which most of us have been blind and a detail of which now provides the effective dust-jacket—in itself a telling instance of 'rediscoveries in art'.

In certain respects, as we have seen, the lectures resemble these historical group portraits. One could imagine a fresco cycle begin-ning with Jean-Baptiste-Pierre Le Brun (1748–1813), the artist, pam-phleteer, keeper and dealer of pictures who was, we learn, 'one of the first art lovers consciously to try to "discover" neglected artists of the past'. The strength of his continued influence, by the way, is testified by the fact that in 1845 an English translation of François-Xavier de Burtin's *Treatise on the Knowledge necessary to Amateurs in Pictures* still incorporates a list based on Le Brun's Gallery of 'most of the best Flemish, Dutch and German painters, with the highest prices at which their pictures have been sold'. Close to Le Brun we would find a group of English collectors who bought paintings from the Orléans Collection when it was exhibited and dispersed at the turn of the century, a crucial episode in which William Buchanan, a Scottish lawyer, played an active role which he revealed in a book and in his correspondence.

The second lecture might provide the 'programme' for the next assembly, centred, perhaps, around the English timber-merchant Edward Solly, who lived in Berlin throughout the Napoleonic wars and who included in his large collection also a good many fifteenth-century pictures; by his side we might find Dominique Vivant-Denon who wrote of himself: 'I had no aim other than to satisfy my taste, no plans for economy other than to buy beautiful things'.

It is in the third and central lecture that we learn how hard it was for anyone to take up such a refreshingly unorthodox position at a time when 'in France as in England, a taste for unorthodox art carried with it political, social and religious as well as aesthetic impli-cations'. In discussing the growing bias for the early Italians in England, and for eighteenth-century painting in France, the author pays due regard to these implications, but here as always his focus is on people rather than on trends: on Mrs Graham for instance (later Lady Callcott), to whom we owe the first illustrated monograph on Giotto's Arena Chapel; on Eastlake, Ottley and William Dyce in England; and on Alexandre Lenoir in France 'who seems to have

been actuated above all by an obsessive and all-embracing passion to preserve under his own authority every surviving vestige from the past at a time when the past was being annihilated as effectively as possible'. We hear of the role which not only nostalgia but nationalism played in the rehabilitation of the brothers Le Nain, and of the various High Church clergymen in England whose taste for early Italian painting was so closely associated with Catholic leanings that it could not but worry Ruskin.

In the next lecture (from which I quoted in my first paragraph) we are back among collectors, starting from three generations of the Baring family, Louis La Caze, a physician of independent means and independent taste, the Baron Isidore Taylor, born in Bruges of Irish descent, a 'soldier, painter, man of letters, collector', and many things besides. It is a splendid gallery of portraits, enriched by those of the brothers Isaac and Emile Pereire, 'the history of whose extraordinary gallery allows us to gauge, almost as on a thermometer, the exact moment at which the new "discovery" becomes absorbed into fashionable consciousness'. It is at this point in the story that the artist-dealer is replaced by the art-historian-dealer as an adviser to collectors. Their pacemaker was Théophile Thoré, the most famous of all rediscoverers whose passionate writings in favour of Rembrandt and of Vermeer have earned him a permanent place in the history of criticism. He must not be seen in isolation, and so he is joined by other father-figures of art-history, such as Joseph Archer Crowe, originally an English painter and ambitious Grub Street journalist, who teamed up with Giovanni Battista Cavalcaselle and became a household name to all students of Italian art; we also catch a glimpse of the German who held the first chair in the history of art at Berlin, Gustav Waagen, to whom we owe the best survey of English collections.

The final lecture, 'Spreading the News', takes its starting-point from the famous Manchester Exhibition of 1857 with its rich and wide-ranging display of old masters of all kinds, from early Byzantine to Goya; after which we move on to Louis Philippe's Galerie Espagnole through which knowledge of Spanish masters became more widely disseminated. We are on the threshold of the 'musée imaginaire': by this time means of reproduction, including photography, had become more widely available, while newly founded art journals and in particular guide-books ministered to the needs of art-lovers and tourists. Art was on the way to becoming a substitute for religion; it offered uplift much as nature did, and this was often reflected in the tone in which works of art were described.

The author takes leave of his audience and his readers by commenting on a text from the end of his chosen period, the remark (in 1884) of a French critic that 'given the right circumstances, artists such as Ary Scheffer, Paul Delaroche, Léon Cogniet and Camille Roqueplan, who had fallen into total oblivion would once again be appreciated'. 'Barely a week goes by', Professor Haskell tells us, 'without students proposing subjects for research which less than ten years ago would have been dismissed as frivolous, involving as they

do the investigation of artists who were then treated with ignorant contempt'. Thus Delaroche's Hemicycle is completed into a cycle taking us back to where we came in. The author expresses the hope that he has 'been able to benefit by comparing the past with the present: the roles played by dealers, private collectors, exhibitions, and museums, both in the United States and in Europe; the element of snobbery and "camp"; the growing number of specialized studies'. Indeed while these lines were incubating in the press, the National Gallery put on its exhibition of Delaroche's *Execution of Lady Jane Grey*, though still behind the thin protective screen documenting a critical article by Théophile Gautier of 1858.

No doubt the factors listed by Professor Haskell have played their part in this development, but are they decisive or are there perhaps autonomous cycles of taste? A recent article by Dwight E. Robinson in the *Harvard Business Review* of November–December, 1975, characteristically entitled 'Style changes: cyclical, inexorable, and foreseeable', claims that external events and outside pressures hardly influence the graphs of changes, which tend to reverse after about fifty years. The 'rediscovery' of Victorian design, of Art Nouveau and Art Deco, suggests such swings of the pendulum, but the subject-matter of Professor Haskell's book could certainly not be pressed into such a straitjacket. Perhaps we could profit from his advice to look at recent developments in order to gain a better understanding of past revolutions in taste. With some psychologists introspection is still a dirty word; but for the historian, to do without it means abandoning his claim to understand the past in human rather than statistical terms. What was, or is it, then, that has kept us from looking at Delaroche? What makes 'Salon paintings' rather embarrassing to those of us who have not yet been caught by the new trend? Is it not a kind of 'taboo' we feel should not be broken? It could be argued, perhaps, that the critical vocabulary used in justifying this taboo, the ban on the 'anecdotal', the 'sentimental', on 'photographic realism' or 'historical melodrama' are little more than rationalizations. We are—or have been—taught to watch out for certain warning signals telling us that we are approaching a kind of art which has fallen under the blanket disapproval of all the right people. An art which exhibits these features cannot be acceptable because it is morally suspect; suspect of making concessions to vulgar taste, to sensationalism and literalism, a pseudo-art usurping the rightful place of the uncompromising and the honest who suffered economic martyrdom rather than paint in a way that would appeal to the jury of the Salon—a jury, by the way, which at one point counted among its members none other than Camille Corot. It is this *fable convenue* which the present generation of art-historians has begun to question, and Professor Haskell himself has had his share in stimulating their healthy scepticism.

If this experience is anything to go by, 'rediscoveries in art' tend to presuppose a sequence of at least two waves in the tides of taste: a lifting of taboos must come first, and only after a style or a genre can be examined again can the process of discrimination set in which

separates the good from the bad, the master from the follower. Such critical approval therefore has to be distinguished from simple 'liking'. There are many pictures 'liked' by the majority of our countrymen which have nevertheless still to be rediscovered, if indeed they ever will be.

If Professor Haskell's book has a weakness, it is his failure to clarify this distinction in the light of history. He understandably gives good marks to collectors who followed their likes irrespective of critical dogma, but this alone is not how rediscoveries happened. Some collections and curiosity cabinets contain items which are aesthetic atrocities by almost any standard. Should we applaud their purchasers?

It is an amusing exercise to imagine what Lord Shaftesbury would have said if he had read *Rediscoveries in Art*. A passage in *Advice to an Author* (of 1710) provides something of an answer:

> I like! I fancy! I admire! How? . . . But I *learn to fancy, to admire, to please*, as the Subjects themselves are deserving, and can bear me out. . . . Grotesque and monstrous Figures often *please*. Cruel Spectacles and Barbarities are also found to *please*, and, in some Tempers, to please *beyond all other Subjects*. . . . Effeminacy pleases me. The *Indian* Figures, the *Japan-work*, the *Enamel* strikes my Eye. The luscious Colours and glossy Paint gain upon my Fancy. A *French* or *Flemish* Stile is highly lik'd by me, at first sight . . . but what ensues?—Do I not for ever forfeit my good Relish? How is it possible I should thus come to taste the Beautys of an Italian Master, or of a Hand happily form'd on Nature and the Ancients?

For this is the advice Shaftesbury gives the aspiring art lover. Having gone to Rome and inquired which are the best antiques, the best works of Raphael or Carracci, he must not allow himself to be put off. 'However antiquated, rough or dismal they may appear to him, at first sight; he resolves to view 'em over and over, till he has brought himself to relish 'em, and finds their hidden *Graces* and *Perfections*'.

Professor Haskell, who, in his earlier book, calls Shaftesbury 'one of the first to stress the role of art in "civilizing" society', knows this passage as well as anyone. But some of its implications are still worth spelling out. Certain tastes are identified with indulgence of the senses and of the appetites and that is why the taboo must be imposed. Other works may be hard to appreciate and that is why in the words of James Harris, quoted by Reynolds, we must 'even feign a relish, till we find a relish come'. No wonder that those who base their preferences on what they 'like' have always accused others of sheer 'affectation'—a charge made by Quintilian against connoisseurs claiming to enjoy archaic Greek art. He may have been right, but how can anyone tell? Is not all taste 'acquired taste'? And is not there something at least in the notion that aesthetic response can be graded so that a pleasure in gaudy tinsel is more natural but not necessarily better than a preference for the plain and the severe?

Granted that the fear of 'liking the wrong thing' may successfully impose the opposite preference on whole groups, can we afford to neglect the psychological dynamics of this process?

There have always been genuine art-lovers who refused to be terrorized into liking the unappealing. But the licence of disregarding all taboos required yet another authority. It is here that developments in German cultural life introduced a new element into the revolt against Shaftesbury's purism. Irked by what they took to be the tyranny of alien taste, the Germans were specially predisposed to question the existence of absolute standards. Did not art change with society? Did it make sense to regret that the German Middle Ages built Gothic cathedrals rather than Greek temples? The rise and spread of German 'historicism' and its roots in the writings of Herder, Goethe and ultimately Hegel, is a subject too large to have been accommodated in the five lectures under review, and Professor Haskell was right in warning the reader on the title-page that Germany was not included in his inquiry. But a doubt inevitably remains whether such a restriction is possible. German artists and travellers mixed with other Europeans in the international atmosphere of Italian tourist centres and are not likely to have kept their views to themselves. Can they be ignored without impairing intelligibility?

Thus the author devotes his third lecture to 'The Two Temptations', mainly the taste for the Italian 'primitives' in England, and for Watteau and the eighteenth century in France. Yet it is worth mentioning that an influential German critic writing at the threshold of this period did not see the two as incompatible. W. H. Wackenroder's notorious *Outpourings from the Heart of an art-loving Monk* of 1797 are briefly mentioned by the author for their aura of medievalizing piety, but the same Wackenroder, whose revampings of Vasari's anecdotes became the German Nazarenes' breviary, published in 1799 a most sensitive essay on Watteau, chiding those 'admirers of the Great Masters' who 'speak of this artist with a certain contempt'. Just as Raphael is supreme in the sacred sphere, so Watteau had a loving sympathy for ordinary mankind. 'Why should it be impermissible . . . to respond to gay hours of sensual delight? . . . It seems to me that the spirit of mankind is of infinite richness, it encompasses subjects from both ends of the scale, and what looks furthest apart is not always as distant as we believe at first'. There is indeed no inconsistency in this appreciation, for Wackenroder's plea is always for 'tolerance'. Tolerance, broadmindedness, a relaxation of narrow dogmatism; a Shaftesbury would have been quick to sense the moral (or immoral) overtones in these demands. Nor would he have been entirely mistaken. Goethe, who, in his long life, changed from an iconoclast to a pope of classical standards and finally mellowed to the point of writing perceptive appreciations of Gothic paintings and a Romanesque relief, clearly summed up the moral permissiveness he associated with such catholicity of taste:

Wie aber kann sich Hans van Eyck
Mit Phidias nur messen?

Ihr müsst, so lehr' ich, alsogleich
Einen um den Andern vergessen.
Denn wärt ihr stets bei Einer geblieben,
Wie könntet ihr noch immer lieben?
Das ist die Kunst, das ist die Welt,
Dass Eins ums Andere gefällt.

Very roughly: 'But how can ever Jan van Eyck/By Phidias' side be set?/Take my advice: The one to like/you must the other forget/If you had always loved the same/Could still your heart be set aflame?/Such is the World, and such is Art/that pleasures come as pleasures part'.

This latitudinarian outlook which regards every style and every work of art as something *sui generis* which can be appreciated by momentarily forgetting other standards, may seem natural enough to us. Any absolutist must have found it incomprehensible. To admire an artistic achievement meant, for men of this persuasion, to consider it a suitable model for imitation by aspiring artists. It is not the least of the merits of this book that it demonstrates how long this attitude survived into the nineteenth century. Professor Haskell quotes what he rightly describes as 'one of the most crucial artistic encounters of the century', the questioning by a select committee in 1853 of the sculptor Sir Richard Westmacott about the wisdom of exhibiting sculptures from Nineveh. Would not 'the very free introduction of more barbarous specimens' have 'a very injurious effect upon taste in general'? To which the sculptor replied that he agreed that 'the less people, as artists, look at objects of that kind the better'.

At the time of this encounter the danger of corruption through the admiration of primitive styles was a very live issue. The good-natured C. R. Leslie, Constable's biographer, harps on this danger in his *Hand-Book for Young Painters* of 1855: 'A system of imitation that rejects what such men as Titian, Correggio, Rembrandt, Rubens and Reynolds, have revealed to the world of the beauties of Nature, is based on a mistake as great as it would be in an astronomer to rest satisfied with the state in which Astronomy was left by Copernicus'. For good measure he adds a footnote calling in evidence a letter by Dr Waagen to *The Times*, criticizing the Pre-Raphaelites on the ground of historical relativism: 'The whole style of feeling proper to those early masters . . . cannot possibly be voluntarily recalled in a period of such totally different tendencies as the present'. This was indeed the neuralgic point of nineteenth-century aesthetics. After all, its architecture (and much of its devotional art) rested entirely on imitation and provoked the repeated questioning 'where is the style of our age?' For the worshipper of the historical process could not also be a worshipper of any past phase. He had to put his trust in change, in the future. Imitation ceased to be a road to excellence. The only measuring rod that remained was creativity, originality. Art could only be valued as the expression of an age, a nation, a personality—in the last analysis of everyone 'doing his thing'.

In the light of this conclusion, which inexorably followed from *Historismus*, it is not hard to see why certain periods of art which had

formerly enjoyed such prestige lost their glamour. It is those which were rightly or wrongly believed to be derivative—most of all Roman copies of Greek originals and the unfortunate Bolognese masters—who had to pay for the praise which had been showered on their alleged 'eclecticism'. Paradoxically this cult of originality may also have contributed to the rise of the art-historian as an adviser to collectors, of which Professor Haskell speaks. Only a specialist could tell who among the half-forgotten masters struck a new note and deserved a new pedestal.

We hardly have such specialists yet for the Salon painters, who still look to many like an undifferentiated grey mass of meretricious time-servers who are not worth bothering about. Once this blanket disapproval is lifted we can surely look forward to genuine rediscoveries. It looks as if the prospect both exhilarates and troubles Professor Haskell, for he would not want to accept the tenets of historical relativism uncritically.

The argument (he writes in the introduction)
that the finest artists have not been affected by changing taste can be reduced in the last analysis to the proposition that for no extended periods since their lifetimes have Raphael, Titian, and Rubens not been considered great painters by the most influential sections of articulate opinion. We should be grateful for such stability, however limited.

But is it all that limited? As long as we retain this canon of artistic mastery we also know what we mean by a great painting. Anyone intending to file an application for rediscovery on behalf of one of the Salon painters still has to accept the fact that the case will come before a formidable tribunal.

The anatomy of art collecting

For this learned but lively tome, based on his Mellon Lectures of 1978, Mr Joseph Alsop has devised a title page which is anything but self-explanatory. 'The Rare Art Traditions' are so named by him because they are the exception rather than the rule in man's attitude to the visual arts. 'The History of Art Collecting and Its Linked Phenomena Wherever These Have Appeared' refers to the author's conviction that this exceptional attitude, which regards artistic creation as an activity divorced from practical use, was first exemplified by art collectors who thus blazed the trail for our modern conception of art for art's sake. It is this conception that the author finds represented in only five distinct cultural traditions, that is, in the ancient world, in China with an offshoot in Japan, in the civilization of Islam, and, of course, in Western societies since the dawn of the Italian Renaissance.

How many of his readers will find this fact as startling as he asserts it to be may be hard to tell. After all, the divorce between the crafts and the arts has been the subject of frequent debate in the past. It was demanded by many artists of the Renaissance who aspired to the status of a 'liberal' profession; it was deplored by the Victorian reformers of design and industry, and still haunts the conscience of artists and anti-artists today. Even so Mr Alsop is surely right in his assumption that the majority of museum visitors today do not realize (because they are but rarely told) how radically a painting by Vermeer, Matisse, or Jackson Pollock differs in intention and purpose from the tribal masks, the prehistoric figurines, even the temple sculpture or altar paintings housed in the same building.

It was indeed a momentous development by which the visual arts were thus lifted above the activities of artisans, however skilled. In making his claim that this emancipation from utilitarian bondage must be credited—every time—to the art collectors, Mr Alsop is rightly anxious not to allow the art collector to be confused with the equally important patron of the arts. The patron, whether he commissioned the building of a temple or a church, the decoration of a castle, or the illumination of a manuscript was, no doubt, interested in the excellence of the product he hoped to sponsor and to acquire; and thus patrons of art from King Solomon to Pericles, from Abbot Suger to Pope Julius II were never slow to recognize the outstanding masters of their time and to secure their services, often in the face of fierce competition. But what they wanted may still be described (in Mr Alsop's terms) as 'art for use', while the art collector who treasures a sample of calligraphy, a fine marble head, or a watercolour is no longer concerned with the original purpose for which these objects were made; he simply values them as 'art'.

If this changed perspective is the most important one of the 'linked phenomena' mentioned in the subtitle, it is not the only one. In fact the author discerns a 'behavioural pattern' exemplified in his five 'rare art traditions' that includes a whole system of connected

Originally published under the title 'The Art of Collecting Art' in *The New York Review of Books*, 2 December 1982, as a review of Joseph Alsop, *The Rare Art Traditions: The History of Art Collecting and Its Linked Phenomena Wherever These Have Appeared*.

features which he announces and briefly describes near the beginning of his investigation. The most prominent are:

1. *Art collecting*: This is the basic by-product of art simply because the rest of the system has never developed without art collecting. It seems certain, indeed, that the other parts of the system cannot develop in art collecting's absence.

2. *Art history*: As will be shown later, art history goes hand in hand with art collecting at all times.

3. *The art market*: Third place goes to the art market, because you cannot have a true art market without art collecting, and art collecting automatically begets an art market to supply the collectors.

To this triad the author adds five secondary 'by-products of art' which are not, however, invariably observed in all the rare art traditions. They are:

4. *Art museums*: Historically, this phenomenon is the most uncommon of the lot, but it takes fourth place today because we now so conspicuously live in the Museum Age.

5. *Art faking*: Wherever there is a booming art market serving competitive art collectors, faking is an automatic development.

6. *Revaluation*: The author here speaks of 'a kind of stock market of taste, on which works of art of all sorts go up and down in estimation all over the world'.

7. *Antiques*: This use by both the rich and the middle classes of borrowed decorative plumage plucked from the past to ornament the present differs from ordinary art collecting because it always starts much later and also introduces the new theme of old-for-old's sake.

8. *Super-prices*: The payment of super-prices for works of art always announces the last and most luxuriant phase of development of the byproducts of art.

It is the author's aim in this study, the fruit of many years of research with the support of an able team, to prove not only the recurrence of these linked features in various parts of the globe, but also their conspicuous absence from other great artistic traditions like those of the ancient Orient, of Mexico, of India, and even of the European Middle Ages.

Every historian knows to his cost that writing the history of any aspect of culture is likely to confront him with a perplexing dilemma. Should he proceed chronologically or systematically? To begin with the beginning and to end with the end will make a good story, easy to follow and easy to remember; but having embarked on this course he is likely to discover that he must first explain why he starts at a particular point, and what his subject is really going to be. Would it not be better to start at the end of the story which is more likely to be familiar to his reader, and to work his way backward? Alas, it turns out that this procedure would be even more confusing. And thus the writer soon finds himself confronted by the need to discard the narrative mode for a systematic exposition, hoping that the historical sequence will somehow emerge all the same.

Mr Alsop's book shows traces of this dilemma, which he has tried

to solve by making his first chapters systematic, the rest chronological. But like the rest of us he must have found that this tidy solution cannot be maintained and that he has to shuttle backward and forward between the two approaches, stopping whenever possible to recapitulate or anticipate. As a result, it is more enjoyable to browse in this book than to consecutively read its 475 heavily footnoted pages, and no attempt to summarize its varied, meandering course is likely to do it justice.

It was no doubt in order to find an arresting opening that Mr Alsop decided to preface his story of art collecting with an account of the dramatic fluctuation of taste the Western world has witnessed during the last two centuries. The chapter centres on the notorious fate of the *Apollo Belvedere*, once celebrated as a supreme masterpiece and now generally dismissed as a copy or even a pastiche. It is perhaps a pity that this particular story has meanwhile been told in greater detail in the masterly book *Taste and the Antique* by Francis Haskell and Nicholas Penny, but what Mr Alsop wishes to emphasize is not so much the breakdown of the academic canon but the unparalleled expansion of the notion of art with the result, in the author's words, that 'all art gradually became equal—although some people's art has never ceased to be more equal than other people's'.

The author speaks in this context of a radical change in the 'way of seeing'. Perhaps it would be safer to say that art lovers began to 'look for' different qualities. Though Mr Alsop does not quote him, he follows Ruskin in looking for the 'mark of the human hand' precisely because this has become increasingly rare in the objects which surround us. Hence he proposes as his definition that 'art is whatever the human hand makes with art, and making with art is making to please the eye'. It may well be that both the great merits and the undeniable limitations of his book spring from his faith in the value and the power of such rigid definitions.

The scholastic origins of this faith could not be better illustrated than by his opening of the second chapter with a quotation from St Thomas Aquinas defining beauty as what 'pleases the eye'. One wonders how much is gained by this formula, which would deny beauty to music; but even in its application to the visual arts the postulation of 'pleasure' is notoriously risky since it would exclude everything that shocks and moves us. Moreover the author's discussion in his chapter on 'Art for Use' also refers to relics and antiquaries, which inevitably remind us of the emotion of awe and reverence that can be associated with art in the setting of ritual.

Turning to art collecting, the author explains again that he has never found a 'definition of art collecting both precise enough and general enough to be universally useful'. Accordingly he sets out to fomulate a definition of 'collecting' which starts: 'To collect is to gather objects belonging to a particular category'. He amasses interesting and amusing examples of the 'collecting impulse', referring us to the Bower Bird and to collectors of beer bottles and

vintage cars; but he is compelled by the straitjacket of his definition not to consider other manifestations of this impulse, such as the craze of 'train spotting' which makes English schoolboys gather near railway stations with a notebook, to write down registration numbers of passing railway engines. There is a sporting element of competition here and, of course, the need to find an interest in life, both of which also influence art collecting. Moreover, the activity serves no conceivable purpose; it is purely an 'aim in itself'.

It is this exclusion of usefulness which the author regards as the first litmus test for the content of a true art collection. Another is the emergence of connoisseurship which the true collector must either possess or hire. As if to counteract the rigidity of his definitions Mr Alsop shows himself the perfect raconteur in illustrating his points, but his more theoretical concern is to show in the next chapter that art collecting and art history are 'Siamese twins' which cannot exist without each other. 'Anyone can perceive that the historical response to art is the egg that art history comes from; and that a little thought will show you that the historical response is also the egg that art collecting comes from.' Tracing the emergence of the canon of excellence in the writings of Vasari, Alsop vividly describes the intrusion of art history into the museum during the eighteenth century, when specimens of early art were at last collected and publicly shown as instructive reminders of the 'rise of the arts'. He insists quite rightly on the importance of the 'historical response' in our appreciation and valuation of the art of the past, and he concludes his section of systematic ground-clearing with reflections on the art market which contain a good many amusing titbits.

Thus it is only in the seventh chapter, on page 170, that the author feels ready to discuss each of his rare art traditions in their turn while always keeping us aware of the parallels he wants to establish. There are more than forty pages on what he calls 'The Greek Miracle' (an expression, by the way, which he attributes to me but which was coined by W. Deonna). Little as we know about the beginnings of Greek art collecting, the author contributes a vivid reconstruction of the activities of Attalus of Pergamon and his successors, who in the third and second centuries BC tried to enrich their small state with many masterpieces from the great centuries of Greek art. This account is based, as Alsop says himself, on 'no more than guesses', but is supported by his general ideas of the likely sequence of such developments.

While much of the material here, especially about Roman art collecting is not unfamiliar, his next chapter on the Far East will certainly be of value to nonspecialists. We shall have to await the verdict of experts, however, about Mr Alsop's bold suggestion that it was the famous founder of the Chinese empire, Ch'in Shi Huang Ti, in the late third century BC who gave Chinese art that new direction which ultimately led to 'the repetition of the pattern' of linked phenomena which interests him. What prompts the author to think so are the sensational finds of the emperor's tomb with its guard of lifelike terracotta warriors which are only now slowly emerging

from the earth. If this kind of naturalism was indeed willed by the emperor and engendered a new style, it may be added that the Western and Eastern patterns may not have been quite independent after all; if, that is, the achievements of Hellenistic realism which influenced the sculptors of Afghanistan and northern India could also have become known in China.

We are on more solid ground, however, in considering the rise of calligraphy as the leading Chinese art, which is here related in its decisive stages. What is equally characteristic of the Chinese art scene is the emergence of the 'scholar painters', amateurs in the strict sense of the term, whose work was rightly cherished by collectors and recorded by the chroniclers of Chinese art—not to forget the imitators and forgers whose existence created the need of connoisseurs. In contrast to this generous treatment of China, which he knows at first hand, the author spends little more than two pages on Japan and three on the later Islamic pattern. Here again he draws attention to the role of calligraphy, mentioning a minor prince of the Safavid dynasty of Persia, Ibrahim Mirza (killed in 1576), who owned no fewer than three thousand volumes of fine calligraphy and miniature painting.

Alsop does not even find a real parallel to such art collecting in the centuries of the Middle Ages to which the ninth chapter is devoted. To illustrate the break with antiquity he quotes to good effect the plea of Cassiodorus in the sixth century to repair and protect the remnants of ancient sculpture in Rome. Despite a few stray references in later texts to an interest in ancient statues, he rightly insists that while we know of plenty of patrons and great masters, neither art collecting nor art history in our sense can be documented from that period. Even the relative frequency of artists' signatures does not convince him of the contrary: he would rather connect it with the traditions of the pre-Christian north, but 'an enormous amount of further scholarly work needs to be done before this problem of signing in the Dark and Middle Ages can be rationally discussed'.

Before introducing us to what is obviously his favourite and most thoroughly investigated topic, the rise of art collecting in the Italian Renaissance, the author pauses for an 'interchapter' devoted to one of his characteristic moods of reflection. For many years, he tells us, he has asked himself the question, 'Why was there a Renaissance?' While disclaiming any proof, he reminds us of that peculiarity of the Renaissance which has often been described, not least, among art historians, by Erwin Panofsky, as the emergence of a sense of history—the same sense the author also considers as underlying his other four 'rare art traditions'. Without such a historical sense, he rightly argues, there can be no historical response to art as is presupposed in the pattern of art collecting and the memory of old masters.

Some of the material assembled about the beginnings of art collecting in the fourteenth century is familiar to specialists, for instance the documents concerning Oliviero Forzetta of Treviso who collected both ancient texts and ancient coins and fragments, but Alsop's interpretation of the evidence is fresh and bold, as is his

extended discussion of the letters of Giovanni Dondi dall' Orologio and of the activities of the Florentine humanist Niccolò Niccoli. As a fellow student of this key figure in the early history of the Renaissance I can only congratulate Mr Alsop for the thoroughness with which he has searched the sources in order to present him as the archetypal Renaissance collector, but I do not find all his arguments equally convincing. He makes much of the story that Niccolò paid five florins for a *calcedonio*, an engraved gem, for which he received 200 florins in later years, suggesting that this increase in price betokened an entirely new pattern of collecting; but we are also told that Niccolò had noticed a boy wearing that *calcedonio* around his neck and paid the sum to his father, who may have been quite unaware of its real value. Even less can I agree that 'there is no evidence that Salutati [the Florentine chancellor] himself took an active interest in the visual arts', for in a paper which Mr Alsop cites I have quoted Salutati's efforts to prove by stylistic arguments that certain buildings in Florence were of Roman origin. In thus separating the search for the relics of ancient art from an interest in classical architecture the author narrows the focus unduly.

There follow some sixty pages on the collecting of the Medici, and let it be said at once that they are by no means a rehash of earlier treatments (including my own) of this intriguing subject. Particularly original is the author's use of the full text of the inventory of the contents of the Medici palace after the owner's expulsion, of which Eugène Müntz had only published extracts and which Aby Warburg had copied but never got round to publishing. In contrast to Eugène Müntz, Mr Alsop is convinced that the valuations entered in this inventory opposite the various works of art deserve serious attention, because they may well reflect the sums found in the ledgers of the Medici bank of money paid for particular items. The author defends Lorenzo de' Medici against such sceptics as myself who doubted the extent of his commitment to art, but, of course, he too reminds his readers of the vast discrepancy between the cost of a contemporary painting and that of a classical engraved gem. This gap, which he calls the 'big surprise', was only closed in the second quarter of the sixteenth century. It is treated more perfunctorily, though the analysis of Fra Sabba da Castiglione's *Ricordi* of 1549 is a model of its kind. Isabella d'Este comes in for some justified scolding for her greed and her treatment of some artists, but she is rightly seen as a 'transitional figure' whose desire to get works from famous contemporary masters foreshadows a shift in art collecting. With the establishment of a canon of great masters, to which Vasari contributed so much through the way he told the story of the rise of the arts to perfection, we have reached the decisive moment when a decree of 1601 by Grand Duke Ferdinando de' Medici listed eighteen famous painters of the past, whose works were not to be sold abroad. The concern for the 'national heritage' had made itself felt for the first time. The study culminates and ends in a chapter on the seventeenth century devoted mainly to the fabulous art collection gathered together largely out of Italy in defiance of these sentiments by Charles I

and dispersed by the Commonwealth. A moving 'Envoi' recalls the scene reported by an eavesdropper of old Cardinal Mazarin, feeling the end approaching, saying farewell to his beloved possessions such as a Correggio, a Titian, and an Annibale Carracci. The author is entitled to end his narrative at this point, for he has anticipated much of the sequel in his opening systematic chapters, where the rise of the art museum and the development of the modern art market are described with many telling episodes.

Even so, it may be argued that in thus ending with Cardinal Mazarin he has missed the final and possibly the most decisive phase in the development he had set out to describe. I mean the assimilation of the visual arts to their 'sister arts', architecture, poetry, music, and the dance. It is here, I believe, that the initial turn the author took in defining art as something made by human hands proves inhibiting. It is curious to reflect that he would have been unlikely to propose this definition had he written in any language other than English. The German term *die Kunst*, for instance, has never been restricted to the visual arts alone, and even English usage still reflects the latitude of the Latin term where *ars* (like the Greek *techne*) meant skill. The adage *Ars longa, vita brevis* refers to the 'art' of medicine; Ovid wrote of the art of love, and Whistler two thousand years later of the 'gentle art of making enemies'.

If this were merely a matter of semantics it would be of marginal relevance to the author's conclusions; but it is never easy in cultural history to separate the meaning of words from what the author calls 'behaviour patterns' which cluster around a term. Hence his procedure of first identifying a rigid configuration of such traits which he finds exemplified in his five 'rare art traditions', and then seeking for their cause, was almost bound to lead him into perplexities. Since he rightly rejects historical determinism, he must fall back on metaphors such as 'mutation' to describe the emergence of his novel traits. It is here that the history of words and concepts might have taken him further, for the continuous adaptability of their meaning hints at the corresponding flexibility of the pattern.

Thus if the author had not started with a narrow definition of 'art' he would also have found a number of clues which connect the history of art as skill more closely with that historical sense he sees as the key to his problem. For in periods when technology and knowledge make visible strides, the passage of time cannot easily be overlooked. In the beginning of Plato's *Greater Hippias* Socrates makes ironic fun of a famous sophist who boasts that his earnings as a counsel and performer testify to his mastery of oratory. 'You must be much better than the sages of yore who never earned such fees', Socrates says, 'just as our sculptors say that if Daedalus [the mythical artist] were born today and were to create such works as those from which he got his reputation, he would be laughed at'. The famous virtuoso gladly agrees that this is indeed the right comparison, but adds that, of course, he never fails in public to praise the ancient masters.

The tensions and complexities that accompany an awareness of

historical change could not be better characterized. We need not, perhaps, be all that surprised that the sculptors of Plato's time noticed the distance which separated their skilful products from the venerated cult images of the mythical past. They had the best opportunities possible of comparing the works of every generation and school. We need only look into the descriptions in the guidebook by Pausanias from the second century AD of the statues surrounding the stadium of Olympia to see that such a comparison must have become all but inevitable, with hundreds of images of Zeus dedicated by various cities at various times and any number of monuments to victorious athletes crowding the precinct. If the athletes competed, why not the sculptors? Jakob Burckhardt, in his *Griechische Kulturgeschichte*, has a telling chapter on what he calls the *'agonal'* spirit of Greek culture, the spirit of competition which expressed itself in so many ways.

Mr Alsop speaks in this context of 'compulsory innovation', but it was not innovation as such that counted in art but systematic progress towards the goal of *mimesis*, the convincing imitation of nature. It was in this respect that 'art' became approximated to science: both were capable of demonstrable solutions to problems. In putting forward a new hypothesis, Plato's pupil Aristotle regularly passes in review the opinions of his predecessors on whom he hopes to improve. It is Aristotle also who, in his *Poetics*, offers the *locus classicus* of the history of any art—his famous account of the development of Greek tragedy from primitive 'dithyrambs', to Aeschylus who first raised the number of actors from one to two, and on to Sophocles 'who introduced three actors and scene painting'. 'After going through many changes tragedy stopped', so Aristotle tells us, 'when it had reached its natural form', though he had conceded in an early passage that it may be another matter 'whether the genre was by now fully developed in all its species or not'.

The parallel with the presumed content of the first histories of Greek art discussed by Mr Alsop needs no emphasis. Nor need it be said at length that the idea of a 'canon' of perfection which dominated the history of Greek sculpture and painting had its counterpart in the history of literature. The Alexandrian critics selected the model plays of the major tragedians and these continued to be performed and recited throughout subsequent centuries, much as Shakespeare and Racine are performed on the modern stage. That there were 'remembered masters' in literature long before there were any in the visual arts need hardly be stressed if we remember the role of Homer and of Hesiod in the ancient world. What may be worth recalling, however, is that poets may have expected to be remembered masters before artists did. Horace was confident that his work would outlast the pyramids and Li Tai Pe claimed that in an impermanent world only his verse would remain forever. They would not have been so confident if the great works of literature had not been treasured in their environment as Alexander treasured his copy of Homer.

We must not ask whether Alexander read Homer for his poetic

mastery or for his reports of the mythical age when gods were still on familiar terms with heroes. Nor should we seek to answer the chicken-and-egg question of whether it was the sense of history that led to the formation of a canon of past achievements or whether this canon contributed to the sense of history. In any case the preservation of such canons will depend on the mechanism of tradition. Buildings easily turn into monuments of the past, but their location in history often becomes hazy and the canon of architecture was slower in developing than that of the visual arts. The retrospective canonization of musical composers as manifested in our concert life is even more recent and would deserve a study of its own.

But as far as the shift in the status of the visual arts is concerned, which is the true subject of Mr Alsop's book, it is the approximation of painting and sculpture to poetry that would deserve most attention. It may well be that this approximation has been confined to the five cultural traditions he had isolated, but the way in which the visual arts found their position between technology and poetry still remains to be investigated. I am not so much thinking of the tired formula *Ut pictura poesis*, but of the ease with which teachers of rhetoric in the ancient world took their comparisons of stylistic features from art and architecture.

Unless I am much mistaken, the association of poetry with calligraphy and painting is even more intimate in the Far East. In the Renaissance we have the testimony of the 'paragone', the comparison of the arts which fascinated Leonardo da Vinci, but the role of poetry here extends beyond such overt comparison. It might be argued, for instance, that if Dante had not remained a 'remembered master', Cimabue and Giotto would not have been remembered either. If the early commentators of Dante apologized for his reference to a mere artisan they merely acknowledged, after all, that there was no Muse of painting and sculpture as there was of poetry, of music, of the theatre, and of the dance. In housing our works of art in museums, therefore, we have done some violence to the nine sisters who looked askance at these grimy practitioners.

But if the Muses were happy on Parnassus before the first art collection was ever dreamed of, we may also follow this lead a little further and ask whether they did not set the pattern which Mr Alsop has undertaken to trace from its origins. Once more the meaning of the word 'collecting' may give us a hint if we do not define it too narrowly. We still speak of collections of poetry and of a writer's 'collected works'. No literate civilization can lack collections of its poetic heritage, whether we think of the Psalms attributed to David, or the Chinese collection of ancient folksongs called the Shi King. There are counterparts and variants of such collections in Japanese, in Sanskrit, and, of course, in the Greek anthology, some of these collections being attributed to a single compiler while others are anonymous. Rather early on we also find manifestations of antiquarian interests, the desire to rescue old works from oblivion, later examples being the *Ambraser Heldenbuch* compiled at the request of Maximilian I, and Percy's *Reliques of Ancient English Poetry* of

1765, leading to the collection of folksongs undertaken by Herder and the Romantics.

Here, too, linguistic usage throws light on the limitations of the author's definitions. Though poems are not 'objects' and cannot be equated with the unique treasures coveted by most art collectors, these collectors never confined their desires to unique objects alone. Coins and prints are specimens of multiples which were eagerly collected, and if we think of a collection of pastoral prints and another of pastoral poems, the gap no longer looks unbridgeable.

What is more relevant here is the role that copies played in the art collecting of the ancients and also of the Chinese. Our low valuation of copies must not blind us to the fact that their production is perhaps the most important symptom of that divorce of art from purpose which is at the very centre of Mr Alsop's inquiry. If the works by Phidias or Praxiteles were largely cult images and victory monuments, the copies, good or indifferent, which were bought to grace a villa or adorn a palestra were in demand because of their beauty. The book by Haskell and Penny referred to before gives ample evidence of the role that copies and casts played in the history of later art collecting. It is true that the popularity of copies also produced the inevitable reaction, the increasing esteem accorded to the 'original'. In the light of this development the downfall of the Apollo Belvedere when it was found to be 'merely a copy' is less surprising than Mr Alsop makes it out to be.

But it would be a mistake to confuse this new emphasis on the value of 'originals' with their 'value' in the auction room. It is here, I fear, that the author has failed to see the decisive change that has come over the attitude of art lovers during the last three centuries. His remark that 'in the twentieth century everyone is an art collector' is surely the overstatement of the epoch. The very antics of the art market he has chronicled so wittily would be inexplicable if the works of the masters were still within easy reach. We cannot covet Leonardo's *Last Supper* or Michelangelo's Sistine ceiling, or, for that matter, the treasures that have long been 'entombed', as Mr Alsop calls it, in the Prado and the Uffizi, the Mauritshuis and the Frick.

The characteristic 'behavioural pattern' of the art lover today resembles rather that of the sightseer whose purchases may be confined to picture postcards or art books of the less expensive kind. These serve to nourish or refresh our imagination and make up together what André Malraux called the *'musée imaginaire'*. In our Western world and wherever its influence extends, that museum is the exact counterpart of the mental furniture of lovers of literature or of music. What part was played in this development by the spread of tourism, what by the rise of photography and the higher standards of living in the Western world, it is impossible to say.

But none of these factors could have become effective if art lovers had not come to seek in art the same kind of imaginative experience they had found in literature and maybe in music. It was this shift also rather than any fluctuation in taste taken by itself which rendered the former canon of artistic excellence obsolete. Here, too, literature

was in the lead. Long before the museums of the world were open to all artistic products of the globe, Goethe coined the term *Weltliteratur* ('world literature') and testified in his oeuvre to his appreciation of Persian, Indian, and Chinese poetry. Thus it was not so much the work of the human hand which became an object of admiration, but any token of the creativity of the human mind.

It has recently been shown that this attitude which so many art educators and art lovers take for granted has its roots in yet another tradition. That great student of the history of ideas, M. H. Abrams, has pointed out in a seminal article that the work of art became an object of 'disinterested contemplation' when the aesthetic response was approximated to the religious experience by writers such as Shaftesbury, Kant, and Schiller.[1] The very demand for 'disinterestedness' made the passion of the collector look irrelevant if not worse. One senses that Mr Alsop in his heart of hearts shares this attitude and looks with contempt at the 'seamy side' of the art world. It is fortunate that this healthy disdain has not prevented him from chronicling its vicissitudes in the first scholarly history of art collecting.

[1] 'Kant and the Theology of Art,' *Notre Dame English Journal*, no. XIII (1981).

The claims of excellence

A good race horse, one supposes, is one that wins races, a good chess player one who can beat his opponents; we can tell a good watchmaker by his skill in making or repairing watches which accurately show the time, and a good linguist by his testable mastery of foreign languages. But how can we tell what is a good work of art or who is a great artist? The question does not only arise in the auction room where genuine or sometimes spurious masterpieces change hands at astronomical prices. Every year countless art students in all civilized countries are admitted or rejected by art schools and colleges, receive degrees of varying grades or prizes for the best work; later they submit their productions to owners of galleries, to critics, and to the public on whose evaluation of their efforts they will depend for their livelihood. By what criteria are they judged? Is it all a matter of fashion and pretence? If it is not, why is there so much disagreement among critics, and, if it is, how can we explain the fact that hard-headed businessmen 'invest' in works of art?

Many specialists have preferred to withdraw behind a smoke-screen of esoteric jargon at the approach of such philistine questions, but in the book under review Professor Jakob Rosenberg has had the courage to come out into the open and to attempt an answer in plain language. He has devoted his Mellon Lectures in the Fine Arts of 1964 to what he calls 'Quality in Art'. The title, perhaps, bears traces of the author's background and professional origins. In German we speak of *Qualitätsgefühl* (a feeling for quality) as a first prerequisite of the Museum man and the connoisseur. Professor Rosenberg has long acquired a reputation in both these fields. He belonged to the great team of specialists who looked after the famous print room of the Berlin Museum, and after emigrating to the United States he continued his distinguished career at the Fogg Museum of Harvard University both as curator of prints and as a teacher. He has never been content merely to practice the intuitive skills of the discriminating collector but has regarded it as his task to pass on his insights to the next generation, and not to specialists only. For many years he gave courses at Harvard in which he tried to open the eyes of his students to the subtle beauties of prints and drawings, and he succeeded, by all accounts, in communicating his love and appreciation to many young people whose lives he has thus permanently enriched.

The method employed in this book goes far to explain his success. For the main body consists of thirty-six pairs of well-chosen comparisons between individual works of art, mostly drawings, which differ appreciably in artistic quality. Comparisons are routine in courses in art appreciation, but what distinguishes Professor Rosenberg's juxtapositions from similar ones is the skill of selection based on an unrivalled knowledge of old master drawings. He has succeeded in finding a large number of works genuinely comparable

Originally published under the title 'How Do You Know It's Any Good?' in the *New York Review of Books*, 1 February 1968, as a review of Jakob Rosenberg, *On Quality in Art: Criteria of Excellence Past and Present*.

in style, subject, and technique, works, that is, of the same kind whose relative value needs to be judged.

It was an excellent idea to select the material from the workshop of the connoisseur. The type of problem exemplified in this book: whether a given drawing is by the hand of van Gogh or by that of a forger, or which of two very similar drawings in Rembrandt's style is the copy and which is the original, raises the question of 'quality' in a severely practical way. It will be assumed, in other words, that the forger or copyist will be less good an artist than the master he imitates, and that this artistic weakness will give him away. The same is also true, up to a point, of that other question which traditionally concerns the connoisseur, the question whether a given work is by the master himself or merely by his 'school'. Here, too, it is generally believed that a drawing in the manner of a certain master which is not quite up to his artistic standards must be attributed to one of his apprentices or imitators.

Of course, where other criteria are lacking there will always be an element of circularity in the procedure. To take the first comparison in the book: two drawings of heads of orientals of which one is attributed to Schongauer, the other to an imitator. It was Professor Rosenberg himself who made this attribution as long ago as 1923 in his pioneering monograph on the artist. He made it on the grounds of quality and he was surely right. But is he equally right now to demonstrate the difference between a master and an imitator by means of the same example? It is a pity, at any rate, that the book lacks any bibliographical references which would enable the reader to check the source of the attributions and the consensus achieved. Among connoisseurs, there are expansionists and restrictionists. The first are popular with collectors who like to see the name of famous masters on the mounts of drawings in their possession, the second are preferred by art historians who want to keep the image of the masters pure and unadulterated. Professor Rosenberg belongs to the latter group. He would no doubt endorse the remark attributed to his compatriot Max Liebermann that it will be the job of future art historians to deny that he ever painted his bad pictures. Just as Homer sometimes nods, so even great artists sometimes may have muffed a drawing, but this caution about the safety of atrributions does not invalidate Professor Rosenberg's method of sharpening our eyes to quality in performance. In reading him we learn how a sensitive and experienced connoisseur argues cases of this kind; no teacher of art history will neglect this lucid demonstration.

There is one limitation to this method to which the author himself has frankly and frequently drawn attention. Rosenberg's criteria derived from connoisseurship apply ideally only to the rating of works very close to each other whose attribution can conceivably be in doubt. They permit him to show the superiority of a study of drapery attributed to Leonardo over one he assigns to Lorenzo di Credi, or of a Biblical illustration he gives to Rembrandt over one he considers to be by his pupil Eeckhout. But they leave still unanswered the larger question whether Leonardo or Rembrandt

was the greater artist or, for that matter, what may have been the relative merits of Lorenzo di Credi and Eeckhout. Yet Professor Rosenberg is confident that in his attempts to show up the difference between the excellent and the mediocre he will gradually arrive at a set of criteria of more general validity. Modestly not staking his claims too high, he has phrased his descriptions in an impressionistic language from which he yet hopes to extract a series of uniform concepts of excellence. Here the result is more vulnerable.

Not surprisingly, perhaps, he is most convincing where he is least theoretical. Going through his descriptions one notices how often he draws attention to success or failure in the accurate and persuasive representation of reality. 'There is in the Leonardo a much clearer expression of the body's form and movement under the drapery' (p. 136). Dürer 'clarifies the complicated opening of the fur coat and the shirt' (p. 162). In a drawing of Rembrandt's school 'the structure of the bridge leading through the middle distance on the left is hard to understand . . .' (p. 185). 'Compared with Watteau's figure, Lancret's appears stiff, in spite of its movement. The light does not model the form with the same intensity, flexibility and ease' (p. 190). This is the language of the good old-fashioned drawing master who urges the pupil to look carefully both at the model and at his own drawing. It is well to be reminded that the masters with whom this book is concerned generally passed this test much more easily than did the tyros, that Leonardo and Rubens knew how the head sits on the shoulders while lesser artists were less sure.

Professor Rosenberg knows as well as anyone that this mastery alone does not suffice as a criterion of excellence. Moreover, representational skill cannot always be tested with the same degree of objectivity. Our judgement becomes increasingly subjective the further we move from representation to suggestion. All representational drawings contain such an element of suggestion. The marks on the paper can be read as indications of solid shapes and of space, but they need not be so read. The less redundancy there is in the drawing (for instance through shading), the more ambiguous will the artist's message become. Thus a perverse or stubborn reader may decline to follow the author when he is asked to 'admire Rembrandt's mastery in creating a highly expressive scene with a minimum of articulate strokes that build up . . . the structure of this sandy, rugged landscape . . . and a sundrenched atmosphere' (p. 184). The same non-cooperative reader might wonder whether the charge levelled against a drawing by van Borssom is not inherent in the medium itself, i.e., that 'his spatial image appears incomplete and vague in the distances' (p. 190). In sober fact not even a Rembrandt can ever give us enough information in a landscape drawing to establish accurately the size and distance of the objects represented, nor, for that matter, can a photograph. Not that such criticism necessarily invalidates Professor Rosenberg's observations: they remain illuminating when applied to particular drawings, but they lose some of their force when they are made to serve for the formulation of general principles. The general qualities Pro-

fessor Rosenberg demands for 'Form' and 'Space' in works of art of proven excellence (p. 204) are therefore both too elusive and too subjective. There must be many run-of-the-mill drawings where the forms can be described as showing 'solidity, organic character, coherence [and] clear distinction of planes', and where the space can be read as 'articulate, continuous and comprehensive'. There must also be masterpieces which could not be so described.

In the author's final list of criteria, however, these representational qualities do not come first. The list begins with 'qualities of line and tone' which are specified as 'sensitivity, articulateness, flexibility, ease, surety, spontaneity, and suggestiveness'. Leaving aside the last (which really belongs to form and space) we have a number of laudatory terms none of which would be easy to explain with precision. Not that they are meaningless, any more than is the word 'quality' they are meant to characterize, but one could think of countless instances where their exact application would be in doubt. Perhaps that criterion of excellence they are meant to convey could best be subsumed under the heading 'control'. The great artist, as Professor Rosenberg shows in so many instances, is in superb control of his medium. He can do what he wants, largely because he only wants what he can do. He is intimately conversant with the potentialities of his means and responsive to the finest shades. Though he may not always be able to predict the exact shape or strength of the mark his pen or brush will leave on the paper, he will still remain in control by adjusting the next to the observed effect.

To talk in modern jargon, there is a constant 'feedback' between the great artist and his medium when he is on top of his form. Professor Rosenberg often brings out this quality in his best descriptions, particularly in those of virtuosos like Rubens and Watteau. But clearly there also are artists who like to wrestle with their medium and who would avoid the impression of 'ease'—Cézanne being the most exalted example. It looks once more as if the criteria of excellence here were also more elusive than the author allows. Moreover, how are we to recognize them? How are we to convince the unwilling skeptic that in the works which displease the author certain virtuoso effects are 'overdone' (pp. 183–189)? And what if our doubting Thomas counters in another instance that he has no objection to 'meticulous execution, . . . mechanical shading [and] hardness of contours' (p. 146)? The truth is surely that every critic is compelled to use such loaded terms in conveying his impression of artistic quality, but that he deceives himself if he thinks that the impression is derived from these observations. The description is often little more than a rationalization of the response.

Many of Professor Rosenberg's most persuasive characterizations, in other words, might be translated into exclamations of delight or of disapproval. They are gestures or pointers rather than the 'concepts' he is after. This applies in particular to the last separate criterion he wishes to establish, that of 'formal organization' which includes 'integration, . . . sense of balance, and richness of relationships'. He is anxious to show that here he has a tool which will also allow him

to assess works of non-figurative art, but the author's approach here is particularly cautious. There is a comparison between a cubist Picasso and a painting by Albert Gleizes in which he claims for the former that 'there is hardly a detail that could be changed without disturbing the balanced order of the whole' (p. 225)—a criterion taken from Aristotle's *Poetics* which is both somewhat obvious and hard to verify. He then presents a Kandinsky which equally contains fragments of the visible world in a jumble that is hardly convincingly described as a 'coherent whole'.

Not that anyone need doubt that we can and do sometimes experience an arrangement of shapes or marks as balanced or coherent. Contemporary painters, of course, frequently prefer the disturbing to the restful and the explosive to the organic. In some respects more 'abstract' art would have provided an interesting test case for the author. For whatever one may think of such experiments it is clear that some of these works exhibit more 'quality' than do others. Perhaps, also, it would be easier to show in such instances that the words we use in describing our reactions can never be more than loose metaphors, no more and no less so than are the descriptions of flavours in wine-seller's catalogues. Such descriptions are certainly not meaningless either. They convey something about the global character of the experience. But their sense easily evaporates when we are tempted to locate them more precisely. Professor Rosenberg is not the first author, nor is he likely to be the last, who has fallen into this trap when trying to give reasons for his reactions to individual works of art. Thus he justly exclaims in front of an enchanting drawing: 'How subtly and expressively Degas contrasts shapes and accents', but tries to account for this intuitive conviction of quality by asking us to 'notice the rectangular corner of the chair with the oval of the head, or the central vertical on the skirt with the diagonals formed in the center. There are variety and integration' (p. 198). This is the language of the art-historical seminar which derives its only justification from the need to keep a lantern slide a little longer on the screen.

True, this type of description is also sometimes claimed to teach beginners to 'see', but is there no danger that it deteriorates into a mild form of brain-washing? For those who know the vocabulary it is fatally easy to apply that technique also to a worthless work. We here read of a fine drawing by Matisse of a nude in an armchair in which 'there is a balance of attraction between the head, framed by the arms, and the legs so interestingly set one above the other' (p. 209). There must be plenty of pinups which could be described in the same terms without exhibiting 'quality'. More dangerous even is the possibility of this rhetoric being used to run down a great work. The cover of Professor Rosenberg's book is graced by a ravishing Picasso drawing of a nude in a landscape. Would it be hard to spoil someone's pleasure by describing the outline as 'wiry', the anatomy as 'superficial', the head as 'merely pretty', and the landscape as 'vague'? Was it not in some such way that great artists (including Picasso) were in fact condemned out of hand by critics of the past?

Was not Cézanne found clumsy and Rembrandt's chiaroscuro 'overdone'?

It is to be feared that Professor Rosenberg overrates the immunity of his method from such failures. He has preceded the main body of his book with five introductory chapters on great critics of the past, each representing a century since the Renaissance: Vasari, de Piles, Reynolds, Thoré, and Roger Fry. These richly illustrated chapters, which are mainly confined to quotations interspersed with a few words of commendation or mild criticism, are frankly disappointing. No effort is made to place these great figures into the context of their time, no hint is given of the relation between art criticism and the powerful theories of rhetoric from which the Academic theory of art derived so many of its concepts. But perhaps the basic flaw in Professor Rosenberg's account is his apparent conviction that this Academic theory was little more than an obstacle on the road to the discovery of artistic quality. On the whole the critics of the past get good marks whenever they appear to transcend the alleged limits of the academic dogma. But much of this rests on a misunderstanding of the issues involved. True, academic doctrine took it for granted that an artist had to learn and master the skills of representation and dramatic evocation, and that he should not offend against the rules of decorum. But ever since Vasari it was part of the tradition that perfection demanded not only a knowledge of the rules but 'a certain license within the rules' and a 'grace that exceeds measurement'. This doctrine of grace is the important correlate of the doctrine of genius and of ideal beauty. Human effort alone can never create a work of art. It also needs grace, a term that hovers between our idea of 'gracefulness' and that favour from heaven which is the free gift of God.

In the last analysis this is the very doctrine Professor Rosenberg applies for the discernment of excellence, though what was known as grace he describes in words such as 'vitality, originality or inventiveness', characteristics which are equally beyond the reach of conscious effort. In trying to show the presence of this divine spark in the work of the masters he has earned our gratitude for inculcating a fresh respect for their towering achievement. But it would be a pity if this respect were gained at the expense of journeymen who used such talents as they had to the best advantage of their art. For where the emphasis on vitality and originality becomes too exclusive it may lead precisely to those attitudes which, in Professor Rosenberg's view, have undermined 'quality' in contemporary art. In the long run it may turn out to be more profitable to probe the traditions of excellence in craftsmanship that produced a Lorenzo di Credi or a Cornelis de Vos than to look for that mysterious quality which may enable a rare genius to absorb, transfigure, and transcend these skills.

Yet it would be wrong to conclude that Professor Rosenberg's pilgrimage in search of the sources of grace was in vain because he has not quite succeeded in plotting the life-giving spring on the map of rational knowledge. Would he really want us to follow its waters

to the source only to bottle and label it? If we could specify in precise words what characteristics combine in that supreme excellence he has taught us to sense in the works he loves most, we could program a computer to match them *ad libitum*. He is the last man to want us to make such an attempt, but even if we wanted to do so, we would surely fail. Our language which was developed for quite different needs is notoriously unable to specify sensory qualities, let alone that resultant 'quality' of which we need not doubt the existence because we cannot pin it down in words.

The story goes that a manufacturer of a mechanical piano approached Artur Schnabel with a request to play into his machine. 'Ours', he assured the artist, 'is not one of these crude contraptions you may well dislike. In fact it has ten gradations of loudness'. 'What a pity', replied the pianist, 'for unfortunately I have eleven'.

The meaning of beauty

To the modern critic of language the so-called problem of beauty provides an easy target. In certain situations, he would argue, we are apt to say 'this is beautiful' or simply to exclaim 'ah, lovely!'; but does it therefore make sense to speak of the 'nature' of 'beauty' any more than it would to speak of the 'essence of ahness' or of the 'laws of loveliness'? But though the historian of art can perhaps afford to watch the Hunting of the Snark with some detachment, the art critic is in a less comfortable position. He is appointed as a cheer-leader and arbiter, and the greater his sense of responsibility, the more he will feel the urge to render account for his use of language.

This is what has happened to Mr Eric Newton. In his role as an advocate and interpreter of contemporary art to a reluctant public he has, so he says, 'been goaded into writing this book' by his own doubts and heart-searchings. Though one may feel that some acquaintance with the tricks of scientific method would have saved him much worry, it is this personal character of the book as the record of a mind earnestly striving to get away from meaningless catchwords and facile clichés which gives it its flavour and its value. For Mr Newton writes as an artist. Wherever he can speak from personal experience, as when he describes the etcher's reaction to his medium, the hold of tradition on the painter, or the transitoriness of standards of design, he writes with that vividness and conviction that comes from living contact with the subject under discussion.

Thus it is perhaps unfortunate that Mr Newton rejected introspection from the outset as far as the main theme of his book is concerned. The philosophers of the past, he argues, were 'doomed' because they were all examining states of mind rather than analysing beauty as 'an inherent quality'. Mr Newton believes that he has discovered this quality in what he calls 'law abiding' or 'mathematical behaviour'. His example of natural beauty is the nautilus shell whose graceful spiral can be described as a logarithmic curve, owing to the laws of its growth. Our love of these shapes is caused by an intuitive recognition of the laws which operate everywhere in nature even where no human mathematician could formulate them, and it is to this love that the artist gives expression by discovering new beauty in the world around him. In his contention that 'the origin of beauty is only to be found in God's geometry' Mr Newton stands of course in the long line of philosophers from Pythagoras and Plato to Fechner and the Gestalt psychologists. But unlike these professional philosophers Mr Newton is far too much in love with the object of his quest to submit it to all the rigours of Procrustean systematisation. He has hardly announced his theory before he cheerfully proceeds to destroy its usefulness even as a working hypothesis. It does not, we learn, explain beauty of colours, and even natural shapes only turn out to be beautiful when the operating 'laws' (by which he means forces) are 'fairly evenly balanced'. But that is not enough. The intuition of mathematical laws must also

Originally published under the title 'Age-Old Quest' in the *Listener*, 22 June 1950, as a review of Eric Newton, *The Meaning of Beauty*.

occasionally be baffled 'by an admixture of unintelligibility' 'or it will become bored', and yet, even our thwarted intuition of the laws operating in the growth of a pig would not cause us to love its form because 'association' is 'a formidable rival' to the mathematical theory of beauty. Yet, Mr Newton insists, 'the world of mathematics . . . is the ultimate goal of every artist' who is 'compelled to make the perilous journey towards it from his starting point in the world of the senses'.

To exemplify his theory Mr Newton devotes two chapters to an analysis of Paolo Veronese's *Mystical Marriage of St. Catherine* (Fig. 32). From the purely representational 'outer skin' he leads us to the 'second layer', the artist's comment on his theme, his noble

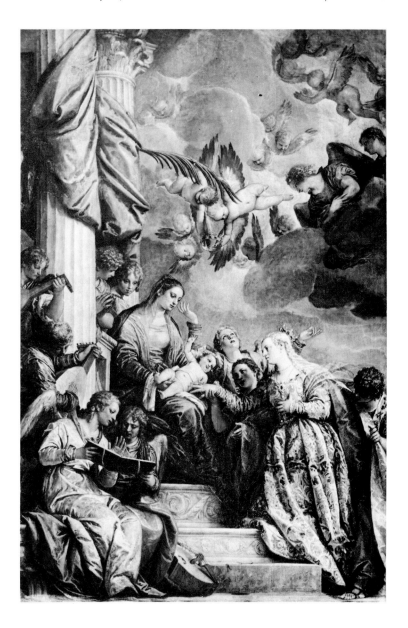

32 Paolo Veronese: *The Mystical Marriage of Saint Catherine*. 1575. Venice, Galleria dell'Accademia

187

'worldliness' which expresses the spirit of the age and of the artist. But to account for the purely visual beauty and to isolate its quality we are asked to burrow deeper. This, we hear, can only be expressed in the 'language of mathematics' by saying, for example, that Veronese 'has ... made extraordinary use of a slowly mounting diagonal that moves in a kind of counterpoint against a set of horizontals and verticals'.

There is more sensitivity and sense in Mr Newton's analysis than can be summarized in this bare outline, but here we must be concerned with its bearing on his theory of beauty. We all like to talk of diagonals and verticals when trying to discuss a painting, but how seriously should we take our language? A schoolboy who drew a diagonal only half as wobbly and vague as that which is said to create the visual beauty of Veronese's picture would hardly find that it engendered his teacher's love, and even a painter who used it might still produce a shocking daub. I suspect that these lines we draw across pictures are really rationalizations of a feeling of balance which derives from very different sources. The few drawings by Veronese which have survived show little concern for the geometry of composition. Nor do they suggest that the painter's 'starting point' is 'the world of the senses'. It is the story he has been asked to tell and which he has to make readable in ready visual symbols. And so in the picture. This is an altar painting and one must be able to pray to its Saints. Ideally they should be turned to the beholder as are the Saints on Byzantine icons. But they are also engaged in a story without which they would not be recognizable and thus their heads and gestures are turned towards each other. Everything centres on the symbolic gesture of union. Whoever is fond of this kind of geometry can draw a circle round it at almost any distance, taking in the head of the Virgin, and he will find that the enclosed roundel makes a well-organized whole, despite the fact that Mr Newton's diagonals have been eliminated. This visible concentration on the sacred theme should make us pause. Is the religious conception of the picture really as 'absurd' as we are told? Is there any truth in the Romantic confusion of the primitive with the mystical and in the Puritan identification of Renaissance beauty with 'worldliness'? Can there be anything more mystical than angels, as tangible and alive as Veronese's? That one could go on arguing like this for ever is perhaps the best compliment that can be paid to Mr Newton's thought-provoking book.

27
Should a museum be active?

Ours is an age of rapid change. Technological progress and social mobility are transforming the world. Those who cannot keep up with the pace may go under. It is little wonder that education and the mass media have become geared to spreading the gospel of adaptability, of dynamism and of a 'forward-looking' policy. Where conservatism may be suicidal one can only hope that this propaganda will succeed. But is there not one small area where the exaltation of change is almost paradoxical? A museum's prime social function is to conserve, it must be conservative, although clearly this function need not conflict with activity. We are all grateful to the scholars and administrators in our museums who devote their lives to very strenuous activity—cataloguing their treasures, restoring damage, answering queries and, above all, making the objects under their care accessible.

If this is what is meant by being active, the answer to the rhetorical question which forms the title of this little essay is an emphatic 'Yes'. Here, as always, it depends what is meant. For in implying a doubt as to whether a museum should be active I was not thinking of advocating laziness or passivity on the part of the staff. The word active has been used in the Western tradition, in contradistinction to a very different value which was once considered to be superior. Ever since Aristotle, two modes of life have been contrasted in ethics, the active and the contemplative. I think it is clear that if this alternative is borne in mind, the museum is the one place which should remain a haven for the contemplative life. Recently the news went round the world that a new and dynamic director of one of the great museums had wonderful plans for the future. Objects would no longer be displayed in square showcases (how can you have 'square' cases and be 'with it'?), they would be suspended from mobiles and lit by spotlights. This may be travesty, but it is not uninstructive. It is clear that even a 'gimmick' of this kind is intended to serve a good cause, the cause of attracting crowds, of bringing people into the museum and making them look at treasures which have remained unnoticed for too long in their square showcases. We can assume that the crowds are likely to come to see a fresh method of display which will be written up by the press and discussed at cocktail parties but will this nine-day wonder really bring the nine-hundred-years wonder of craftsmanship nearer to the beholder? Will not the attention caused by the method of display distract us from contemplation?

True, the objects in those glass cases (whether square or round) are remote, they are the products of ages long past, they embody values which differ from those of the present. The admiration for sheer skill and patience, the pride in precious materials, the love of finish and the standards of beauty we may discover in such an object would be sufficient to puzzle the up-to-date art lover even if it were not for the strange intellectual content of the symbols and stories he may find represented. Clearly, moreover, these works were made to be turned

Originally published under the same title in *Museum*, 21, 1968.

189

in the hand, to be lovingly discussed when the owner brought them out on festive occasions. Sometimes, it is true, the goblet or the casket found its way into the *trésor* of a cathedral or into the curiosity cabinet of a prince where it was meant mainly to enhance the owner's prestige, the impression of wealth and variety which should dazzle the eye. But whatever the original intention and subsequent context, the taste and the ideas, the social conditions and the attitude of mind prevalent in past ages are bound in every case to have differed enormously from those of the present. If the beholder is to see and understand them he simply must make an effort, not an intellectual effort necessarily, but an attempt to make contact which presupposes the contemplative, the receptive mood. Is this mood really likely to be fostered by spotlights and movement, by bustle and showmanship?

In making this point, I hope I am forcing open doors. Few people concerned with museums need be told that what we want of them is self-effacement, that all their methods should be directed towards letting the object speak for itself without unnecessary distractions. Sometimes, however, I feel that the display still underrates the power of concentration that belongs to the contemplative state of mind which the museum should foster. The great drive for selectivity, for spacing out the exhibits, may be due to this psychological mistake. Those who withdraw to the stillness of a museum may be much more capable of concentration than they are usually given credit for. The idea that an object can only be seen if it is surrounded by vast empty spaces is belied every day of our lives. We can read a newspaper column without even noticing the adjoining print; we can look at a picture book without being disturbed by the picture on the opposite page. A display case full of 18th-century snuffboxes will not prevent a lover of these dainty objects from looking at them one by one. It is perfectly true that for those who have never acquired a taste for this style and craft the sight of a single snuffbox which they may be shown in a private house will be infinitely more pleasing and rewarding than the showcase. But what can we do about this? The museum is unfortunately an accumulation which nobody can ever hope to exhaust in one visit or in fifty. This drawback of the public collection would remain even if only one of these boxes were shown, for there will be enough counter-attractions to compete even with the isolated item. All we gain by such radical 'thinning out' is the doubtful advantage of preventing the visitor from choosing for himself. Willy-nilly the director becomes the arbiter of taste, and styles not considered to be in tune with present trends are in danger of being forgotten altogether.

I venture to think that some of the traditional palliatives are still the best we can do to overcome the shortcomings of any large collection. One is the arrangement of 'secondary' or study collections which should always be accessible without special application, to be explored not only by connoisseurs but even more eagerly by the curious in search of novel discoveries. It should be possible to encourage a frame of mind which finds the study collection especi-

190

ally attractive precisely because things are not there presented 'on a platter'. As to the tourist and hurried visitor of the primary collection, I believe it to be right to draw attention discreetly to a few of the most outstanding pieces by a mark. The method will satisfy the sightseer who will think he has at least seen the best; it also has a more subtle educative advantage because it implies that there are differences in quality and in noteworthiness among the objects exhibited. Thus the more contrary or independent-minded may be led to disagree with the curator's selection; they will want to make their own discoveries of a little, unmarked piece which they much prefer to the more famous items, and once they do this they are well on the road to real appreciation even if their first choice is capricious and wrongheaded. The real source of the confusion, fatigue and even giddiness that so easily overtakes the visitor to a large and crowded museum is not so much the mass of objects as a sense of disorientation. Even the practised museum visitor can fall victim to this state. But the point is that he, like everybody else, will be much more prone to this breakdown in an unfamiliar museum than in one which he has visited before.

This is certainly not because he knows all the objects, but because he knows the building and its layout. Floorplans and clear signposting in every room are certainly the best means of counteracting the sense of confusion and disorientation that distracts the bewildered visitor and prevents him from attaining that contemplative frame of mind which the museum should inspire. The experienced visitor will try in addition to supplement the information thus gained by first making a rapid round of the museum before concentrating on individual objects. He knows that once he has mastered the plan he will no longer be disturbed by the restlessness and labyrinthine layout of the collection. He will remember that this door on the left leads only to a small cabinet with Etruscan urns he does not particularly want to see again and that the hall with the ivories he is looking forward to seeing will be the third on the right. This knowledge will help to put his mind at rest, he is safe from those daunting surprises we sometimes experience when we turn a corner in the Louvre and find a whole flight of rooms we have never visited before.

This does not mean that there is no pleasure in exploring one of these great storehouses of the treasures of the past; the sheer wealth and variety of objects, of collections and sections still to be discovered can be exciting and educative (Figs. 33, 34). The princely collection mentioned before, with its accumulation of riches, is a phenomenon of the past which should be conserved rather than disturbed. We shall never see its like again. To groom and streamline it to conform to the taste of the present is to cut yet another link with the past which the contemplative are eager to ponder. They will see no contradiction between the immensity of these crammed galleries and the desire to find an object they love, provided only the object remains where they last saw it.

And here I come to the most serious dilemma which the problem of change, of activity, presents to those in charge of museums, a

dilemma, one feels, of which they may not always be aware. The lover of a collection wants to know his way about, he wants to treat it as his own, as a place where he can go when he has a few minutes to spare for contemplation, to look at a favourite painting or vase which means much to him. Sometimes he may want to show 'his' little bronze statuette to a friend, sometimes he wants simply to refresh his memory. What a disappointment awaits him if he finds the room closed for rearrangement or open but so changed that he cannot find what he has gone to look for. It has been sent to the provinces, or become the victim of some thinning-out process, it was of a period which pundits now call decadent, it is gone. Alas, this is more likely to happen in an active museum than in a stagnant collection. In such moments the lover of art begins to wonder, no doubt unjustly, whether all this change was really necessary, whether it was even intended for his benefit, or whether it was simply the outcome of the contemporary desire to change, to do something, to show initiative and to assail the public with fresh impressions which the press can write about.

Two contrasting experiences I recently had on a visit to the United States of America may explain these sentiments, even though they may not excuse them. In one of the great galleries of that rich continent a little unpretentious sketch by Corot once struck my fancy. It

33 Pitt Rivers Museum, Oxford. The layout designed according to the principles laid down by General Pitt Rivers in 1883

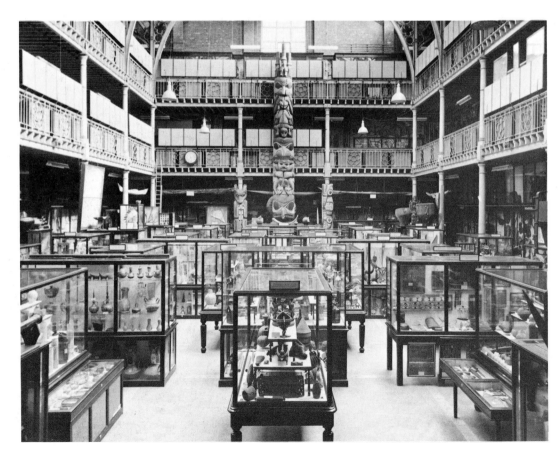

192

seemed to me a real gem of a painting, immensely subtle in tone, immensely simple in subject matter. I broke my journey to go to that museum mainly looking forward to a fresh encounter with this little masterpiece. I could not find it. Everything had been rearranged, and though there were still enough masterpieces, including Corots, to satisfy any visitor, my pleasure was spoilt. I wondered whether to look up the keeper and inquire, but such visits are usually more distracting than contemplative, and so I still do not know what happened to that painting and why it was removed.

In Boston I went to the Isabella Stewart Gardner Museum. I always do. The eccentric lady who bequeathed her collection under the condition that nothing must be altered or removed has often been criticized for this imposition. It cannot be denied that the interiors of her palace of which she was so proud now look rather dowdy, that some of the works there displayed are not as good as she thought they were, and that some of the masterpieces she did possess are not displayed to their very best advantage. There has been much criticism of the way she hung her greatest treasure, Titian's *Rape of Europa*, and it is true that one might see it more easily if it hung a little lower and away from the window. But who would grudge the little effort that is needed in front of this marvel? Would it really be all the more memorable if the effort were spared us? And are we not

34 Palazzo Pitti, Florence. The Palatine Gallery. Saturn Room

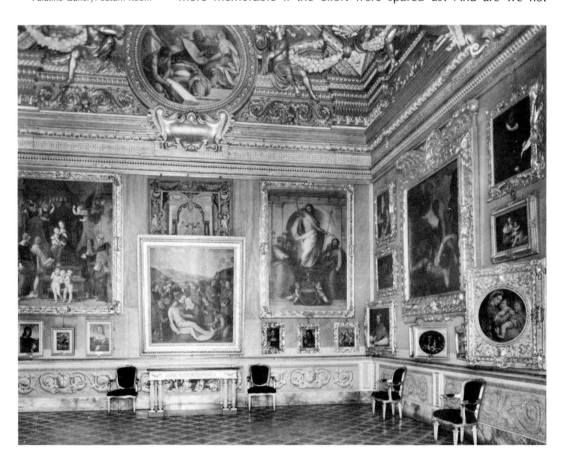

compensated by the knowledge that we always know where we shall find the painting again, where it awaits us, so to speak, and where we shall see the other pieces we have come to revisit? Admittedly it must be rather frustrating to be in charge of such a frozen collection. There are no show-cases to be re-arranged, no pictures to be removed into storage, no colour schemes to be studied, no tapestries to be swapped round, no rooms to be emptied to accommodate some circulating exhibition which will be the talk of the town. Worst of all, there are no new purchases to be made and so the connoisseurship and the collecting instinct of the director is not allowed an adequate outlet.

I would not want to advocate such a state of affairs as the norm for museums. There is no danger of this happening in any case. The pressures of our time are all for change, for activity, for public relations. If this were not so I would not have wanted to put the case for the opposite point of view even at the risk of being misunderstood or misrepresented. That case, I repeat, is not for inactivity. If a display can be improved and a collection made more accessible, who would want to prevent this? But I do believe that those in charge of our heritage should never be oblivious of the title they still carry in some countries, that of 'conservator', and that they should possess that rarest of abilities, the ability to leave well alone.

The few reflections of an historian which are here presented may at first seem to have little bearing on the topic under discussion. Yet I know that there are many young architects who are intrigued, fascinated, and perhaps occasionally exasperated by the secret magic of old towns. This secret seems to lie in some quality that is only inadequately described by the word 'organic'. Compared to these products of slow and almost unplanned growth the products of the boldest plans of our urbanists often look mechanical, cold and cheerless. How far can the modern planner hope to recapture the secret of the old cities without relapsing into a false historicism and a wasteful romanticism?

The attraction of old towns is not an invention of a few nostalgic aesthetes. Millions of tourists vote with their feet or with their wheels every year, crowding the narrow streets of Bruges and Salzburg, of Dinkelsbühl and San Gimignano (Fig. 35), Toledo and Mont-Saint-Michel beyond capacity. Unplanned and unhygienic as are these clusters of houses overtopped by a castle and accented by the steeples of ancient churches they seem to present something to these refugees from metropolis which they value and appreciate.

I shall try to approach this problem from two sides, considering first the modern visitor's subjective response to buildings he values as relics of the past and then some characteristics of these buildings themselves. It will be in this second part of my enquiry that I shall approach the central problem of this symposium, for I shall propose the hypothesis that the very conditions of slow and unplanned growth may sometimes be productive of qualities that are hard to imitate by deliberate planning. Those who know Professor Popper's writings, particularly his rejection of Utopian planning in favour of what he calls 'piecemeal engineering' will no doubt be able to anticipate my second argument. But to avoid overstating this hypothesis I must first turn to the subjective or psychological aspect that generally predisposes us to look with favour at human handiwork that has survived from distant ages.

It is not only the general tendency to ancestor worship I have here in mind, nor that vague nostalgia for the pretended 'good old times' that transfigures the old into the venerable. Our unwillingness to criticize the buildings of an old town has, I think, more subtle motives. Rightly or wrongly we see history as a process of growth which is largely removed from our actions and therefore from our judgements. This was by no means always the case. A traveller of the eighteenth century who was forced to spend a night in a mediaeval town would complain of its barbarous style that reflected the sorry conditions of those dark ages when good taste had been destroyed by the Goths and Vandals. Mozart found Nuremberg an ugly town, and Goethe notoriously failed to see anything at Assisi except the few columns of a Roman temple. Romanticism brought the change. The transition to a new attitude was marked by the vogue word of the

Originally published under the same title in *Architectural Association Journal*, April 1965.

'picturesque' that was applied to the irregular beauties both of nature and of art.[1]

I believe this fusion to be significant. To the Romantic it is as ridiculous to criticize nature as it is to condemn history. It is this attitude that won. Most of us will smile when we read the Poem on Landscape Painting by the eighteenth-century traveller William Gilpin who still warns the picturesque painter not to 'fix the scene, where Nature's lines run falsely, or refuse to harmonize' (verse 286–7). We no longer approach nature with some critical standard of beauty in mind, though we may all agree that the view from one spot may be preferable to that from another, or that the Swiss Alps are more beautiful than the Pomeranian plains. But such preference is not criticism. It merely means that we'd rather go to Switzerland than to Pomerania, or that if we must climb onto a mountain top we'd rather sweat with the reward of the better and more beautiful view. A critical attitude I would call one where the tourist on the Gornergrat would say 'magnificent, except that I wish the Southern slope of the Matterhorn were a bit steeper and the snowpatch on the peak of Monte Rosa were swept away.' We do not criticize mountains, trees or flowers and we do not criticize old buildings or towns even though we may have our preferences.

It is this 'mental set' (as psychologists call the way we tune ourselves up for an experience) which changes so radically when we are confronted with a new building. Rightly so, I would contend. For

[1] Christopher Hussey, *The Picturesque*, London, 1927.

35 San Gimignano

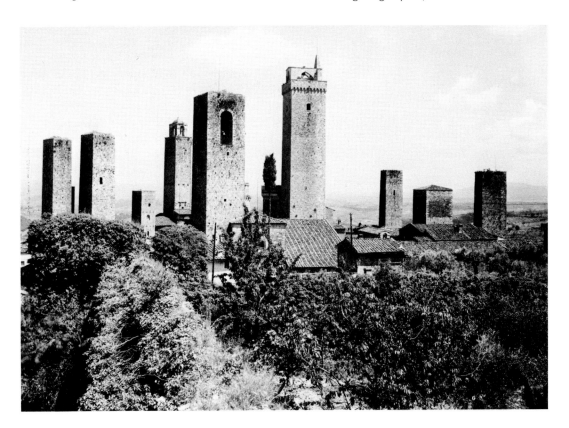

after all, when the product is one of our own time, we may still achieve something through our criticism. Even if we do not happen to know the architect, we know him potentially, as it were, we could ring him up or write and ask why on earth he made this door so small or that staircase so steep. The extreme of this critical 'mental set' will obviously be observed whenever a plan is up for discussion and when we know that criticism is what is asked of us. We feel (and here I touch on the theme of this symposium) that we are to share in a number of decisions and that our criticism will influence the ultimate shape of the building. When we see a recent project illustrated in an architectural journal we still feel involved with the process of decision-making, we wish we had been on the jury or we hope it will really be built in our town. Even a design of a new building in Brasilia will force us to take sides, we may wonder hopefully or fearfully whether that fashion or gimmick will 'catch on' and become fashionable in our parts.

All this, of course, does not enter when we look at old buildings. We may still be sufficiently close to the nineteenth century to remember Ruskin and his justified rages and therefore look with abhorrence at the slums of the industrial revolution. There are signs, however, that for the young even nineteenth-century buildings are gradually receding into the past which is beyond recall and beyond reproach. Of course if we want to study the other extreme we must watch our attitude to archaeological remains. Who would criticize Stonehenge and wish that one of the sarsens were a little broader or taller? It is part of the landscape, our mental landscape, first of all, and our physical scenery if we join the tourist pilgrims who want to reinforce that mental image and make sure Stonehenge is real.

The same, surely, is true of all the great landmarks of the past. They are seen and admired as landmarks, not criticized as human artefacts that are the products of decisions. The Palazzo Ducale at Venice (Fig. 36) must be one of the most photographed and gazed-at-buildings in the world. One wonders how many of the visitors to Venice even noticed that two of its windows are not aligned with the others, or asked themselves whether they would prefer the building, if it were more symmetrical or less. Imagine a modern designer coming up with such a solution and having to defend his decision! Needless to say we meet with such irregularities in nearly all old buildings. We accept them as tokens of their slow growth just as we accept the signs of weathering and decay as tokens of age (Fig. 37). They are part of the landscape, part of nature. How much this is the case for us becomes evident when human hands propose to interfere for the sake of restoration or preservation. We need only be told that what we see is largely the product of nineteenth century restorers for our attitude to shift. Acceptance is disturbed by suspicion.

We can easily observe this reaction in ourselves when we compare the picture of Mont-Saint-Michel such as it had survived from the Middle Ages into the nineteenth century (Fig. 38a) with the restoration proposed in 1886 and partly carried out in a somewhat modified form (Fig. 38b). Who would not now want to stay the

restorer's hand? Why could he not leave well alone? Why did he have to gild the lily and to falsify the genuine? Our reaction is not necessarily grounded on aesthetic preference or antiquarian piety. We may conceivably even grant the beauty of a high crowning steeple or the historical justification of certain additions; and yet we are left with the uncomfortable feeling that a natural growth has been interfered with. We are aware of arbitrary decisions recently made and imposed and our mood of happy acceptance has been spoilt. We almost wish we had never been shown the two pictures.

Yet we must be careful with this kind of psychological analysis, for it might easily explain too much. For though it may be important for our understanding of the Romantic approach to the creations of the past to watch the 'willing suspension' of our critical judgements in the face of nature and of old and weathered walls, it is even more important not to attribute the beauty of ancient cities to this reaction alone. For an uncritical attitude is not the same as an undiscri-

36 Canaletto: *Venice: the Molo, with the Palazzo Ducale and the prison*. 1743. Royal Collection
37 Merton College, Oxford. Mob Quad

minating one. We do not admire any old castle or any ancient townhall equally much. Some cities are renowned for their beauty rather than for their age and it would be rash indeed to claim that all this beauty is only in the beholder's uncritical eye.

The hypothesis I should like to put forward might be called one of conservative aesthetics. I would not want this to be confused with romantic or reactionary aesthetics. On the contrary, I put it forward in the belief that it might assist the modern architect in the criticism of his decisions and therefore lead to a closer approximation in the modern idiom of the happy results that marked the growth of the old towns.

Dr A. Jonckheere, in a recent discussion, spoke of the immense psychological difficulties that confront anyone who wants to envisage a finished building from the plans and elevations. He asked a group of architects whether they were never surprised when they saw their projects take shape and implied that such surprise, far from

38 Mont-Saint-Michel as it was in 1886 (top) and architect M. Corroyer's proposed restoration (*The Builder*, 13 November 1886)

being discreditable, would almost be inevitable. He aptly contrasted the difficulties of the architect in this respect with the relative ease with which a painter can adjust and steer the appearance of his painting while working at the canvas or even the wall. The painter, and particularly the contemporary painter, will always have an open mind as to what the picture still 'needs'. He will step back from the canvas and allow the half-finished configuration to stimulate his invention, grouping his way piecemeal to some kind of optimal solution. The architect, of course, can only remain flexible while the work is on the drawing board. He cannot, in modern conditions, go to the building site and tell the builders that he has changed his mind and would like the upper window a shade wider. I say 'under modern conditions', for it has been claimed on good evidence that such piecemeal changes were more acceptable in the fifteenth and sixteenth centuries and that the plan or model was very frequently altered during the process of erection as the building began to take shape and either patron or architect had second thoughts.[2] But quite apart from this fortuitous advantage of slow and inefficient building organization, there were in earlier times other safeguards against the kind of 'surprise' Dr Jonckheere considers normal. Briefly speaking the architect or builder operated with types of which he had seen many finished examples. The Dutch builder who was commissioned to build another house on one of Amsterdam's grachten (Fig. 39) knew as well as his patron how narrow were the limits within which he was allowed to be inventive. He had seen countless houses of the type, he may have liked one distribution of windows better than

[2] James S. Ackerman, 'Architectural Practice in the Italian Renaissance' *Journal of the Society of Architectural Historians,* October 1954

39 Amsterdam, Prinsengracht

another, one gable more than its neighbour, and so he developed that feel for the 'right' kind of shape that may well have enabled him to foresee pretty closely what kind of fenestration would go with what gable and how the door would look exactly right for this kind of façade.

As these types of townhouses or villas developed slowly there was plenty of time for the criticism of earlier mistakes and the groping for better solutions. It need not be pure romanticism, therefore, if we feel instinctively that many an old building, from a Cathedral to a lowly farmhouse, exhibits a sureness of touch, a balancing of effects and an air of appropriateness that is often absent from present day solutions. These solutions really 'evolved' more or less as organisms do, through the survival of the fittest and the elimination of undesirable mutations. If the snail's house or the seashell strikes us as 'organic', so does the form of the tribal hut or of the castle with its keep.

But not only did types develop and grow, thus enabling the architect to choose more or less between known alternatives, even the individual building would not represent for long a creation off the drawing board. Alterations would be made with every generation to adapt the house or the church to new requirements and new usages. And in these alterations the builder and his patrons would often enjoy the advantages of piecemeal planning that the painter or modeller seeks today. It is true that practical considerations would generally tell more with him than any conscious aesthetic bias. If the farmer wants an extra window or an extension of his stable, if the church needs a larger choir or the townhall another watchtower, decisions will rarely be overtly made with respect to the appearance of the whole. Yet I wonder whether we do not sometimes underrate the instinctive tact and aesthetic sense with which these alterations or additions were made in the past. It is my contention that we know so little about this aspect of architectural tradition because people have rarely looked for the evidence. I believe that this possible gap in our knowledge is due to the architectural historian's pre-occupation with style. It is well known that in the past alterations to older buildings were nearly always made in the current style. A Cathedral such as Canterbury represents, in its appearance, a whole history of changing styles from Norman through all the phases of Gothic and beyond. Such episodes as the incident of San Petronio of Bologna where the board of governors in the full tide of the Renaissance desired the church to be completed in the gothic style are deservedly famous as exceptions. Indeed it was the revulsion from the alleged incongruity of styles in these older buildings of slow growth that provoked the nineteenth century to some of its worst crimes of restoration.

I wonder, however, whether this emphasis on changing styles has not sometimes blinded architectural historians to the sense of continuity and balance that governed these earlier alterations. It would have been difficult indeed, both organizationally and artistically, to make alterations in a defunct idiom. The pattern books had dis-

appeared and the techniques been forgotten. But surely this need not imply that in all cases the architect or builder called in to extend a church or to alter a house was blind to the qualities of the building entrusted to him and that he would not want to fit the new to the old?

I do not want to idealize the past and to romanticize the workmen responsible for the appearance of these old buildings. But a careful reading of the building history of some of the famous landmarks of Europe does indeed suggest that there was more sensitivity to the need for adjustment than is usually allowed. The history of St Stephen's Cathedral in Vienna which, as a Viennese, I happen to know, presents a case in point. The Romanesque West Façade was not only left standing when the Gothic extension was decided upon in the fourteenth century; it was carefully fitted into the new plan with the additions on either side matching and mirroring the round windows and the niches of the earlier style in the new idiom (Fig.

40 St Stephen's Cathedral, Vienna. West front. Lithograph, c.1840

202

40). A different kind of adaptation can be seen in the same building after it had been decided in the fifteenth century to match the famous Northern steeple by another in the South (Fig. 41). Work was actually begun, but as soon as the second tower began to rise over the roofline it slowed down. We can see the ever decreasing pace of the operation through the dates marked there by the masons. And then the work stopped. Economic reasons and reasons of fashion may have played their part, but Hans Tietze[3] the historian of the building was surely right when he suggested that this was also due to a realization that the North spire was better without a rival. In the seventeenth and eighteenth centuries baroque accretions were added outside and inside the building, much to the regret of later purists. I have always wondered whether their strictures are justified. Is it only my romantic attachment to the landmark of Vienna as I have always known it which governs my judgement, or did these craftsmen know

[3] *Geschichte und Beschreibung des St. Stephansdomes in Wien*, Vienna, 1931. (vol. 23 of *Österreichische Kunsttopographie*).

41 St Stephen's Cathedral, Vienna, from the north-east

what they were doing when they fitted the Capistranus pulpit snugly into the existing framework? (Fig. 42). A little of both perhaps.

What is true of the individual church is also true, in a way, of the city as such. We can follow the growth of an ancient town like Vienna step by step, its development round the grid of the Roman camp, its widening circumvallations (Fig. 43). Each extension, each new building was certainly governed by practical considerations, but these need not exclude an instinctive attention to the appearance of things. And thus, when the tourist is driven in his charabanc to the famous view over Vienna from Prince Eugene's Belvedere (Fig. 44) he may be right in feeling that what he sees, however unplanned and (if the word is permitted) unplannable it may be, represents the outcome of an 'organic' growth, precisely, maybe, because it is not the outcome of a few large decisions but of innumerable small and manageable ones.[4]

[4] The kind of evolution I had in mind has meanwhile been described more fully and explicitly by Christopher Alexander, *Notes on the Synthesis of Form* (Cambridge, Mass., 1964), as the 'unselfconscious process'. (See review by R. Studer, *AA Journal* March 1965.) I have had occasion to re-state this hypothesis in a preface to an anthology of photographs from Austria, S. Krukenhauser, *Heritage of Beauty*, 1965.

42 The pulpit of Capistranus, St Stephen's Cathedral, Vienna
43 Vienna. The inner city from the air
44 Vienna from the Belvedere

Dilemmas
of modern art
criticism

Sixty-six years ago the German art historian Carl Justi, author of masterly monographs on Winckelmann, Velazquez, and Michelangelo, gave a lecture in Bonn under the title, *Der Amorphismus in der modernen Kunst* (Amorphism in Modern Art). He denounced the lack of form in the paintings produced by the younger generation, by which he principally meant the Impressionists. The title of Professor Erich Kahler's series of three lectures, now published in book form, is almost identical. He speaks of the 'disintegration of form in the arts', and raises his voice against what he calls 'the triumph of incoherence' in concrete poetry, contemporary music, and the visual arts.

In the apologetics of contemporary art it is usual to point to such precedents as Justi's lecture in order to argue that the earlier critic is now seen to have been wrong and the present one will surely share his fate. The validity of this argument is open to doubt. After all, it is possible that both critics will ultimately prove to have been right, or it is possible that one of them was wrong and the other right. Professor Kahler himself would not, perhaps, condemn Justi's diagnosis of Impressionism out of hand. He is convinced that what he calls the disintegration of form is a process of long standing which can be traced at least as far back as the origin of romanticism in the eighteenth century, but he also thinks that it is only during the last decade or so that this development has accelerated to such a frightening degree that it is time to sound a warning. For in his view the antics and excesses of the *avant garde* are symptomatic of the same tendencies toward dehumanization which have produced the crimes against humanity in our age.

Professor Kahler is not a conservative in the arts. He knows how to appreciate twentieth-century movements, but his appreciation does not alleviate his anxiety about the direction art and mankind are taking. It is difficult not to share these anxieties and yet it could be argued that Professor Kahler's reasoning in these lectures can be faulted. Steeped as he is in the philosophical tradition of aesthetics, he takes as his starting point Aristotle's comparison of a work of art with an organism. This organic character he describes as 'form', which in its turn he finds increasingly lacking in modern art. He quotes with emphasis and approval Aristotle's assertion that in such a structure nothing can be taken away or changed without destroying the whole. Strangely enough neither he nor the many other critics who have repeated his assertion appear to have noticed that if it were strictly true, there would be very few works of art indeed left to us. It would be hard to find a single building, temple, or cathedral we could still appreciate as a work of art nor would there be many ancient statues or old paintings which would stand up to this criterion. By this standard neither the poetry of Homer nor the beauty of the Bible could be appreciated.

Nor will the traditional contrast between the organic whole and

Originally published under the title 'Waiting for Cézanne' in the *New York Review of Books*, 20 June 1968, as a review of Erich Kahler, *The Disintegration of Form in the Arts* and James Johnson Sweeney, *Vision and Image*.

the merely mechanical shape stand up to criticism. Professor Kahler contrasts the fortuitous shape of a lake with the coherence of a living form, but Karl Popper showed long ago in *The Poverty of Historicism* that this type of contrast is illicit. The distribution of pressures and temperatures in a lake are far from fortuitous and incoherent, and if you regard it as an environment, its ecological balance is probably more delicate than that of many works of art. It is worth recalling, moreover, that Aristotle could know of neither the wonders of self-regulating mechanisms which have narrowed the gap between the organic and the machine, nor of the miracle of organ transplantation, which also tend to belie the traditional metaphor of organic unity. Be that as it may, neither Professor Kahler nor, it would seem, anybody else has ever succeeded in offering criteria for 'organic form' which would make it possible to account for that feeling of coherence and of 'necessity' which we do indeed experience when we come into contact with acknowledged works of art.

Could one blame anyone who attributed this feeling more to the force of habit created by familiarity than to any principle inherent in the works themselves? It is an old observation that man will call natural whatever he is used to, though nothing in human civilization is really natural as distinct from man-made. To most of us the sequence of courses in a meal may look natural, coherent, organic, and if we were served the dessert first and the soup last we would feel uncomfortable. Psychologically this is not surprising. We have built up expectations which cannot easily be unlearned. Is it not possible that such expectations also play their part in the experience of order and inevitability which Professor Kahler rightly discerns in our reaction to the great art of past ages? If this were indeed the case we could understand more easily why the middle-aged so rarely agree with the young about what is natural in art or in social habits.

To acknowledge this possibility does not mean to lapse into complete relativism. There may still be rich and poor traditions in art, crude or subtle conventions in poetry which we can acknowledge even where we can no longer learn or explore them in all their refinement. In this respect the coming of a new style presents no different problem to appreciation than does the discovery of an exotic idiom. Both have to be mastered and nobody can claim to have mastered them all.

Professor Kahler, however, intends to show not only that the artistic idioms of our present age are lacking in form, but that they deliberately embrace chaos. He quotes and illustrates a number of instances of the shock effects familiar to the art of our time and claims that they must be regarded as portents of our impending disintegration. He knows himself that his reading of these portents will not be shared by everybody:

> Many people, including intellectuals, are inclined to consider these movements as vogues of folly that will pass. But it seems to me that they are to be taken very seriously. They are the outcome of an evolutional trend, a consistent artistic and broadly human development.

It is this last assertion particularly that must be challenged. The application of evolutionism to the diminutive span of recorded human history rests on a metaphor which is no more valid or convincing than the comparison between organisms and works of art. The interpretation of the changing styles of art as manifestations of the evolving human spirit will not stand up to searching criticism. Like Hans Sedlmayr's *Art in Crisis*, and like his own earlier work, *The Tower and the Abyss*, Professor Kahler's lectures exemplify an approach which is closely allied to that historicism dissected in Popper's book which I have noted above. Art, in these and similar works, is treated as a symptom of an 'age'. There is no denying that such interpretations can be suggestive in the hands of skilled practitioners, but they will always suffer from the inherent weakness of what might be called retrospective collectivism. The age itself is personified and its 'art' is seen as its inevitable 'expression'. But 'art' meant different things to different civilizations, and the functions of literature, and even more so those of image-making, have shifted so radically that we are really not comparing like with like if we try to read the history of collective psychology—if there is such a thing—into the history of artistic forms. On the contrary, it is more likely that the excesses and puerilities in contemporary art which Professor Kahler deplores are the direct consequences of the historicist doctrines he shares with so many contemporary writers on art.

It so happens that these *idées reçues* are once more propounded and defended with disarming verve in another short book on the situation in contemporary art, *Vision and Image* by James Johnson Sweeney. It matters little here that Mr Sweeney's overt tendency is the opposite of that of Professor Kahler. He takes the orthodox line as a champion of modernism against the Philistine. Admittedly his task is made slightly easier by the fact that his book appears to have been written some ten years ago, before the most extreme tendencies which disturb Professor Kahler had made their full impact. But one doubts whether Mr Sweeney would have been deterred by them, for if his book expresses one anxiety it is that of falling behind. This preoccupation leads him to a Homeric simile which deserves to be quoted at some length:

> I have often thought of living art as a bus rolling down a long boulevard. We run to catch it. It does not stop. . . . If we do not board it, it gradually draws out of our sight. We are left with only the afterimages of what excited us while we were alongside it. . . . But if we board it . . . we can enjoy the new landscapes as they open up on each side and still look back comfortably, from our position, on the art of the past. . . . Perhaps the figure would be better if one imagined the would-be passenger, hanging precariously outside the rail on the rear of the bus, forced always to make an effort to maintain the position of vantage he has won for himself. For true and courageous art collecting demands this constant effort to keep the view forward and the eyes clear.

There seems to be a confusion here between buses and

bandwagons. Not that the comparison between art and vehicular traffic is altogether inspiring, but if it is to be made it is just as well to remember that buses run in many directions and that it is we who decide where we want to go. Mr Sweeney's convictions rest on the same fallacious evolutionist beliefs which Professor Kahler expresses with so much more learning and sophistication. He repeats again and again that the artist is an explorer, that 'every true work of art bends the frontier of human expression over fresh ground'. Hence to the man in the street, 'the unfamiliar inventions and the new terrains of pictorial expression are unintelligible'. He extols what he calls the 'tastebreakers' rather than tastemakers, and is naïvely convinced that all great artists from Giotto to the present day belonged to this desirable category.

Perhaps a Sienese layman in Duccio's time or a simple dweller in Paris in the twelfth century was just as bigoted in his hostility to fresh art developments as our contemporaries are today.

In view of Vasari's story that Duccio's Madonna Rucellai (which he attributes to Cimabue) was carried in triumph by the populace of Florence, as we also know Duccio's *Maestà* was carried, the example is especially unfortunate. But of course the idea of the rejection of innovations in the past is as much a myth as is the assumption that modern artists lack success. Compared to Picasso's success story Duccio indeed lived in obscurity.

But innovation, in Mr Sweeney's view, must never be confused with a repudiation of tradition. He appeals to the authority of T. S. Eliot and Stravinsky to show that a faith in the *avant garde* does not exclude a respect for the past. Yet if we were to probe how he can tell whether or not any particular new work of art continues the tradition, we would find his criteria no less elusive than Professor Kahler's criteria for form. Subscribing as he does to the metaphor of evolution, he can only think of one direction taken by art along that boulevard that extends into the future. It is the artist alone who is the conductor and inspector of this one-way traffic. The critic is explicitly told not to assess values but only to encourage 'the adventurous and exploratory in contemporary art'.

If we read and ponder these earnest reflections of an influential figure in the world of art, we shall perhaps be less surprised about the phenomena in contemporary art which so worry Professor Kahler. To put it crudely, artists have become like spoiled children—at least this applies to some of the self-appointed 'tastebreakers' who must constantly live up to the role of *enfant terrible*. They are asked to 'disintegrate' all existing forms and conventions and they do their best to oblige. Indeed, what can one expect of a group of people who are fed on the idea, from the moment they enter art school, that their products will of necessity be unintelligible, and will only reveal their profound significance to future generations? How is it possible to preserve sanity if you are treated as an oracle revealing the secret essence of our troubled times in words and images the true import of which you yourself cannot yet fathom? Considering the situation

208

into which modern criticism has placed the modern artist one can only be grateful for the amount of serious work that is still produced in our much maligned age.

Professor Kahler nowhere criticizes these assumptions; on the contrary, he shares them. His position, after all, rests on the belief that the artist is the mouthpiece of the *Zeitgeist*, the conscious or unconscious revealer of its hidden essence. He quotes with approval the remarks of von Huelsenbeck that the Dadaists '—far ahead of their time—were people whose peculiar sensibility made them aware of the approaching chaos and who tried to overcome it. . . .'

Indeed here it may be possible to discern some of Professor Kahler's allegiances, which are the consequence of his background and generation. His allegiances lie with expressionism, and what worries him most in the pronouncements of contemporary critics and artists, whom he quotes fairly and liberally, is their avowed rejection of expressionist aesthetics. But need we really see this rejection as a symptom of dehumanization? Are there not other grounds for this reaction with which even a humanist might sympathize? The longing for a cold, hard-edged objectivity, a dispassionate 'elimination of human sentiment' might, after all, merely represent a swing away from the emotional orgies of the previous generation. Here Mr Sweeney is more genuinely tolerant in emphasizing the element of playfulness in artistic explanations. Professor Kahler also acknowledges that 'artistic ingenuity does not become extinct with the advent of even the most precarious fashion of presentation . . . even among the products of pop art, and most particularly of op art, with its craft derivations . . . we encounter . . . combinations and inventions of a delightful quality'.

Have we a right to expect more? Was true artistic ingenuity ever widespread? What distinguishes the art of the past from the 'precarious fashion' of the present is that nobody in earlier ages thought of art as a bus. Images served a more intelligible, indeed, if the word is to be allowed, a more 'natural' or more 'organic' function in society than something to be shown at exhibitions and museums as signs of the times, or (in Morse Peckham's view[1]) to prepare us for the shocks of life in an age of change. As long as art had intelligible aims it was not beyond the reach of understanding. There certainly exists an historical problem in the decline of these functions and a more pressing social problem in what might be called the lack of a normal ecological niche for art in the life of our times. The propaganda surrounding art, the preaching to the man in the street that he take it on trust, the links with the stock market, the cliquishness, the loneliness of artists who dislike the bandwagon, all this provides a better explanation of the artistic scene today than the alleged psychology of our age. The malaise of the artists is not the same as the malaise of society. Granted that our society is beset by many passing and torturing problems it really has no monopoly of horrors. The historian who remembers Tamerlane in India, Cortes in Mexico, Cromwell in Ireland, the religious wars or the slave trade, even the slums of Dickens's and Hogarth's London is unlikely to be nostalgic for the past.

[1] The Views of Morse Peckham are discussed in detail in the next chapter.

Professor Kahler has emphasized in *The Tower and the Abyss* that the horrors our age has witnessed are worse. But if one must insist on such questionable comparisons one must not omit all mention of the efforts and of the capacity to alleviate suffering, which are at least equally characteristic of our age. Clearly one must respect and endorse the author's stand against inhumanity, but does it serve this important purpose to make our flesh creep about the agonies of the human condition in this age of science? Are we really as de-humanized and fragmented as he depicts us? Is there no human warmth left, because our modish art is cool? After all, we can take it or leave it, and many young people who are not philistines have developed a healthy sales resistance against this ballyhoo. There is no reason to think that the psychological balance of the young is less stable now than it was during periods when art may have flourished more luxuriantly. Even that permissiveness in education and in the arts which may be responsible for the less attractive forms of calculated silliness can also be regarded as a sign of strength.

Granted we all have a right to prefer the superlative discipline and artistry with which Velazquez turned his portraits of the dwarfs and jesters of the Spanish Court into poetry. Must we therefore succumb to a romantic longing for that alleged coherence of life that also produced the institution of the *auto de fe*? Is not the very lack of coherence a source of hope rather than of despair? When Carl Justi, lifting his eyes from Velazquez, attacked the artists of his time for their 'amorphism' he could not know that his strictures were refuted by a near recluse who was quietly working in Southern France—Cézanne, who neither wanted nor needed to exhibit. Maybe there is another Cézanne at work somewhere, whose *oeuvre* will one day confound Professor Kahler's gloomy diagnosis of our age—unless, jaywalking across the Boulevard, he has prematurely been knocked down by Mr Sweeney's bus.

'*Etonnez moi*'—the famous words which Diaghilev is said to have spoken to the young Cocteau—conveniently sum up the theory of art proposed in this book. Stripped of its involvement with trans-actionist psychology and translated from a rather polysyllabic termi-nology into simple language, Professor Peckham's hypothesis amounts to the assertion that art is an institution to which we turn when we want to feel a shock of surprise. We feel this want because we sense that it is good for us once in a while to receive a healthy jolt. Otherwise we would so easily get stuck in a rut and could no longer adapt to the new demands life is apt to make on us. The biological function of art, in other words, is that of a rehearsal, a training in mental gymnastics which increases our tolerance for the unexpected. In the author's words: 'There must . . . be some human activity which serves to break up orientations . . . to prepare the individual to observe what the orientation tells him is irrelevant, but what very well may be highly relevant' (p. xi); '. . . art is the re-inforcement of the capacity to endure disorientation so that a real and significant problem may emerge' (p. 314).

It is clear from the whole tenor of the book that it was his encoun-ter with contemporary *avant-garde* art that gave the author this shock of disorientation that set him in search of a new and significant problem. To accommodate it, he had indeed to break up the aes-thetic orientations on which he had been brought up. 'The artist', he came to conclude, 'is the challenger; his role requires him to create unpredicted situations' (p. 76). As an example of what he calls 'the inarticulate insight into exactly this way of defining art', he quotes John Cage's notorious concert-item entitled '$3\frac{1}{2}$', which consists of so many minutes of non-performance at the piano. Any decision that governs the artist's choice of the surprises he wishes to offer the public, the author infers, 'is determined by the values, both implicit and explicit, of his cultural environment. If he is a New York artist of the 1960s, those values tell him that, to be a successful artist, he must make a great innovative leap; if he can, he must start a whole new artistic fashion. If that is beyond him, he must make as much of a discontinuity as he can in the current fashion' (p. 262).

It has often happened that the innovations of contemporary artists have helped critics and historians to look at the past with fresh eyes and to discover new values in previously neglected styles. True, these rediscoveries were often accompanied by certain distortions of the historical truth, but even when these were corrected and adjusted by subsequent generations enough remained to justify such an exercise in projection. I was therefore very ready to go along with the author of this book and to test with him how far his generaliz-ations may take us in that revision of aesthetic orthodoxy that he demands. It is indeed a radical revision. His emphasis on surprise makes him contemptuous of the traditional idea that art should be in any way concerned with order. He has a point when he insists that

Originally published under the title 'Art at the End of its Tether' in the *New York Review of Books*, 23 June 1966, as a review of Morse Peckham, *Man's Rage for Chaos: Biology, Behavior and the Arts*.

order is something we impose on any perception and that the picture of a chaotic world of experience is untrue to biology and psychology. 'Whatever the world of an amoeba or an earthworm may be like'—I myself once argued against Malraux—'it certainly is not chaotic but structured. Where there is life there is order'. I also gladly hailed the author as an ally when I found him attacking and dissecting the approach to period styles, popular with survey courses, which looks for a common structure in the poetry, the music, the paintings and architecture of a given period. His insistence, mentioned above, that art is not a peculiar kind of structure but rather an institution demanding a type of behaviour also strikes me as fruitful. Moreover it is always fun watching a gifted critic demolishing tired old orthodoxies. Like the artists from whom he takes his cue Professor Peckham is out to astonish by innovatory behaviour, and in his first chapters he succeeds remarkably well. I particularly liked his pages on the dramatic metaphor (p. 49–59), in which the sociological concept of role-playing is vividly presented and illuminated. Altogether I would not hesitate to recommend his opening chapters as a subject for any seminar in criticism and the arts for, whether one agrees or not, they contain many excellent debating points.

It is all the more disappointing to have to confess to a feeling of let-down as soon as the author attempts in the subsequent chapters to build up a theory of his own that could be successfully applied to the arts and styles of all times. Stimulated, as he says, by the experiments of abstract art, notably by the theories of Kandinsky and Malevich, he first goes in search of what he calls 'primary signs' in the arts, those aspects, that is, of sensory experience like loudness and softness in music to which we can respond physiognomically. Strangely enough he believes that 'little study has been devoted to them' (p. 101). He is quite unaware of the tradition that reaches back from Kandinsky to the Romantic painter Humbert de Superville's *Essai sur les signes inconditionnels dans l'art* (1827), the content of which Charles Blanc had passed on to Seurat.

With his characteristic verve Professor Peckham seeks to disarm criticism by telling us that 'if the reader feels annoyed and disgusted I will not blame him in the least'. But what if he feels bored and dispirited? What else can be the result of reading that 'in painting and architecture verticality is a sign of demand, horizontality of acceptance' (p. 161)? Those, for instance, who entered Mussolini's notorious audience chambers, in which the dictator sat at the distant end from the door, did not report that they experienced the vast horizontal expanse they had to cross till they reached the presence as 'a sign of acceptance'. Here as always it has been shown long ago that there is no generalization of this kind to which a counter-example cannot easily be found. This does not prove that the quest is entirely useless, but it is useless on this level. The author is quick in accusing critics of what he calls ethnocentricity, the tendency to look at all art in the light of their own national tradition, but the ethnocentricity of his treatment of 'primary signs' in poetry really

212

takes one's breath away. 'In English poetry', he observes, 'comic verse is invariably rhymed, while double and triple rhymes are so thoroughly identified with comic verse that they are entirely excluded from serious verse' (p. 140). Rhyme, he therefore concludes, is a primary sign of 'adequacy' and thus 'rhymed tragedy flourished only briefly'. This may be true of England, but obviously not of France. His conclusion that this sense of adequacy belonging to comedy is achieved by short lines rather than long ones is equally refuted by Aristophanes. Goethe also often experimented with short lines and even with repeated rhymes in dramatic context of high seriousness.

It must be admitted, though, that the weakness of this chapter, of which the author is aware, is not fatally damaging to his fundamental thesis, which identifies art with the upsetting rather than with the creation of order. But the subsequent chapter on the formal aspects reveals, to my mind, such a fatal misunderstanding that little, if anything, can be rescued of his original hypothesis.

His starting-point here is the correct observation that works of art do not generally exhibit mathematical order and that the form postulated as a rule would feel lifeless and mechanical if it were not broken and transgressed in a thousand ways. Great poems do not scan with relentless regularity. Renaissance Madonnas are not really arranged in triangles, and Bach's fugues are not merely exercises in musical patternmaking. Here too the author may overrate the novelty of his emphasis. The Bergsonian philosopher Ludwig Klages stressed more than a generation ago that the hallmark of real music is not the monotonous beat (*Takt*) but the living flow of rhythm—not identical units in identical intervals of time, but similar units in similar intervals. Nearer to our time Dr. Anton Ehrenzweig in his book on *The Psychoanalysis of Artistic Vision and Hearing* has drawn attention to the many elements of 'disorder' that play hide-and-seek in art behind the façade of measured regularity. All this is true and important, but it does not suffice to establish Mr Peckham's central thesis that the work of art comes into being by what he calls 'discontinuity', the violation of form or more exactly of the receiver's expectation. If this were all, Cage's '$3\frac{1}{2}$' would really be the supreme piece of music and the best stories ever told would be 'shaggy dog' stories.

Obviously the surprise which great art offers us is of a very different character. What we experience is not only unexpected, it is better than we ever managed to expect, a thrilling masterstroke which yet triumphantly meets and exceeds the perceiver's expectation. It is true, of course, that the entirely expected move in art strikes us as trivial, boring, and lifeless. After a time it may even fail to register altogether and becomes mere background. Simple music moving regularly between tonic and dominant can have this effect. But if a deviation from the expected were all that was required to relieve the situation, any false note would do the trick. It may indeed wake us up, it may even train us painfully to face the imperfections of life in general, but it is not art. When we listen to great music of the classic

period, every move arouses expectations, we know of familiar paths by which the tension might be relieved. But we find to our delight that the master knows of a better, more unexpected and yet more convincing way to take us home to the tonic on an adventurous road. The same is true in literature. The rigid conventions of certain genres do not exclude surprise, they arouse it. Even where we know that in the end the lovers will fall into each other's arms we may still admire the surprising way in which the author reaches and presents this expected consummation. Even our response to performance on the stage or in music depends not only on our being surprised but on our being convinced. It would be easy enough to stage Hamlet as a comedy or to open his monologue with a yawn. It would not be convincing. When we say that a performance has restored the freshness of the work of art we do not mean that it has upset the expected order, but that it has shown us much more of it than we ever knew.

Granted that order may be something we impose. There are limits, both logical and psychological, to this relativism. It is not meaningless to say—as Professor Peckham seems to think—that an order can be discovered. There is an objective difference between crystals and clouds. It is true that our ability to see order differs and that it can be trained and extended to take in greater complexities. Nobody has ever denied this. But the introduction of greater complexity, which has indeed been traditionally connected with stylistic developments, surely differs from that discontinuity Professor Peckham sees as the dynamism behind any change in art.

If he were entirely right that the sole function of art is to teach us how to cope with unsettling experiences, there would be no point in ever returning to a work of art we have encountered before. This may be true of Cage's trick, for it loses its point once we know what he is up to. Mozart is more durable. Indeed one of the psychological mysteries of artistic surprise is that it does not wear off. A thriller may not be worth re-reading once we know who dun it. But we can read the Odyssey any number of times and look forward to the vicarious surprise Penelope will feel when the hero reveals himself at last. We can even wait with keen anticipation for a certain modulation in Schubert which we know by heart.

A theory of stylistic change based on such insecure foundations is bound to disappoint. Professor Peckham's idea that the dynamics of change are all-pervasive in art and apply to the styles of all cultures is fundamentally mistaken. He emphasizes (p. 261) that the immutability of Egyptian art is a myth because Egyptologists are able to date Egyptian artifacts with some confidence. Yet the discussion concerning the dates to be assigned to some famous products of conservative cultures—Chinese scrolls, Byzantine ivories, or Russian ikons—certainly show that such confidence is not unlimited. Moreover—and this is decisive—there is a vital difference between stylistic drift and a desire for change. Language too changes with time but vowel shifts do not occur to perform the biological function of disorientation. Where art is bound up with ritual, as it is in the majority of cultures, its social function is preservation rather than change.

214

Ritual, religious or secular, should reinforce expectations, not disappoint them. Its consoling and edifying character lies precisely in its relative immunity to change. Even in times of stress and disintegration people will try to hold fast to ritual, to celebrate Christmas and to sing the old songs which give them the reassurance of stability. Historians may discover that the Christmas tree is a comparatively recent innovation, but surely it was not introduced to provide a shock of novelty. Change in social institutions is not always due to the search for originality.

Professor Peckham chides academic critics who believe in the rules inherent in certain forms and who debate, for instance, whether Tchaikovsky's Sixth Symphony deserves to be called a symphony. In calling it so, the author argues (p. 237) that the composer intended the listener to relate his work to the tradition of the symphony from which he departed. The point is well taken where the arts of the last hundred years are concerned, but it would be unintelligible to members of more ritualistic cultures. It would be senseless to say that any poem one chooses to call a haiku thereby becomes a haiku. The form demands the arrangement of words in a certain order just as it demands the competition in haiku to follow certain ceremonial rules. These rules may drift but they are not revolutionized.

It may be argued, even, that the subtlety and refinement that develop in the arts of a stable élite, where connoisseurship learns to appreciate the slightest nuance, are unattainable in rapidly changing styles. Compared to Chinese bamboo paintings, European art may always be coarse-grained. Be that as it may, the author's proposal for the explanation of the relationship of the arts rests entirely on combining his ideas about primary signs with his interpretation of discontinuity. In other words, what the various arts of an individual period have in common is not a particular structure, but a certain preference for primary signs of adequacy or the reverse coupled with a given tolerance for rule-breaking and for change. It is clear that this solution is also derived from a contemplation of the contemporary scene. The attempt to apply it to the traditional sequence of Baroque, Enlightenment, and Romanticism lands the author unfortunately in the same kind of vague generalization about periods he had promised to banish. Even his verve and wit almost desert him in a chapter that recalls the worst sins of Spenglerian historicism. Thanks to the emergence of science (we are told), 'Baroque artists were governed by an orientation that gave a high value to problem exposure ... their art showed an unusually high level of discontinuity' (p. 265).

The direct influence of science is also seen in the emergence of a lucid prose style (again a very ethnocentric observation); the fugue emerged from the *ricercare* which means 'research' and the 'plunge into depth of the Baroque landscape ... is exposure without the defenses of recession in planes and successive reduction of colour iconicity ...'; 'the essence of Baroque architecture is spatial disorientation and the dissolution of solids and screens' (p. 269). We

215

are thus back with our old friend the 'essence'. In contrast to the 'cognitive tension' experienced on the top of the cultural pyramid during the period of the Baroque, the pleasures of cognitive harmony descended on the intellectual leaders of the Enlightenment leading to a reduction of tension. Thus, while 'the melodies of Bach in the 1740s are jagged . . . those of Mozart ripple up and down the scale of the triad' (283), in Tiepolo's ceiling frescoes 'the proportion of figures to sky becomes steadily smaller' (p. 283), and English poetry declines into prose. It is only too easy to recognize in these characterizations the old clichés about the shallowness of the Age of Reason.

But it would be unfair to concentrate too much on this attempt to apply the author's theory to the history of the arts. For even here, as I have said, this somewhat misguided exercise springs from his wish to generalize on what he has found true of the contemporary scene. There must be something that unites the arts, his argument runs, for the same break that is visible in painting with the rise of Cubism is noticeable in music with the emergence of atonality, and in literature with its various forms of experimentalisms. If all these exhibit these discontinuities, if all these, moreover, show the same preference for primary signs of tension and inadequacy, the same unity must be observed in previous stylistic breaks. The argument looks plausible, but it overlooks an important novel element in the twentieth-century situation that was absent from earlier epochs. This element is the degree of historical self-consciousness that governs the behaviour of both the producers and the perceivers of art. It was the philosophy of Hegelian historicism (to use Popper's term) which reacted back on the arts to an ever increasing extent and led to that self-fulfilling prophecy of a 'new art for a new age' which the various forms of futurism had postulated. The historiography of art history had its share in this self-consciousness that aimed at continuing the sequence of styles which had allegedly expressed the changing essence of past ages. If this experience is any guide, Professor Peckham's book in its turn will speed up the Rage for Chaos and the craving for novelty 'at the top of the cultural pyramid'. It would be a pity if this happened. For the author himself is shocked by what he considers the 'arrogance and indifference . . . of artist and perceiver . . . so perplexing, so monstrous'; his human compassion is outraged by what he sees as the 'cruelty of art' (p. 307).

The sentiment does him credit. But instead of trying therefore to justify the ways of art to man by inventing a new theory that fits the contemporary scene, he could also have looked at it with more critical detachment. It may be true (as I myself have recently suggested) that 'today the conviction is almost universal that those who stick to obsolete beliefs and who refuse to change will go to the wall . . . that we must adapt or die.' Hence the eagerness of those who want to stay on that 'top of the pyramid' to jump on the bandwagon (for which there always seems to be room on the top). But to equate this strenuous exercise with art is really an illicit extrapolation.

Quite near the opening of his Preface the author tells us how he sat

216

in a concert some ten years ago and found it increasingly astonishing 'that a couple of thousand people should sit quietly in a darkened auditorium while another hundred people made carefully predetermined sounds'. It was right that he wondered, but he would not have done so in a ritualistic culture, nor—dare one guess?—in a concert that everybody really enjoyed. If today those thousands are ready to submit to the cruelty of art in a ritualistic celebration of progress, a painful initiation ceremony into the priesthood of change, this is indeed an interesting phenomenon. Whether it is also as healthy as Professor Peckham thinks is a different matter.

Malraux on art and myth

André Malraux's *Psychology of Art* (later metamorphosed into *The Voices of Silence*) was an impressive if somewhat exasperating book. A selection of striking photographs exemplified the transformation which works of art of the past undergo as we prise them loose from their context to contemplate them in the Museum without Walls. But while other critics warned us against the falsifying effect of such isolation Malraux hailed it as a triumph of our myth-making faculty. This dialectical feat enabled him to have his cake and eat it; to bring out the appeal of ancient images to modern sensibilities without directly implying that the meanings he found in them were those intended by their makers.

Compared to this dazzling piece of sophisticated double talk the new book on The Metamorphosis of the Gods is disappointingly conventional. True, the preface still alludes to the old position, but the author's growing confidence in the universal validity of his own reactions has almost drowned his Spenglerian scepticism about understanding the past. Art can bridge the chasm that separates us from earlier civilizations, or, to quote the dark words of the oracle: 'That ineluctable "Nevermore" whose shadow falls across the history of civilizations is challenged by the magnificent enigma of these undying presences'.

What is it, then, that the Pythia now extracts from the images of the past? It is the message of their 'Otherness', their difference from what we call appearance. It is this otherness which draws people into the museum and fills them with religious awe. This kind of attraction might be summed up in the Tacitean tag *omne ignotum pro magnifico*, whatever is strange is majestic.

But the burden of Malraux's book appears to be that this reaction is the surest guide to the essence of ancient styles. Dismissing the idea of any art aiming at an imitation of Nature, he identifies artistic value with the distance from appearances. Art, he believes, owes this distance to the efforts of successive civilizations to invent forms consonant with their religious experience. The images of the ancient East were created to embody the sacred. Greek sculpture, it is true, abandoned the sacred in favour of the divine, but this elusive transition spelt disaster only when the art of the Romans 'aimed no longer at superseding appearance but at embellishing it'. It is with relief that the French Minister of Culture sees that civilization disintegrate: 'Darkness was falling on the Western world but the eyes of the sacred were kindling once again within the shadows.'

Arresting details of Byzantine mosaics, Merovingian miniatures and Romanesque reliefs are thus invoked in their turn to demonstrate their 'power of liberating the world of God from the thraldom of appearance'. Twelfth-century images of doom call forth the most eloquent prose hymns. When, in the subsequent century, 'joy makes a triumphant entry into sculpture', M. Malraux feels less happy, for the time is soon at hand for the most 'baffling mutation' when 'the

Originally published in *The Observer*, 9 October 1960, as a review of André Malraux, *The Metamorphosis of the Gods*.

artist's self-effacement was ending and the "saint" becoming a statue'. Even so, Giotto, like the Greeks, can still be defended against the charge of realism, but soon 'the world of men replaced the world of God'. Luckily even van Eyck's realism is deceptive and Botticelli 'painted Venus because she did not exist'.

This, I take it, is the outline of the story that Malraux wants to tell. Given his premises, it is not a surprising story but his tone suggests that the conventional history of art has at last been turned upside down and inside out. While Pliny, Vasari and their modern successors described the progress of art towards imitation he wants to rewrite history to conform to modern insights and modern taste. What he fails to see or to say is that this process of revision started in fact with the Romantics and came to a climax in German expressionists such as Wilhelm Worringer. It was Hegel, the arch-Romantic, who first systematically interpreted the changing art-forms of the past in terms of changes in the collective spirit and the dangerous half-truth which he thus launched has long become the small coin of art appreciation classes.

It is true, of course, that the arts of the past may help us to understand religious attitudes and truer still that without an understanding of religious attitudes we cannot hope to understand the art of the past. It is also painfully obvious that cult images were never intended to look like casual snapshots and that the duplication of objects does not result in what we call art.

And yet I fear this equation of artistic spirituality with lack of realism conceals a dangerous muddle. The modern artist who rejects photographic realism in favour of invented shapes refuses to adopt a method he feels to be stale, vulgar or tainted. He does not 'reject appearance' but certain discoveries and tricks (like perspective) by which appearance can be simulated. The assumption that the twelfth-century artist did the same is no more tenable than the idea that the Crusaders expressed their heroic fervour by rejecting the aeroplane as a means of transport to the Holy Land. Of course it is not their heroism which must be in doubt but the method of its diagnosis. Similarly there are countless aspects of medieval art that must fill us with awe and admiration but to make their distance from the real world of appearance the basis of such admiration betrays a fundamental misunderstanding of the nature of representation.

Appearances are not simply given to the artist to be copied or rejected. They must first be stalked and caught by those roundabout methods which the much maligned history of an earlier dispensation recorded. All styles make use of signs and symbols, but the notion that these must be the result of a particular act of abstraction is as stultifying as is the prejudice that their unreal appearance must be due to an incapacity for imitating nature. The principal question, in short, with which M. Malraux approaches the changing symbols of 'the Gods', the question 'Why do you not look like reality?', is as loaded as the proverbial 'Have you stopped beating your wife?' It smuggles a false alternative into the discussion from which we can extricate ourselves only by a fresh analysis.

The main objection against M. Malraux's style and method is that they make such an analysis almost impossible. He does not argue, he proclaims:

In the vastness of Santa Sophia the narrow windows, images in the heart of darkness, glimmer like distant constellations in the skies of Babylon, while the tapers before the icons keep vigil on the age-old seclusion of the Saviour. But into the never changing light of lamps, the eternity of *that which is*, the stained glass window introduces the everchanging light of the sun and the seasons, rhythms of the universal flux, bathing with vagrant gleams the sacred figures.

It takes some effort to work out that the semi-transparency of the window is here taken as a symbol or symptom of the gradual widening of the Hegelian consciousness to embrace the outside world. This may be poetry, it certainly is not history. Unfortunately (or fortunately) it is a kind of poetry to which the genius of English prose is particularly resistant. Stuart Gilbert is called, on the dust cover, the 'finest translator from the French into English in the world today', yet he can write: 'In the same manner as the Asiatic high places are gigantic pedestals for vanished apparitions, the Acropolis is the high place of the death of *Being*'. Few people will be able to endure this all the way in order to wrestle with Malraux's seductive epigrams. Even those of us who prefer footnotes to fireworks and daylight to dusk must find this a pity.

Freud's influence on the practice and criticism of art in the twentieth century is so all-pervasive that we are rarely aware of his reticence and caution in his published utterances about these matters. It is all the more welcome to find that he was less restrained in his private correspondence. In the wonderful selection of letters[1] that was published in 1960, Freud's attitude to the visual arts of the past and the present can be seen in the context of his rich and consistent culture that is so deeply rooted in the traditions of German classical *Bildung*. Indeed, to the end of his life Freud looked at art and at literature through the eyes of Goethe and of Schopenhauer. Those of us who were still in contact with his generation of highly-educated doctors and lawyers will recognize in his letters the approach to art that characterized the most cultivated 'Victorians' of Central Europe. It is an irony of fate that Freud's teachings were largely instrumental in undermining and destroying this tradition. Today, after some sixty years of this revolution, we may have sufficient distance to appreciate his own values and to ask afresh how far an acceptance of Freud's psychological theories need commit us to a rejection of his taste and critical outlook. It would be strange indeed if it did.

We are fortunate enough to have a record of Freud's discovery of painting in a long letter he wrote to his fiancée after a visit to the great Dresden galleries in December 1883:

> I think this visit will have brought a lasting gain to me, for up to now I had always thought there was a kind of conventional agreement among people who have a lot of time, to enthuse about paintings by famous masters. Here I sloughed off my barbarism and began to admire. There are wonderful things there; some of them I knew from photographs and reproductions and was able, for instance, to show the two English people the painting by van Dyck in which he most charmingly portrayed the children of the unfortunate Charles I, the later Charles II and James II and that stout young little princess. Then I saw Veroneses with the most beautiful heads and bodies, Madonnas, martyrs, etc., I hardly managed to glance at each of them.
>
> In a little sideroom I discovered what, from the type of arrangement, was bound to be a special treasure. I looked, it was the Madonna by Holbein (Fig. 45).[2] Do you know the painting? Several ugly women and a graceless young Miss kneel in front of the Madonna on the right, on the left a man with a monkish face holds a boy. The Madonna holds a boy in her arms and looks with such a holy expression down to the praying people. I was annoyed about the common ugly features and learned later that they were the portraits of the family of the Mayor of X who had commissioned the painting for himself. It is also said that the sick and misbegotten child which the Madonna holds in her arms is not the Christ child at all but the poor son of the Mayor who was expected to derive healing from this painting. The Madonna herself is not exactly beautiful either, her

Sigmund Freud, *Briefe 1873–1939*, ausgewählt und herausgegeben von Ernst L. Freud (London, 1960).

I hope and trust that my use of the German original edition of Freud's letters and writings will not be taken as a sign of disrespect for the authorized English translation. I am quite aware of the fact that the translations I have here attempted do not match the published version in their combination of readability and accuracy. But every translation is an interpretation, an act of choice, and having found more than once that I had to choose differently from Freud's translators if a given nuance that was relevant to my context was to be preserved, I had to translate the whole text or justify every alteration and amendment in a footnote which would have resulted in a messy text and a misleading impression.

The Dresden version is now considered a copy of the original in Darmstadt.

Originally published under the same title in *Encounter*, 26, 1966.

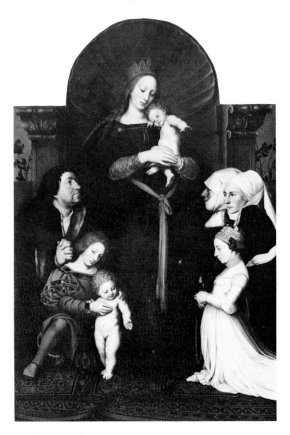

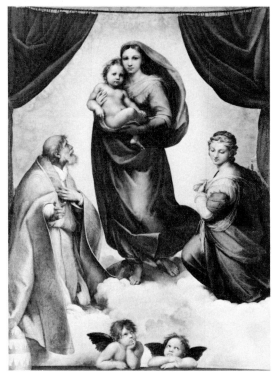

45 After Holbein: *Virgin with the
Family of Burgomaster Meyer*.
c.1525. Dresden, Gemäldegalerie
46 Raphael: *Sistine Madonna*.
c.1513. Dresden, Gemäldegalerie

eyes are protruding, her nose long and thin and yet she is the proper Queen of Heaven such as the devout German heart would dream of. I began to understand something of this Madonna.

Since I knew that there was also a Madonna by Raphael there I looked and found it at last in a similar room, shaped like a chapel with many people in front of her in silent contemplation. You know her certainly, it is the Sistine Madonna (Fig. 46). Surrounded by clouds which consist of nothing but little angels' heads, the Madonna stands there, a child with a deeply intense look sitting on her arm; Saint Sixtus (it might also be Pope Sixtus) looks up to her from one side, Saint Barbara looks down on the other towards the two wonderful little angels far down on the edge of the painting. The beauty of the painting exerts a spell which it is impossible to resist. And yet I had an important criticism to make of the Madonna. Holbein's is neither woman nor girl, her sublimity and holy humility excludes any further questioning. But Raphael's is a girl, one would think her sixteen years, she looks into the world with such innocence and liveliness that the idea obtruded itself against my will that she was a charming and appealing nurse-maid from our own world rather than from heaven. Here in Vienna this opinion was rejected as heresy, they praised a trait of greatness round her eyes that made her into the Madonna but this escaped me in the brief time I had.

But the only painting that really enthralled me completely was Titian's *Tribute Money* (Fig. 47), though I had known it before without paying special attention to it. This head of Christ, my darling, is the only plausible one that allows us too to imagine such a person. Indeed, I had the feeling that I now *had* to believe that that person was really so important because its representation is so successful. Yet there is nothing divine in it. A noble human face far removed from beauty but full of seriousness, sincerity, profundity, a mellow aloofness and yet deep-seated passion—if all this does not lie in this picture physiognomics does not exist. I would have liked to take the picture with me but there were too many people around, English women who copied, English women who sat and spoke softly, English women who went and looked. So I left with an exalted heart. . . .

The modern reader might feel tempted to see in Freud's reactions to these masterpieces the future explorer of the human soul. But we must not forget that in the tradition of the nineteenth century what was called the 'spiritual content' of a painting came first. The way the artist visualized the sacred personages and the events in which they were involved was always considered the true test of his greatness. It was the critic's task to elucidate these subtleties rather than to enlarge on the balance of the composition or the characteristics of the brushwork. I remember a remark made by an old lady of Freud's generation who was steeped in this Goethean tradition. A large photograph of Titian's *Tribute Money* from Dresden hung in her parlour and she explained to me that she even preferred this

reproduction to the original where, as she thought, the colour some-
what distracted the mind from the painting's spiritual content.

Nor should we be surprised at the responsiveness to Christian
scenes in a letter by a young Jew who always remained conscious of
his Jewish ancestry. For the interest in spiritual content excluded any
rejection of the religious element in the artistic heritage of the past
among those who wanted to share in this culture. We find the same
reaction in Freud when he writes to his bride about his first visit to
Nôtre-Dame in Paris (19 November 1885):

> When I entered, my first impression was a feeling I have never
> had before: 'This is a church'. I turned to Ricchetti who, after all,
> knows the churches of Italy. He stood in silence, quite overcome.
> I have never seen anything as awesome as its stark gloom, quite
> without decoration and very narrow, which may have contributed
> to the impression.

The next letter, five days later, shows not only how lasting this
impression was but how much these ancient symbols must have

47 Titian: *Tribute Money*. c.1518.
Dresden, Gemäldegalerie

224

meant in Freud's intellectual universe. Writing about Charcot's lecture and his admiration for that genius he continues:

>After some of his lectures I leave as I left Notre Dame with a new feeling of what perfection means.

The Louvre had found him a little less responsive. On October 19th he reported on his visit to the Department of Greek and Roman Antiquities:

>There are a few splendid things there, the ancient gods are represented umpteen times. I also saw the famous Venus de Milo without arms and paid her the usual compliment. I remembered that old Mendelssohn (the father in *The Mendelssohn Family*) writes about her from Paris as of a new exhibit without much enthusiasm. I think the beauty of that statue was not discovered till later and there is a lot of convention about it. For me these things are of more historical than aesthetic value. I was most attracted by the many busts of Emperors some of whom are excellently characterized. Many of the Emperors exist several times and do not resemble each other at all. There is bound to be a lot of mass-produced stuff and routine here. I only had time for the merest glance at the Assyrian and Egyptian rooms to which I must still return several times. There were Assyrian kings tall as the trees who hold lions like lap dogs in their arms, winged bull-men with tidy coiffures, cuneiform inscriptions as neat as if they were made yesterday, in Egypt painted reliefs in glowing colours, whole royal colossuses, real sphinxes, a world as in a dream.

The mysterious dream-like aura of these images, of course, retained its fascination for the explorer of dreams. As soon as he could afford it at all Freud started collecting ancient and near-Eastern *objets d'art*. Perhaps the memory of his visits to the admired Charcot also played a part here. In describing Charcot's lavishly furnished study Freud did not fail to notice:

>Showcases with antiques of Indian and Chinese origin, the wall covered with tapestries and paintings . . . the other rooms I fleetingly saw contained the same profusion of pictures, carpets and curiosities—in one word, a museum. (*20 January 1886*)

The passion for antiques and the love of collecting were among Freud's few permitted indulgences. Writing from Berlin a few weeks later he tells of his decision to interrupt his work and spend a morning in the museum:

>After all, as my colleague Dr Türkheim is fond of saying, you can't be a doctor twenty-four hours a day. . . .

>I glanced at the various ancient potsherds with sincere regrets not to understand more about it all and with nostalgic memories of the Louvre which is much more rich and splendid. Of course the most interesting things here are the excavations from Pergamon, all fragments representing the fight between the gods and the giants, scenes full of dramatic movement. (*10 March 1886*)

Readers of Ernest Jones' *Life* will remember how important it became for Freud, even during the years of his most intense research, to escape for a while to Italy, the traditional haven of the art lover. The summaries and itineraries given by Jones are sometimes tantalizingly short, but they suffice to show that Freud's Italian holidays, the places he visited and the length of his stay were very much in line with the habits of his time and environs. For this reason the lengthy speculations which Jones reports (and elaborates) on the reasons why Freud did not go to Rome before 1901 are, possibly, redundant. Most Viennese art lovers, Jew or Gentile, usually confined their trips to northern Italy and Tuscany. Rome seemed very far away compared to Venice or even Florence. Journeys on the crowded Italian trains were no pleasure, and if you did not yet know the Uffizi well, the Vatican could wait. It is true that after his first visit to the Vatican Freud wrote 'and to think that for years I was afraid to come to Rome'; but all art lovers were constantly told what a formidable task awaited them in Rome, how scholars such as Gregorovius had insisted that you needed at least a year for a proper appreciation of the Eternal City, and that it was utterly barbaric to go to Rome for a few days. If there was a reluctance on the part of Freud to take the plunge, it was hardly connected with his Jewish upbringing but rather with the awe with which German *Bildung* surrounded the city of which Goethe had said that he counted his rebirth from the moment he had arrived there.

What was much less usual in those days was a trip to Greece, and Freud's visit to Athens in 1904 is a measure of his interest in Greek art and civilization. Freud himself, as he later wrote to Romain Rolland, could hardly believe that he was really standing at the sacred spot, and to appreciate this feeling we should banish from our minds that ant-heap of tourists which the Acropolis has become in recent years. It was an achievement to travel that distance, but then it was worth the effort. Jones records that even twenty years later Freud said that 'the amber-coloured columns of the Acropolis were the most beautiful things he had ever seen in his life'.

There are few similar remarks in his published letters, but one reference to a museum visit written during his happy stay in Rome in 1907 proves that even during the years of his most intensive analytic work Freud remained faithful to the maxim that 'you can't be a doctor twenty-four hours a day'. Describing the Villa Borghese he tells his family:

> The Museum possesses what is probably the most beautiful Titian, it is called *Sacred and Profane Love*. . . . You certainly know the picture. The title makes no sense; what else the painting may signify is not known; suffice it, that it is very beautiful. . . . (*21 October 1907*)

It is with a slight shock that one discovers that Freud himself would not have shared the passion for unriddling the symbolic meaning of this and other Renaissance allegories which certainly prospered in the atmosphere his researches created. Symbols, for

226

him, were for the consulting room. In a Titian he looked for beauty.

It is true, of course, that Freud invited one great artist of the past into his consulting room. His monograph of 1910 on Leonardo da Vinci approaches at least two of Leonardo's paintings, the *Mona Lisa* and the *St Anne*, as if they were the phantasies of a patient. A large bibliography criticizing or defending Freud's use of the evidence has grown up round this venture[3] which has, perhaps, coloured the popular image of Freud's approach to art more than any other of his publications. It comes as a relief to the sceptical historian to read in Freud's letter to the painter Hermann Struck (7 November 1914) that he regarded it as 'half a novelistic fiction'—'I would not want you to judge the certainty of our results by this sample'.

What matters in the present context is only to what extent even this 'fiction' is based on Freud's physiognomic reactions to one of Leonardo's masterpieces. Readers of the monograph will remember the flash of recognition that comes over Freud as he contemplates Leonardo's painting of St Anne. Here was a record of the master's own childhood story, for in the house of his father he not only found his good step-mother but also a grandmother 'who—let us assume— fondled him no less than grandmothers usually do'. But this grand-mother's image, so Freud postulates, was fused in the artist's mind with that of his own mother Caterina. Leonardo, after all, had had two mothers and this explains the germ of the painting.

> The motherly figure farther removed from the boy represents in appearance and spatial relation to the boy his real earlier mother Caterina. The blissful smile of St Anne was probably used by the artist to deny and cover up the envy which that unfortunate woman must have felt when she had to yield to her more noble rival first her lover and now also her son.

Are not these physiognomic divinations the direct descendants of Freud's reflections on Raphael's Sistine Madonna—more nurse-maid than Queen of Heaven? He always took it for granted that what we must seek in the work of art is the maximum psychological content in the figures themselves. That this belief did not desert him we discover in Freud's second published paper on art, his study of Michelangelo's *Moses*. Here we are fully back in the tradition of nineteenth century art-appreciation. Not only do we read in the introductory words that the author 'is more attracted by the content of works of art than by their formal and technical qualities to which artists attach the greater importance'. In the final pages Freud also acknowledges that his reading of the statue had been nearly anticipated by W. Watkiss Lloyd in 1863. Two letters (25 September 1912, and 12 April 1933) tell us with what intensity Freud had wooed this great work of sculpture to find out its physiognomic secret. He went to S. Pietro in Vincoli every day throughout three weeks in Rome in 1912. 'I studied it, measured it, and drew it till I arrived at that insight which nevertheless I only dared to express anonymously in that paper. Only much later did I legitimize this

[3] The reference has been expanded in my lecture on Freud (*Tributes*, Oxford, 1984), in which I also returned to several of the texts and ideas here discussed.

227

non-analytic child'. Non-analytic in so far as Michelangelo's statue is approached in the same way in which Winckelmann or Lessing approached the *Laocoön Group* or Goethe the *Last Supper* by Leonardo. The beholder wants to know why Moses sits in exactly this posture, what had gone before, to explain it, and what would follow.

Jones suggested that Freud's concentration on the figure of the wrathful patriarch in that year was due to the tensions that he experienced in the Psycho-Analytical Society—i.e., that he identified with Moses who came down from the mountain only to find his people dancing round the golden calf. Something of these feelings may have entered into Freud's thoughts in the hours of communion with a great work of art, but again, it would be a mistake to underrate the force of tradition in his choice of Michelangelo's *Moses*. If there is any work of art that the cultured Jews of Central Europe adopted, it is this vision of the Hebrew leader. In the same context it is not surprising to read that Freud told Jones that Rembrandt was his favourite painter. Rembrandt's predilection for Old Testament scenes and the interest and sympathy with which the Dutch painter studied his Jewish models have generally secured him a place in the pantheon of assimilated Jews.

If confirmation were needed for this conservative and traditional character of Freud's approach to art it would be found in the utterances on modern movements which are contained in his post-war letters. The uncompromising hostility that is expressed here must indeed have surprised those who saw in Freud the champion of all contemporary trends. In June 1920, Oscar Pfister had sent Freud his pamphlet on *The Psychological and Biological Background of Expressionist Paintings*. In his introduction Pfister states that the movement of Expressionism had by now outgrown the stage in which it caused horrified spinsters to shriek. True, he continues, there still exist philistines who think that they have done enough if they affix the labels of ghastly, barbaric, bungling, perverse or pathological to this new movement. The author wants to remind the reader that Expressionism is a movement that embraces all the arts and includes masters who cannot be accused of incompetence. Pfister proposes to approach the problem through psycho-analysis. The bulk of his pamphlet concerns the work of an Expressionist artist whom Pfister had in analysis. We are given the associations of the artist to his own drawings (Fig. 48) which are treated like dreams. Asked for his associations to the angular cheek he drew, for instance, the artist said:

> The cheek of my father, a beautiful strong bone. . . . Now I must think of something nonsensical. The angular rhythm of the cheek reminds me of the square chair on which my father used to sit. . . .

The right-hand eye produced the association of the greatest fright of his life when a hare pursued by a dog had crossed the artist's path at night. . . .

What Pfister concludes from these and other transcripts is that the

48 Drawing by patient of Oscar Pfister

Expressionist artist is an autistic, introvert type, imprisoned in his own repressions. Much as he respects the high seriousness of the movement he still concludes with the hope that a new idealism would create a new kind of art that would combine a profound sense of reality with genuine idealism.

Freud's response shows his usual combination of uncompromising honesty and good breeding:

> I took up your pamphlet about Expressionism with no less eager curiosity than aversion and I read it in one go. In the end I liked it very much, not so much the purely analytic parts which can never get over the difficulties of interpretation for non-analysts, but what you connect with it and make of it. Often I said to myself: 'What a good and charitable person free from all injustice Pfister is, how little you can compare yourself to him and how nice it is that you must come to agree with everything at which he arrives in his own way'. For I must tell you that in private life I have no patience at all with lunatics. I only see the harm they can do and as far as these 'artists' are concerned, I am in fact one of those philistines and stick-in-the-muds whom you pillory in your introduction. But after all, you yourself then say clearly and exhaustively why these people have no claim to the title of artist. (*21 June 1920*)

Two years later Freud's position had hardened even more. Karl Abraham had sent him a drawing made by an Expressionist artist and this time Freud's response goes to the limit of politeness:

> Dear Friend, I received the drawing which allegedly represents your head. It is ghastly. I know what an excellent person you are, I am all the more deeply shocked that such a slight flaw in your character as is your tolerance or sympathy for modern 'art' should have been punished so cruelly. I hear from Lampl that the artist maintained that he saw you in this way. People such as he should be the last to be allowed access to analytic circles for they are the all-too-unwelcome illustrations of Adler's theory that it is precisely people with severe inborn defects of vision who become painters and draughtsmen. Let me forget this portrait in wishing you the very best for 1923. (*26 December 1922*)

It took almost sixteen years and the powerful advocacy of an admired friend, Stefan Zweig, to persuade Freud to receive such a modern artist. He agreed to see Salvador Dali in the second month after his move to London. The few lines he wrote on 20 July 1938, after this visit, contain the most revealing utterance by Freud on his attitude to art:

> I can really thank you for the introduction which yesterday's visitor brought me. For up to then I was inclined to consider the Surrealists who appeared to have chosen me as their patron saint, pure lunatics or let us say 95 per cent, as with 'pure' alcohol. The young Spaniard with his patently sincere and fanatic eyes and his undeniable technical mastery has suggested to me a different appreciation. It would indeed be very interesting to explore the

origins of such a painting analytically. Yet, as a critic, one might still be entitled to say that the concept of art resisted an extension beyond the point where the quantitative proportion between unconscious material and preconscious elaboration is kept within a certain limit. In any case, however, these are serious psychological problems.

For all its brevity this letter throws a flood of light on Freud's ideas about art and on his reasons for rejecting both Expressionism and Surrealism as non-art. It confirms the brilliant analysis of Freud's theory of art which we owe to Ernst Kris. It was Kris who, in his *Psycho-Analytic Explorations in Art* (New York 1952, and London 1953), pointed to Freud's book on *The Wit* (or to use Mr James Strachey's superior translation, *The Joke*) as the germinal model for any account of artistic creation along Freudian lines. It is indeed to this model that Freud alludes in the letter when he speaks of keeping the quantitative proportion between unconscious material and preconscious elaboration within certain limits.

For let us remember Freud's formula for the joke: 'A preconscious idea is exposed for a moment to the workings of the unconscious'. What the joke owes to the unconscious in this formula is not so much its content as its form, the dream-like condensation of meaning characteristic of what Freud calls the primary process. It is a process in which the impressions and experiences of our waking life are mixed and churned in unpredictable permutations and combinations. In the dream no less than in insanity the dynamism of this vortex overwhelms our waking thought, the reality principle of the ego. In the joke the ego merely makes use of this mechanism in order to invest an idea with a peculiar charm. A thought which it would perhaps be rude or indecorous to utter plain is dipped as it were into the magic spring of the primary process, as one can dip a flower or a twig into the calcine waters of Karlsbad where they emerge transformed into something rich and strange. In this new guise the idea is not only acceptable but even welcome.

What Freud had most in mind in constructing this model were puns. Take the famous answer to the question: 'Is life worth living?'—'It depends on the liver'.[4] It is easy to see what Freud calls the preconscious ideas which rise to the surface in this answer—ideas, that is, which are not unconscious in the sense of being totally repressed and therefore inaccessible to us but available to our conscious mind; in this case the joy in lots of alcohol which the liver should tolerate and the even more forbidden joy in the aggressive thought that there are lives not worth living. Respectability has imposed a taboo on both these ideas and to express them too boldly might cause embarrassment. But in the churning vortex of the primary process the two meanings of 'liver' came accidentally into contact and fused. A new structure is created and in this form the ideas cause pleasure and laughter. But this laughter is caused among sane grown-ups only because they can appreciate the delicate balance between preconscious thought and unconscious elabora-

[4] I take this example from a lecture by Leonard Forster, in *Translation*, Studies in Communication No. 2 (London, 1958).

tion. If the idea were smothered in a welter of punning the result would be more like gibberish than like a joke; if the pun were poor the idea would not be good enough to compensate for this lack of structure.

Clearly to Freud there was no artistic value in the primary process as such. It is a mechanism that belongs to every mind, the feeblest as well as the most developed. If he dismissed Expressionists and Surrealists as lunatics it was because he suspected these movements of confusing these mechanisms with art. Dali's 'undeniable technical mastery' had convinced him that he had been a little rash in this conviction. He was not persuaded, however, that this mastery had been put to the use of investing a preconscious, that is, a communicable idea, with a structure derived from unconscious mechanisms.

One may argue about the complete applicability of Freud's model of the joke to other forms of artistic creation, but this model certainly has two supreme virtues which must recommend it to the historian and critic of art. It explains the relevance both of the medium and its mastery: two vital elements which are sometimes neglected in less circumspect applications of psycho-analytic ideas to art.

That puns depend on the medium of a particular language scarcely needs demonstration. Without the accidental homophone the pun about the liver could not have seen the light of day. It is true that an ambitious genius has tried to translate this particular answer into French not without some measure of success: '*La vie vaut-elle la peine?—Question de foie*'. But inspired as is this translation, it still lacks the *double entendre* that it also depends on whose life it is.

Puns are not made: they are discovered in the language, and what the primary process does in Freud's account is really to facilitate this discovery by its rapid shuttling of associations. Take the famous rhyme by Hilaire Belloc:

When I am dead I hope it may be said
His sins were scarlet but his books were read.

There can be few writers who never had this slightly shocking thought that fame is more important to them than a good reputation. But it is the accident of the medium that permits its condensation into a joke. It is the mastery of the writer, moreover, that gives the joke such a concise and memorable form.

Freud's book on wit gives at least one clue to this mastery which we neglect at our peril: the discussion of the role of the child's pleasure in playing with language which, to Freud, is a functional pleasure connected with the acquisition of mastery. Surely it is convincing to think that such accidents of sound and meaning as make up the perfect pun are discovered by those who cultivate the childhood pleasure of experimenting and playing with words and nonsense syllables. It is in this play that the ego gains control and mastery of the primary process and learns to select and reject the formations that emerge from the welter of the unconscious.

Seen in this light there is indeed a kinship between the poet and

231

the punster. Both make their discovery in and through language. If great masters found satisfaction for many centuries in the device of the rhyme it was obviously not only because they were fond of jingling sounds. The search for the rhyme gives a purpose and satisfaction to the search for the thought which, in its turn, can only take shape within the medium of the poet's language. Poets' drafts often bear witness to this interaction. Where Keats in the *Ode to a Nightingale* had first written 'grief' he changed the word to 'sorrow' to rhyme with 'to-morrow'. He surely would not have done so had the slight change of nuance not satisfied him, had he not tested it against his own feelings and found it answering his mood. But the possible rhymes in the English language remain a reality to which his poetry had to adjust.

It is the denial of such realities which Freud dismissed as 'lunatic'. Far from looking in the world of art only for its unconscious content of biological drives and childhood memories he insisted on that degree of adjustment to reality that alone turns a dream into a work of art.

If this interpretation is correct it may permit us to formulate the vulgar misinterpretation of Freud's ideas in almost diagrammatic form. Expressionism and its derivatives in criticism appear to take the word *ex-pression* almost literally. They believe that an unconscious thought troubles the artist's inside and is therefore expelled outward by means of art to trouble the minds of the public as well. Form, on this reading, is little more than a wrapping for the unconscious contents which the consumer in his turn unwraps and discards. Freud's view clearly allows us to look at the matter from the other angle. It is often the wrapping that determines the content. Only those unconscious ideas that can be adjusted to the reality of formal structures become communicable and their value to others rests at least as much in the formal structure as in the idea. The code generates the message.

One of the most famous messages in the English language is Nelson's signal before the battle of Trafalgar. We know that Nelson approached his Signal Officer and said:

'Mr Paso, I wish to say to the Fleet, England confides that every man will do his duty' and he added, 'you must be quick. . . .' Paso replied, 'If your Lordship will permit me to substitute the word *expects* for *confides*, the signal will soon be completed, because the word *expects* is in the vocabulary, and *confides* must be spelt'.[5]

We owe the immortal formulation *England expects*, etc., to the character of the flag-code. We may owe some of the world's great masterpieces to similar accidents discovered in the potentialities of medium and style.

If we choose to call the Expressionist idea of art centrifugal, we might label this influence of the language on the message centripetal. It is this centripetal element that is so often neglected in popular accounts of artistic creation despite the fact that artists have always stressed its supreme importance.

There is perhaps no more beautiful introspective account of poetic

[5] E. B. Sargeant, *An Account of Lord Nelson's Signal* (London, 1908).

232

creation than the moving pages in Pasternak's *Dr Zhivago* in which Yuri sits down, during a crisis in his life, to write poetry:

> After two or three stanzas and several images by which he was himself astonished his work took possession of him and he experienced the approach of what is called inspiration. At such moments the correlation of the forces controlling the artist is, as it were, stood on its head. The ascendancy is no longer with the artist or the state of mind which he is trying to express, but with language, his instrument of expression. Language, the home and dwelling of beauty and meaning, itself begins to think and speak for man and turns wholly into music, not in the sense of outward, audible sounds but by virtue of the power and momentum of its inward flow. Then, like the current of a mighty river polishing stones and turning wheels by its very movement, the flow of speech creates in passing, by the force of its own laws, rhyme and rhythm and countless other forms and formations, still more important and until now undiscovered, unconsidered and unnamed.
>
> At such moments Yuri felt that the main part of his work was not being done by him but by something which was above him and controlling him: the thought and poetry of the world as it was at that moment and as it would be in the future. He was controlled by the next step it was to take in the order of its historical development; and he felt himself to be only the pretext and the pivot setting it in motion.
>
> This feeling relieved him for a time of self-reproach, of dissatisfaction with himself, of the sense of his own nothingness.[6]

The passage does more than merely confirm the role of language and of mastery, the way the relation of content and form is 'stood on its head', as Pasternak puts it. It throws an additional light on the psychological relevance of the process, the way, as we read, in which the forces of language relieve the artist of his 'self-reproach'. It is the medium, not he, that is active and that expresses these thoughts. There is something objective in his discoveries that rids the work of art of the taint of subjectivity and exhibitionism. Even the idea of historical forces whose instrument the artist becomes at such a moment can be stripped of its Hegelian and 'historicist' guise and placed in this objective context. For, surely, it is true that it is not only the medium and its potentialities but also the historical situation which the artist finds in the stylistic developments of his art which suggest, and sometimes even dictate, the solutions of which he makes use.

There is an element in all art—and certainly in all Western art—which might for brevity's sake be called the 'cat's cradle' element. Art, as Malraux has stressed, is born of art. The young artist takes over the game from his predecessors and as he does so he introduces variations. In Western communities, at least, art has thus become a social game played among artists and the pattern that emerges with each move owes at least as much to the moves that have gone before

[6] The translation in the English edition is by Max Hayward and Manya Harari (London, 1959).

233

as it owes to the ingenious variations introduced by the present player.

In the introductory chapter to his *Psychoanalytic Explorations in Art*, Ernst Kris drew attention to this aspect: the developments of art within a given problem-situation to which the artist adjusts and contributes. But the historian may be forgiven if he feels that in this problem of the interaction between medium, tradition, and personality a lot still remains to be done. If I may be permitted to quote a casual and private remark in this context, Ernest Jones himself expressed his perplexity to the writer as to what artists meant when they continually talked about 'the problem'—the problem that is, with which their paintings confronted them. But to those who play the game of cat's cradle these are real problems which are at least as much part of reality as are the problems of science or of daily life. They are dictated by the situation and not by the artist's mood or childhood experience. Once he is engrossed in this task of creating intricate and meaningful structures nothing else can matter to the artist. The problem has taken command.

There is a famous lecture by Paul Klee, *On Modern Art*, which contains as telling an introspective account of the modern painter's experience of the game as Pasternak's moving description of the poet's experience. Klee describes the many elements, line, colour, shape, out of which the artist creates his order. Their importance, as he puts it, is decisive also in the negative sense since it is they which decide 'whether a certain content may remain inexpressible despite the most favourable psychological disposition'. Klee sees the artist as a builder of structures who lifts the element up into a new order:

> While the artist is still entirely absorbed in his effort to group these formal elements so neatly and logically that each is necessary in its place and none impairs the others, there will be some layman who has been looking over his shoulder ready with the devastating remark: 'This does not yet look like a real man at all'. If the painter has enough self-control he will think 'real man' is neither here nor there, I must go on with my building. . . . This new building stone, he will tell himself, may be a shade too heavy and pulls the whole caboodle too much to the left; I shall have to put quite a telling counterpoise on the right to restore the balance.— And thus he alternates, adding something on either side till the pointer of the scales is centred. He will be only too glad if he finds that he did not have to upset the combination of a few suitable elements which had begun so well, at least no more than to introduce those contradictions and contrasts which are in any case inseparable from any configuration that is alive.

> Sooner or later, however, an association may occur to him even without the intervention of a layman and nothing prevents him from accepting it if it presents itself under a very fitting name. This assent to a representation may occasionally suggest in its turn one or the other addition that has a necessary connection with the formulated reference. If the artist is lucky these representational supplementations can still be fitted to a passage which faintly

234

seems to ask for them from a formal point of view and they look as if they had always belonged there.[7]

The psycho-analyst who is confronted with such an account may at first be tempted to doubt it. If he submits entirely to what I have called the centrifugal theory of artistic expression he will take it for granted that the artist always knew unconsciously what object would emerge and that the whole elaborate pretence at building a formal structure first is nothing but a rationalization hiding the real process from the artist and his audience. But this is not the interpretation suggested by Freud's 'centripetal' theory of wit. In this theory, it will be remembered, the aspect of play, the infantile pleasure in trying out combinations and permutations, is given due weight.

There must be (and there are) procedures in science and engineering where some medium or model is used for trying out structures through analogies and where techniques of systematic variation and permutation are used to discover fresh possibilities. The potentialities of these media—the way the analogue is and can be wired, as it were—its past history and results—all these form part of reality. To say that the experimenter knew somewhere, or somehow, beforehand which combination would prove useful for his purpose would surely be unrealistic. Wherever their disposition may stem from—and Freud never claimed to know the full answer—the painter will be inclined thus to play with forms, the musician with tones. Both of them may be no more able to predict these possibilities than anyone can predict what happens when we shake a kaleidoscope; but having shaken it we can admire and remember some of the results; we can even elaborate them when they strike us as meaningful while we discard and forget others. Hence the benefit even the greatest genius derives from the conventions of his time and from their mastery. Even a Mozart, when writing a light-hearted *divertimento*, may not have known or thought precisely what was going to happen to the simple theme he chose. But he knew that by putting it through the paces of certain modulations and developments something delightful was bound to emerge. Naturally his genius and his training made him select a theme suitable for this exercise, and even allowed him to foresee and reject out of the corner of his eye certain alternatives which would result in less interesting developments. But even a Mozart was indebted to the marvellous instrument of, say, the sonata or rondo form which his predecessors had handed to him and of which he had experienced the potentialities in continuous practice. The artist who thus experiments and plays—who looks for discoveries in language if he is a writer or a poet, in visual shapes if he is a painter—will no doubt select in that preconscious process of which Freud speaks the structures that will greet him as meaningful in terms of his mind and conflicts. But it is his art that informs his mind, not his mind that breaks through in his art. Just as the temptations of a pun may sometimes bring out an aggressive thought that would otherwise have remained unexpressed, so the structural possibilities of the cat's

[7] Paul Klee, *Über die Moderne Kunst* (Bern-Bümpliz, 1945).

235

cradle or the shake of the kaleidoscope may sometimes bring out a mood or an experience that would have remained dormant in the artist but for this vital suggestion.

It is this aspect that needs stressing if we are to gain the full benefit of Freud's Theory of Wit. No psycho-analyst will be inclined to doubt the power of circumstance in 'bringing out' a person's dormant or suppressed characteristic. When we say that 'the emergency brought out the best in him' or that 'army life brought out the worst in him' we mean precisely that these traits of the personality which would otherwise have been minimized by the conventions of everyday life were maximized by certain opportunities. Granted that it may be futile to ask whether it was the situation in literature that 'brought out' the romantic in Byron or whether it was Byron's temperament and disposition that bent the tool of literature further in this direction, no serious analysis of an artist's life and art should ever neglect the centripetal force of traditions and trends. Even Byron's art is not all 'self-expression'. Nor, if it is not, need it therefore be an empty pose. The alternative between genuine expression and mere convention which both artists and critics have sometimes framed in Freudian terms finds no support in Freud's theory of art.

At least one artist challenged Freud to spell out his views of this problem, and the precious record of this exchange is also published in the correspondence. It was Yvette Guilbert, the great *diseuse*, who in 1931 sought Freud's opinion about the actor's psychology. Clearly, she seems to have implied, the idea of self-expression must break down here since what makes a great actor is the capacity to identify with any number of different characters.[8] From Yvette Guilbert's autobiography, *La Chanson de Ma Vie*, it is obvious why this problem concerned her so much. She had gained her success with *chansons* of most dubious morality, representing on the stage prostitutes and criminals. She had been hurt and worried by the vulgar identification of the actress with the characters she portrayed, and she had naturally stressed the distance that separates the two.

Freud did not want to allow her this easy way out:

I should like to understand more about this and would certainly tell you all I know. Since I don't understand much of it I would ask you to be satisfied with the following hints. I would think that what you assumed to be the psychological mechanism of your art has been very frequently asserted, perhaps universally so. Yet this idea of the surrender of one's own person and its replacement by an imagined one has never satisfied me very much. It says so little, it naturally does not tell how it is done and, most of all, it does not tell us why something which allegedly all artists desire succeeds so much better in one case than in another. I would rather believe that something of the opposite mechanism must also come into play. Not that the actor's own person is eliminated but rather that elements of it—for instance, undeveloped dispositions and suppressed wishes—are used for the representation of intended characters and thus are allowed expression which gives the character concerned its truth to life. This may be less simple than

[8] The actress could here rely on the authority of Diderot's famous dialogue on acting, *Paradoxe sur le Comédien*.

236

that transparency of the ego you imagine. Naturally I would be eager to know whether you can sense anything of that other aspect. In any case this would be no more than one contribution towards the solution of the beautiful secret of why we shudder when we hear your *'Voularde'* or assent with all our senses when you ask *'Dites-moi si je suis belle'*. But so little is known. (*8 March 1931*)

The actress was not satisfied, and in his next letter Freud enjoys what he calls 'the interesting experience' of having to defend his theory against Yvette Guilbert and her husband, Max Schiller:

Really I have no intention of giving in to you, beyond confessing that we know so little. Look, for example, Charlie Chaplin was in Vienna. . . . He is undoubtedly a great artist though admittedly he always acts one and the same character, the weakly poor helpless and awkward youth for whom however things turn out well in the end. Do you believe that he had to forget his own ego playing this role? On the contrary he always acts himself as he was in his sad youth. He cannot get away from these experiences and still derives compensation to-day for the hardships and humiliations of those times. His is, as it were, a particularly simple and transparent case.

The idea that an artist's achievements are conditioned internally by childhood impressions, destiny, suppressions and disappointments has yielded much enlightenment to us and that is why we set great store by it. I once ventured to approach one of the very greatest, an artist of whom unfortunately all too little is known, Leonardo da Vinci. I was able at least to make it probable that his *St Anne*, which you can visit every day in the Louvre, would not be intelligible without the peculiar childhood story of Leonardo. Nor, possibly, would other works.

Now you will say that Madame Yvette has more than a single role, she embodies with equal mastery all possible characters; saints and sinners, coquettes, the virtuous, criminals and *ingénues*. That is true and it proves an unusually rich and adaptable psychic life. But I would not despair of tracing back her whole repertory to the experiences and conflicts of her early years. It would be tempting to continue here but something keeps me back. I know that unsolicited analyses cause annoyance and I would not like to do anything to disturb the cordial sympathy of our relationship. (*26 March 1931.*)

How sad it seems for us now that this fascinating exchange was terminated in a polite agreement to disagree. For if Yvette Guilbert had followed the hint and gone back to Freud's paper on Leonardo she would not only have found there the idea which Freud considered 'probable', that the *St Anne* reflected Leonardo's childhood story; she would also have found a much better documented account of Leonardo's intriguing playfulness, his enjoyment of riddles and fantasies. Moreover, she could have reminded Freud of his own

eloquent description in the opening pages of his study of Leonardo's many sketches 'each of which varies every one of the motifs that occur in his paintings in the most manifold manner ... displaying a wealth of possibilities between which he often wavers'. Putting these two observations side by side she might have shown how many of the features of Leonardo's Louvre picture were pre-figured in earlier drawings of the Virgin and Child in which the interaction of mother and son is studied in ever fresh permutations. Thus, taking her cue from this 'historical romance' she might have described to Freud what she was to describe in her memoirs—her own fascination with her medium and her ceaseless desire to explore and master all the potentialities of this instrument. It is not enough, we read there, for an actress or *diseuse* to articulate clearly:

> In addition she must be able to set any word aflame or extinguish it, to bathe it in light or plunge it in darkness, to throw it in relief or to soften it, to caress it or grasp it harshly, to advance or withdraw it, to envelop it or expose it naked, to extend or shorten it. Anything that brings a text to life or kills it, anything that makes for vigour, colour, style, that imparts elegance or vulgarity, all this science was the constant object of my endeavours.

The story is told (and it is an authentic story) of a young singer who approached Yvette Guilbert for lessons. She declined, but she gave the aspiring artist one piece of advice: to practise any simple statement such as '*Prenez place, Madame*' in some twenty different nuances from haughtiness to humility and pity. The way in which this phrase is said could reveal a whole situation.

Clearly in playing this game the great actress would not have to rely on situations she experienced in her childhood. What may be connected with her history and disposition is not the mastery itself but the will to obtain mastery, the interest in what can be done with language, the enjoyment of the game. True, if we may venture to reconstruct a dialogue that never took place, once this mastery was achieved certain combinations and configurations of tone and language might indeed have evoked a particular response in the artist, an echo from her own past. It is here that what Freud calls 'undeveloped dispositions and suppressed wishes' might have found an outlet inducing the actress to work on these with special zest and to embody these opportunities in her repertory. If that happened Freud might therefore have succeeded in making good his claim that he could trace these numbers in her programme back to their origins in an early personality trait—while Yvette Guilbert would still have remained right in claiming that the actor's art is rooted in the mastery of countless expressive elements.

It is this mastery alone which can arouse and liberate the dormant memories that come to life in the performance. Are we straining the meaning of Freud's words too much if we find this compromise implied in Freud's own remarks in the earlier of these two letters? He merely reminds the actress, after all, that besides her skill in impersonation '*something* of the opposite mechanism must *also*

come into play' (my italics). There is nothing here that contradicts his observations in the letter about Dali that 'the concept of art resisted an extension beyond the point where the quantitative proportion between unconscious material and preconscious elaboration is kept within a certain limit'.

The interpreter of the utterances of an admired master must especially guard against the danger of 'Talmudism': the temptation to read into the text whatever he desires to propound. There are many questions that remain open in Freud's theory of art, but it seems to me that there is nothing in his published writings and letters that conflicts with his outlook and his taste which are so firmly based on conservative standards. Unlike some of his less cautious followers, moreover, Freud never claimed to be in possession of the answer. He always stressed that 'we know so little'. It remains true.

Signs, language and behaviour

This book attempts, in the words of the preface, 'to develop a language in which to talk about signs, whether the signs be those of animals or men . . . whether they are signs in science or signs in art, technology, religion, or philosophy. . . .' Its main purpose is to make good the claim of behaviourism that it should be possible to describe all basic 'sign processes' in 'non-mentalistic' terms and that the way is therefore open toward a 'unification of science' in which the cleavage between science and the humanities will be overcome. To this end the author carries out a detailed analysis of what he considers to be the basic modes of signifying and the basic uses to which signs can be put in order to prove that all the principal classes of signs and of discourse can be described 'in terms descriptive of behavioural processes' (p. 60). In eight chapters with copious notes on technical points, a glossary, a historical appendix, and an extensive bibliography, Mr Morris hopes to lay the foundations for a comprehensive science of signs of the future which he proposes to call *semiotic*. It should embrace *semantics* or the study of significations, *syntactics* or the study of the mutual relation of signs, and *pragmatics* or the study of the origin, use, and effect of signs.

Two issues raised by this book are of vital concern to the historian of art. The programme 'to push semiotic as rapidly as possible in the direction of a natural science' (p. 8) closely affects the history of art as a branch of the humanities. The section 'Are the Arts Languages?' (pp. 192–196) provides us with a sample of scientific semiotic at work.

Mr Morris proposes to introduce a distinction between the *humanities* as a name for various types of discourse such as literature, art, morality and religion, and '*humanistics*', the 'metalanguage' in which we discuss this discourse (p. 230). His proposal is based on the distinction, which has proved so fruitful in modern logic, between the 'metalanguage' in which we talk about a system of signs and the 'object language', this system itself. Mr Morris is at pains to show that such a distinction, far from lowering the status of the humanities, would really help to establish it more firmly, because a developed 'humanistics' would be able to demonstrate the reasons why the types of discourse usually called humanities are of such importance to the individual and to society. It is the terminology of 'humanistics' which the author proposes to construct out of terms descriptive of the behaviour of organisms; in other words, of terms formulable in biological concepts which, it is hoped, might be formulable in their turn in terms descriptive of physical events. Once that has happened 'nothing prevents the formulation of laws concerning its subject matter whose relation to the laws of other branches of science can then be investigated' (p. 233).

It is fortunately not necessary for the discussion of this programme to reopen the whole controversy of behaviourism versus 'mentalism'. Mr Morris is far from denying the value of descriptive studies of signs in 'mentalistic' terms, and most 'mentalists' (if they

Originally published in *Art Bulletin*, 31, 1949, as a review of Charles Morris, *Signs, Language and Behavior*.

accept this label) may be ready to grant the possibility that behaviourism may one day make an important contribution to our knowledge of certain sign processes. But if the behaviourist urges 'humanistics' to commit its whole terminology to a behaviourally grounded science of signs, the onus is on him to prove that such a science is not only desirable but also possible. This, in fact, is the central theme of Mr Morris's book. He admits from the outset 'that we are certainly not at present able to analyze in precise behavioural terms the more complex phenomena of aesthetic, religious, political, or mathematical signs, or even the common language of our daily existence' (p. 11). He does not even assert that such terms as 'consciousness', 'thought', or 'ideas' in which we usually describe these phenomena are 'meaningless' (p. 28). His contention is merely that such terms are 'scientifically irrelevant', as any statement about them cannot be subjected to empirical tests. His position is, therefore, that if we want to have scientific statements about the humanities they must be grounded on an 'empirical science of signs' or they will not be scientific. Having arrived at this conclusion he is doubly anxious to prove that his programme is capable of fulfilment. But the way he chooses to furnish this proof may conflict with the very standards of empirical tests which the book is designed to uphold.

The author mentions the 'characteristic dogmatism of most philosophies with respect to other philosophies in their culture . . . their tendencies to claim as knowledge what is only belief' (p. 236). It can hardly have escaped him that this description also applies to his own outlook. More than once in the book we find him so eager to anticipate the results of a 'scientific semiotic' that he presents us with hypothetical experiments in which hypothetical dogs respond to certain sign combinations as Mr Morris postulates. There is admittedly a place for imaginary experiments in the exposition of terms, but those of Mr Morris are not only used for exemplification but affect the whole argument of his book.

He uses this type of construction to build a precarious bridge across the formidable abyss which to most philosophers of language seemed to separate the signalling systems of animals from the developed language of human society in which statements can be made. Language, as we learn from logicians, owes this distinctive capacity mainly to inconspicuous signs like 'and', 'or', 'all', 'not', the type of signs, in fact, which occur in the syllogism and which have come to be known as 'logical' or 'formative' words. In his treatment of what—with great fairness to the reader—he admits to be 'the most debatable issues in the field of the science of signs' (p. 153) Mr Morris wants to prove that these distinctive signs of language can, in fact, be described in behavioural terms. As the linchpin, then, of his whole argument that an 'empirical science' of semiotic is possible, we are presented with an elaborate description of an experiment (pp. 156f.) in which a dog is to respond to a sign signifying 'alternativity' (or the equivalent of the English word 'or'). The author does not claim that such an experiment has ever been carried out. But even if it had taken place in the form described, it is

241

doubtful whether logicians would admit that the meaning of 'alternativity' had thereby been translated into behavioural terms. For that to succeed, Mr Morris would have to show that the sign concerned had become to the dog—in the author's terminology—'plurisituational', that the dog recognized its signification in new contexts and even in combination with signs he did not know (as we would if Humpty Dumpty told us that 'the slithy toves did gyre *or* gimble in the wabe'). But is the introduction of such a fictitious dog not altogether an example of the tendency 'to claim as knowledge what is only belief'? The semiotic terminology of some two thousand years from Plato and Aristotle on was partly vitiated by the introduction of 'higher intellects' who could enjoy the 'direct intuition' of Ideas or Essences. Is the terminology of the next period to be burdened with the belief in the existence of some equally hypothetical 'lower intellects'? There is no reason to despair of the ultimate solution of the crucial problem of historical semiotic, the origin of language. In fact the recent book by Geza Révész, *Ursprung und Vorgeschichte der Sprache*, Bern, 1946—not yet known to Mr Morris when he wrote his book—seems to offer ground for hope, but if we are to have empiricism in semiotic let it at least be empirical empiricism.

Will the humanities, then, have to remain unscientific till these and possibly similar fissures in Mr Morris's edifice are repaired? And what if they prove irreparable? Are we then to be thrown back into irrationalism for good and all? It would not be the first time that the failure of a scientific theory to live up to its (unscientific) promise did grave harm to the credit of the scientific attitude. If we accept Mr Morris's conception of what constitutes scientific 'humanistics', this danger seems to me very real. But it also seems to me that the implication of his book that 'humanistics' can only be scientific if its basic terms are formulable in terms of the natural sciences rests on a very one-sided conception of what science does or can do. Even physics, after all, was a science long before its basic terms were scientifically defined—if indeed they are so defined now. The demand raised by Mr Morris that the statements occurring in 'humanistics' must be capable of objective tests is certainly of utmost methodological importance. Only a hypothesis which can be tested deserves to be called scientific. I would maintain, however, that a large body of such tested hypotheses does exist in what might be called the practical semiotic of the past. These hypotheses, it is true, are not of the same generality as those we meet with in the natural sciences. They do not concern 'laws' as to the 'nature of signs' but theories about the meaning of particular signs.[1] Such hypotheses we call, of course, interpretations, and these interpretations not only *can* be tested but often *have* been tested by standards which apply to the natural sciences and the humanities alike. The intelligence officer who 'interprets' an aerial photograph deals with 'natural signs'. He knows what shade of grey corresponds to what intensity of light and he is able on the ground of that knowledge to formulate a testable hypothesis about the objects denoted on the

[1] Cf. K. R. Popper, 'The Poverty of Historicism', *Economica*, May and August 1944, May 1945.

photograph. The same officer decoding a message deals with symbols. But here, too, his interpretation is based on the knowledge of certain rules of translation that allow him to formulate a hypothesis which he may be able to test by various means. It would hardly occur to him that by changing from one activity to the other he passes from scientific to unscientific procedure because he cannot express the modes of signifying of his message in biological terms. The methods and thought processes are the same, but the theories to which they refer are of more general validity in the first case (photoelectric laws) and of more limited validity in the other (the code). What may be different is the direction of his interest. He may refer to a known code to find out the meaning of the message, or he may collect messages to get at the code. In the first case his procedure is that of the technician who applies existing knowledge; in the second, that of the scientist who tries to arrive at new hypotheses.

The same, I suggest, holds good for the method of interpretation in the humanities. Some time ago in these pages (March 1941) Mr Millard Meiss interpreted certain signs on a painting by Piero della Francesca as signifying an Augustinian saint. His knowledge of this class of monuments and of the documents about the artist enabled him to formulate the hypothesis that the altarpiece in question must also have contained the figure of St Augustine. The 'prediction', it will be remembered, was verified by Sir Kenneth Clark (*Burlington Magazine*, August 1947), who found the missing fragment in Portugal. The fact that it fits into the gap can be proved by the measurements. This jigsaw puzzle test (as one might call it) must surely satisfy any scientific standards. In this case the historian's interest lay in the direction of a singular fact; he applied his knowledge of a certain class of signs (iconography) to a particular work. Admittedly the fragmentary preservation of the historian's material does not often permit such a neat testing of this type of hypothesis. But this difficulty concerns the methods of historical research rather than that of applied semiotic. Where material is abundant and the direction of interest reversed (toward hypotheses of more universal validity), the semiotician can in fact test his interpretations to a degree comparable to that of the natural scientist. Such triumphs of semiotic as the deciphering of hieroglyphs and cuneiform scripts have resulted in knowledge which is as scientifically grounded as that of the chemical properties of certain elements, and that for the same reason—the material for testing our 'readings' is practically unlimited. It is comforting to think that these results were obtainable without appeal to the fundamental issues of behaviourism versus 'mentalism'.

The problem of scientific statements in the humanities (or 'humanistics') and the criterion by which they can be tested may therefore turn less on a behavioural classification of signs than on a general methodology of interpretational procedures. Such a methodology would have to clarify the difference between the observation of responses to signs, the classificatory description of signs, and the translation of signs into other signs. Mr Morris's book is mainly con-

cerned with these first two questions but the third, a general theory of translation, may well prove indispensable for the development of a scientific semiotic. As we can only talk about signs in terms of other signs, we come up against the problem of the interchangeability of signs whenever we try to formulate what a sign we discuss in the humanities 'says'. The analogy with the metalanguage in logic breaks down at this point. The logical investigation of an inference is not concerned with its content but exclusively with its form. In the history of art we must discuss the 'meaning' of signs (whatever that may mean) in discursive speech. We are in fact not only observing responses and classifying signs but we are forced to probe into the possibility of their translation. Mr Morris's approach to the arts as a type of language poses this problem with increased urgency, for it seems a criterion of a language that it is (at least to a limited extent) translatable into another language. But Mr Morris's treatment of the signs in art gives us little guidance in this matter.

The author argues against Susanne K. Langer's *Philosophy in a New Key* that 'the case for the linguistic character of music and painting can be maintained with some plausibility if the iconic sign is made central (though not all-sufficient) in the analysis' (p. 193). An 'iconic sign'—it may be remembered from the author's earlier writings—'is any sign which is similar in some respects to what it denotes. Iconicity is thus a matter of degree' (p. 191). 'In the case of "realistic" painting and "programme" music . . . it seems clear that recognizable objects . . . furnish a vocabulary of signs which are then combined "grammatically" in various ways according to the style of a particular school or artist. It is true that such icons may become very general, as in the case of the "formal" or "automorphic" kinds of painting and music, but generality of signification is not the absence of signification' (p. 193).

The question is hardly quite as simple as the author would wish it to be. It is just the point that the 'recognizable objects' are translatable signs. Van Gogh's chair represents a chair. But we are all agreed that the picture, apart from denoting an object, also 'says' something else, and that this something (the aesthetic aspect) is less easily (if at all) translatable into words. Now a Kandinsky does not represent something 'more general' than a chair (if the term 'generality' is accepted in its usual meaning); it simply omits the translatable sign and 'says' what it says with other signs. We usually speak of 'expression' in this context but Mr Morris rightly reminds us of the 'disastrous' confusion surrounding this word (p. 69) 'since any sign whatsoever may be expressive' (p. 68). In fact it is not only the way in which Van Gogh paints a chair which is 'expressive' of his personality but also his decision to make a chair the subject of his painting or, for that matter, any other document of his life, letter or laundry bill, if we are only able to interpret its expressive significance. But this wholesome warning against an unprecise usage of one of the favourite terms of modern aesthetics cannot absolve us from the problem of describing the difference between Van Gogh and Kandinsky, between representational and non-representational

244

art. Mr Morris's example of what he means by 'generality of significa-
tion' is hardly very happily chosen. He tells us that he asked several
persons what Stravinsky's *Rite of Spring* might signify. He lists a
number of answers he received, such as 'a herd of wild elephants in
panic, a Dionysian orgy, . . . dinosaurs in conflict' (p. 193) and notes
with satisfaction that all the images had something in common (a
cynic might suggest that they all described noisy events). None of Mr
Morris's subjects thought that the music denoted a quiet brook or
lovers in the moonlight. The author concludes that the true signifi-
cation of the music must be formulable as the common denominator
of all answers received and lie in the direction of 'primitive forces in
elemental conflict'.

The legitimacy of Mr Morris's procedure in this instance is open to
serious doubts on the grounds of method. He uses the result of his
enquête to illustrate his theory that music denotes and may therefore
be plausibly described as a language. But his subjects were asked
something like a leading question. If Mr Morris had asked them what
a railway engine might possibly denote (and there are amusing par-
lour games on these lines), he would also have received a number of
corresponding answers (no one, I presume, would have suggested a
quiet brook) but this would hardly prove what railway engines do
denote. Mr Morris mixed the method of translation and that of
response. His subjects responded to the music by translating it into
imagery (faintly suggestive of Disney's *Fantasia*), and it was Mr
Morris who then 'generalized' the signification into a more abstract
concept. The way towards a scientific 'humanistics' can hardly lie in
this direction. It is certainly possible to translate one type of sign into
another, music into imagery, painting into lyrical prose, poetry into
music, and so on. A general theory of translation would have to
specify what it is that is translated in these procedures. But these
interpretations are certainly not scientific because there is no means
of testing their validity. It is precisely this type of interpretation
which we are striving to get away from in the humanities. If Pater's
famous interpretation of the *Mona Lisa* had included the response of
various of his friends or students it would not have become more
'scientific'—only less artistic.

But Mr Morris's discussion of interpretation is only incidental to
the main argument of his section on art which aims at allocating to
painting and music a place in his classification of types of discourse.
Two chapters of the book are devoted to the theme that an analysis of
basic sign behaviour reveals four basic modes of signifying, together
with four principal uses to which signs can be put. As each of the four
principal types of sign ('designative', 'appraisive', 'prescriptive',
and 'formative') can be put to each of the four types of use ('informa-
tive', 'valuative', 'incitive', and 'systemic'), Mr Morris arrives at a
kind of a priori classification of sixteen types of discourse which
he tries to identify with such existing categories as scientific
('designative-informative'), religious ('prescriptive-incitive'), critical
('appraisive-systemic') and propagandistic ('prescriptive-systemic')
discourse (p. 125). The author admits to a certain feeling of disap-

pointment at the result of this analysis (p. 185). It remains to be seen whether linguists or literary critics will find them of greater practical use than I. A. Richards's simple division into emotive and referential signs which they are meant to supersede.

Mr Morris's application of these behavioural classifications to signs in art does not go much into detail but this is not the main reason for the disappointment it causes. An analysis of the limitations of the 'iconic sign'—shades of Lessing!—leads him to the conclusion that 'music and painting have shown themselves most indispensable for appraisive valuative discourse, since they can embody vividly and concretely in their icons the very characteristics of the objects which in their appraisive capacity they signify as valuata' (p. 195). If Mr Morris rereads the page on which this argument occurs he will perhaps agree that the words he uses in this connection seem less suited to characterize the proverbial apples by Cézanne than a coloured advertisement for apples in which indeed 'an object can be presented for inspection which itself is prized and which iconically embodies the very characteristics of a goal-object concerning which the aim is to induce valuation'. Such icons may even cause some of us to 'salivate' in the most orthodox manner but they are hardly the type of sign we usually associate with art.

Perhaps it is not quite fair, however, for the art historian to blame the semiotician if he has failed to provide him with the tools necessary for the discussion of signs in art. While linguistics has collaborated with semantics for many years to elucidate problems of mutual interest the history of art has done little so far to prepare the ground for such studies. The distinction between poetry and language has always been accepted as natural; the distinction between art and imagery is only gradually becoming familiar.[2] Mr Morris himself stresses the need for more descriptive studies on visual signs (p. 190). It is all the more a pity that he does not seem to have taken cognizance of the emerging discipline of iconology, which must ultimately do for the image what linguistics has done for the word. In Mr Morris's bibliography of more than thirty pages we find only two items on pictorial art; one is Loran's book on Cézanne's compositions, the other Wölfflin's *Grundbegriffe*. The works of such pioneers in the study of the symbolic aspect of the image as A. Warburg and E. Panofsky are absent.

It will remain for a general iconology to clarify the relations between image and language which Mr Morris has raised. Mr Morris hardly distinguishes sufficiently clearly between the question of the linguistic character of 'art' and that of the visual sign. His statements on this question are unusually vague and hesitant. We hear (p. 194) that the arts may 'at least approximate the formative ascriptors of speech and writing' but (p. 195) that 'formators are clumsily handled in other media than speech or writing'. But are there any 'formators' corresponding to 'logical words' in the language of the image? Lessing noticed almost two hundred years ago that negation cannot be expressed through the image. What are the formators which the image can 'approximate'? The question may be formulated in this

[2] Cf. H. de Waal's inaugural lecture at Leiden University, *Traditie en Bezieling*, Rotterdam, Antwerp, 1946.

way: Are there images equivalent to verbal statements? That such images are possible in what Mr Morris calls in a useful term 'post language symbols' is not in dispute. Writing would never have been invented were it not for the capacity of images to replace words. But what of the images unaided by words or a fixed code of equivalences between words and images? The likelihood that such an image can be equivalent to a statement and contain 'formators' is a priori small, for if it did, something corresponding to the process of inference must be possible between images, as it is between statements. The question certainly deserves renewed analysis. Mr Morris quotes with approval a remark by Peirce that 'a portrait of a person together with the name of a person ... is no less a statement than the verbal description of the person' (p. 194). The historian of art knows surely that even this problem of the aided image is more complex than that. If he sees the image of a man with the name 'Hans Memling' written under it, he usually infers that the picture and the name do not add up to the type of statement to which Peirce referred. It is true that in other instances we are equally confident that the name identifies the sitter but this only emphasizes the information we receive through contextual aids. Karl Buehler has shown how the verbal statement gradually emancipated itself from its situational ('sympractic') context. The image has not travelled far along that road. A name and an image do not add up to a statement. The name must first be expanded into the statement: 'The above image is the portrait of X' to fulfil the condition Peirce had in mind. But even in that amended form the statement is far from unambiguous. We know that what functions as a portrait in one civilization may not be regarded as one in another. The mediaeval images of kings and rulers, or the 'altered portraits' of popular broadsheets, are not, as we know, equivalent to the verbal description of the person. They are highly generalized types or *similes*, and yet they are used to denote a particular individual. Conversely a highly individualized image of a person, in fact a portrait photograph, need not be used to denote the individual it 'represents'. It can be used in a generalized way to signify a fictitious hero or a social type—as any realistic Quattrocento saint or any poster showing the photograph of a benign butler offering a flask of whisky will testify. The fact is that the image unaided (because of the absence of such formators as definite and indefinite articles) is unable to signify the distinction between the universal and the particular. We cannot tell whether an image represents 'a horse' or a particular horse; any image in fact can be made to function either way. The attempt of classicist aesthetics to identify the 'generalized' or 'idealized' image with the 'abstract' or 'universal' is interesting mainly as an example of mistaken semiotic analysis. Looking back to Mr Morris's use of the term 'generality of signification' in relation to art one might sense the danger of a similar confusion. It is the danger that a diminishing 'degree of iconicity' might be identified with increasing generality of signification.

If the concept of the iconic sign is to carry us beyond the restatement of a mimetic theory of art it will have to be subjected to a very

close analysis. Linguists have shown that 'iconic' (onomatopoeic) words are not 'imitations' of certain sounds, but approximations of the sound, built out of the available 'phonemes' of a given language. Iconology may be able to demonstrate that an image that passes as highly iconic of reality is really less directly related to the object it denotes than it would at first appear. It, too, is built out of some primary noniconic shapes. We may find that it is these elements out of which icons are built, rather than the way in which they are then combined, which determined the 'style' of a school or period. Mr Morris's remark that 'the extent of . . . iconicity is a difficult matter to determine' (p. 191) points to another weakness in his conception of a continuum from highly iconic to noniconic signs. Perhaps there is hardly an image which is purely iconic. We are always confronted with an admixture of 'post language symbols'. The analysis of primitive art and of child art has made us familiar with the role which the 'conceptual sign' plays in these styles. Its link with the linguistic faculty (drawing is enumeration of characteristics) is known. Does the decrease of the conceptual (and conventional) image in art mark an increase in 'iconicity'? Is the primitive manikin, complete with ten fingers and toes, less iconic than the patch of colour which may denote a gondolier on one of Guardi's paintings? Here again many difficulties may be avoided by concentrating less on a morphological classification of signs than on an analysis of their interpretation. Guardi relies on the beholder's capacity to read 'iconicity' *into* his sign. The contextual, emotional, or formal means by which this type of interpretation is evoked or facilitated—in other words, the relation between objective 'iconicity' and psychological projection—would have to form one of the main fields of study of a descriptive semiotic of the image. Perhaps it will show that what has been called the history of 'seeing' is really the history of a learning process through which a socially coherent public was trained by the artist to respond in a given manner to certain abbreviated signs.

Once the beholder's attitude rather than the objective structure of the sign is moved into the focus of attention, even more problems relating to the concept of 'iconicity' will probably arise. Is God the Father in an altar painting, or Justice in a courtroom, to be regarded as an iconic sign (of God or Justice) or as a post-language symbol, a mere substitute for a written word? The answer clearly depends on the attitude and beliefs of the beholder. It even seems that certain classes of religious and allegorical imagery derive their appeal from the very fact that their 'degree of iconicity' remains indeterminate. They are neither regarded as mere ideograms of rational concepts nor as iconic representations of a visible reality but rather as the visual embodiments of a suprasensible entity.[3]

There is no end to the list of problems which the semiotic approach to art and imagery may raise. It is in this fact rather than in the specific methods he advocates with such power of conviction that I see the principal value to the art historian of Mr Morris's book. In the excellent concluding pages of his book the author shows himself fully aware of the fact that his account 'bristles with prob-

[3] I have discussed one aspect of this question in 'Icones Symbolicae', *Journal of the Warburg and Courtauld Institutes*, xi, 1948.

lems; it sketches a programme more than it records an achievement' (p.246). 'As the descriptive and logical aspects of semiotic expand, with mutual influence of each on the other, semiotic will become more a science and less a programme' (p. 248). Whether this 'science of signs' which 'is both on its way and yet has very far to go' (p. 246) will ultimately conform to the programme so persuasively drawn up for it by Mr Morris is perhaps only of secondary importance. Every one will agree, however, that 'the application of semiotic will further the growth of semiotic as a science'. The history of art and aesthetics can still make a contribution to this end.

Sources of photographs

The publishers would like to thank all the private owners, institutions and museum authorities who have kindly allowed works in their collections to be reproduced. Every effort has been made to credit all persons holding copyright or reproduction rights.

1: courtesy Marian Wenzel (Photo: Joel Shiner); 5: Historisches Museum Basel; 2: Courtesy of The Art Institute of Chicago, Gift of Mrs Potter Palmer; 26: The Detroit Institute of Arts, Founders Society Purchase, Eleanor Clay Ford Fund, General Membership Fund, Endowment Income Fund and Special Activities Fund; 45–47: Gemäldegalerie Alte Meister – Staatliche Kunstsammlungen Dresden; 11, 12, 25: Reproduced by Courtesy of the Trustees of The British Museum; 10: Photograph by courtesy of the Courtauld Institute of Art, London University; 38: Photo courtesy librarian BAL/RIBA; 13, 14, 27: Photographs by courtesy of the Warburg Institute, London University; 8, 9: Bildarchiv Foto Marburg; 3 & 4 (The Cloisters Collection, 1953); 6: The Metropolitan Museum of Art, New York; 37: Thomas Photos Oxford; 40–44: Bild-Archiv der Österreichischen Nationalbibliothek, Wien; 36: Reproduced by Gracious Permission of Her Majesty the Queen; 33 (Photo: © Pitt Rivers Museum, University of Oxford); 34: Courtesy of the International Council of Museums.

Index

254